P9-AOM-811

Zenkōji AND ITS ICON

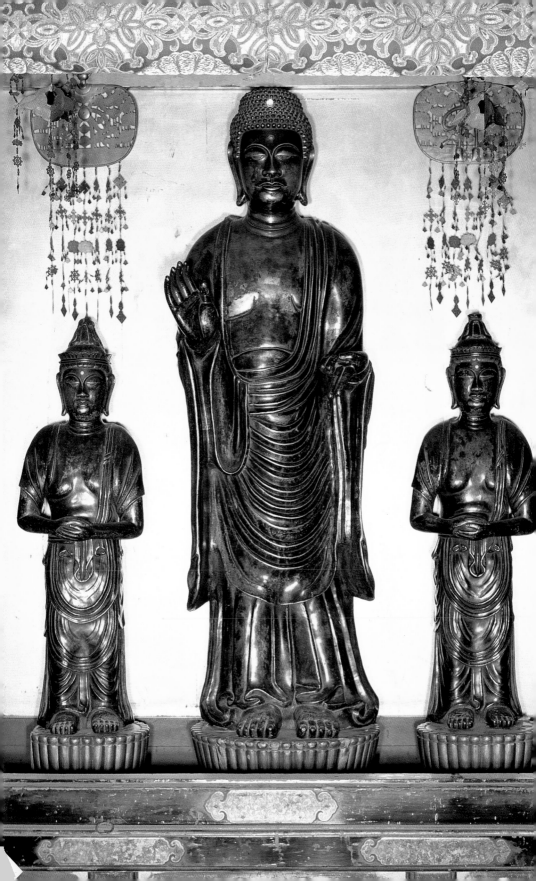

Zenkōji AND ITS ICON

A Study in Medieval

Japanese Religious Art

Donald F. McCallum

PRINCETON UNIVERSITY PRESS

PRINCETON, NEW JERSEY

Copyright © 1994 by Princeton University Press
Published by Princeton University Press, 41 William
Street, Princeton, New Jersey 08540
In the United Kingdom: Princeton University Press,
Chichester, West Sussex
All Rights Reserved

Library of Congress Cataloging-in-Publication Data

McCallum, Donald F.
 Zenkōji and its icon : a study in medieval
Japanese religious art
 /Donald F. McCallum
 p. cm.
 Includes bibliographical references and index.
 ISBN 0-691-03203-3
 1. Amitābha (Buddhist deity)—Art. 2. Gods,
Buddhist, in art. 3. Gilt bronzes, Japanese—To
1600. 4. Gilt bronzes, Buddhist—Japan. 5. Amitābha
(Buddhist deity)—Cult—Japan. 6. Zenkōji (Nagano-
shi, Japan) I. Title
 NK7984.A1M4 1994
 730'.952—dc20 93-41543
 CIP

The costs of publishing this book have been defrayed
in part by the University of California and by the 1992
Hiromi Arisawa Memorial Award from the Book on
Japan Fund with respect to *Noh Drama and the Tale of
Genji* and *Of Heretics and Martyrs in Meiji Japan*
published by Princeton University Press. The Award
is financed by The Japan Foundation from generous
donations contributed by Japanese individuals and
companies

This book has been composed in Janson

Princeton University Press books are printed on acid-
free paper and meet the guidelines for permanence
and durability of the Committee on Production
Guidelines for Book Longevity of the Council on
Library Resources

Printed in the United States of America

10 9 8 7 6 5 4 3 2 1

Frontispiece: Amida Triad (1195), Zenkōji, Kōfu.
Kamakura Period. Gilt-bronze.

FOR Toshiko

Contents

List of Illustrations

Preface and Acknowledgments

THIS MONOGRAPH responds to a large group of precisely defined icons distributed throughout Japan. Many date to the Kamakura period (1185–1333), although examples were produced in later periods as well. The icon is an Amida Triad: the central figure a representation of Amida, the Buddha of the Western Paradise, and the two flanking figures, Kannon and Seishi, his attendants. The normal material is gilt-bronze, and the great majority of extant icons are of small scale. This iconic lineage, referred to as the "Zenkōji Amida Triad tradition," is perhaps the most widespread example of the process of replication in Japanese religious imagery.

I first became generally aware of the significance of Zenkōji and its icon during a visit to Nagano City in 1966, at which time I lodged at one of the subtemples and witnessed the early morning ceremonies in the Main Hall. The following year, 1967, the Shinano Art Gallery, directly adjacent to the temple, held an extensive exhibition of Zenkōji-lineage Amida triads as part of its inaugural celebration. That show, surveying a broad and representative group of images, remains the largest that has been devoted to this icon type and represents a landmark in the study of the Zenkōji tradition. While I was deeply interested in this material, in the 1960s it was not seen as an appropriate topic for concentrated research and thus I focused my attention on more mainstream currents in Heian sculpture. Nevertheless, over the years I have taken advantage of opportunities to see numerous examples of Zenkōji images in exhibitions, and collected relevant information as it came to my attention.

For the last few years I have devoted a great deal of time to the study of the Zenkōji tradition. This effort has been motivated by both the intrinsic interest of the material and my growing awareness of new currents in the study of art history, taking into account developments in political and social history, economics, and religion. I concluded that the Zenkōji tradition provides an excellent case study for an exploration of some of these issues, particularly in terms of interdisciplinary investigation. A narrow focus on stylistic or iconographical factors clearly would not have produced fresh and useful results, but a broader perspective promised a more interesting outcome. And yet this very promise was fraught with

difficulties, for the variety of methodologies necessary and the great abundance of available data preclude mastery by a single scholar. I am well aware of the methodological and informational limitations of this study, but I have persisted in the hope that it will be seen as a preliminary effort toward an enhancement of the discourse concerning Japanese religious art.

While an increased sophistication in the study of art history has been developing rapidly in the Western world, these tendencies have as yet had only a limited impact on the study of Japanese art by scholars in and outside of Japan. Theoretical debate has raged in art historical circles in Europe and North America during the last couple of decades, making it difficult if not impossible for any art historian to be unaware of challenges to traditional practice. Some of this debate seems highly esoteric and not directly pertinent to actual art historical scholarship, but it is apparent that an increasing self-awareness about the nature of what we do as art historians can only have salutary consequences. As I will articulate in the following chapter, I intend this study to be an exploration of some of the crucial areas of human experience as related to the conception, production, and use of sculptural icons. In that respect, I hope that the results obtained will have a resonance extending far beyond the boundaries of Japanese Buddhist sculpture or even East Asian religion and religious art. In my view, the time is ripe for the incorporation of East Asian experience into a broader synthesis of human experience throughout the world.

Because of the long period of time occupied by this study, a rather large number of people offered me assistance and encouragement. I am afraid that recognition can be extended to most only by citing their names, but several require more detailed acknowledgment.

The late Dr. Kurata Bunsaku, Director-General of the Nara National Museum, enthusiatically supported my study of Japanese Buddhist sculpture from the beginning, and was especially helpful with regard to the Zenkōji tradition, a topic in which he himself had pioneered. Professor Kobayashi Keiichirō, the doyen of Zenkōji studies, has been unfailingly encouraging over a number of years, and a fountain of knowledge concerning the temples and Shinano Province. Mr. Takeda Kōkichi, the author of the first major study of Zenkōji icons in the Tōhoku region, greatly assisted my study in Yamagata Prefecture. Mr. Nishikawa Kyō-tarō, formerly Director-General of the Nara National Museum, and now Director-General of the Tokyo National Research Institute of Cultural Properties, has gone to extraordinary lengths to facilitate my research, especially with regard to the difficult problems of obtaining photographs

and reproduction rights. Dr. Nishikawa Shinji, Professor Emeritus of Keiō University, has established a standard of excellence in scholarship that remains a constant source of inspiration to me and others working in this field. Professor Shimizu Zenzō of Kyoto University has encouraged my studies for many years, and welcomed me to Kyoto University as a visiting scholar during the Fall of 1992.

On these shores, I wish to acknowledge directly the contributions of several people. It is with profound sadness that I must thank my mentor, Professor Alexander C. Soper, posthumously; his passing on January 12, 1993 took from us the last member of a towering generation of pioneers in Asian art history. Professor Soper enthusiastically read this study in manuscript and made numerous helpful comments; I deeply regret that he did not live to see it in published form. Professor John M. Rosenfield is another scholar who has encouraged my research for many years. He first suggested that this topic be worked up as a small article for *Archives of Asian Art*, and he was subsequently most helpful in giving the manuscript a close, critical reading.

Several colleagues generously read earlier versions of the study, and offered detailed comments and critiques. I would especially like to thank Drs. Karen Brock, Christine Guth, Audrey Spiro, and Melinda Takeuchi for all of their help. Closer to home, my colleagues in the Department of Art History at UCLA, particularly Professor Susan B. Downey and Professor Robert L. Brown, generously supported my research with friendly encouragement and advice. Also at UCLA, Professor Fred Notehelfer, Director of the Center for Japanese Studies, has unstintingly offered intellectual, moral, and financial support over the years. My students, Dr. Mimi Yiengpruksawan and Dr. Junghee Lee were of enormous assistance, while my research assistant, Ms. Yoshiko Kainuma, cheerfully and efficiently undertook numerous difficult and time-consuming tasks. Students in undergraduate classes and graduate seminars were remarkably tolerant of my long-term engagement with this topic, and enthusiastically responded to the issues it raised.

A number of colleagues in Japan helped with photographs and other matters, and I would especially like to thank the following: Mr. Asai Kazuharu, Mr. Harada Kazuhiko, Mr. Kaneko Hiroaki, Mr. Kitaguchi Hideo, Mr. Kobayashi Ichirō, Mr. Manabe Shunshō, Mr. Matsushima Ken, Mr. Matsuura Masaaki, Mr. Morimura Kinji, Mr. Sekine Shun'ichi, Professor Tanaka Yoshiyasu, Mr. Usui Kazuo, and Mr. Yamamoto Tsutomu. In the United States similar assistance was rendered by Mr. William Rathbun of the Seattle Art Museum and Dr. Ann Yonemura of the Freer Gallery of Art.

Much of the research for this study involved fieldwork throughout

Japan, and I am most grateful to priests in temples from Yamagata to Hiroshima for generously welcoming me and facilitating my work. Additionally, a number of librarians helped me to obtain obscure, local publications that are impossible to locate in this country.

Dr. Margaret Case, formerly Assistant Director of Princeton University Press, enthusiastically supported this project at the initial stages. Subsequently, I benefitted greatly from the advice and assistance of Ms. Winifer Skattebol, Mrs. Elizabeth Powers, and Ms. Elizabeth Johnson. Mr. J. Chase Langford, cartographer of the Department of Geography at UCLA, prepared the maps. To all of these individuals, my heartfelt thanks.

My parents in Canada and my parents-in-law in Japan have offered consistent help and encouragement over the years, for which I am most grateful. My greatest debt is to my wife, Toshiko, without whose unfailing support this project would never have been completed.

Zenkōji AND ITS ICON

CHAPTER 1 Introduction

Around that time, word spread that the Zenkōji

had been destroyed by fire. As regards that

temple's Buddha: there was a certain Amitābha

[Amida] triad sixteen inches tall, the most

precious set of images in the entire world.

JAPAN's most beloved and important story-cycle, *The Tale of the Heike,* here reports the disastrous burning of Zenkōji, which apparently occurred about the year 1179.[1] This tragedy is deepened when we are told that the Amida (Amitābha) Triad is "the most precious set of images in the entire world," an assertion that suggests unparalleled importance. While the text is not specific about the fate of the icon, one might reasonably assume that it, too, was lost in the flames, although this is not stated directly. In fact, other legendary literature recounts the miraculous escape from destruction by the Amida Triad on numerous occasions over the centuries, and certainly it was generally believed that the icon survived the fire of 1179.

Our story begins with the claim that a small, sculptural triad representing the Buddha Amida flanked by the attendant Bodhisattvas Kannon and Seishi is the "precious" icon referred to in *The Tale of the Heike.* The icon is believed to be still enshrined at Zenkōji (fig. 1, maps 1, 3), one of the largest and most famous of Japanese temples, located in Nagano City, the capital of Nagano Prefecture (Shinano Province in the pre-modern period). The triad in question is, however, no ordinary piece of sculpture, for worshipers have fervently believed that this icon is actually alive.[2] An extraordinary idea, but one which has to be accepted on faith since the Zenkōji Amida Triad is a secret image, not available for vulgar inspection. Associated with the icon is an elaborate cult that promised believers various rewards, including release from the terrors of hell and ultimate salvation in the Western Paradise of Amida. Historically, Shinano Province was considered a rather remote region, difficult of access because of the high mountains that cut it off from adjacent provinces. Nevertheless, over the centuries numerous pilgrims made the taxing journey to Zenkōji to pay their devotions to the triad. Originally there

was only one icon—the Living Buddha of Shinano Zenkōji—but the power of the main icon was such that replications were made and distributed to temples throughout Japan (map 2).

Considerable attention will be given in this study to beliefs and practices connected with the cult of the Zenkōji Buddha, with the aim of elucidating relations between worshiper and icon. While we obviously do not have direct access to the minds of premodern Japanese, the documentary evidence provides important data as to how they conceptualized the Zenkōji icon. The focus will be placed on how the worshipers responded to icon and cult, and an effort will be made to show how this response relates to changes in consciousness that occurred in Japan during the thirteenth century.

The great importance of sculptural icons for Buddhist practice in Japan can hardly be overestimated. From the earliest stages of Japanese Buddhism, during the sixth and seventh centuries, such icons played a crucial role in the propagation and growth of the new religion, and they continued to occupy a central position in the subsequent centuries. Most temples have a three-dimensional icon as the main object of worship, and many temples have a variety of such icons. I am stressing here the function of the sculptural icon as the focus for religious devotion, in order to direct attention away from conventional viewpoints that conceptualize these icons as works of art.

In contrast, Buddhist paintings do not normally function as the main object of worship in a temple. The range of Japanese Buddhist painting is great, including such categories as narrative scrolls, representations of single deities or groups of deities, abstruse theological diagrams such as the *mandala*, and the like. Clearly these and other types of paintings were highly significant for the religious life of the temple, and it would be a mistake to minimize their importance. Nevertheless, it is rare for a painted icon to serve as a central object of worship; this role is almost always taken by a three-dimensional, sculptural icon. A principal goal of this study is the explication of why this is so, with particular reference to Japan, but also in the context of sculptural icons used in religious practice throughout the world.

The corpus of Japanese Buddhist sculpture is extraordinarily large, ranging over a time period of more than a millenium, and including images representing a wide variety of materials, techniques, styles, and iconographies, spread throughout most of the country's regions. The sheer extent of this corpus is dramatized by the high aesthetic quality that characterizes a substantial proportion of its monuments. This quality, combined with the interesting variety seen in the extant examples, has

made Japanese Buddhist sculpture an attractive field for scholarly inves-
tigation. Although such research is still relatively undeveloped outside of
Japan, numerous Japanese scholars have devoted great energy to sculp-
ture, especially to monuments from Asuka through early Kamakura.
Thus, a subdiscipline—the history of sculpture—has dominated the
study and interpretation of sculptural icons, and there are seldom obser-
vations by art historians outside of that subdiscipline concerning Japa-
nese Buddhist sculpture.

Critical self-consciousness is not yet highly developed in Japanese art
history. Individual scholars identify themselves as specialists in fields
such as sculpture, painting, or architecture, and little attention seems to
be devoted to the examination of interdisciplinary boundaries. In a sense,
these fixed categories are perceived as natural, as given, thus not requir-
ing further thought. However, I believe that careful attention to these
categories is an essential prerequisite to further advances in the study of
the material. For this reason, I would like to spend a little time consider-
ing these matters.

Is the present monograph an example of the "history of sculpture"? On
a simple level, since it deals with a number of sculptural icons, it might
logically be designated as a work of that genre. And yet in important
respects it does not really fit the conventional definition of that category:
little attention is devoted to stylistic issues such as development and
innovation; not much is said about technical features; no effort is made to
extol the virtues of the images considered. In fact, I intend this study to
challenge some of the basic premises of orthodox "history of sculpture,"
in that the focus will be shifted from works of art thought of in aesthetic
terms to icons conceptualized in terms of religious function; what David
Freedberg refers to as "the power of images."[3]

One embarrassing problem of vocabulary must be confronted here.
Throughout this study I refer to art, art history, and art historians, but I
must confess great unease with regard to the applicability of the term
"art" to the types of icons with which we are concerned. Of course, this is
a broader issue within the study of religious imagery, since obviously
aesthetic motivations were not primary in the production of religious
paintings and sculptures. On the other hand, the care taken in the making
of images—call it artisanry—is evident, resulting in the possibility that
such images can be plausibly analyzed within a standard art historical
framework. In the case of monuments that are universally recognized as
"great art," there is an all-but-irresistible tendency to shift the focus from
religious to aesthetic factors, to offer explication in terms of "art." The
Zenkōji-related icons lack such dramatic aesthetic qualities, and thus

more easily accomodate a different approach. However, I would like to generalize this methodology to the degree that we can begin to look at all icons outside of the context of "art" as an aesthetic category.

While this study is a response to the general phenomenon of sculptural icons in the Japanese Buddhist tradition, a more specific area of concern is the process of replication. This is a matter requiring some explanation as it is absolutely central to comprehension. In a certain sense, all Buddhist icons must relate to a prototype, since clearly individual examples do not emerge out of a void, fully formed. Nevertheless, this sort of general developmental process differs significantly from what is here designated as replication, because it almost always involves subtle or not-so-subtle variations in style and iconography that occur over time and space. Of course, art historians are trained to investigate these broad stylistic and iconographical currents, and most studies concentrate on such matters. In the case of replication, a specific, precisely defined prototype forms the beginning of the sequence, with copies necessarily being directly based on the prototype, at least in theory. Such a situation does not offer a great deal of material for conventional art historical analysis since variation (i.e., stylistic or iconographical development) is largely absent. Consequently, replication traditions, such as the Zenkōji Amida Triad discussed in this monograph, have not usually received a great deal of attention from art historians. A fundamental premise of the present monograph is that failure to study carefully such traditions greatly impoverishes our ability to understand the function of icons.[4]

In the preceding paragraphs I have offered some general observations about the significance of sculptural icons and replication traditions in Japanese Buddhist art. Moving now from a rather abstract, theoretical approach to a more concrete analysis of specific monuments, let us consider briefly some of the important characteristics of the Zenkōji Amida Triad tradition. It consists, of course, primarily of sculptural icons that are produced through a process of replication. At present there are over two hundred examples of sculptural icons of Zenkōji affiliation, and there certainly were many more that have been lost over the centuries. This number makes the Zenkōji tradition one of the most important examples of replication in Japanese Buddhist sculpture. Especially interesting from a historical perspective is the fact that examples of the Zenkōji Amida Triad are found throughout most areas of Japan from the Kamakura period onward. This monograph will attempt to elucidate this phenomenon, examining both its origins and its development.

Although the Zenkōji Amida Triad tradition flourished during the Kamakura period, its foundations were established earlier, a fact that necessitates careful analysis of the preceding periods. Such an analysis

will enable us to understand the sources for this very impressive growth. However, it is as a Kamakura development that the Zenkōji tradition is most important.

There were fundamental transformations in political, economic, and social institutions during the thirteenth century in Japan. Ordinarily, this process is understood in terms of evolution from the Heian period, characterized by aristocratic culture, to the Kamakura period, embodying warrior culture. Often this aristocrat/warrior contrast is too strongly drawn, thereby blurring elements of continuity from the twelfth to the thirteenth century. In particular, the early decades of the Kamakura period, say the forty years from ca. 1185 to ca. 1225, exhibited cultural forms fundamentally determined by the tradition of preceding centuries. This is a highly important issue, for the standard viewpoints on Kamakura art are formulated almost exclusively in terms of monuments produced during these early decades, especially the works of Unkei, Kaikei, and their followers.[5]

The element of continuity from Heian to Kamakura that I have referred to is frequently neglected in standard discussions of early Kamakura sculpture. Virtually all treatments of this material imply a seemingly immediate, almost automatic transformation in forms, motivated by the rise of the warriors and the decline of the traditional aristocracy. This standard approach seems to me misleading, for it fails to consider the phase at which the new political and social forces at work actually begin to register a significant impact on the production of sculptural icons. The "realism" of early Kamakura sculpture, as seen in various works by Unkei, or the elegance and refinement of Kaikei's representations of Amida are not, in my opinion, direct reflections of the new political and social developments of the early Kamakura period. As is generally recognized, Unkei's realism is grounded in styles that hark back to the Nara period, but what is not usually much thought about is that Nara "realism" is directly associated with the highest levels of eighth-century society. Similarly, important qualities of Kaikei's sculptures are comparable in expression to many later Heian images, and certainly have little if anything to do with an aesthetic that can be associated with the rise of the warrior.

If the first few decades of Kamakura are seen in terms of significant continuity with the tradition that went before, at what point should we expect to see substantial transformation in religious imagery? I believe such a transformation would inevitably be a gradual process, but in searching for historical markers one might pay some attention to the Jōkyū Disturbance of 1221. The Kamakura military government endeavored to establish an administrative structure that concentrated polit-

ical and economic power in its own hands, but of course this system, being new, and contrary to the interests of court and aristocracy, was open to challenge. Retired Emperor Gotoba (1180–1229, r. 1184–1198), the dominant member of the imperial family at the time, balked at the usurping authority of the warrior class, and wishing to restore imperial rule, tried to marshal forces loyal to the court, but his supporters were quickly defeated by the Kamakura government. Hence, the strength of the military was significantly enhanced, not only in terms of confiscated property but also in a symbolic sense, for from this stage on it is apparent that there was little possibility for a full resurgence of traditional imperial institutions.[6]

The evidence suggests that the fundamental transformation from aristocratic to warrior culture probably became marked from about the 1220s. The solidification of military rule, the dominance of the warrior class throughout most areas of Japan, and the decreased power of court and old aristocracy are some of the defining factors. Certainly during the years 1220–1250 one can see a variety of changes coming to a head within social and political institutions that truly separate aristocratic from warrior culture. In starkly juxtaposing aristocratic and military culture, I may be overemphasizing to some extent the role of the warrior in the formation of a new social, political, religious, and cultural milieu. Certainly, the warrior was of tremendous importance throughout Japan during the Kamakura and subsequent periods, but there were many other social groups who also contributed to the formation of new attitudes, beliefs, and practices.[7] Without the establishment of innovative governmental and political institutions by the warrior class, a framework for the expansion of the Zenkōji cult would not have existed, but the creative efforts that produced that cult did not originate among the warriors per se. Rather, a complex mixture of elements from diverse sources, including orthodox Buddhism and popular religious beliefs, combined to mold a religious system that was enthusiastically accepted by many levels of society.

A period of significant social change inevitably involves imaginative changes that are manifested in religion and art.[8] The greatest error in the study of Kamakura sculpture, in my view, is the assumption that these changes are seen in the first decades of the period, as the dynamic political, economic, and social forces that established a medieval society based on warrior goverment were only beginning to build up momentum in the period 1185–1225. Thus, we cannot postulate a significant shift in artistic forms in these years. A change in consciousness powerful enough to determine religious and artistic forms only becomes historically evident

when we observe the Kamakura military government consolidating its power, and local warriors asserting their authority over the land.

This monograph seeks to demonstrate that the warrior class, as it grew in strength and self-confidence during the first half of the thirteenth century, thereby sought to establish religious practices and images appropriate to its own needs. In general, icons emerging from a traditional upper-class milieu—let us call it aristocratic—would be too expensive and probably inappropriate to the religious concerns of the local warriors. While there were obviously many possibilities, I would like to suggest that the icon type that is the subject of this study—the Zenkōji Amida Triad—is one important example of the selection of a specific icon for worship.

The implications of this hypothesis are startling. It requires us to eschew traditional ideas that would equate, say, the Muchaku and Seshin by Unkei at Kōfukuji, characterized by intense realism, with a new warrior aesthetic and consciousness and, instead, associate an "unrealistic" icon type—the Zenkōji Amida Triad—with warrior society.[9] One then can easily understand why mainstream art historians, both in Japan and abroad, have focused so singlemindedly on images such as the Muchaku and Seshin, seeing these, by traditional definition, as "great art" and examples of the Zenkōji tradition as more modest in artistic value. Needless to say, this study is not concerned with aesthetic rankings, and consequently we need not worry about the relative merits of various sculptures.

I have argued that the phenomenal growth of the Zenkōji cult was based on changes in consciousness amid the warrior class and other non-aristocratic groups during the course of the thirteenth century. The evidence for this, of course, is the very widespread distribution of Zenkōji temples and icons thoughout most areas of Japan, especially after about 1250. In order for this process of conceptual alteration to commence, a well-articulated cult had to be established at a central location, which is what occurred at Zenkōji during the latter part of the Heian period. Later in this monograph a good deal of effort will be devoted to an analysis of the establishment of the cult at the main temple. Nevertheless, nationwide diffusion of Zenkōji belief is undoubtedly the most convincing evidence of the power of the cult and its icon, since it directly aligns religious practice with new social and political developments among the warrior class.

The time has arrived for a substantial reevaluation of conventional assumptions concerning religious icons in Japan. No longer can we afford to devote the vast majority of our attention to images produced only

for the ruling classes, thinking of such monuments in terms of aesthetic quality. Rather, we should begin focusing on religious beliefs and practices that might appear, from a conventionally intellectual perspective, to be somewhat primitive, even embarrassing. This study will touch on topics such as "living icons" and "otherworld journeys," issues that seem to me to be of fundamental importance in providing a full and convincing explication of the significance of the cult of the Zenkōji Amida Triad.[10] While there is an intrinsic value in presenting a full analysis of the Zenkōji icon, I believe that the results achieved in this study will also shed a great deal of light on the overall significance of icon worship in Japan. In that sense, the goals of the study are ambitious, perhaps too ambitious, but I will be satisfied if more attention begins to be directed to a broader range of religious icons, and away from the seductiveness of so-called great works.

Above all, this study is an interpretation of a rather large number of sculptures that belong to a precisely defined iconographical category. Of fundamental importance, from a religious perspective, to its execution is the relationship between the Living Buddha of Shinano Zenkōji and its numerous replications. However, since the Shinano Zenkōji Amida Triad cannot now be inspected, our only access to its appearance is through the numerous copies, most of which can be seen in their respective temples on special occasions. While all of these copies share some features, we cannot designate any specific image or group of images as the authentic version of the prime object. Consequently, at this stage the best procedure is probably to sketch a composite picture general enough to capture the features common to the overall tradition.

Complete versions of the Zenkōji Triad have as their central element a standing figure of the Buddha of the Western Paradise, Amida, flanked by standing depictions of two attendant Bodhisattvas, Kannon to Amida's left and Seishi to his right. Each deity is placed on an individual pedestal, and the three are backed by a large, boat-shaped mandorla. The central figure is approximately 45 cm tall; the flanking figures each about 30 cm tall; and all components of the triad are normally made of gilt-bronze, although there are a few examples of the utilization of other materials. Examples of essentially complete triads include those of Engakuji (1271—fig. 30) and Nyoraiji (1304—fig. 46). This format is characteristic of a number of sculptural icons in early China, Korea, and, to a lesser extent, Japan. Later in this study a detailed analysis will be provided of the varied configurations of Zenkōji tradition Amida triads, but here it should be noted that the key identifying element of a Zenkōji Triad is the hand position of the two Bodhisattvas. As can be seen in any of the Bodhisattvas illustrated, all hold their hands together in front of the

chest, sometimes in a form depicting the grasping of a jewel, at other times with the two hands flush, palm to palm. If either of these hand positions is present in the flanking Bodhisattvas, one can be virtually certain that one is dealing with a Zenkōji Amida Triad.

The format just described is characteristic of earlier phases of Japanese Buddhist art, namely the Asuka and Hakuhō periods, and it would normally be thought of as archaic in typology. Moreover, the utilization of gilt-bronze is also typical of these earlier periods. Surprisingly, indications of the long evolution of Japanese Buddhist sculpture from the eighth through the twelfth centuries are generally absent in the available examples of the Zenkōji-type Amida Triad. Clearly, then, the icon type dealt with in this study is what is conventionally referred to as an "archaistic" type. The motivations behind the utilization of such an archaistic type of icon, and the reasons for its great popularity, will occupy our attention later; here we need only emphasize how really unusual this icon type is within the broader evolution of later Japanese Buddhist sculpture.

The chronology of the Zenkōji Amida Triad is a matter of central importance for this study. In subsequent chapters I will present the data relating to the legendary history of the icon and analyze the extant sculptures; as will be very apparent, grave difficulties are encountered when one attempts to establish a plausible chronological framework for the Zenkōji tradition. No extant images date before the Kamakura period, although the documentary evidence clearly indicates the existence of a Zenkōji cult by about the middle of the Heian period. Within this framework we are dealing with an icon type, just described, which is related to a much earlier stage in Buddhist art, basically the sixth and seventh centuries in its Japanese development. One of the most puzzling problems associated with the Zenkōji tradition is how to explain the existence of an archaic icon type as the focus of a cult that flourished in the Kamakura period.

Two explanations need to be considered. Perhaps an old image from the early phases of Buddhist sculpture in Korea and Japan was already enshrined during the seventh century at a temple that subsequently became Zenkōji. This image was treasured over the centuries, and was transformed into the central icon of the Zenkōji cult some time about the middle of the Heian period. I favor this hypothesis since it offers a plausible explanation for the archaic character of the images of the Zenkōji tradition. A second hypothesis suggests that an image was brought to Zenkōji during the later part of the Heian period and that it was this image that became the central icon of the cult. The attractiveness of this viewpoint is that it connects the genesis of the cult with the introduction of the main icon to Zenkōji. What it fails to do, in my view, is to offer

a convincing explanation of why images in the Zenkōji tradition have an archaic form that is essentially unrelated to Amidist imagery of the Heian period.

Setting aside this issue for the present, we must consider briefly what can be said about the development of Zenkōji triads during the Kamakura period. Later I will show that there is a small group of icons dating to the early decades of the Kamakura period of extremely varied characteristics. Then, from about 1250, we see numerous icons that are quite consistent in iconographical traits. This situation suggests that while there may not have been a generally accepted canonical icon type at the beginning of Kamakura, during the first half of the thirteenth century a process of standardization occurred. I will argue that this process was probably completed in the course of the second quarter of the thirteenth century, a time framework that connects neatly with the increasing dominance of the warrior class after the Jōkyū Disturbance, discussed earlier.

A central focus of this study will be the process whereby a single sacred prototype—the Living Buddha of Shinano Zenkōji—became the source for a multitude of copies found in temples throughout Japan (map 2). In explaining this process, considerable attention will have to be paid to the role of itinerant religious practioners—*hijiri* (聖) —in the diffusion of the cult. The significance of the hijiri looms large, for their lifestyle and activities were substantially different from the orthodox priesthoods associated with the traditional schools of Buddhism. Concomitantly, the temples in which the icons were installed, frequently called *Shin Zenkōji* ("New Zenkōji"), differ in many respects from the older establishments, chiefly in their association with a powerful current of popular religion that has long been a crucial, but neglected, aspect of Japanese religion.

There is one other aspect of the cult of the Zenkōji Buddha worthy of detailed analysis. In contrast to the traditional schools of Buddhist practice, which generally began at higher social levels and then spread downward, many aspects of the Zenkōji cult appear to have originated at a folk or popular level. Subsequently, after the cult was well formulated, it achieved support from various powerful groups, especially the warrior class, ultimately receiving the patronage of the supreme political leaders of the land. The socioeconomic analysis of the history of the cult of the Zenkōji Buddha should prove useful in understanding some of the fundamental transformations that took place in Japanese culture from the Heian to the Kamakura and succeeding periods. In particular, we should be alert for signs of ideas and practices percolating up from below, for this tendency accounts for some of the vigor observed in later Japanese society.

It might be useful to try to locate this study within the broader frame-

work of Japanese Buddhism and Buddhist art. With regard to the academic study of Japanese Buddhism, anyone familiar with the standard accounts will know that the Zenkōji cult is never emphasized, and frequently goes totally unremarked. For example, a recent discussion of Kamakura Buddhism by Ōsumi Kazuo, which can be regarded as an orthodox treatment, has absolutely no mention of Zenkōji or its icon.[11] Does this situation indicate that our subject is only of peripheral interest? I believe that a number of factors must be considered in understanding the widespread—and inappropriate—neglect of the the Zenkōji tradition.

Perhaps the most significant factor is that the Zenkōji cult does not have a charismatic founder who can serve as the focus for a carefully constructed narrative. Of course there was a legendary founder, Honda Yoshimitsu, whom we shall consider presently, but no individual of the stature of Hōnen, Shinran, Eisai, Dōgen, Nichiren, or Ippen, the "founders" of the new schools of Kamakura Buddhism. The study of Kamakura Buddhism has been dominated by a preoccupation with specific individual contributions, with the result that broader, more anonymous developments are often slighted. I will argue that such is the case with the Zenkōji tradition. Related to this is the absence of a sophisticated textual corpus. Scholars who study Buddhism tend to be text-oriented, and they seek as objects of research writings that are susceptible to a type of philological and theological explication related to their background and training. In recent years some attention has been directed to Zenkōji-related texts by scholars concerned with popular religion, but the level of interest is still relatively low.

Shinano Zenkōji, of course, is a temple located outside of both the old capital and newer centers of power, such as the city of Kamakura, the seat of the military government, during the Kamakura period, and the majority of the Shin Zenkōji are in remote areas. This factor seems to have worked against research on the Zenkōji tradition, since most scholars have tended to emphasize developments in the central regions. Furthermore, the Zenkōji cult frequently catered to the needs of less prominent members of society, people who have been largely ignored by mainstream investigators. I believe that the old paradigm, which concentrated on the upper classes, is in need of basic revision. Fundamental changes in Japanese society took place during the course of the thirteenth century, and many of these changes occurred outside of the capitals among so-called peripheral groups. Continued failure to address these issues precludes a full articulation of some of the most important developments in medieval Japan.

A final issue is of particular importance. In essence, the Zenkōji tradi-

tion is an icon cult, but, as stressed above, it is a replication tradition of a type that has not drawn widespread interest on the part of orthodox art historians. On the other hand, historians of Buddhism are usually not well equipped to analyze icons, and they have consequently slighted this body of material. In a sense, the Zenkōji cult has fallen between the cracks, not receiving adequate attention from either of the most relevant disciplines. In my view this is a most unfortunate situation, for it prevents a comprehension of one of the most dynamic processes in Kamakura and post-Kamakura Japan. I will make very strong claims for the importance of Zenkōji and its icon, for the replications enshrined throughout the country, and for the related cult practices; I see this body of material as one key to our understanding of important developments in Japanese society, rather than as a footnote to traditional art history or Buddhist history.

The second chapter, "Shinano Province before the Kamakura Period," will consist of a detailed consideration of Shinano Province from earliest times through the Heian period, and is designed to lay the foundations for our subsequent analysis of the origins and growth of the cult of the Zenkōji Amida Triad. Such intense concentration on local history may initially seem excessive, but is intended to direct the reader's attention to a major focus of the present study, namely, the contrast between center and periphery. This monograph is an investigation of a provincial rather than a capital-city phenomenon, and the full richness of the local tradition must therefore be properly articulated. Naturally, some consideration will also be given to developments in the capital in order to provide the appropriate framework for the more careful discussion of Shinano.

Chapter 3, "The Origins of the Zenkōji Amida Triad," will be entirely different in character. Here we will approach the problem from two directions, first analyzing the documentary sources associated with the triad, and then considering the evidence that may allow at least a hypothetical reconstruction of the original icon. This two-pronged approach is intended to produce a general conception of the sort of cult and icon that ultimately developed into the Zenkōji Amida Triad tradition. Chapters 2 and 3 should have the cumulative effect of enabling the reader to grasp how and why this cult sprouted in Shinano Province sometime after the middle of the Heian period, but at latest by ca. 1100. Thus, although the two chapters are contrasting in methodology, they are complementary in purpose and results.

It is as a Kamakura phenomenon that the cult of the Zenkōji Amida Triad achieves its fullest flowering, and so Chapter 4, "Zenkōji and Its Cult in the Kamakura Period," will strive to elucidate the very broad

range of factors that contributed to this growth. Particularly important
will be the analysis of the relations between Zenkōji and the Kamakura
military government, for the Zenkōji cult had an extremely close associa-
tion with all levels of the warrior class, from the *shōgun* on down. Follow-
ing this discussion of what might be designated as the political dimen-
sions of the Zenkōji cult, we shall turn to a consideration of some of the
major aspects of Kamakura Buddhism, focusing on the Amidist currents
especially as they developed on the popular level. Needless to say, these
political and religious factors are intimately related, so that our separate
treatment of them must be understood in terms of clarity of presentation
rather than as implying two distinct spheres of human activity. With this
material in place, it will be necessary to concern ourselves with some
more specific aspects of the Zenkōji cult. Earlier I referred to the great
importance of the hijiri (itinerant preachers) and the network of temples
that they established (Shin Zenkōji), and here a detailed analysis of these
factors will be presented. The aim will be to delineate a unified presenta-
tion of the context that includes icon, texts, priests, and temples.

In Chapter 5, "Early Kamakura Copies of the Zenkōji Amida Triad,"
we will undertake a careful analysis of the small group of icons produced
at the beginning of the Kamakura period. This discussion will enable us
to observe the salient characteristics of these very important early monu-
ments, as well as providing a basis for our consideration of the much
larger number of images dating to the later part of the period. Some
attention will also be paid to the significance of gilt-bronze as a material
for icons of the Zenkōji tradition.

Chapter 6, "Later Kamakura Copies of the Zenkōji Amida Triad," will
discuss the main corpus of icons, which dates between ca. 1250 and 1330.
Because of the richness of the extant material from these decades, all
examples cannot be considered, but enough will be analyzed to produce a
reasonably comprehensive picture of their characteristics. Chapters 5
and 6 will be primarily art historical in character, aiming at a descriptive
analysis of both individual images and broader lineages. For that reason,
not a great deal will be said here about the broader contexts within which
the icons functioned. Nevertheless, it is essential that we remember that
they were produced and utilized in the type of environment articulated in
Chapters 2 through 4, and thus a certain imaginative effort is required to
unify these two sections of the study.

With the preceding chapters we have a basic presentation of the Zen-
kōji tradition through the Kamakura period. The discussion could be
terminated at this point, for the major components of the cult had cer-
tainly all been formulated by this stage. However, the story is not yet
over, for in later centuries the Living Buddha of Shinano Zenkōji became

entwined with some of the most important events of Japanese history. Thus in Chapter 7, "The Later History of Zenkōji and Its Icon," we shall deal with some fascinating episodes, particularly those originating with the Kawanakajima Battles of the mid-sixteenth century. We shall see how the Main Icon of Shinano Zenkōji was taken from the temple by the warlord Takeda Shingen and transferred to his seat at Kōfu. Following this event, the triad passed through the hands of Oda Nobunaga, Toyotomi Hideyoshi, and Tokugawa Ieyasu, before finally returning to Shinano in 1598 (map 4). It is fair to say that no other Buddhist icon in Japan was ever subjected to the treatment received by the Zenkōji Amida Triad during the second half of the sixteenth century. Why this took place is clearly a crucial part of the total story. Beyond the intrinsic interest of these events, an understanding of their significance should assist us in elucidating the status of the icon and its cult in late medieval Japan. Chapter 7 will conclude with a brief survey of the activities of Shinano Zenkōji during the Edo period. Here we will see how the temple coped with the radically new circumstances for religious institutions that resulted from the policies of the Tokugawa *bakufu*.

In Chapter 8, "Conclusion," an effort will be made to draw together all of the strands of evidence investigated in the preceding chapters, moving from a focus on specific detail to more general observations and synthesis. Here the theoretical implications of the cult of the Zenkōji Amida Triad will be probed, revealing the icon and its cult within the broadest possible framework. This should enable the reader to see the significance of the cult of the Zenkōji Amida Triad within the broader fabric of Japanese history. Beyond this specific goal, my hope is that this analysis will be a general contribution to the study of icons and their use throughout the world.

CHAPTER 2 Shinano Province
before the
Kamakura Period

THE ORIGINS of the temple that became the
historical Zenkōji are shrouded in the mists of early Japanese history and
perhaps irretrievably lost. Nevertheless, an attempt to reconstruct the
context within which the earliest temple may have developed is essential
as background to the flourishing activity of the temple during later pe-
riods. Although the following remains speculative, as the available data
do not allow definite assertions, a general picture can be sketched that has
a reasonable degree of plausibility.

Zenkōji is located in one of the most attractive mountain areas of Ja-
pan (maps 1, 3). The beauty of the region and the fame of the temple have
combined to make this area a desirable goal for very large numbers of
both pilgrims and tourists. This is the situation today, and also seems to
have been the case in premodern times. In terms of contemporary geo-
graphical designations, Zenkōji is situated in Nagano City, the capital of
Nagano Prefecture, within the central highlands of the main island of
Japan, Honshū. Nagano City dominates a broad basin, called the Zenkōji
Plain, in the northern part of the prefecture. The city is located near the
intersection of two major rivers, the Chikumagawa and the Saigawa,
which cross the Zenkōji Plain. Frequent flooding of these rivers has
produced rich alluvial soil, which has allowed for intensive agriculture. In
addition, the spawning of salmon on the Chikuma River provided a
reliable source of food up until recent times. Although the area has rather
cold winters and hot summers, generally speaking the climate is moder-
ate and hospitable to human habitation.

The Zenkōji Plain in the Yayoi
and Kofun Periods

The archaeological record indicates a sub-
stantial population in the Zenkōji Plain from early times. During the
Yayoi period there was a well-developed culture along the Chikuma
River referred to as the *Hakoshimizu* tradition.[1] Widespread cultivation

of rice led naturally to the development of complex social institutions throughout Japan during the Yayoi period, and undoubtedly the same process was operative in the Zenkōji Plain.

Building on the agricultural foundations established during the Yayoi period, the succeeding Kofun period witnessed a cultural florescence in the Zenkōji Plain.[2] Generally, Nagano Prefecture seems to have lagged somewhat behind the developments seen in the central region. Thus, the Yayoi continued into the fourth century in Nagano, and there does not appear to have been a period equivalent to Early Kofun (fourth century) there. In the fifth and early sixth centuries, a fully formed Kofun culture developed in Nagano. A significant proportion of the large number of tombs erected throughout the prefecture during the Kofun period are found in the Zenkōji Plain, thus indicating the economic and political importance of the area. In particular, the presence of twenty-three large-scale keyhole tombs in the Zenkōji Plain dating from the fifth and sixth centuries suggests the existence of a political unit with chiefs of considerable power.[3]

Surveys of Japanese political and cultural history assume a transition from the proto-historic Kofun period to the historic Asuka period some time during the sixth century.[4] A convenient marker for the postulated shift is the so-called official introduction of Buddhism, traditionally given as A.D. 552 and now usually thought to be 538; however, the usual concept of Kofun-Asuka transition is based primarily on an examination of the situation in the Yamato basin. The introduction of Buddhism, as well as a whole range of aspects of continental civilization transmitted via the Korean Peninsula, radically altered the political, religious, and cultural situation of the Asuka region and perhaps some adjacent areas as well.[5] Clearly, the process observed in the Yamato basin does not signify similar processes in all other areas of Japan; Nagano Prefecture apparently experienced no historical era analogous to the central region's Asuka period. What, then, can be said about Nagano during the decades equivalent to the Asuka period?

A Kofun-type culture continued to flourish in Nagano well into the seventh century.[6] This, of course, is not surprising, since a similar phenomenon can be seen in many areas of Japan. Archaeologists have shown that some of the Nagano tombs of the later sixth and seventh centuries have typological relationships with tombs found on the Korean Peninsula, suggestive of the presence of immigrants from Korea.[7] Since a unified Korean/Japanese sphere existed along the Japan Sea coast, the Korean elements seen in northern Nagano Prefecture presumably reached the region from the coastal area corresponding to present Niigata Prefecture. Later, an examination of the Korean connection in

Nagano may be helpful in explaining certain important aspects of the Zenkōji tradition.

The Early Historical Period

One of the most controversial problems in the historiography of early Japan is the nature of the so-called Taika Reform of 645.[8] Traditional historians, following the imperial ideology of *Nihon Shoki*, maintain that this event signified the establishment of a well-regulated central government, based in the Asuka region, which exerted considerable authority over the various areas of Japan. Proponents of this viewpoint suggest that a remote area, such as Nagano, came under the direct authority of the "imperial court" shortly after the promulgation of the reforms. Revisionist historians have argued in recent years that the evidence for the Taika Reform is at best shaky, maintaining that it is largely a fiction devised by the authors of *Nihon Shoki* in the early eighth century to create the impression that the then-dominant imperial clan was already in effective control of the state at the middle of the seventh century. We need not resolve this controversy here, although the revisionist position appears to offer a more plausible interpretation of the political situation of Shinano Province during the second half of the seventh century, since during that period little evidence of the authority of a central government is apparent. Traditional political and cultural institutions continued, often with quite close connections to those of the Korean Peninsula. Such connections probably reflected people's coming directly across the East Sea/Japan Sea rather than indirectly, via the Yamato area.

The preceding pages have traced the political and cultural development of the Zenkōji Plain through the seventh century. The basic image that emerges is of a vigorous, locally based culture, much like that in other outlying regions of Japan, and presumably largely independent from the political authority of the Yamato polity. Before turning to the situation during the eighth century, a final important problem related to the seventh century must be addressed. Most studies of Zenkōji have argued that the temple—or at least a forerunner thereof—was established during the Hakuhō period (645–710) on the basis of a number of roof tiles discovered at the site of the present Zenkōji.[9] Some scholars have interpreted the recent discovery of closely related tiles from an Early Heian site in Nagano City as suggesting that the tiles found at Zenkōji are themselves of a later period, rather than dating to the Hakuhō period. However, Ushiyama has pointed out that the same form was used for tiles at a given temple for long periods, even centuries, when

repairs were made, and thus he argues that the newly excavated tiles do not necessarily prove that the tiles found at Zenkōji date to the ninth century.[10] Currently, there is no reliable evidence of a pre-Heian temple at the site of the present Zenkōji.

On the other hand, the possibility of a temple dating from the seventh or eighth century cannot be dismissed entirely, and I would like to develop a tentative hypothesis postulating the existence of an early temple at the Zenkōji site. There is substantial evidence for the presence of immigrants from the Korean Peninsula in the Zenkōji Plain during the later sixth and seventh centuries. It is well known that during the later Three Kingdoms period in Korea, especially from the mid-sixth century onward, a gradual transition from a tomb culture to Buddhism occurred. Leaders of the ruling clans shifted their resources from the construction of mounded tombs to the erection of Buddhist temples containing icons. As mentioned earlier, archaeological evidence suggests that immigrant groups crossing the East Sea/Japan Sea brought Buddhism with them directly from the continent to their new communities along the Japan Sea coast. Perhaps a prominent local immigrant clan constructed a Buddhist temple in the Zenkōji Plain during the seventh century. This proposal goes counter to the usual assumption that people from the Korean Peninsula reached the outlying areas of Japan via the Yamato basin, but a reexamination of the basis of that idea is in order.[11]

Historians of Japan refer to the formation of a centralized state as the establishment of the *ritsuryō* system, a system consisting of civil and penal laws allowing the effective administration of the country.[12] While the beginnings of the ritsuryō system are frequently taken back to the so-called Taika Reform of 645, I believe that this "event" is largely a later reconstruction. Presumably the central government in the Yamato basin began to assume more than local authority some time after the triumph of Emperor Tenmu in the Jinshin Disturbance of 672.[13] Also, the unification of the Korean Peninsula by Silla in the 670s would have provided a strong motivation for the dominant Yamato clans to attempt a similar unification of the Japanese islands. Regardless of whether this was a significant factor, by the 680s and 690s indications of a strong administrative structure emerging in the Yamato basin are observed. Certainly the move to the Fujiwara Capital in 694 is persuasive evidence for the existence of a central government with sufficient political power to exert authority on outlying areas. The process of enhanced centralization reaches an early culmination with the foundation of the large-scale capital, Heijōkyō (Nara) in 708 and the move of the court there in 710. The years between 710 and the shift of capital to Heiankyō (Kyoto) in 794, are referred to by historians as the Nara period. During this period a

bureaucratic state developed, able, at least in theory, to govern the entire country.[14]

When we shift focus once again from the capital region to the provinces, the situation becomes rather unclear. Probably the Yamato polity was not able at first to exert direct administrative authority over Shinano Province, although this may have happened toward the end of the seventh or the beginning of the eighth century. The traditional name of Nagano Prefecture was "Shinano," a name first seen in *Kojiki*, compiled in 712. An even more relevant reference appears in *Nihon Shoki* (compiled 720), under the fifth year of Empress Jitō (691), recording that envoys were sent to worship the god of Minochi in Shinano; Minochi is the area around present-day Zenkōji.[15] Other early occurrences of the name can be found in *Man'yōshū*, the eighth-century poetry anthology, where soldiers from Shinano who have been sent to northern Kyūshū to protect Japan are described as longing for their home province and loved ones.[16] Thus, by 700, if not earlier, there was a definite conception of a province called Shinano among the inhabitants of the central region.

In the process of bringing the local areas under central control, the Yamato government appointed local chieftains to the position of *kuni no miyatsuko*.[17] These officials were technically under the authority of the central government, although in many cases they retained substantial autonomy as a result of their local power bases. Nevertheless, with such appointments one sees at least tacit recognition of the primacy of the Yamato government. The next stage in this process was the dispatching of governors (*kuni no kami*) from Yamato to the provinces. In the case of Shinano, the earliest record of such a governor is that of a man called Oharida no Ason Yakamochi, who received his appointment in 708, just at the time of the foundation of the new capital at Nara.[18] Further evidence for relationships between Shinano and Yamato at this stage is the discovery of a wooden tablet (*mokkan*) at the site of the Fujiwara Capital that records tribute sent to the capital. Tribute, or taxes in kind, was the fundamental basis for the early economic system, and the discovery in recent years of large numbers of mokkan in the excavations of the Fujiwara and Heijō capitals has greatly clarified the relationship between center and provinces. The reference to Shinano records the sending of fifteen *kin* of *daiō*, a medicinal herb, from Takai County in the Zenkōji Plain.[19] The record of the appointment of a governor in 708, combined with the evidence of the mokkan excavated at the Fujiwara Capital indicates the beginning of strong penetration by the capital authorities into Shinano by around 700.

The early provinces were organized into counties (*kōri*), with Shinano divided into ten such counties. Individual counties were administered by

officials, referred to as *gunji*, who normally came from the old kuni no miyatsuko clans. In Shinano officials came primarily from the Kanasashi, Osada, and Miwa clans.[20] Above mention was made of the Minochi citation in *Nihon Shoki*, but there is a later reference to Minochigōri that is especially important for our purposes. *Shoku Nihongi*, the official history following *Nihon Shoki*, in an entry of 770, refers to the promotion in rank of a woman of the Kanasashi clan, Kanasashi no Toneri Wakashima, and in an entry of 772 it states that this woman, who came from Minochigōri, served at court as a *nyoju*, a category of female attendant. Women who occupied these positions hailed from prominent local clans, suggesting that the Kanasashi clan were the hereditary rulers of Minochigōri. If this is the case, it is possible that the proto-Zenkōji could have been the clan temple of the Kanasashi.[21] Below the county level was a more compact administrative unit called the *gō*, each consisting of about fifty smaller units known as *ko*. By the ninth century there were sixty-seven gō in Shinano Province, of which twenty-nine were located in the northern part of the province, in the region of Zenkōji Plain.[22] The available evidence suggests that the Zenkōji Plain was one of the main economic centers of the province, not surprisingly, considering developments during the Yayoi and Kofun periods. Ushiyama has argued that the excavations at the Agata-machi site, about one kilometer southwest of Zenkōji, may provide important data as to the political organization of this area during the early period. Among the pieces discovered were several objects, including an impressive ink stone, that can be associated with a governmental center. He believes that this site may have been the headquarters of the local government.[23]

One of the basic policies of the central government to further the unification of the country was the establishment of a *Kokubunji* (National Monastery) and *Kokubunniji* (National Nunnery) in each province.[24] The edict commanding the building of these temples was issued in 741 by the court in Nara. Intensive archaeological research in recent decades has succeeded in locating practically all of these temples in the various provinces. The Shinano Kokubunji is located in present-day Ueda City, called at the time Chiisagatagōri, just to the south of the Zenkōji Plain.[25] Although the exact circumstances of the construction of Ueda Kokubunji and the nearby Kokubunniji are unclear, work on these temples probably would have begun shortly after the issuance of the edict. A record of 938 refers to a battle taking place near the Shinano Kokubunji, sure indication that the temple lasted well into the Heian period.[26] In many cases the Kokubunji did not survive the end of the Nara centralized government, apparently being burned down by the local populace, who resented them as symbols of outside authority. Although there is no

direct evidence for the existence during the Nara period of a temple at the site of the present Zenkōji, I assume that a private temple, associated with one of the local clans, was probably located there. In distinction to the official status of the Ueda Kokubunji, any temple that existed at the Zenkōji site at this time would have been outside the official structure.[27] Thus the coexistence of an official and a private temple in northern Shinano Province during the eighth century can be posited. Perhaps the somewhat artificial governmental patronage of the Kokubunji led to decline, whereas the local patronage of the proto-Zenkōji enabled it to develop into the flourishing temple seen in the twelfth and thirteenth centuries.

There are a few other bits of evidence for Buddhism in the early period of Shinano Province. In addition to the complete excavation of Ueda Kokubunji and the chance find of tiles at the present Zenkōji, early tiles have also been found at the site of the now defunct Akashinaji near Matsumoto City.[28] Most important are a few examples of Asuka and Hakuhō period bronze sculpture extant in Nagano Prefecture. The earliest piece is a fine representation of a Hanka Bosatsu (Meditating Bodhisattva) in Kanshōin, Matsukawa Village (fig. 2).[29] It probably dates to the first half of the seventh century and is either a direct import from the Korean Peninsula or an extremely close copy of a Korean prototype. In either case, the Kanshōin Bodhisattva should be thought of as evidence for the influence of the Korean cultural sphere mentioned above. Somewhat later is the Sanzenji Kannon Bosatsu (fig. 3), a standing figure that can be dated to the Hakuhō period.[30] This image, a member of the quite large category of standing Kannon figures made during the second half of the seventh century, is not likely to be an imported work, although it does display the continued strong impact of continental styles on early Japan via the Korean peninsula. Finally, the Chōfukuji Kannon Bosatsu (fig. 4), another standing image, probably dates to the end of the seventh or the beginning of the eighth century.[31] While still within the general sphere of East Asian–influenced Hakuhō sculpture, this piece begins to show more of a Japanese sensibility in the gentle, soft forms, which differentiates it from monuments derived more directly from the Korean Peninsula.

The sculptures just discussed are all enshrined in temples located in northern Shinano Province. Although in no case can their original locations be determined, there is also no evidence that they reached Shinano in recent times; probably all, or some, of the three pieces reflect the existence of Buddhist worship in northern Shinano during the seventh century. Three may seem like a very small number on which to base statistical arguments, but actually is a rather large group of seventh-

century images for a province outside the central region.[32] Certainly these sculptural remains suggest a developing Buddhist presence, presumably under strong Korean inspiration, during the seventh century in Shinano.

While the economic situation of Shinano Province in the eighth century would have conformed generally to that prevailing in preceding centuries, one important new development was the prominence of horse ranches.[33] Early texts describe the establishment of horse ranches in various areas of Japan to provide an adequate supply of horses for the military and civil agencies and as post-horses for the stations on the national roads. Shinano was particularly suitable for the raising of horses: in the Zenkōji Plain ranches were located at Ōmuro and Takai; and by the Heian period, the horses produced in Shinano had a high reputation.

Thus far, I have endeavored to set the stage for the appearance of a fully developed Zenkōji at the beginning of the twelfth century. While there is no absolutely certain evidence for Zenkōji prior to the early twelfth century, the political and cultural situation of Nagano during the seventh and eighth centuries suggests the strong possibility that some sort of temple did in fact exist at the site of the historical Zenkōji from a relatively early date. Nevertheless, Zenkōji first appears as a Heian temple, and so we must now shift our attention to the Heian period.

The Heian Period (794–1185)

Historians mark the beginning of the Heian period by the transfer of the capital from Heijōkyō (Nara) to Heiankyō (Kyoto) in 794. While such a momentous event must have had the greatest significance in the central region, presumably it would not have seemed equally important in a remote province such as Shinano. One of the goals of the present study is to focus on the differences and similarities between capital and province, particularly in the realm of religious art, and thus a careful consideration of Heian-period Shinano is basic to this discussion.

In political terms, the Heian period saw the breakdown of the Chinese ideal of a strong, centralized government that was, at least theoretically, the basis of the Nara state. That anything approaching total central control over Shinano existed during the eighth century is unlikely, and I assume that the situation there during the ninth century was not significantly different. Whether there was a gradual rise of local autonomy in Shinano in the course of the Heian period, or simply a perpetuation of a long-term situation is uncertain; clearly the local clans had a good deal of power, and were relatively independent from the central authorities. With the decline of the central government's ability to govern the prov-

inces directly, local estates, called *shōen*, were established. These were under the control of the capital aristocracy and the great monasteries and shrines. The ensuing privatization of land rights was a nationwide process that also affected Shinano.

In addition to the political and economic factors that characterize Heian Japan, significant developments also occurred in Buddhism. The beginning of the ninth century witnesses the introduction of two very important Chinese sects, *Shingon* by Kūkai, and *Tendai* by Saichō.[34] The importance of these two sects for the general development of Japanese Buddhism and Buddhist art cannot be exaggerated, although they probably did not have an immediate, strong impact on distant provinces like Shinano. At first the Shingon and Tendai schools were important primarily for the capital aristocracy, although missionary activity to the provinces increased in the course of the ninth century.

The discussion of Shinano Province during the seventh and eighth centuries tried to relate the situations in the capital and the provinces. We noted that capital and province did not experience symmetrical development processes, but were quite divergent in their historical evolution. As the study of provincial history expands, such capital-province discrepancies will likely become increasingly evident, providing a useful corrective to an older methodology that tended to see history almost exclusively from the perspective of the center. An important task for this study is to ascertain the degree to which Heian Shinano relates to the institutions and practices that characterize the capital government and aristocracy from the ninth to the twelfth century. Let us first look at quite tangible phenomena, such as road systems and land tenure, and then consider important religious developments.

One goal of the central government from the Nara period onward was to establish a system of national roads that would serve to unify the state by improving communications (map 1). A full consideration of the development of this road system is not relevant here, but an overview of what is known about the national roads in Shinano is useful, for this allows the formation of a general idea about the centers of power and the major routes taken by travelers.[35] *Engi Shiki*, a text compiled in the early tenth century, provides full details of the completed system of national roads as it presumably existed in the Early Heian period. Important for Shinano Province is the road called the Tōsandō, which originated in the capital, Kyoto, and then went through Ōmi Province (now Shiga Prefecture) and Mino Province (in what is now Gifu Prefecture) to Shinano and then through Kōzuke Province (now Gunma Prefecture) and Shimotsuke Province (now Tochigi Prefecture) to Mutsu Province (what now comprises Miyagi, Iwate, and Aomori Prefectures). The main purpose of this road was to provide a route from the capital to the far north, something

of considerable significance in view of the extremely weak and limited control of the north exercised by the central government. In Shinano Province itself, a branch road separated from the main Tōsandō at a place called Nishikigōri (near Matsumoto) and then traversed the Zenkōji Plain, ending at the provincial headquarters of Echigo (in what is now Niigata Prefecture) on the Japan Sea (map 1). This branch road was of great importance for Zenkōji since it passed right by the site of the temple.

During the eighth century the provincial headquarters of Shinano was located at Chiisagatagōri, but by the Heian period the headquarters had been moved farther south on the Tōsandō to Chikumagōri (present-day Matsumoto City).[36] In considering the significance of the locale equivalent to present-day Nagano City in both the Nara and Heian periods, one notes that at neither time was this the location of the provincial headquarters. Moreover, it was not on the main route of the Tōsandō, but on a branch road. Of course this location was still of considerable importance, because of traffic to and from the Japan Sea across the rich Zenkōji Plain. During the Kamakura period there was some type of branch headquarters in the area around Zenkōji, but in later periods the political center was usually elsewhere. For the long time span of the Edo period the government was at Matsushiro, the seat of the Sanada clan. Of course now Nagano City is the capital of Nagano Prefecture, and thus there is a tendency to consider that its current political status also applied in the past. However, for most of the past 1,000 years the main significance of what is now Nagano City was its prominence as the location of a great temple, Zenkōji.

Land Tenure in Heian-period Shinano

The evidence is vague about the nature of land tenure in Shinano Province during the eighth century. Some scholars have argued that the *handen* (equal field) system of land distribution, based on the ritsuryō codes, existed in Shinano, although this is uncertain. In the Heian period the shōen system became very important in Shinano, as was the case throughout Japan. As is well known, shōen began to develop in the central region by the later eighth century.[37] At first shōen consisted of a limited number of estates outside the official system of taxation, which were owned by the imperial family and the great aristocratic clans, and by important Buddhist and Shinto establishments; or of lands that were owned by private individuals and had been newly brought under cultivation. Gradually, the amount of land that was controlled by private owners increased, and the resulting shōen became essentially independent and autonomous territories. Since a decreasing

amount of land was available for taxation by the central authorities, there was a tendency to increase the tax rate of that land still under the jurisdiction of the government. The result of this repressive taxation was that smaller landholders commended their properties to established shōen, which were held by the court, aristocracy, or Buddhist and Shinto institutions. The more power the shōen patron possessed, the greater the security for the person commending land, and so property naturally became concentrated in the hands of the most powerful patrons. Occasionally the government issued decrees against the development of shōen, but these were largely ineffectual, for those who benefitted most from the shōen incomes were, of course, themselves leaders of the "government." This process led to the increased privatization of land and to the formation of a system totally at odds with the ideal Chinese "equal field" system. Nevertheless, the shōen system would never have been so long-lived and extensive if it had not met the fundamental needs of the land-owning classes.

Information about the development of the shōen system in Shinano is limited. An entry of 768 in *Shoku Nihongi* refers to the exemption from taxation granted to an individual called Kurahashi-be Hiroto of Minochigōri.[38] Apparently Hiroto paid the delinquent taxes owed by the local farmers out of his own resources, a sure indication of the great amount of wealth that he had accumulated. While this situation does not specifically involve a shōen-type structure, it does show the concentration of wealth in the hands of powerful clans, in distinction to the ideal "equal fields" system. The next step was for such powerful local figures to affiliate with a central patron, thus establishing a relationship beneficial to both parties.

Evidence for the shōen system in Shinano during the ninth and tenth centuries is scanty, but by the eleventh and twelfth centuries the system seems well developed. Particularly important was the type of commendation of property by local landlords to the powerful patrons mentioned above. By the end of the Heian period there were between 120 and 130 shōen in Shinano Province. Of these, 11 were controlled by Ise Shrine, 6 by Zenkōji, and 5 by Suwa Shrine.[39]

Buddhism in Shinano during the Early Heian Period

Difficulties are encountered when we try to reconstruct the history of Buddhism in Shinano Province during the Heian period. Earlier I made some tentative comments about the situation in the seventh and eighth centuries, and here subsequent developments must be considered. At the beginning of this chapter, where

reference was made to the introduction of Tendai and Shingon in the early ninth century, I suggested that at least initially these very important new sects probably had limited impact on outlying regions. However, as Tendai and Shingon consolidated their positions in the central area they gradually began establishing branch temples in the provinces. For example, monks such as Ennin and Tokuichi were active in taking Tendai Buddhism to the Eastern provinces.

The most important extant evidence for the impact of the new Buddhism on Shinano Province during the Early Heian period is a small group of icons housed at Seisuiji in present-day Matsushiro. As I have dealt with these images in detail elsewhere, here only a summary discussion is necessary.[40] Practically no information is available for the early history of Seisuiji; at present it is affiliated with the Shingon sect. The four main icons now located at the temple do not appear to be a unified group, suggesting the strong possibility that they were brought together from two or more temples, perhaps as a result of the destruction of their original homes. This indicates that the Seisuiji images can only be used as general evidence of the presence of a new Heian style of Buddhist sculpture in the Zenkōji Plain. A number of Japanese scholars have argued that at least some of the four sculptures date to the ninth century; in my study I suggest that they date from the early to late tenth century. While these differences are of considerable importance for the chronology of Heian wood sculpture, for the present study we can compromise and conclude that the new currents of Heian sculpture appear in Shinano by the later ninth or earlier tenth century. Such a dating correlates well with the evidence for other provinces of Japan, since one can show that from around 900 there is a substantial increase in the number of icons produced for local temples.[41] The reasons for this increased production of icons are too complex to go into here, but I would like to stress a tendency of the new Buddhism of the Heian period, which developed in the capital after 800, to assert a strong impact on the provinces, beginning about one hundred years later. Certainly Shinano Province—at least as exemplified by the Seisuiji sculptures—shared to some degree in this development. In addition to the Seisuiji images, there are a few other images in Nagano Prefecture that can be associated with the new currents of Buddhist sculpture of the tenth century.

While one cannot associate the extant icons in Shinano directly with the Tendai and Shingon schools, the general stylistic characteristics of these images are comparable to many images found in Tendai and Shingon temples in the capital. Consequently, I assume that by around 900 the impact of the new Tendai and Shingon Buddhism was felt in Shinano. Possibly there was even earlier penetration, although convincing evi-

dence is unavailable at present. At this early stage in the development of
Buddhism in Japan the type of Tendai and Shingon referred to above was
probably still limited to the private temples of the wealthy classes in
Shinano; more broadly based mass movements would not have devel-
oped so early.

Buddhism of the Late Heian Period

Fundamental changes in the nature of Japa-
nese Buddhism are seen in the Late Heian period. Although Shingon and
Tendai, as well as the Nara Schools, continue to be significant, the major
developments are seen in the cult of Amida and the Pure Land.[42] Of
course the Buddha Amida was not a newly introduced deity in the Late
Heian period, for important representations of Amida occurred in the
Hakuhō and Nara periods, such as the Yamadaden Amida Triad, the
Tachibana Shrine, and the Hōryūji Kondō wall paintings.[43] The cult of
Amida seems to have been relatively unimportant during the ninth cen-
tury, when other deities such as Yakushi and various members of the
esoteric pantheon such as Jūichimen Kannon (Eleven-headed Kannon)
were prominent. What then explains the increasingly central position of
the Buddha Amida from about the year 1000 on?

Needless to say, the magnificent Amida Halls, representations of
Amida, and lavish ceremonies dedicated to Amida that are such charac-
teristic features of Heian Buddhism during the eleventh and twelfth
centuries did not appear out of a void; an important strain of Amidist
devotion appeared in the Tendai sect almost from its beginnings in Japan.
Saichō's disciple Ennin (794–864), encouraged the *jōgyō-zanmai*, ("per-
petual moving concentration") on Amida, also called the *nenbutsu-
zanmai*, and apparently nenbutsu practices became important in Tendai
from about the middle of the tenth century.[44] The abbot of Mt. Hiei,
Ryōgen (912–985), supported Amidist practices,[45] and it was his disciple
Genshin (942–1017) who wrote the famous *Ōjō Yōshū* ("The Essentials
of Salvation"), the central text of Heian Amidism.[46] Thus, gradually
increasing concern with the cult of Amida can be noted, although we
should recognize that at this stage the cult was not exclusive, but was
integrated into the broader context of Tendai Buddhism.

The attractiveness of the cult of Amida lay in the explicit guarantees
offered for rebirth in the wonderful Western Paradise. The usual image
of this promise is associated with the Heian aristocracy, who lived in a
sumptuous and luxurious style in this world and desired a continuation
after death. Surely the most beautiful and poignant surviving monument
to this desire is the Phoenix Hall of the Byōdōin at Uji,[47] and documen-

tary sources indicate that even more splendid Amida halls and images were constructed in the capital itself.[48] This standard image of Late Heian Amidism is connected with the wish of a highly privileged class to perpetuate its good fortune, but of course there is much more to the cult of Amida than that, for the promise of Amida was also extended specifically to the lower orders. The unsettled nature of life in the eleventh and twelfth centuries made the salvationist promises of Amida especially appealing to the masses in the provinces, who in many cases had little to look forward to in this life. As it developed, the cult of Amida became an increasingly significant part of Heian Buddhism, and, of course, it forms one of the main themes of this book.

The process by which Amidist belief spread from the capital to the provinces was complex. In some cases the local ruling classes attempted to emulate the magnificence of the central aristocracy by constructing beautiful temples with splendid icons. A few examples of this phenomenon could be cited, although the most elaborate were probably the temples erected by the Ōshū Fujiwara at Chūsonji.[49] However, this type of establishment, built for the ruling classes, should perhaps be analyzed in relationship to the capital prototypes, and here the routes by which Amidist belief was diffused to less elevated ranks of society must be considered. Of greatest importance, of course, was the activity of itinerant preachers who traveled throughout the countryside spreading their messages. One of the most important examples of this is Kūya (903–972), an itinerant monk who practiced a shamanistic type of Buddhism that included a strong Amidist component.[50] As Kūya moved among the people he would deliver sermons, focusing on the evocation of the name of Amida, the nenbutsu. Kūya belonged to the category of religious practioners called hijiri, a group that in a subsequent chapter will be seen to be of key significance in the establishment of the Zenkōji cult.

When exactly Amidist beliefs became important in Shinano Province is uncertain. Utilizing the methodology employed above in the discussion of Shinano Buddhism in the ninth and tenth centuries, one notes that representations of Amida are relatively frequent there from the later eleventh century and on into the twelfth century.[51] Stylistically, the images extant in Shinano derive from the *Kōshō-Jōchō* style of the capital region, which was formulated at the beginning of the eleventh century, and presumably after a lag of a few decades the influence of the dominant capital mode diffused to Shinano Province, just as it did to many other provinces. The Heian representations of Amida preserved in present-day Nagano Prefecture were probably made for temples patronized by the higher levels of provincial society. In that sense, they are probably embedded in a cult that is a remote version of the capital type, rather than

being reflections of a more broadly based mass movement. Nevertheless, the presence of these Amida images, combined with the activities of the hijiri, suggests that by around 1100 at the latest the cult of Amida was well established in Shinano.

The Rise of the Warrior

In a preceding section, I made some comments about Heian land holding, concentrating primarily on the development of the shōen system. A topic of equal, if not greater, importance for this study is the rise of the warrior class during the Heian period, since in many respects Zenkōji and its cult were closely intertwined with the development of warrior society.[52] Scholars have often referred to the contrast between the ideals of theory and the realities of practice in early Japanese history, as, for example, in the way the shōen system superseded the impractical "equal field" system of classical Chinese theory. Similarly, the ritsuryō governmental structure assumed a central bureaucracy that would control provincial authorities, ranging from a governor dispatched from the capital down through humble clerks. Such a bureaucratic system was never fully in place in a province such as Shinano, and certainly by the later part of the Heian period groups of local warriors were active in assuming dominant roles, at least in their own areas.

Perhaps the most peculiar aspect of the control of the shōen system by the upper aristocracy and the great ecclesiastical establishments was its very durability. While the image of the Kyoto courtiers as effete aesthetes has always been overdrawn, they nevertheless did not possess a degree of military power adequate to exert coercive force on the provincial notables. Why then did the latter not boldly take the land that legally belonged to the holders of shōen charters and declare it their own? Initially, at least, this idea probably did not cross the minds of the provincials, for the complex system of land rights within which they operated had the sanction of history as well as being dependent on the tremendous prestige of the court, upper aristocracy, and great temples and shrines. Perhaps most fundamental was the role of the capital patrons to sanction and guarantee the land rights of the local leaders. Certainly, at earlier stages in the development of the warrior class, it would have been practically impossible for one warrior in a given locality to take personal possession of the land he administered under a shōen arrangement, since obviously the central authorities could readily deputize other warriors in the area to discipline the offender. During most of the Heian period the shōen system was mutually beneficial to capital patrons and provincial administrators, especially since members of the latter group were not yet

united to the degree that they could present a common front against their "superiors."

Historians now recognize that the Heian period was a good deal less "tranquil and peaceful" than was earlier believed. By the tenth century the country already was troubled by the major rebellions of Taira Masakado in the east (935–940) and of Fujiwara Sumitomo in the west (939), certain indication of the existence of provincial bases of power.[53] While these two rebellions were ultimately put down, they are, of course, symptomatic of the rapid rise of the military class, although more than two hundred years passed before the final triumph of the warriors. These centuries, characterized by considerable tensions and crises, saw the warriors consolidating their positions at the same time that the central government became increasingly ineffective. The shift from Heian aristocratic government to Kamakura military rule was not a sudden transformation at the end of the twelfth century, but rather the culmination of a process lasting hundreds of years, whereby the balance of power moved dramatically from capital lord to provincial warrior.

The dislocations and unease accompanying this transformation led to a degree of social instability that was fertile ground for new religious movements. Certainly the traditional schools of Buddhism centered in the capital region were not in a very good position to meet the new needs of the provinces, particularly as they were so strongly associated with the old order. There were, of course, numerous responses to the developing situation by various religious leaders, although the most important currents were related to the cult of Amida. The cult of the Zenkōji Amida Triad is intimately connected with the development of warrior society in the provinces, and thus we must clarify the nature of this process, especially in the Eastern provinces and specifically in Shinano.

The complex mechanisms associated with the administration of shōen and provinces led inevitably to powerful local families assuming dominant positions in each area. These warrior clans at first accepted their subordination to the capital authorities, since the system within which they functioned was mutually beneficial. However, by the eleventh and twelfth centuries serious tensions were appearing, leading ultimately to the demise of the old order. The local warrior clans were normally associated with only one province, which inevitably precluded their functioning on the broader stage. For this reason, even though these clans were consolidating their local positions, they were not in a position to challenge the central government. That challenge was carried out by the activities of the Taira and Minamoto clans, two military families of aristocratic lineage who traced their origins to the imperial house. These two families did have the national prestige to threaten the old

order and, of course, the conflict between them in the second half of the twelfth century led to the establishment of a new type of government, the Kamakura bakufu.

We need not trace here the early histories of the Taira and Minamoto clans.[54] Noteworthy, however, is the fact that by the twelfth century warrior bands throughout Japan were affiliating themselves with one of the two national clans, and referring to themselves as "Taira" or "Minamoto." This involved a type of relationship clearly distinct from one with either the "official" central government structure or the dominant shōen system, and is indicative of a new self-awareness on the part of the developing local warrior clans. The balance of power at first seemed to lie with the Taira, especially after the Hōgen (1156) and Heiji (1159) Disturbances, for from this time until 1180 the Taira clan was dominant in the capital while the Minamoto clan seemed to be in a very weak position.[55] However, the ascendancy of the Taira proved to be short-lived, for their organization was strongly associated with the older loci of power in the capital, and had quite weak connections with the provincial warrior clans. It was the Minamoto clan, under Yoritomo, which was able to forge close, personal bonds with significant numbers of strong local warriors, especially in the Eastern provinces. The Minamoto policy, based on an accurate assessment of the realities of power relations as they had developed by the end of the Heian period, enabled it to emerge triumphant.[56] However, the story of the victory of the Minamoto clan will be postponed until it is time to consider the Kamakura period.

The developments just discussed from a national perspective were of course mirrored on a smaller scale in Shinano. Strong clans developed during the Heian period out of those groups who had earlier served as kuni no miyatsuko, or as administrators of governmental agencies, horse ranches, etc. Among the most powerful of these clans were the Suwa, Shigeno, Nishina, Murakami, and Inoue.[57] The Hōgen and Heiji Disturbances inevitably led to a sorting out of clan loyalties, and the following decades witnessed the dominance of Taira-related forces in Shinano. Nevertheless, Minamoto interests were not absent, and, as we will see, the activities of Kiso Yoshinaka, a Minamoto, were of great importance both for Shinano Province and for the founding of the Kamakura bakufu.

Here I will summarize briefly the preceding discussion, in order to render apparent the world in which Zenkōji existed during the Late Heian period. By the twelfth century, large areas of Shinano Province had been organized into tax-exempt shōen that were at least nominally under the control of central aristocrats or religious bodies. Other land was still theoretically under the control of the old government system, described earlier, and thus subject to taxation. However, both types of

land were increasingly dominated by powerful warrior families. Reve-
nues continued to flow into the center, but at a decreasing rate, as the
warrior clans more strongly asserted their independence. This social
class—the warriors—arises at a major transition point in Japanese his-
tory and will be central to this study, for all concerned, from the lowest
level farmer-warriors to the luminaries of the bakufu, were largely re-
sponsible for furthering the development of the cult of the Zenkōji
Amida Triad. Warrior activism must be emphasized, for, when the Heian
textual sources are considered, we will observe that these documents
come, rather, out of a context intimately associated with the central
aristocracy and the ecclesiastical establishment.

Early Documentary References to Zenkōji

The first occurrence of the name Zenkōji in a
documentary source, not of a very edifying nature, is in *Chūyūki*, the
extensive diary of the courtier Fujiwara Munetada, Minister of the Right,
which covers the years 1087–1138.[58] *Chūyūki* is considered one of the
most reliable sources for the period, so a reference to Zenkōji should be
given considerable weight. An entry for Eikyū second year (1114), fifth
month, ninth day states that attendants of the *bettō* (Director of the
Administrative Headquarters) of Zenkōji caused a disturbance within the
precincts of Hosshōji. This disturbance was investigated and action
taken the next day.

Hosshōji, built by Emperor Shirakawa (1053–1129, r. 1072–1086) in
1077, was the most famous and splendid of the *Rikushōji* (The Six "Shō"
Temples).[59] Although Shirakawa's reign was relatively short he subse-
quently held the position of *In* (Retired Emperor) from 1086 until 1129,
during which time he was the most powerful figure in the central political
world. The reason for the appearance of the bettō of Zenkōji at the
Hosshōji apparently is based on the fact that this position was an "addi-
tional post" assigned to the *Jimon* (Onjōji branch of the Tendai sect), and
since the Jimon often participated in religious ceremonies at Hosshōji,
perhaps this is the reason the Zenkōji bettō was present on the day in
question.

The fact that the initial appearance of the name Zenkōji is connected
with a disgraceful event is perhaps to be regretted. Nevertheless, to the
historian this documentation is invaluable as clear indication that by
1114 officials connected with Zenkōji could be present at ceremonies at
one of the most prestigious temples in the land. Presumably, Zenkōji had
already been flourishing for at least some decades prior to the year 1114,

and so a judicious combination of the *Chūyūki* entry and the general religious and political background presented earlier in this chapter certainly suggests that the initial rise to prominence of Zenkōji is closely associated with the eleventh-century development of Amidism and the warrior class.

Another reference to Zenkōji appears in *Chōshūki*, the diary of Minamoto no Morotoki, covering the years 1097–1136. An entry of Gen'ei second year (1119), ninth month, third day, describes a boating excursion taken by the Empress Shōshi and other members of the court, in which several boats were used, including one belonging to the bettō of Zenkōji, a priest called Seien. The *Chūyūki* and the *Chōshūki* references indicate that the Zenkōji bettō was a relatively prominent individual at the beginning of the twelfth century.[60] A third important Heian-period reference to Zenkōji, appearing in *Fusō Ryakki*, a history of Japan emphasizing Buddhist subjects, will be analyzed in detail in the next chapter, when the development of the legendary *Zenkōji Engi* is considered. Consequently, here the discussion will be limited to the implications of the appearance of Zenkōji in *Fusō Ryakki*. The book covers the period from the mythical Emperor Jinmu until Emperor Horikawa (1079–1107), and is usually attributed to a monk of Enryakuji called Kōen. Although the exact date of its composition is uncertain, Kōen's death date of 1169 gives a definite *terminus post quem*. Since Horikawa's successor, Emperor Toba (1103–1156; r. 1107–1123), is not included, possibly *Fusō Ryakki* was produced during his lifetime, perhaps some time near the middle of the twelfth century. I assume that the *Fusō Ryakki* account is not too many decades later than the *Chūyūki* entry of 1114 and the *Chōshūki* entry of 1119.[61]

Material connected with Zenkōji appears in the entry for Kinmei 13.10.3 relating to the official introduction of Buddhism into Japan from Paekche.[62] The text refers to the Amida Triad of Zenkōji in Shinano Province, said to have been sent there on the orders of Empress Suiko. Following this is the even more interesting section where *Fusō Ryakki* quotes *Zenkōji Engi*. The substance of this quotation will be discussed in detail in the next chapter, and so here we need only note that the existence of a *Zenkōji Engi* compendium of legends by at least 1169, and most likely some decades earlier, is a convincing indication that the temple itself was of considerable significance by this stage and well known in the capital. Certainly a relatively lengthy process must be assumed before a specific temple is developed to the extent that an *engi* can be produced.

The earliest reference of a pilgrimage to Zenkōji has to do with Kakuchū (1118–1177), a prominent monk of Onjōji. A poem written by

Kakuchū, included in *Zoku Kokinshū*, refers to his pilgrimage to Zenkōji. The headnote reads:

> At the time of a pilgrimage to Zenkōji, I
> made this poem
> while staying at the foot of Mount Obasute.
>
> *Former Abbot Kakuchū*

And the poem can be rendered:

> Who will know that tonight I am waiting
> for the moon
> at the foothills of Mount Obasute.

Mount Obasute was a famous beauty-spot on the way to Zenkōji, frequently referred to in poetry. Kakuchū was associated with the pilgrimage cycle of the "Thirty-three Temples of the Western Region," and he is said to have undertaken the pilgrimage in 1161. The last stage of the cycle is Kegonji in Gifu Prefecture (Mino Province), and later the normal practice was to travel from that temple in Mino Province to Zenkōji in adjacent Shinano, so I assume that this is the route taken by Kakuchū.[63] Interestingly, a contemporary of Kakuchū's, the very famous monk Chōgen (1121–1206), is recorded as having visited Zenkōji twice. Presumably Chōgen's pilgrimages were connected with his activities as a hijiri. Although just when Chōgen traveled to Zenkōji is unknown, the trips are usually assumed to have been during his middle years, at the end of the Heian period, rather than in the early Kamakura period when he was occupied with other matters. The distinct possibility that both Kakuchū and Chōgen made pilgrimages to Zenkōji toward the end of the Heian period strongly suggest that the temple was well established by this time.[64]

The last text to be cited is *Azuma Kagami*, a semiofficial history of the Kamakura bakufu, and one in which Zenkōji is seen through the eyes of warriors, not the civilian aristocrats of earlier sources. *Azuma Kagami*, covering the years 1180–1266, provides essential information concerning relations between Zenkōji and the bakufu and will be cited extensively in subsequent chapters. Here a particular entry of 1187, which refers to the destruction by fire of Zenkōji in 1179, should be noted.[65] Although no other sources directly corroborate this event of 1179, there seems no particular reason to doubt the accuracy of the entry, which further supports the argument that Zenkōji was fully established by the middle of the twelfth century if not significantly earlier.

Most of the documentary sources we have analyzed indicate that Heian period Zenkōji was directly affiliated with Onjōji (popularly called

Miidera), the headquarters of the Jimon branch of the Tendai School. Both the *Chūyūki* (1114) and *Chōshūki* (1119) entries refer to the Zenkōji-bettō as an individual who was appointed from among Jimon priests. This clearly demonstrates that at least by the beginning of the twelfth century Zenkōji was under the control of Onjōji. Kakuchū's pilgrimage (1161?) is also suggestive of such a relationship, since he served as *chōri* (Chief Priest) of Onjōji. The four estates of Zenkōji, listed in *Azuma Kagami*, would yield sufficient wealth to explain why an important central temple such as Onjōji would be interested in maintaining control over the temple in distant Shinano.[66]

The data just presented imply a primarily economic relationship between Onjōji and Zenkōji, but Ushiyama has pointed out another possible connection of considerable interest. During the Late Heian period Shitennōji was also under Onjōji, and a Jimon priest was appointed as its bettō. Shitennōji was an important center for the development of Amidist belief, and there are common features in the religious practices of Shitennōji and Zenkōji. Furthermore, as we shall see in the next chapter, Shōtoku Taishi (574–622), the putative founder of Shitennōji, assumed a highly significant role in the cult of the Zenkōji Amida Triad. These relationships certainly suggest that characteristic features of the Zenkōji cult may have derived in part from new Amidist developments centered at Shitennōji. In that sense, the impact of the Jimon branch of the Tendai School may have been somewhat indirect, flowing through the more popularly based Shitennōji rather from Onjōji itself. The latter temple seems to have been more concerned with profit than theology as regards Zenkōji.[67]

CHAPTER 3 The Origin of the
Zenkōji Amida Triad

A CRUCIAL ROLE in the development of the
cult of the Zenkōji Amida Triad was played by the extensive body of
literature describing the origin of the icon and its early history. This
literature is legendary in character, and yet should not be dismissed too
quickly, since it embodies some of the fundamental aspects of Zenkōji
belief. Furthermore, when these legends describe events that are pur-
ported to have happened in Shinano, one can discern distant reflections
of historical reality. For these reasons, considerable attention will be
directed in this chapter to the development of *Zenkōji Engi* and related
texts. Even more important, of course, is the icon itself. Although it
cannot be seen by mere human eyes, it is an awe-inspiring, spiritual
presence at Zenkōji and the central feature of the cult. Thus engi and
icon can be said to be a unit, and they interact to form the belief system
that, I would suggest, is the key to understanding the growth and diffu-
sion of the Zenkōji cult.

The development of engi literature is a topic beyond the scope of this
study.[1] These pious legends, however, were highly significant in the
histories of various temples in early Japan. Perhaps most well known is
Shigisan Engi, a set of three scrolls filled with lively narrative detail.[2]
Charming and miraculous stories such as these must have fascinated
believers privileged to hear them, and thus have motivated the type of
support desired by the clergy of a given religious establishment. A well-
constructed engi would help to crystallize and focus the cult, thus serving
an indispensable role in its dissemination. As will be shown presently, it is
into exactly this sort of context that *Zenkōji Engi* must be fitted. The body
of textual material generally referred to as *Zenkōji Engi* is surprisingly
broad and diverse, consisting of several full-scale texts as well as innu-
merable smaller versions or sections of other works. Because Zenkōji and
its belief system are not part of the traditional, orthodox expressions of
Japanese Buddhism, its literary manifestations have been largely ignored
by mainstream scholarship, and thus the student approaching this mate-
rial will often feel the absence of an appropriate guide.[3] For that reason,
my account of the *Zenkōji Engi* literature will undoubtedly be less satis-
factory than would be the case with a more extensively studied tradition.

Nevertheless, given the fundamental importance of this literature to the Zenkōji cult, a serious effort must be made to illuminate its salient characteristics.

Different problems from those posed by the available documentary literature are encountered in approaching the icon. The main icon of the Shinano Zenkōji is a completely secret image never shown to the public. Textual descriptions and data derived from the very large number of copies, however, provide information adequate to allow a relatively precise visualization of the appearance of what can be thought to be the original icon. If such a conjectured reconstruction can be accepted, at least in general terms, we should be able to delineate the likely prototypes in China, the Korean Peninsula, and Asuka-Hakuhō Japan. This chapter will progress from two directions—from the engi literature and from a reconstruction of the original icon—toward the goal of understanding the mature Zenkōji cult as it appears at the beginning of the Kamakura period. In the preceding chapter the history of Shinano Province through the Heian period was considered in order to establish a context for the first definite signs of Zenkōji at the beginning of the twelfth century. If those foundations were properly laid, information adequate for an understanding of the political, social, and religious environment within which Zenkōji grew and developed should be available. An important task is to seek the intersections between that type of history and the legendary materials to be discussed in a moment.

Legendary Accounts

By ca. 1400, there is convincing evidence for a fully developed *Zenkōji Engi* that includes the essential components of the cult.[4] Presumably, all or most of these elements were in place earlier than 1400. In this section we will look back from the definitive *Zenkōji Engi* to what came before, in an effort to determine as far as possible the developmental stages leading to the final version. Although the evidence is limited, the major outlines of the development can be delineated.

The earliest extant account of the Zenkōji Amida Triad is contained in *Fusō Ryakki*, the chronicle-style history of Japan, with a strong emphasis on Buddhism, which was briefly discussed in the preceding chapter.[5] The *Fusō Ryakki*'s discussion of the Zenkōji Buddha appears under the year Kinmei 13. This date is highly important in the early history of Buddhism in Japan because it is supposed to be the year of the official introduction of Buddhism into Japan as a result of the donation by King Song of Paekche of an icon and other objects to Emperor Kinmei of Japan. Scholarly controversy has raged about the absolute date of Kinmei

13, since *Nihon Shoki* gives the year equivalent to 552, whereas *Gangōji Engi* offers 538.[6] The consensus now appears to favor the earlier date, although this problem need not be solved here since it is more relevant to the beginnings of Buddhism in Japan than to the origins of the Zenkōji cult. The relationship of the Zenkōji Buddha to Kinmei 13, however, is of fundamental significance, since it aligns the arrival of that icon to the most important event in the early history of Japanese Buddhism. Before this matter is considered in more detail, the *Fusō Ryakki* account should be analyzed at some length.

The specific date of the entry is Kinmei 13.10.13. The first section of the *Fusō Ryakki* text follows quite closely the account of King Song's donation as found in *Nihon Shoki*, Kinmei 13.10 (*Nihon Shoki* does not give the day).[7] *Fusō Ryakki* says that King Song presented a gilt-bronze image of Shaka, scriptures, banners, etc., and a letter praising the virtues of Buddhism.[8] This is followed by a long passage describing the reception of the image at Kinmei's court, and the debate between the pro-Buddhist faction, led by Soga no Iname, and the anti-Buddhist faction, led by Mononobe no Okoshi and Nakatomi no Kamako, regarding the desirability of permitting the practice of the new religion. Here too *Fusō Ryakki* generally follows the account given in *Nihon Shoki*. After describing Soga no Iname's acceptance of the icon, and its installation first in his Oharida and then in his Mukuhara residence, *Fusō Ryakki* then, however, deviates substantially from the earlier text. *Nihon Shoki* presents a detailed description of a plague that struck Japan, and the destruction of the icon and temple at the urging of Mononobe no Okoshi and Nakatomi no Kamako, who blamed the plague on the acceptance of Buddhism; *Fusō Ryakki* abbreviates this part of the story greatly, merely referring to the plague, with a mention of Mononobe no Okoshi's accusations, but entirely ignoring the crucial part about the throwing of the icon into Naniwa canal. *Fusō Ryakki* does, however, include the final sentence of the *Nihon Shoki* entry, which refers to the fire that mysteriously destroyed the Great Hall of the palace, presumably as a result of Emperor Kinmei's order that the Buddhist icon and temple be destroyed. Moreover, the next entry in *Fusō Ryakki* states that Mononobe no Okoshi died in this year. These details indicate that *Fusō Ryakki* is a text that is far more favorable to Buddhism than *Nihon Shoki*.[9]

This first section of the text, which does not deal with the Zenkōji icon, has been discussed here to provide a proper context for the second section, which deals specifically with the Zenkōji Amida Triad. The compiler of *Fusō Ryakki* is quoting another source, and this second-section passage begins:

One text says: In the same year (i.e., Kinmei 13), Mizunoe-saru year, the tenth month, King Song of Paekche presented an image of Amida Buddha (one *shaku*, five *sun* tall) and images of Kannon and Seishi (one *shaku* tall).

What is most significant is that the gift of the Amida Triad, described in this second section, is treated as separate from King Song's gift of an image of Shaka, described in the first section (which follows the *Nihon Shoki* account). Thus, the first two sections of *Fusō Ryakki* imply that King Song actually donated two icons in Kinmei 13.10, an image of Shaka, and an Amida Triad. The second section of *Fusō Ryakki*, once again following the *Nihon Shoki* account, continues:

The memorial says: "Your Minister (i.e., King Song) has heard that amongst the myriad doctrines Buddhism is the most wonderful. Of the (ethical) paths of this world, Buddhism is the highest. Your Majesty the Emperor should practice it. Therefore, I have respectfully presented a Buddhist icon, sutras, and monks to accompany this tribute.

Of course, in the present context, the interesting thing about this second section of the *Fusō Ryakki* account for Kinmei 13 is the way it closely parallels the first section (and the *Nihon Shoki* account), but describes the gift of an Amida Triad, rather than the gilt-bronze image of Shaka that orthodox history acknowledges.

Fusō Ryakki then cites a third source to explain more clearly the identity of the Amida Triad just mentioned:

A certain text says: "The Amida Buddha of the Zenkōji in Shinano is accordingly this Buddha. In the reign of the Oharida Empress (Empress Suiko), the Mizunoe-inu year, fourth month, eighth day, (602), the Empress commanded Hata no Kose no Maetsukimi, requesting that he take the image to Shinano Province."

For purposes of this discussion the fourth part of the *Fusō Ryakki* account is of the highest significance, since it begins with the clause: "*Zenkōji Engi* says." From this one can conclude that, by the middle of the twelfth century, an account of the origin of the main icon of Zenkōji had already been written. As will be seen presently, the basic account was substantially elaborated and altered in later centuries, but some of the central details already appear in the version of *Zenkōji Engi* cited in *Fusō Ryakki*. This section of the text reads:

Zenkōji Engi says: "In the thirteenth year, Mizunoe-saru year, tenth month, thirteenth day of the reign of Amekuni Oshiharaki Hironiwa no Sumera Mikoto [i.e., Emperor Kinmei] an Amida Triad came floating over the

waves from Paekche and landed in Japan at Naniwa harbor in Settsu
Province. After this thirty-seven years passed and (the people of Japan)
began to recognize the virtue of Buddhism. That is to say, this triad was the
earliest Buddhist icon (in Japan). Consequently, lay people all called this
image *Honshi-nyorai*. In the tenth year, Mizunoe-inu, fourth month, eighth
day of Oharida Empress Suiko, in accordance with an oracle of the Bud-
dha, the Empress sent down a command that the image be transferred to
Minochi-gun in Shinano Province. Because it was the first image (in Japan)
it produced many religious miracles. This image originated while Shak-
yamuni was still on this earth. The rich man, Gakkai of the Kingdom of
Bishari in India, following the teachings of Shakyamuni, faced directly to
the west and worshiped into the distance. With full concentration he
prayed to Amida Nyorai, Kannon, and Seishi. Incidentally, the triad which
appeared at Gakkai's gate had a body which was only one shaku, five sun
tall. The rich man saw before his eyes one Buddha and two Bodhisattvas.
Immediately he used gilt-bronze to cast (an icon) copying the Buddha and
Bodhisattvas (that had appeared). After Gakkai had died, the Buddhist
image rose to the sky and flew to the Kingdom of Paekche. Then about
1,000 years passed. After this (the image) floated to Japan. Today this
Buddhist icon is the triad of Zenkōji.

A number of details that *Fusō Ryakki* quotes from *Zenkōji Engi* are
important. The year-month-day formula seen in the first section is uti-
lized, in contrast to the second section, which omits the day. This
13.10.13 formula would seem to associate the account of the Amida Triad
with King Song's donation, but nothing is said in the quote from *Zenkōji
Engi* about King Song and, in fact, the image is described as "floating" to
Naniwa from Paekche.[10] The section also maintains that the image was
the earliest Buddhist icon in Japan, and that lay people referred to it
as Honshi-nyorai ("The Original Buddha"). The text then describes the
transfer of the Amida Buddha to Shinano Province in 602, relating this
directly to an oracle uttered by the Buddha. (Later in this study I will
show that such oracles are a central part of the Zenkōji cult.) In describ-
ing the 602 transfer, this section does not refer to Hata no Kose no
Maetsukimi, who figured in the third text discussed above.

Having explained how the Amida Triad came to Shinano, the *Zenkōji
Engi* citation in *Fusō Ryakki* then deals with the origin of the icon in India.
This is extremely important, since it presents certain basic elements of
the mature *Zenkōji Engi* account. The story of Gakkai's having an image
of the Amida Triad made through the assistance of Shaka is based on an
account in *Shō Kanzeon Bosatsu Shōfuku Dokugai Darani Ju Kyō*.[11] The

Zenkōji Engi section in *Fusō Ryakki* does not explain why Gakkai prayed to Amida, and wished to have a copy made, but this can probably be understood in terms of the brevity of the quotation. The citation closes with a mention of the triad's flight to Paekche, its sea voyage to Japan, and its transfer to Shinano, where it becomes the main icon of Zenkōji.

To recapitulate briefly, the Kinmei 13 part of *Fusō Ryakki* consists of four sections:

> 1. The account of King Song's presentation of an image of Shaka to Emperor Kinmei, the so-called official introduction of Buddhism. This image is not directly related to the Zenkōji Amida, although the two are frequently confused.
> 2. The account of the presentation of an Amida Triad by King Song.
> 3. The citation of a "certain text" that identifies the Amida Triad described in (2) as that of Zenkōji. Empress Suiko orders Hata no Kose no Maetsukimi to take it to Shinano in 602.
> 4. The citation from *Zenkōji Engi*, which presents the greatest amount of information as to the origin and early history of the Amida Triad.

Since one can assume that Kōen drew from several texts in compiling *Fusō Ryakki*, the four sections just enumerated should be understood as deriving from various textual traditions. Particularly interesting is the increasing specificity concerning the Zenkōji Buddha from section (2) to (3) to (4). In section (2) there is no mention of Zenkōji, although the measurements of the Amida and two Bodhisattvas are the standard ones for a Zenkōji Triad. Section (3) makes clear the identification of the triad and explains how it got to Shinano. Finally, section (4) presents the core of *Zenkōji Engi*. Presumably the text of the latter, which Kōen utilized, already had the Kinmei 13.10.13 date attached to the arrival of the Amida Triad to Japan; he simply inserted it in the appropriate place. The person responsible for the original attribution of this date will always remain a mystery, although one can easily enough imagine that a prelate familiar with the establishment of Buddhism in Japan would have selected Kinmei 13.10.13 as an especially auspicious and prestigious date.

The preceding analysis of *Fusō Ryakki* demonstrates that a version of *Zenkōji Engi* existed by the mid-twelfth century. How much earlier one could have existed is, of course, unknown. However, some of the data presented in the preceding chapter, especially the *Chūyūki* reference of 1114, suggest that Zenkōji must have been a flourishing cult center by at least the end of the eleventh century. A few scholars have assumed very early dates for the origin of *Zenkōji Engi*, going back even as far as the Nara period.[12] Although these arguments are unconvincing to me, possi-

bly the origin of *Zenkōji Engi* lies in the middle Heian period, and perhaps a conservative eleventh-century date for its formation might be suggested.

Chronologically following *Fusō Ryakki* are a number of texts that describe the arrival of the Zenkōji Buddha in the year Kinmei 13. Some, for example *Mizu Kagami*, provide relatively detailed accounts, including material concerning the conflict over the acceptance of Buddhism in Japan, while others, such as *Iroha Jirui Shō*, offer very brief accounts.[13] These, and other texts, indicate that the basic narrative of the arrival of the Zenkōji triad was well known by the early Kamakura period. In addition to accounts in historical sources, there are numerous references to Zenkōji in a variety of other texts. Perhaps most important is the chapter in *The Tale of the Heike*, "The Burning of Zenkōji," referred to at the beginning of this book. The simple fact that an entire chapter is devoted to Zenkōji is highly significant, since it is the only temple so honored in *Heike*. Moreover, as noted above, an extraordinary claim is made about the preciousness of Zenkōji's triad, that claim being of a type not seen elsewhere in the text. In addition, *Heike* provides an account of the auspices under which the Amida Triad was made, how it traveled from India to Paekche, and then how it got to Japan and finally to Shinano. Of course, the whole point of this narrative is found at the end of the chapter, with the statement and question:

> We are told that the end of the secular law is preceded by the destruction of the Buddhist Law. Perhaps this is why people said: "Might all this destruction of holy temples and sacred mountains portend the fall of the Heike?"

If Zenkōji had not been regarded as a tremendously important temple, then its destruction by fire would not have had the significance that it apparently did for the medieval audience.[14]

Buddhism, Buddhist temples, and Buddhist icons are crucial components of *The Tale of the Heike*. A survey of the text reveals, however, that relatively few temples are mentioned frequently, in particular Enryakuji, Onjōji (Miidera), Kōfukuji, Tōdaiji, and Mt. Kōya. Others, such as Kiyomizudera, Ninnaji, Tōji, Hosshōji, Jingoji, Byōdōin, Hasedera, Hokkeji, and Tennōji, appear less often. The temples in the former group are all of the greatest political and religious significance, and consequently their roles in the story are easily understood. Those of the latter group are also well known, and thus their inclusion should not be surprising, although some famous temples that we might expect to find, such as Taimadera or Hōryūji, are absent. In any case, this survey of the text should make evident the strong implications of the prominence of

Zenkōji in *The Tale of the Heike*; certainly, no other "provincial" temple has a similar role.

While there are various references to Buddhist icons in the text, the only icon that receives somewhat greater attention that that of Zenkōji is the Great Buddha of Tōdaiji. Since the latter is arguably the most important icon in Japan, this situation clearly implies the importance of the Zenkōji Amida Triad in the medieval period. The prominence of Zenkōji and its icon in *The Tale of the Heike* surely indicates that information concerning the cult would be spread throughout the entire country, as itinerant storytellers traveled to the most distant regions of Japan. Some scholars have suggested that there was a close relationship between those who performed *The Tale of the Heike* and the propagators the Zenkōji cult.[15]

The earliest full-scale account of the Zenkōji legend that is extant is a small text in the Kanazawa Bunko called *Zenkōji Nyorai no Koto*.[16] This text is thought to date to the late-Kamakura period, and it includes a detailed description of the origin of the Zenkōji Amida Buddha in India. An examination of *Zenkōji Nyorai no Koto* suggests that it is a summary of a larger engi, rather than being the complete text; presumably it was used as an aid for preaching or perhaps for private devotion.

There are two complete versions of *Zenkōji Engi* that appear to have been written during the Muromachi period (1333–1573), one printed in *Zoku Gunsho Ruijū*, the other in *Dai Nihon Bukkyō Zensho*. While these two texts are very similar, there are minor variations. In terms of dating, the most important variation is found in the section that refers to the various fires that ravished Zenkōji. *Zoku Gunsho Ruijū Zenkōji Engi* refers to the fire of Ōan third year (1370), but not to the fire of Ōei thirty-fourth year (1427), and thus this version is usually referred to as *Ōan Zenkōji Engi*.[17] The text printed in *Dai Nihon Bukkyō Zensho* includes the Ōei fire and is thus called *Ōei Zenkōji Engi*.[18] Presumably it was written not too long after 1427. Both the Ōan and the Ōei versions are written in Chinese characters (i.e. *kanbun*), although the latter includes *kaeri-ten* marking to assist the reader in understanding the kanbun prose.

The evidence currently available suggests the following process in the formation of *Zenkōji Engi*. In the Late Heian period, perhaps by the eleventh century, a basic version was already in existence, and apparently this version was cited in *Fusō Ryakki*. Knowledge of the story became widespread during the Kamakura period, as can be seen in the frequent references to the Zenkōji Amida Triad in widely different sources. A tantalizing piece of evidence for the Kamakura version of the story is found in *Zenkōji Nyorai no Koto*. Finally, in the Muromachi period,

lengthy and detailed versions were produced, presumably drawing on the earlier textual materials. I cannot attempt here a philological analysis of the evolution of *Zenkōji Engi*, but that is unnecessary, since the demonstrable existence of the engi from the Late Heian period onward is adequate to indicate its role in the development of the Zenkōji cult.

By the Edo period (1615–1868) printed editions of *Zenkōji Engi* became widespread. *Kanbun Hachinen-Ban Zenkōji Engi* (1668) is written in kanbun, and follows in general terms the Ōan and Ōei versions.[19] A new development is seen in *Genroku Gonen-Ban Zenkōji Nyorai Engi* (1692), since it is written in vernacular Japanese, based on the preceding account.[20] The existence of a vernacular text suggests a more general readership, since one can assume that the earlier kanbun versions were for the use of priests rather than laypeople. There are a number of other versions of *Zenkōji Engi*, some fully illustrated, from the Edo period, but the 1668 and 1692 texts suffice for the moment to indicate the state of development of Zenkōji literature by the seventeenth century.[21]

In the preceding pages the process leading to the development of the mature *Zenkōji Engi* has been considered, and here I will briefly summarize the story. The basic mode of propagation of the Zenkōji cult was by means of preaching, as the *Zenkōji Engi* must have been initially an oral tradition, only later committed to written form. As the latter version is what has been preserved, however, we must utilize a textual tradition in describing the story. I mention this here to make the point that the following recounting of the *Zenkōji Engi* narrative is probably more complete and coherent than the fragmentary versions normally preached to the visitors.[22]

The legend begins in India, in the Kingdom of Bishari.[23] A wealthy man, Gakkai, has innumerable possessions; the only thing he lacks is a child. Fortunately, at the age of 51 he has a daughter, who is named Princess Nyoze.[24] Gakkai dotes on this daughter, paying little attention to anything else. Nearby, the historical Buddha, Shaka, is living and preaching in a grove, but Gakkai does not go to hear him. Shaka sends one disciple after another to Gakkai's gate to beg, but the rich man makes no offerings at all; Shaka himself goes to Gakkai's residence and, although at first it seems as if Gakkai will offer Shaka some rice, in the end he does not. On his return to the grove, Shaka receives an offering of rice water from a girl who is washing rice, and the point is made that no matter how humble, all offerings to the Buddha are of merit.[25] About this time a serious fever strikes the kingdom, and Gakkai dispatches soldiers to the roof of his palace to guard against the evil spirits who are bringing the epidemic, but the guards quickly succumb to the fever. Soon Princess Nyoze also contracts the fever and becomes seriously ill. Gakkai sum-

mons a famous doctor named Giba, but the latter can do nothing and gives up in despair.[26] All of Gakkei's rich friends urge him to go to the grove to receive Shaka's assistance.

Gakkai makes a pilgrimage to Shaka's residence and implores his help in saving both his daughter and the other sick people of the kingdom. Shaka explains that in the west there is a Buddha called Amida who can offer salvation and instructs Gakkai to return to his palace and pray to that direction. Upon returning home, Gakkai follows the instructions, faces west, and invokes the name of Amida ten times. Thereupon Amida and his two attendants, Kannon and Seishi, appear over Gakkai's western gate, causing all of the epidemic spirits to flee. Although Princess Nyoze has already breathed her last, she is brought back to life, and all of the sick people of the kingdom are restored to good health.[27]

The Amida Triad continues to hover in the sky, protected by heavenly spirits, and Gakkai is so deeply moved that he goes to the residence of Shaka and requests that the form of the triad be preserved for the world. To obtain the precious gold of the appropriate purple shade for the casting of a copy, Shaka sends one of his principal disciples, Mokuren,[28] to the palace of the Dragon King. The Dragon King is reluctant to provide this valuable gold, but Mokuren succeeds in persuading him to yield up a quantity of his magical treasure. Mokuren returns with the gold, and, radiating magnificent light from their holy bodies to the metal, Shaka and Amida mysteriously transform the gold into a living manifestation of Amida and his two attendants; this ultimately becomes the main icon of Zenkōji. Gakkai builds a temple for the icon, diligently worshiping it for the rest of his life. The relationship between the copy—the Living Buddha—and the actual Amida Triad that appeared with Shaka in ancient India is ambiguous. It is certain that two triads existed at the same time, and both are considered to have been alive. The icon that is central to this study, however, which was itself copied repeatedly over the centuries, appears to have assumed an independent existence in some mysterious manner.

As a result of his devotion, Gakkai is reborn in the Korean kingdom of Paekche as King Song; regrettably, he has forgotten his past virtue, and has fallen into evil practices. The Amida Triad that had been produced magically in India for Gakkai hears of King Song's bad behavior, flies to Paekche, and exhorts King Song to change his ways, which, of course, the king does, becoming a virtuous monarch. In this connection, King Song desires to be reborn as a poor man in his next existence. At the time of King Sui-mei, a ninth generation descendant of King Song, the Amida, now resident in Korea, gives an oracle saying that he next wishes to go to Japan. This deeply saddens the people of Paekche, and at the time the

Amida Triad embarks by ship for Japan, many women, beginning with the king's consort, dive into the water after it.[29]

The Amida Triad arrives at Naniwa, in Settsu Province, and a debate ensues at the court of Emperor Kinmei concerning whether the Buddha image should be accepted. Mononobe no Okoshi is opposed and Soga no Iname is in favor, so Iname is ordered to worship the icon, which is installed in his residence.[30] Subsequently, a fever spreads through the country, and Mononobe no Okoshi argues that this ill fortune has arisen because the native gods of Japan are angry. Okoshi tries to melt down the icon, but fails, and so it is thrown into Naniwa Canal.[31] Thereupon demons appear above the palace, predicting the death of the emperor and Okoshi, and the flames that erupt from their mouths burn down the palace.[32] In the next year the emperor passes away, and Okoshi contracts a horrible fever, dying and then falling into hell.[33] Three years after the death of Mononobe no Okoshi, Emperor Bidatsu becomes ill, and it is said that this was the result of a curse pronounced by the Amida Triad. Consequently, the triad is fished out of Naniwa Canal and installed in Bidatsu's palace. Mononobe no Moriya, the son of Okoshi, also tries to destroy the icon, but he, too, fails and thus throws it into Naniwa Canal, as before. Once again, demons appear and predict the deaths of the emperor and Moriya.[34]

At this point *Zenkōji Engi* goes back in time a few years to introduce a new character, Prince Shōtoku (Shōtoku Taishi, 574–622), who then assumes an important role in the story.[35] This prince is born in the third year of the reign of Emperor Bidatsu, and from his infancy there are various miraculous happenings. Mononobe no Moriya attempts to kill him, but the Prince gathers together warriors to protect himself.[36] He rides a black horse that had come from Kai Province, and inspects the whole country.[37] Prince Shōtoku has an initial battle with Moriya, but is defeated and only barely escapes with his life. He then rallies his troops and makes a vow to the Four Heavenly Kings, supplicating them for victory. With their protection, the Prince defeats Moriya, and out of gratitude to the Four Heavenly Kings he constructs Shitennōji in Naniwa.[38] He also formulates the "Constitution in 17 Articles" and dedicates forty-six temples. After his triumph, Prince Shōtoku goes to Naniwa Canal and invites the submerged Amida Triad to come out of the water to be enshrined in the palace. The triad proclaims an oracle saying that it awaits someone else, and thus declines Prince Shōtoku's request.[39]

A certain person named Honda Yoshimitsu, from Omi Village, in Shinano's Ina County, comes around this time to the capital to perform national labor service.[40] After three years of service, he sets out for home, passing by Naniwa Canal. As he passes, the Amida Triad appears from

the water and calls: "Yoshimitsu, Yoshimitsu." In an oracle, the triad explains that Yoshimitsu had been Gakkai and King Song in previous existences. Yoshimitsu carries the icon on his back and returns home to Shinano, where it is placed on top of a mortar in his humble house.[41] The wife of Yoshimitsu, Yayoi,[42] is skeptical about her and her husband's connection with the Amida Triad, so the latter provides them with a vision of all of their previous incarnations. Yoshimitsu decides that the icon needs a hall of its own, but, when enshrined in the separate hall, it refuses to stay, flying back into Yoshimitsu's house at night.[43] During the reign of Empress Kōgyoku the triad issues an oracle, saying that it wishes to be moved to Imoi Village in Minochi County (present-day Nagano City).[44] After being moved, the Amida emits a radiant light from his *urna* that ignites the oil in the lamps at the front of the altar. These lamps have never been extinguished and are called the "Eternal Lamps" of Zenkōji.

Yoshimitsu and Yayoi have a son called Yoshisuke who, tragically, dies young.[45] In his bereavement, Yoshimitsu complains to Amida about the bitterness of having a child predecease its parents, and so Amida intercedes with the King of Hell, Enma, requesting that Yoshisuke be allowed to return to this world. The request is granted, but it is decided that, since Yoshisuke has come all the way to Hell, he might just as well see some of the sights. On his way back to the human realm, he comes across a woman who is suffering on a mountain of needles. Curious about her, he asks his demon-guide who she is and is informed that this is Empress Kōgyoku of Japan, who has fallen into hell because of her evil deeds.[46] Yoshisuke wishes to save the life of the empress by offering his own life in exchange for hers, but this is not allowed.[47] Instead, Amida sends Kannon to the office of King Enma to negotiate for her release. Subsequently, both Yoshisuke and Empress Kōgyoku are returned to life, and the empress, out of gratitude, summons Yoshisuke and Yoshimitsu to court, appointing them as governors of Shinano and Kai provinces. They present their desire to construct a hall to enshrine the Amida Triad and, through the power of Empress Kōgyoku, the humble dwelling of Yoshimitsu is made into a magnificent Buddha Hall.

This concludes the basic legendary account of the origin of the Zenkōji Amida Triad, but *Zenkōji Engi* continues with a number of other details that describe subsequent happenings at Shinano Zenkōji, some of which are extremely important to the Zenkōji cult. Particularly significant is an account of the exchange of letters between the Zenkōji Amida and Prince Shōtoku.[48] There is also a description about how the Buddha came to be a secret image.[49] Miraculous events are narrated, and there are references to various monks, including Chōgen of Tōdaiji, who made pilgrimages to Zenkōji.[50] Of great importance for this study is the de-

tailed account of the copy of the secret Amida Triad made by the monk
Jōson in 1195, since this would seem to represent the beginning of the
practice of making copies.[51] The next section describes the making of
another copy, this time by the monk Jōren.[52] The final section of *Zenkōji
Engi* refers to various fires and rebuildings, with data regarding the
donors who provided funds.[53]

I would like next to outline in general terms the essential components
of *Zenkōji Engi*. Clearly, the initial section, taking place in India, is de-
rived from *Shō Kanzeon Bosatsu Shōfuku Dokugai Darani Ju Kyō*, men-
tioned above.[54] The movement of the Zenkōji Buddha from India to
Japan is referred to as a *sangoku denrai* (Three Kingdom Transmission),
but it is important to recognize that China is not included in this trans-
mission.[55] Rather, the triad went from India to the Korean kingdom of
Paekche prior to coming to Japan. I assume that the association of the
Zenkōji Amida Triad with King Song of Paekche is based on knowledge
of the "official transmission" of Buddhism from Korea to Japan in the
thirteenth year of Emperor Kinmei.[56] In its developed form, *Zenkōji Engi*
presents an impossible chronology, stating that the icon stayed in
Paekche for nine generations after King Song, but nevertheless arrived
in Japan during the reign of Emperor Kinmei! However, obviously such
chronological niceties are not the stuff of legendary literature. A large
section of *Zenkōji Engi*, in dealing with the arrival and early history of the
icon in Japan, conflates the story of the Zenkōji Amida Triad with the
image that traditional histories tell us was presented by King Song to
Emperor Kinmei. Above we saw how these two "events" were inter-
woven and ultimately confused in the early texts, beginning with *Fusō
Ryakki* and continuing through various Kamakura and Muromachi texts.
Clearly, the compilers of *Zenkōji Engi* drew on *Nihon Shoki*, *Gangōji Engi*,
and other sources in developing the account of how the Zenkōji Buddha
came to be the central icon in the Mononobe-Soga conflict over the
introduction of Buddhism into Japan.

In studying the summary of the engi, the reader may have been struck
by the prominence of Prince Shōtoku's role. Of course, Prince Shōtoku
was a major actor in all of the traditional and orthodox narratives dealing
with the early history of Buddhism in Japan, and in this respect his
presence is not surprising. However, there are other reasons for his
prominence in *Zenkōji Engi*. To be more specific, the cult of Prince
Shōtoku was intimately related to the cult of the Zenkōji Amida at the
latter's early stage. Consequently, Prince Shōtoku is given an important
role in the early part of *Zenkōji Engi*'s account of the coming of the triad
to Japan, and he is also dealt with near the end of the text in the context of
the exchange of letters between the prince and the Buddha.[57]

Greater difficulties are encountered in trying to elucidate the signifi-cance of the transport of the image by Honda Yoshimitsu to Shinano. In distinction to the sections of the text just analyzed, which were clearly based on preexisting textual traditions, this part presumably constitutes the "original" core of *Zenkōji Engi*. Here the specific details are found that account for the presence of the Amida Triad and the explanation of the icon's significance. Especially important are the roles of Honda Yoshimitsu, his wife Yayoi, and their son Yoshisuke in the development of the Zenkōji cult.

An effort has been made thus far to trace the process by which *Zenkōji Engi* was formulated. Next the various components of the story will be considered once again, but this time in terms of an analysis of their religious significance rather than in the context of textual evolution. A thorough understanding of the major motifs of *Zenkōji Engi* is clearly essential to a broader conception of its significance within the cult as a whole.

The initial section of *Zenkōji Engi*, which deals with the wealthy man Gakkai and his daughter Princess Nyoze, sets the stage by establishing a picture of a selfish, impious old man who is devoted only to his daughter and totally lacking in any concern for the teachings of Shaka. The reader—or better, auditor of a sermon—is provided with an image of abundant good fortune that, however, is suddenly reversed by the grave illness of Princess Nyoze. Little effort is required to imagine the dra-matic impact that such a story would have had on premodern listeners, especially those who had lived long enough to experience for themselves the travails of human existence. The problem is resolved when the father throws himself on the mercy of Shaka, begging for the healing of his daughter. From the perspective of the Buddhist church, Gakkai has seen the light, submitted to the Buddha, and, as a result, his daughter is cured. The simple but effective causal chain seen here would lend itself well to the talents of a good preacher.

Following this poignant account, the narrative proceeds to an explana-tion as to how the miraculous Amida Triad came to be made. Here a wonderful description is provided about where and how magical gold is obtained for the casting of the icon, and the manner whereby Shaka and Amida join their powers to mysteriously produce the triad. The detailed transition from the potential tragedy of Princess Nyoze's illness to the fantastic rendering of the magical creation of the Amida Triad enhances the resonance of the narrative and keeps the listener interested. From the perspective of a premodern Japanese person, these events would have appeared to take place in a fabulous environment that was itself all but mythological.

The story becomes somewhat more concrete when the icon is transported from India to Paekche, since the latter kingdom was located in the southwestern part of the Korean Peninsula, well within the geographical confines of what was then, to the Japanese mind, the known world. Gorai Shigeru has argued that the concept of the sangoku denrai is not entirely Buddhist in origin; rather, he believes that it is related to a pre-Buddhist, early Japanese idea that has to do with deities who return to Japan from a distant realm, sometimes referred to as *tokoyo*.[58] These returning deities bring with them powers that can benefit humanity, and their presence is thus highly prized. At times they are conceived of as icons or images that are washed ashore, or extracted from the ocean. This, of course, closely parallels the *Zenkōji Engi* account of the Amida Triad's crossing the sea from Paekche to Naniwa. Gorai marshals an impressive amount of evidence to place the arrival of the Zenkōji Amida Triad within the general context of the "returning deity" concept. If his hypothesis is correct, it would suggest that much of the appeal of the Zenkōji Buddha lies on the level of popular folk beliefs that appeared very early in Japanese culture. Certainly we must be aware of this possibility, since otherwise the sangoku denrai will be thought of only within the framework of the historical transmission of Buddhism from India through central and Southeast Asia to China and then, via the Korean Peninsula, to Japan. The fact that the "Three Kingdom Transmission" of *Zenkōji Engi* excludes China, focusing instead on the passage from Paekche to Naniwa, may be taken as an indication of the metaphorical character of this account.

Gakkai now is seen reincarnated as King Song of Paekche. This serves as an interesting theme in itself, perhaps intended to prepare the listener for the next stage of the narrative. I demonstrated above how the King Song/Emperor Kinmei incident was borrowed by the *Zenkōji Engi* narrative from the early history of Buddhism in Japan. Here—in the context of an analysis of religious motifs—this material must be approached differently, for the exciting and dramatic events of the Mononobe/Soga conflict are woven effectively into the fabric of *Zenkōji Engi* in a way that is intended to veil their connection with orthodox Buddhist history. Instead, the listeners hear an engrossing tale that places the Zenkōji Amida Triad at the very center of the early history of Japanese Buddhism. The important role played by Prince Shōtoku in *Zenkōji Engi* would also have had a strong effect on listeners; and the importance of the Amida Triad is further enhanced by the great concern that Prince Shōtoku had for it. And yet, in the end, the Amida declines to follow the prince's wishes when it refuses to come out of the canal. Here, too, a fascinating twist in the story is observed, one that must have been particularly appealing to the audience.

Until this stage in the narrative, all of the events depicted have important connections with other traditions. With the account of Honda Yoshimitsu and his carrying of the Amida Triad to Shinano, however, we arrive at the unique features of *Zenkōji Engi*. The first consideration is Honda Yoshimitsu's true identity. *Zenkōji Engi* explains that he is a humble man from Shinano who goes to the court to perform his national service. We subsequently learn that he is, in fact, a reincarnation of King Song, and thus an individual of considerable prestige in terms of the karmic cycle. Within the structure of *Zenkōji Engi*, Yoshimitsu's seemingly humble status is apparently designed to make him attractive to those hearing his story. Presumably, all classes, but especially the lower orders, could readily identify with Honda Yoshimitsu.

Gorai believes that behind Honda Yoshimitsu lie the hijiri, the itinerant religious figures of premodern Japan.[59] Later the role of hijiri in the propagation of the Zenkōji cult will be considered in some detail; here we should note that the story of Yoshimitsu's carrying the Amida Triad from Naniwa Canal to Shinano may suggest the pilgrimage activities of a hijiri. Hijiri often carried small icons on their backs, which they used when they performed religious ceremonies. Whether people hearing of Yoshimitsu's activities would conceive of him as a hijiri is uncertain; perhaps not, for *Zenkōji Engi* does not identify him as such, although there may have been a general recognition of his relationship to the type of movement exemplified by the hijiri. This possibility is strengthened by the frequent appearance of oracles in the text, some of which were given to Yoshimitsu, since the ability to receive oracles was a shamanistic talent cultivated by the hijiri. Possibly Yoshimitsu's wife, Yayoi, was a partner in the receiving of oracles, for there are many instances of male-female partnerships in this process. Much of the shamanistic material in *Zenkōji Engi* is now veiled, but Gorai's careful investigation of the text, particularly in terms of comparative analysis, has revealed striking evidence for shamanism.[60] For example, the concept of the eternal flame that now burns in the lanterns at Zenkōji is related to a motif frequently found in Japanese folk religion, one deriving from shamanistic ideas.[61] Consequently, one can assume that a number of the motifs seen in *Zenkōji Engi* were understood by medieval believers in terms of contemporaneous popular religion, rather than in the context of orthodox Buddhism.

The prime importance of the "Three Founders"—Honda Yoshimitsu, Honda Yayoi, and Honda Yoshisuke—is a relatively unusual component for a Buddhist cult. Of course, the Amida Triad is the primary focus of the Zenkōji cult, but the three members of the Honda family nevertheless have a significant role to play. They seem to serve as intermediaries between the worshipers and the Amida Triad, thus directly participating

in the sacred while not being deities themselves. Here once more we note how the Zenkōji cult is carefully adjusted to the goals and expectations of the common believer. In a sense, it eschews basic doctrines of Buddhist orthodoxy, since there is little theological justification for the role of the Hondas. Gorai has presented interesting comparative data from the legends of Sensōji in Tokyo, for there, too, one has a case of a temple founded by laymen.[62]

The single most important element in *Zenkōji Engi* is the death of Yoshisuke and his return to life as a result of the mercy of the Amida Triad.[63] This provides a parallel to the Gakkai/Nyoze story at the beginning of the engi, for in both cases a happy family group is interrupted by sickness and death, but then receives the grace of Amida.[64] While the Gakkai/Nyoze drama may have seemed somewhat remote and distant to the Japanese audience, the Honda story was set in their own society and would have been easy to comprehend directly. The salvation of Yoshimitsu carried out by the Living Buddha guarantees salvation for all believers, and thus forms the central focus of the cult. Also worthy of note is that after Yoshisuke ensures that Empress Kōgyoku has been rescued from hell, he and his father are summoned to her court, whereupon she appoints them as governors of Kai and Shinano provinces. Thus, the beneficence of the Zenkōji Amida Triad is not limited to salvation in the next life, but also offers the possibility of material rewards in this world.

Zenkōji Engi combines an interesting narrative—a good story—with motifs designed to strengthen the believer's faith in and devotion to the Amida Triad. The story's entertainment value and power were clearly critical aspects in the dissemination of the Zenkōji cult among broad segments of the populace.[65] Presumably the entire story was not created at one time, but rather grew through gradual accretion and development. Of course, by the time we see it in *Ōan Zenkōji Engi*, the story is fully mature, but that text must reflect a developmental process that spanned a relatively long period.

The Icon

The development of *Zenkōji Engi* and related literature has been considered in some detail in order to understand something of the theological underpinnings of the cult. We can now turn to the icon itself, the Living Buddha of Zenkōji. As I have stressed repeatedly, the Amida Triad at Shinano Zenkōji cannot be seen, and thus absolute statements cannot be made about its appearance. This leads to an unusual situation for the art historian, for this is an entire cult built

around a secret image, and yet only speculation is possible regarding its characteristics. To use George Kubler's terminology, there are numerous replications, in the form of copies, but the prime object—the Amida Triad at Zenkōji—is not available for inspection.[66] However, as Kubler has shown, a reasonably accurate reconstruction of a prime object can be established on the basis of "signals" transmitted by the replications. Before an attempt to do this is made, one important problem has to be faced. In the following analysis I will assume that a seventh-century icon long present at Zenkōji formed the basis for the historical Amida Triad there, but it must be acknowledged at the outset that this is not necessarily the case. Hypothetically, an icon—old or new—could have been brought to Zenkōji during the Late Heian period, with this image then becoming the main icon of the temple. This is possible, and yet not likely, for there must have been some sort of functional relationship between temple and icon, whereby both grew in authority and prestige over the centuries. Perhaps the development of the Zenkōji cult can be best understood by assuming this sort of gradual growth, rather than by postulating a late introduction of an icon that then became the principal image.

Early textual sources provide only limited information concerning the icon. Of course, it is an Amida Triad, and in addition, information is provided about the dimensions of the three figures. As far back as the *Fusō Ryakki* account the Amida is recorded as one shaku, five sun—approximately 45 cm—while the flanking Bodhisattvas each measure one shaku, or approximately 30 cm.[67] The triad is made of metal. While this information is limited, it does place the triad within a definite context, as will be shown in a moment. Later texts provide more detailed descriptions of the icon, but these could well be retrospective, based on knowledge of the extant copies.

In the effort to reconstruct the appearance of the original icon, I will proceed from general to more specific traits. The proportions of the three figures—30 cm/45 cm/30 cm—strongly suggest that all are standing, for otherwise the relationship between the central Buddha and its flanking Bodhisattvas would be disharmonious. All extant copies show this standing format; and since there are numerous prototypes on the continent, there is no reason to doubt that this was the form of the original icon.

In continental triads of this type it is standard to have a tall, boat-shaped mandorla backing the three figures. A number of the extant Zenkōji copies still possess such a mandorla, but in most cases the mandorla has disappeared. This is not surprising, since, as a result of fire and other destruction, subsidiary elements such as mandorlas and pedestals

were frequently lost throughout the history of Japanese Buddhist sculpture. Whether Zenkōji-style triads were ever made without mandorlas is uncertain, although this seems unlikely in terms of the prototype deduced here. Copies that possess their original pedestals indicate that the pedestals were rather tall and may have had a mortar shape.

Finally, the *mudras* of the three figures, as seen in the copies, are extremely consistent. The right hand of the Amida is held up, palm out, with all fingers extended, while the left hand is pendant, also palm out, but with only the second and third fingers extended. The two Bodhisattvas clasp their hands in front of their chests, palm to palm, sometimes with right above left, other times the opposite. This positioning of the hands is based on the form where a Bodhisattva holds a jewel between the two hands.[68] While this jewel-clasping is clearly represented in some of the copies, in many the original significance appears to have been lost, and the two hands are flush.

The features just described seem to be the most basic elements of the Zenkōji-type Amida Triad and thus probably were present in the prototype. Complete consistency cannot be found except with respect to these elements, suggesting that we will be unable to elucidate all of the details of the original triad. For instance, considerable variety is found in the costumes of the Buddha and Bodhisattvas. Similarly, the crown and jewelry of the Bodhisattvas all show much variety. In some cases, specific components seem to have been introduced long after the archaic phase of Buddhist sculpture of which the prototype is presumably a member; and thus one can assume that such elements were introduced into the tradition at a late date.

The triad format, fundamental in East Asian Buddhist art, is based, of course, on the idea that each of the major Buddhas is accompanied by two attendant Bodhisattvas. The arrangement, with a central Buddha figure flanked on either side by a Bodhisattva, leads to a particularly satisfying symmetrical composition that appears to touch deep psychological roots. While other arrangements are seen, sometimes with a total of five or seven figures,[69] the three-figure format is by far the most frequent.

Practically all triads belong to one of two basic categories: in one type the central Buddha figure is seated in the lotus position, flanked by standing Bodhisattvas; in the other all three figures are standing. The former type is most frequent in early Japanese art, as in such groups as the Hōryūji Kondō Shaka Triad, the Tachibana Shrine Amida Triad, and the Yakushiji Yakushi Triad.[70] This format is so popular in Japanese Buddhist art for reasons too numerous to discuss here. I believe, however, that its popularity during the Asuka period must be related to a canonical type patronized by the Soga clan. In addition to the Hōryūji Kondō

Shaka Triad mentioned above, this group includes the original Asukadera Triad as well as the 628 Triad in the Hōryūji Museum.[71]

The format with all three figures standing is far less frequent in early Japanese art: the triad designated as Number 143 in the Forty-eight Buddhist Deities group of the Tokyo National Museum will be discussed presently. All figures in this triad stand, although interestingly, recent Japanese scholarship has attributed its provenance to the Korean Peninsula.[72]

Curiously, the three-figures-standing type is most frequently encountered in early Korean Buddhist sculpture.[73] Of course, in the case of both early Korea and Japan, our sample is extremely small, thus rendering statistical statements somewhat tenuous. Nevertheless, the available evidence suggests that the seated-central-Buddha type was most popular in early Japan, whereas the three-figures-standing type had the greatest popularity in Korea. Since the latter type is encountered in the Zenkōji Amida Triad, we shall analyze some of the Korean examples here, for purposes of comparison.

A small triad, now in the Kansong Museum in Seoul (fig. 5), illustrates a number of the important features of this type as seen in Korea.[74] The central Buddha figure is large in proportion to the other figures, thus dominating the group. In facial expression, modeling, and treatment of the robes, the Buddha reflects the late-Wei style of China as developed by the second quarter of the sixth century. The flanking Bodhisattvas, which are cast as a piece with the mandorla proper, are approximately one-half as tall as the central Buddha. The Bodhisattvas also reflect the essential traits of the late-Wei style. The viewer is struck in particular, in both Buddha and Bodhisattvas, by the way in which the hems of the robes flare out dramatically at left and right.

The Kansong Triad has a date given in cyclical characters that can be interpreted most reasonably as equivalent to the year 563, thus corresponding well to the stylistic elements of the figures. The mandorla is tall and relatively narrow; an elaborate floral halo encircles the head of the Buddha, and another section of the mandorla marks out the Buddha's body. The upper area of the mandorla is filled with flame patterns, but there is no depiction of subsidiary Buddhas in this zone. The feet of the Buddha extend down beyond the lower margin of the mandorla to rest on the pedestal. The pedestal's upper part is a rather small, unadorned piece, which has been inserted into a large, drum-shaped lower part that is decorated at the top with lotus petals. The flanking Bodhisattvas have much smaller pedestals, which were cast together with the mandorla. In overall character, the Kansong Triad is a relatively simple, somewhat naive piece of sculpture, and in these respects reflects a Korean inter-

pretation, as yet undeveloped, of the Chinese styles of the first half of the sixth century.

Of a slightly later vintage is a triad in the Kim Collection, Seoul (fig. 6), which bears a cyclical-character date equivalent to 571.[75] Stylistically, this monument is more advanced than the 563 triad just discussed, which may indicate a Chinese prototype dating from a later phase than that of the 563 triad. Nevertheless, in their basic elements, the two triads are quite similar. The 571 triad now lacks the lower part of the pedestal, although in its original form it must have looked something like that of the 563 triad. The relative sizes of the three figures in the two triads are similar, and their costumes are closely related in motif. The hems in the 571 triad do not flare out as strongly, however, as do those of the 563 triad, and the folds seem softer and less angular. These features, in the context of Chinese Buddhist sculpture, signify a stage in stylistic development later than the early sixth century. While the configurations of the two mandorlas are generally related, the contours of the 571 mandorla are more complex and subtle. Most striking, perhaps, is the presence of three subsidiary Buddhas within the "flame zone" of the upper part of the mandorla.

An undated triad at the Puyo Branch of the National Museum of Korea (fig. 7) manifests a rather crude version of the styles seen in the 563 and 571 triads, while preserving the basic forms described above.[76] Also in the collection of the same museum is a very fine mandorla (fig. 8) with a cyclical-character inscription that is best interpreted as equivalent to 596.[77] In terms of the usual mode seen in Korean images, the flanking Bodhisattvas have been cast with the mandorla, while the central Buddha was made separately and then affixed. Since that figure is now lost, its original form is uncertain; the inscription on the back of the mandorla refers to Shaka, the historical Buddha, and the proportions suggest that it was a standing representation of the same type seen in the triads analyzed above.

The monuments just discussed illustrate the basic characteristics of the three-figures-standing triad as seen on the Korean Peninsula during the second half of the sixth century. While there are several examples of single, seated Buddha figures from the same period,[78] triads consisting of a central seated Buddha flanked by standing Bodhisattvas were much less common. This is not to say that they did not exist, for strong evidence is preserved in early Japan suggesting that this format derives from the Korean Peninsula. Nevertheless, there was apparently a preference for the three-figures-standing type, particularly during the initial phases of Korean Buddhist sculpture, up until around 600, when the Sui styles began to play a decisive role. As noted above, the Korean triad form

discussed here was based on a type developed in China during the late-Wei period; that is, from about 500 to 550. For example, a large stele in the Fujii Yūrinkan Museum, Kyoto (fig. 9), dated 535, shows many of the characteristics seen in the Korean examples.[79] One could trace the Chinese sources for all of the features seen in the Korean images, but it is the possible Korean prototype for the Zenkōji Buddha that is of interest here.

The Korean triads discussed above are all extremely small, ranging from 12 to 17 centimeters in total height. It is well known that there are very few large-scale bronze Korean Buddhist sculptures preserved, and the images that have managed to survive the ravishes of history tend to be tiny.[80] This does not mean, of course, that larger images were not made in Korea; only that they have not survived. The extant three-figures-standing triads from Korea are not nearly as large, however, as the canonical size of the Zenkōji Amida Triad. For instance, the 571 Triad has a total height of 15.5 cm, so that the Buddha figure is less than 10 cm tall, not one-quarter the standard size of a Zenkōji Amida. Proportionally, the flanking Bodhisattvas are even smaller, since they are only half as tall as the Buddha, whereas in the Zenkōji Triad the ratio of Buddha to Bodhisattvas is 3:2.

In addition to these disparities in size, there are differences in motif between the extant Korean images and Zenkōji Amida Triads. This is difficult to interpret, however, since there is no way of knowing exactly how the original Zenkōji icon was fashioned. Nevertheless, I suspect that none of the Korean images discussed above can be thought of as manifesting the exact form of the prototype that lies behind the Zenkōji tradition. None of the Korean triads, for example, shows each of the two flanking Bodhisattvas clasping a jewel between his hands. This motif is seen quite frequently in independent Bodhisattva figures and thus was an important iconographical trait in early Korean Buddhist sculpture.[81] One must assume that the Korean prototype for the Zenkōji Triad—perhaps the original image itself—was a triad substantially larger than those discussed, with the jewel-clasping Bodhisattvas present.

There is one triad preserved in Japan (fig. 10) that displays a number of features closely relating it to the Zenkōji Triad. This is the icon, conventionally referred to as Number 143, that is included in the Forty-eight Buddhist Deities group housed at the Tokyo National Museum.[82] As noted earlier, some scholars now identify this image as Korean, and it is so labeled at the Tokyo National Museum. In its basic configuration, Number 143 is quite similar to the Korean triads analyzed above. It is dissimilar, however, in that all three figures in Number 143 have been cast separately from the mandorla and stand in front of it on a platform.

Although these figures are larger than those of the other triads, they are still somewhat smaller than the canonical proportions of the Zenkōji Amida Triad. However, their sizes—24 cm/32 cm/24 cm—have proportions closely paralleling the 3:2 ratio noted in the Zenkōji Triad. The boat-shaped mandorla, with subsidiary Buddhas placed atop the flame-pattern zone is also closely related to the Zenkōji tradition as evinced through numerous copies made in the Kamakura period. Perhaps the most intriguing feature of this triad—in the context of Zenkōji research—is the hand position of the flanking Bodhisattvas, for they are clasped in front of the chest but hidden under the robes. Consequently, we cannot determine if they hold jewels between their palms. Whether they were conceived as doing so or not, the fact that their hands are held together in this manner seems significant. Moreover, the central Buddha holds his hands in the standard mudra of the Zenkōji Amida. Therefore, this triad seems to come as close to the Zenkōji Amida Triad as is possible given the available evidence.

A different type of monument provides important comparative data for the hand positions of the flanking Bodhisattvas in the Zenkōji format. The large bronze plaque (fig. 11a) of Hasedera in Nara has a cyclical date usually interpreted as equivalent to 686 or 698.[83] Its principal iconographic feature is the pagoda housing Shakyamuni and Prabhutaratna, which is described in the eleventh chapter of the *Lotus Sutra*. For present purposes, however, the groups of deities to the left and right of the central pagoda are of significance (fig. 11b). In both cases a seated Buddha is flanked by four standing Bodhisattvas, two on each side. The two Bodhisattvas that are closest to the Buddha hold their hands clasped together in front of their chests. Because of their small size, the exact configuration of the hands is unclear, although they seem to be clasped together rather than holding a jewel. Nevertheless, in essential format this hand position relates closely to that of the Zenkōji Bodhisattvas.

The aim of the preceding discussion has been to delineate the types of triads seen in early China, Korea, and Japan that conceivably might have served as prototypes for the Zenkōji Amida Triad, as this image is understood from literary descriptions and later copies. The evidence suggests strongly that an image-type related to the Zenkōji Triad was common in Korea during the second half of the sixth century. This type—with all three figures standing—was not the format that exerted a strong initial influence on early Japanese sculpture; rather, as seen above, it was the alternative format—with the central Buddha figure seated—that became the standard type especially during the Asuka period. However, examples of the former type probably came from Korea to Japan, and

among these was probably at least one that incorporated the characteristic elements of the Zenkōji Amida Triad type.

A number of possibilities can be suggested as to how the prototype triad ended up in Nagano. *Zenkōji Engi* relates that Honda Yoshimitsu brought it from Naniwa Canal to Shinano Province during the reign of Empress Suiko. Earlier, in the analysis of the formation of *Zenkōji Engi*, I argued that this possibility is unlikely, and suggested that various well-known traditions were combined to create a powerful and interesting story explaining the source of the Zenkōji Buddha. Clearly the compilers of the text were seeking the most prestigious possible origin for their icon.

Even if the *Zenkōji Engi* chronology is rejected, the assumption might be entertained that someone called Honda Yoshimitsu brought the icon to Shinano at a later date, perhaps in the Heian period. As mentioned above, this scenario is based on Gorai's idea that Yoshimitsu was a hijiri. While it is perhaps unwise to reject this possibility out of hand, serious arguments must be raised against it, of which the most fundamental is the very nature of the numerous copies. Although late stylistic traits are present, the basic format is one of an archaic type that dates approximately to the seventh century. If Honda Yoshimitsu—or his equivalent—were carrying a small triad on his back, why would it be such an old and rare type of image, rather than something more up-to-date? In particular, if the icon brought to Zenkōji was of Heian-period manufacture, presumably we would note a more specifically Amidist characterization such as that seen in images of the tenth and eleventh centuries, rather than the early forms present in the extant copies.

I believe that there may have been an early triad from the seventh century at the proto-Zenkōji site. In the preceding chapter substantial evidence was mustered to indicate penetration into northern Shinano Province by immigrants from the Korean Peninsula. Furthermore, there are numerous icons dating from the seventh century along the Japan Sea coast, from Izumo to Akita.[84] Thus the assumption that a small, gilt-bronze triad came to Nagano City as part of this seventh-century movement is certainly plausible. Perhaps this icon was originally a depiction of Shaka rather than Amida and only received its present identification as a result of the transition to Amidist worship.[85]

If this scenario is accepted, what is to be done with Honda Yoshimitsu? He, as a symbol of an individual or a group, may have brought the new Amidist practice to the already established "Zenkōji" during the Late Heian period, perhaps in the eleventh century. There he encountered a cult, centering on the archaic gilt-bronze triad, which attributed great

power to that icon. Yoshimitsu and his successors accepted the worship of the old image, but altered the cult so that the original icon was transformed into the Amida Triad later described in *Zenkōji Engi*. Presumably this transformation took place in such a way that it would not have been perceived by local residents as inappropriate; perhaps the Buddha issued an oracle explaining his true identity.[86] As the compelling new message came to attract more and more devotees to the temple, however, people would have been able to convince themselves that their icon was, in fact, the original image to have come to Japan and, indeed, the Living Buddha.

CHAPTER 4 Zenkōji and Its Cult
in the Kamakura Period

In the preceding chapters I made an effort
to trace the history of Shinano Province and Zenkōji through the Heian
period and to analyze the origins of *Zenkōji Engi* and the sources of the
main icon of the temple. With this material in place, we can now turn to
the Kamakura period, for it was then that belief in the Zenkōji Amida
Triad manifested its fullest flowering. A completely articulated account
of the development of Zenkōji and its cult during the Kamakura period
involves the analysis of extremely complex political and religious factors.
While one might present these two types of factors together in a parallel,
chronological account, such a format would result in unnecessary confu-
sion. Thus, the following discussion will deal first with the political
aspects of the growth of Zenkōji and then with its religious dimensions.
Needless to say, a narrative presentation of political support for Zenkōji
and its cult separated from its religious aspects will have a somewhat
artificial quality, but this should provide the historical framework essen-
tial for an understanding of the context within which the cult developed.

Documentary evidence indicates that patronage by the Kamakura
bakufu during the period of Minamoto Yoritomo (1147–1199) was very
significant for the development of Zenkōji. This pattern of official sup-
port continued to be important during the thirteenth century, when the
bakufu was controlled by the Hōjō Clan. Consequently, this chapter
begins with a consideration of support by the ruling classes for Zenkōji.

Following the discussion of political factors, the salient religious de-
velopments are discussed, for without an analysis of certain aspects of
Kamakura Buddhism one cannot understand the growth of the Zenkōji
cult. Obviously, this section does not aim at a comprehensive analysis of
the very complex currents seen in Buddhism during the Late Heian and
Kamakura periods but is limited to a consideration of those factors essen-
tial to the development of an appropriate context for the Zenkōji cult. A
somewhat more specific discussion is undertaken of the role of the
Zenkōji-hijiri, for the religious activities of these itinerant preachers was
essential for the extraordinary development of the Zenkōji cult through-
out Japan. Consequently, studies both of the activities of the hijiri in
general terms and the specific activities of Zenkōji-hijiri are necessary.

Related to this discussion is an analysis of the Shin Zenkōji system. In this context, an investigation of how local temples strove to replicate the cult practices seen at the main Shinano Zenkōji is presented. Since this system is unusual within Japanese Buddhism, its significance within the development of Zenkōji belief must be elucidated.

Interwoven with the discussion of the Zenkōji-hijiri and the Shin Zenkōji system are further comments concerning the basic cult practices. This material should permit an understanding of how the Zenkōji icons functioned in their temples throughout the country. The aim of this chapter is to clarify the range of support for the Zenkōji cult, approaching the problem from both the level of patronage by the ruling classes and from the level of popular religion. Ultimately, the analysis of these levels must be unified, for there are strong connections between upper class and popular interest in the Zenkōji cult. Without the folk religious dimension of Zenkōji belief, the cult of the Zenkōji Amida Triad would not have developed to the stage where it could attract strong support from the bakufu and powerful members of the warrior class. Similarly, without this upper-class patronage, the Zenkōji cult probably would never have gained the momentum that enabled it to diffuse so widely throughout Japan.

Zenkōji and the Kamakura Bakufu

The establishment of the Kamakura bakufu by Minamoto Yoritomo and his allies was the culmination of a long-term political process that witnessed the transfer of substantial power from the old aristocracy to a newly risen warrior class. This change significantly affected society as a whole, although its impact was particularly strong in eastern Japan. Here I will focus on certain religious developments that are intimately associated with the rise of this warrior government. However, we also need to consider in some detail specific political occurrences related to Shinano Province at the end of the Heian and the beginning of the Kamakura period.[1]

During the period of Taira ascendancy, Shinano Province was largely controlled by warriors allied to the Taira clan. A cousin of Yoritomo, Kiso Yoshinaka (1154–1184), succeeded, however, in building a strong base of power in Shinano, and with the commencement of hostilities between the Minamoto and Taira clans (Genpei War, 1180–1185), Yoshinaka became one of the major participants.[2] His campaigns against Taira generals are legendary, culminating in his capture of the capital in 1183. And yet the very success of Yoshinaka led to his downfall, for Yoritomo feared the power of his cousin, while Yoshinaka in turn had every reason

to be worried about Yoritomo's plans. The predictable outcome of this situation was conflict between the two Minamoto factions, ending with the death in battle of Yoshinaka at the beginning of 1184. With Yoshinaka out of the way, Yoritomo was able to concentrate his energies on the defeat of the Taira clan, and by early 1185 the Minamoto were victorious.

Seen in retrospect, Yoritomo's triumph in 1185 appears decisive, but of course at the time the situation would have been perceived by him and his advisors as fraught with peril. Especially worrisome was the strategic and political status of Shinano Province, the base of his archrival Yoshinaka, for it threatened the Kantō Plain from a particularly dangerous direction. Moreover, some evidence suggests that factions still loyal to Yoshinaka remained in Shinano. Consequently Yoritomo acted decisively, making Shinano a "Proprietary Province" and appointing one of his most important retainers, Hiki Yoshikazu (?–1203), as the *shugo* (constable).[3] In addition, loyal warriors from the Kantō area were dispatched to Shinano to ensure the authority of the bakufu.

While the settling in the province of loyal warriors was obviously basic to the bakufu's policies for Shinano, other sources of authority would not have been neglected by a politician as astute as Yoritomo. Yumoto Gun'ichi has argued that there were two critical centers of power in Shinano, the Provincial Headquarters (at present-day Matsumoto) and a Branch Headquarters (at present-day Nagano City), which dominated the two richest areas of the province.[4] Closely associated with these political entities were the two most important religious institutions of medieval Shinano: the great Suwa Shrine near Matsumoto and Zenkōji at Nagano City (map 3). The bakufu established close connections with Suwa Shrine, and there is very strong evidence that Yoritomo intended to avail himself of Zenkōji's prestige in his efforts to buttress the authority of the bakufu. Taken together, bakufu connections with Suwa Shrine and Zenkōji clearly indicate a pattern of patronage designed to enhance the government's power in critical areas of the province.

Azuma Kagami, in an entry of 1187, relates that Zenkōji was destroyed by fire in 1179.[5] Yoritomo is said to praise the temple and to order his retainers to assist in the gathering of funds for reconstruction. An entry of 1191 indicates that the project is complete.[6] Since Shinano Province was controlled by Yoritomo, he had a duty to facilitate the rebuilding of Zenkōji, although he probably would not have been enthusiastic about the prospect if potential benefits were not anticipated. The initial order to begin raising funds occurs only a couple of years after the consolidation of the bakufu. Even though Zenkōji burned down in 1179, resources to rebuild it were not likely to have become available before 1185. Con-

sequently, the 1187 entry in *Azuma Kagami* may correspond to approximately the earliest possible date for a reconstruction campaign to begin. In any case, Yoritomo's patronage of Zenkōji constitutes a definite recognition of that temple's stature in Shinano Province.

The next chapter includes a detailed consideration of the relationship between the account in *Zenkōji Engi*, which describes the making in 1195 by the monk Jōson of a life-sized bronze copy of the Living Buddha for Shinano Zenkōji, and the large bronze triad bearing an inscribed date of 1195 now enshrined in the Kōfu Zenkōji, Yamanashi Prefecture (fig. 15) I believe that the latter image is, in fact, Jōson's copy, but in any event *Zenkōji Engi* describes the making of a life-sized icon in 1195.[7] Since the casting of a monumental bronze triad is a considerable undertaking, the making of Jōson's icon may have been associated with the prestigious bakufu support that Zenkōji was receiving in these very years.[8] Might it have been the case that the temple authorities decided that they needed something more impressive than a small-scale bronze? Definitive answers to these questions are not possible, but it is still worth speculating about the motivations behind the casting of the full-scale bronze triad.

The available information suggests that by the mid-1190s Zenkōji possessed both a full complement of buildings and a splendid new life-sized image. The exact extent to which the temple was beholden to Yoritomo and the bakufu for its prosperity is, of course, uncertain, but the story becomes more interesting, indeed, when we read in an *Azuma Kagami* entry of 1195 that Yoritomo planned to embark on a pilgrimage to Zenkōji.[9] The plans for this trip may have been related to the completion of the buildings and icon just mentioned, for they would have provided a suitable goal for Yoritomo's pilgrimage. As it turned out, the trip was postponed until the following spring. Since entries for that year are missing from *Azuma Kagami*, no definite proof exists that Yoritomo actually visited Zenkōji. Nevertheless, there are numerous legends in Nagano concerning Yoritomo's pilgrimage to Zenkōji, and it is likely that he did in fact visit the temple at least once.[10]

A fascinating account of Yoritomo's connection with Zenkōji is contained in *Kokon Chomonjū* (completed 1254).[11] The text relates that during a trip to the capital Yoritomo made a pilgrimage to Tennōji, where he met the abbot, Prince Toba. Yoritomo told the abbot that he had visited Zenkōji twice and that, upon worshipping the Amida a second time, he noticed that its mudra had changed. The change of mudra is an obvious indication that the icon is living, and one assumes that Amida intended this to convey a special sign to Yoritomo. Naturally, the abbot was amazed by this account, and he declared that Yoritomo was not an ordinary person. Clearly, this recognition of Yoritomo's spiritual power

by the abbot also validates the mysterious nature of the Living Buddha. Although most other accounts state that the Zenkōji icon was a totally secret image, the author of *Kokon Chomon Jū* maintains that Yoritomo actually saw it during his two visits. In addition to religious significance, the story is also highly relevant here, for by the mid-thirteenth century, at the latest, it was thought completely natural that Yoritomo would visit Zenkōji.

Mention was made earlier of the Kōfu Zenkōji Amida Triad. Further material at Kōfu Zenkōji is also relevant to the present theme, for the temple also possesses statues representing Minamoto Yoritomo (fig. 12) and his son Minamoto Sanetomo.[12] These statues were probably brought to Kōfu in the sixteenth century by Takeda Shingen at the same time that the other treasures from the Shinano Zenkōji arrived. The exact date of the two statues is controversial, but they certainly belong to the Kamakura period. In any case, their greatest importance lies in the fact that they symbolize the belief at Zenkōji itself in the significance of the Minamoto shoguns as patrons.

There are two entries in *Azuma Kagami* that demonstrate a considerable degree of belief in the Zenkōji cult amongst the warrior class during the time of Yoritomo. The first entry refers to Ōiso no Tora, the mistress of Soga no Sukenari (Soga Jūrō, 1172–1193), who became a nun at Zenkōji after her famous lover was killed.[13] The fact that a woman associated with such a prominent warrior became a Zenkōji nun clearly indicates the status that the temple had achieved by the early 1190s. A second entry tells how a warrior, Naganuma Munemasa, petitioned Yoritomo, requesting to be appointed the *jitō* (steward) of Zenkōji.[14] His reason for desiring this post was that, since he had been sinful in previous existences, he now wished to be near the Living Buddha of Zenkōji to eliminate his sins. While it is doubtful that piety was Munemasa's sole motive for seeking the position, the important point here is that devotion to the Zenkōji Amida could be plausibly cited as a reason. There is some possibility that Sanetomo himself made a contribution to Zenkōji, since *Azuma Kagami* has an entry of 1215 recording a gift of silk to the temple.[15]

Drawing together these various strands of argument, a general summary of the importance of bakufu patronage of Zenkōji during the period of Yoritomo can be presented. As suggested above, compelling reasons existed for the *bakufu* to strive for control of Shinano Province, which had been the main center of power for Kiso Yoshinaka. Consequently, the 1187 entry in *Azuma Kagami*, in which Yoritomo praises Zenkōji and orders his retainers to assist in the fund-raising to finance the rebuilding campaign, seems to be a perfectly appropriate action. Whether Yoritomo

actually visited Zenkōji remains open to question. The evidence suggests that he probably made such a pilgrimage, but even if he did not, by the mid-thirteenth century it was widely believed that he had. Consequently, Zenkōji would have been seen by warrior society as having been supported by the most prestigious of all warriors, Minamoto Yoritomo. Another possibility, of course, is that Yoritomo had a personal belief in the Zenkōji Amida Triad, although this is a factor that need not be examined here, since our emphasis is on broader political considerations. Regardless of Yoritomo's motivations, however, he must have been perceived as strongly supportive of Zenkōji. This may be one of the important reasons for the rapid diffusion of the Zenkōji cult among the local warriors of the Kantō and Tōhoku regions.

Control of the Kamakura *bakufu* did not, of course, remain in the hands of the Minamoto family. Moreover, the position of shogun soon became primarily ceremonial, with real power residing in the office of *shikken* (regent), which became hereditary in the main branch of the Hōjō clan. Hōjō warriors were important supporters of Yoritomo during his campaigns to establish the bakufu, and his principal wife was the redoubtable Hōjō Masako.[16] As a result of the struggles between the various vassals of Yoritomo, the Hōjō clan succeeded in gaining the ascendent position with its leaders able to dominate the political world for the remainder of the Kamakura period. The image of Minamoto Yoritomo is so strong that we should remember that the Kamakura period was in actuality a period of Hōjō rule. Similarly, bakufu patronage of Zenkōji, after the initial phase of support by Yoritomo, was very closely tied to the Hōjō clan. Before some specific instances of Hōjō patronage are examined, the more general question of Hōjō religious policy must be considered.[17]

Invariably, the Hōjō clan is thought of in connection with the establishment of the great Zen monasteries of Kamakura during the thirteenth century. The importance of Zen Buddhism in the Kamakura period, and especially during the subsequent Muromachi period, makes the study of its origins and growth a key topic in the history of Japanese religion. The creative flowering of Japanese Zen in poetry, painting, and calligraphy, combined with the vitality of its religious practice, surely entitles the Zen tradition to its preeminent position. This flowering of Zen Buddhism was generally limited to small, upper-class groups, however. In recent years there has been a growing recognition that other religious currents, frequently characterized as "popular Buddhism," were of far greater importance for the population as a whole. Thus the facile equation of the warrior ethic with Zen meditative practices has a

very limited application to the vast majority of warriors, especially those residing in the countryside.

The Hōjō clan clearly had, for its own part, no exclusive commitment to Zen; rather, its members appear to have been eclectic in their support of various religious movements. For example, Hōjō leaders patronized the *Shingon Ritsu Shū* (Shingon Ritsu School) founded by Eison (1201–1290). Consequently, the pattern of support that they manifested for Zenkōji should not be seen as deviating from their general practice, but rather as part of an overall policy. The degree to which the various leaders of the Hōjō clan truly "understood" the more abstruse schools of Buddhism remains difficult to assess, although many of the most important Hōjō figures were extremely sympathetic toward popular Buddhist beliefs such as those of the Zenkōji cult. In this respect, their religious attitudes were close to those of the warrior class in general.

Connections between the Hōjō clan and Shinano Province date back to the beginning of the bakufu, when Hōjō Tokimasa (1138–1215), the patriarch of the clan, was granted estates in Shinano by Yoritomo.[18] However, as mentioned above, the first shugo of Shinano was not a Hōjō, but rather one of Yoritomo's closest followers, Hiki Yoshikazu. Thus in the first years of the bakufu the Hōjō clan seems not to have been intimately associated with the affairs of Shinano Province. All of this changed with the fall of the Hiki clan in 1203, when Hōjō Yoshitoki succeeded in occupying the position of shugo. For the rest of the Kamakura period, control of Shinano Province remained in the hands of the Hōjō clan. Naturally, the fact that the family exercised general political authority over the country as a whole, as well as having specific control of Shinano Province, meant that its power was very great.

Before considering the specific evidence for Hōjō connections with Zenkōji, let us analyze somewhat more fully the reasons for the clan's intense interest in Shinano Province.[19] Economic considerations were clearly of fundamental importance. The Hōjō clan was not a traditional great landowning family and thus its members were extremely concerned about expanding their holdings. Since Shinano was not under the control of a single great clan, the Hōjō could easily assert their authority in gaining new land. Gradually they accumulated a number of estates scattered throughout Shinano, usually located in areas of strategic importance. In addition to accumulating land, the Hōjō also sought allies among the Shinano clans in order to increase the number of their own supporters. Another military significance of Shinano was its status as a major center for the breeding of horses and thus a reliable source for a prime component of medieval warfare. Not only would fine horses be

attractive to the Hōjō rulers, but warriors skilled in their handling could be a key factor in battle as well.

Considerable research has been devoted to the strong connection between the Hōjō clan and the Suwa Shrine, although relatively less attention has been paid to its relations with Zenkōji.[20] A number of reasons can be suggested why the Hōjō would wish to maintain a close connection with Zenkōji. Of obvious importance is the temple's political significance, an issue discussed earlier in the consideration of Yoritomo's patronage. Also important is the fact that Zenkōji was a very popular temple, with a wide following in both Shinano and adjacent provinces. Since Zenkōji was not a clan temple, there would not be the sort of complications that would arise if the Hōjō had tried to appropriate a temple already associated with a specific family. Zenkōji's very independence from such support made it more attractive to the Hōjō.

No evidence exists for support of Zenkōji by Hōjō Yoshitoki (1163–1224), although his sister, Hōjō Masako (1157–1225), the widow of Yoritomo, seems to have been a temple patron. *Zenkōji Engi* states that she donated a Nenbutsudō to the temple, without indicating when this took place.[21] *Shinshō Hōshi Shū* records that early in 1225 the priest Shinshō carried out a memorial ceremony at Masako's Jibutsudō (in Kamakura) for the sake of her son Sanetomo and then set out for Zenkōji.[22] Masako said that she too would make a pilgrimage to Zenkōji, in the coming fall. Shinshō remained at Zenkōji but then returned to Kamakura upon hearing of Masako's death later in 1225, and Kobayashi Keiichirō has suggested that Shinshō was waiting at Zenkōji for Masako to arrive on her pilgrimage.[23] Possibly the extensive Hōjō patronage of Zenkōji during the thirteenth century was in some way related to an interest in the Zenkōji cult on the part of Hōjō Masako. Since the shikken, Yoshitoki, did not directly support Zenkōji, after the initial spurt of support under Yoritomo, Zenkōji was apparently no longer so central to the concerns of the government. Perhaps by the early thirteenth century the bakufu had consolidated its power in provinces such as Shinano to the degree that extraordinary measures were unnecessary.

Following the death of Yoshitoki in 1224 his son, Yasutoki (1183–1242), succeeded to the position of shikken. Yasutoki did not take the post of shugo of Shinano Province, but instead granted it to one of his younger brothers, Hōjō Shigetoki (1198–1261).[24] From this time on the shugo post remained in the lineage of Shigetoki, although since that family cooperated closely with the main Hōjō line, one should not assume that there was any conflict in the administration of Shinano Province. According to *Zenkōji Engi* Yasutoki had a Kannondō constructed at Zenkōji, but unfortunately the circumstances surrounding this are

vague.[25] There is more reliable evidence for a donation of land by Yasutoki to support an eternal Nenbutsu at Zenkōji, since *Azuma Kagami* records that in 1239 Yasutoki ordered that six *chō*, six *tan* of fields at Chiisagata-gun, Muroga Gō in Shinano Province be given to Zenkōji as payment to provide for the continuance of the unending chanting of the Nenbutsu.[26] This event took place toward the end of Yasutoki's life, perhaps designed to assure his rebirth in Amida's Western Paradise. Yasutoki specified in seven articles in *Azuma Kagami* the details of this endowment. Shortly after the donation just described, Yasutoki became seriously ill, and the monk who led the services on his behalf was Chidō Shōnin of the Kamakura Shin Zenkōji.[27] This, combined with the donation, suggests strongly that Yasutoki had a personal belief in the Zenkōji Amida.

Conflicts between the various branches of the Hōjō clan also affected the relationships between Zenkōji and the Hōjō clan. Most important is the role of the Nagoe line, established by Hōjō Tomotoki (1193–1245). Tomotoki, the younger brother of Yasutoki, was a particular favorite of their father, Yoshitoki. Thus, while Yasutoki inherited the *tokusō* (headship) of the Hōjō clan, and became shikken, Tomotoki was in no way shut out from wealth and power. He received the Nagoe mansion in Kamakura, from which the name of his line derived, and had a position nearly as strong as that of the tokusō line itself. *Zenkōji Engi* relates that Tomotoki, like his elder brother Yasutoki, donated a building to the temple.[28] Yumoto has argued that these gifts were not simply personal acts, but rather must be at least partially understood as manifestations of competition between the tokusō and the Nagoe lines of the Hōjō clan.[29] If this suggestion can be accepted, we can assume that there was a rather complex relationship among the various branches of the Hōjō clan at this time. Further evidence for the interest of Tomotoki in the Zenkōji cult is the occurrence of the name Nagoe Zenkōji.[30]

With the death of Yasutoki, the political situation became uncertain. His son, Tokiuji (1203–1230), had predeceased him, so the position of shikken passed on to a young grandson, Tsunetoki (1224–1246), who in turn died after only a few years in office. Tsunetoki was succeeded by a younger brother, Tokiyori (1227–1263), who was only nineteen when he became shikken. Tokiyori served officially as shikken for a decade, 1246–1256, but remained powerful behind the scenes until his death in 1263. He emerged ultimately as one of the most effective of Hōjō regents.

During this period of uncertainty, Nagoe Tomotoki died, in 1245. Following the wishes of their father, the sons of Tomotoki became great patrons of Zenkōji, and in 1246 an important ceremony celebrating the completion of construction that they had financed was carried out at

Zenkōji.[31] Apparently this activity took place without any connection with either the shikken, Tsunetoki, or the shugo, Shigetoki, and thus can perhaps be interpreted as further evidence of the Nagoe clan's assertion of an independent role for themselves at Zenkōji. At the time of this ceremony the shikken, Tsunetoki, was already seriously ill, and he died shortly thereafter. Possibly the Nagoe clan's power would have continued to grow, but shortly after Tsunetoki's death a conspiracy by Nagoe Mitsuoki against the tokusō line was discovered and suppressed by the forces of the new shikken, Tokiyori. This substantially reduced the political power of the Nagoe clan and eliminated the dual patronage of Zenkōji by both the tokusō line and the Nagoe line.[32] From this stage onward the tokusō line maintained exclusive control over Zenkōji. In 1253 a ceremony connected with repairs was held at Zenkōji, on which occasion the patron was the shugo of Shinano Province, Hōjō Shigetoki.[33] Shigetoki was one of the closest advisors to the shikken, Tokiyori, and in fact a daughter of Shigetoki became the wife of Tokiyori. Consequently, Shigetoki's activities with regard to Zenkōji should be seen in the context of policies associated with the tokusō line.

Tokiyori, like his grandfather, Yasutoki, made a substantial donation to Zenkōji in his waning years to support religious services on his own behalf.[34] This donation, in 1263, gave twelve chō of land at Fukada-gō (Nagano City) to support both an eternal reading of the *Lotus Sutra* and an eternal chanting of the Nenbutsu at the Main Hall of Zenkōji. Detailed instructions were given about how the religious services were to be carried out. Yumoto has argued that, as Fukada-gō was directly adjacent to Zenkōji, significant benefits would accrue to the temple.[35] He also suggests that it would have served as an effective base for the Hōjō clan to safeguard its interests in this key area of Shinano Province. Here, therefore, the development of a mutually beneficial relationship between the authorities of Zenkōji and the Hōjō clan in terms of their respective interests can be discerned.

No evidence connects the next two regents, Nagatoki (1229–1264; shikken 1256–1264), and Masamura (1205–1273; shikken 1264–1268), with Zenkōji, but they were not in control much beyond the death of Tokiyori in 1263. A somewhat tenuous connection between the next shikken, Tokimune (1251–1284; shikken 1268–1284), and Zenkōji is suggested by the presence at the great Zen monastery Engakuji of a Zenkōji Amida Triad (fig. 30) dating from 1271. Tokimune established Engakuji in 1282,[36] and since the triad in question was made a decade earlier, Tokimune may have donated it to Engakuji—although there is no doctrinal reason for a Zenkōji Amida Triad to be enshrined at a Zen monastery. If Tokimune, or someone in his circle, did in fact donate the

triad, this would be one more indication of the eclecticism of Hōjō religious beliefs. The last Hōjō shikken, Takatoki (1303–1333; shikken 1316–1333), is reputed to have rebuilt the main hall of Zenkōji, which had burned down in 1313.[37]

The preceding pages constitute an outline of Hōjō-Zenkōji connections at the highest reaches of the Hōjō clan, but we should also look at a few instances of Hōjō-Zenkōji relations at slightly less elevated levels. There were, of course, numerous branch families of the Hōjō clan, most apparently loyal to the main (tokusō) line. One of the most important of these branch families was the Kanazawa line, established by Sanetoki (1224–1276), a grandson of Yoshitoki. The fortunate survival of the Kanazawa's wonderful library, the present-day Kanazawa Bunko, has meant that a great deal more information concerning activities of the family exists than is often the case. Among the manuscripts preserved at Kanazawa Bunko is *Zenkōji Nyorai no Koto*, discussed earlier in the account of the development of the *Zenkōji Engi* literature. In the present context, this text is a precious bit of evidence confirming Zenkōji-Hōjō relations.

A second piece of evidence, also kept at Kanazawa Bunko, is an early fourteenth-century map of Shōmyōji (Fig. 13), the family temple of the Kanazawa clan.[38] This map (or perhaps more correctly, diagrammatic plan) shows the main structures, precincts, and hills surrounding Shōmyōji as they existed in the late Kamakura period. Although much has changed since the time the map was executed, the pond in front of the Main Hall is represented much as it exists today, including the small island in the center, which is linked by bridges to the banks of the pond. Of concern here is the prominent tomb on the hillside at the left (i.e., west) margin of the map which is inscribed "Zenkōjidono Byō" (Tomb of Zenkōjidono). Who the occupant of the tomb was is unknown, but it is certainly significant that one of the very few tombs represented in the map is so inscribed. This must indicate a particularly close relationship between someone of importance in the Kanazawa clan/Shōmyōji milieu and Zenkōji.

The evidence presented in the previous pages demonstrates a pattern of substantial support of Zenkōji by many of the most powerful leaders of the bakufu. Before beginning a discussion of the religious situation, it is fitting to briefly summarize the pertinent aspects of bakufu patronage and policy.

The geographical importance of Shinano province to the early bakufu, especially as Yoshinaka's former base of power, meant that Yoritomo would devote considerable efforts to securing it for himself. Thus, regardless of his personal feelings towards the Zenkōji cult, Yoritomo

might reasonably be expected to have patronized Zenkōji as the central religious institution of the northern part of the province. The evidence available suggests that Zenkōji grew substantially during the 1190s, presumably at least in part as a result of Yoritomo's support.

When control of Shinano Province passed to the Hōjō clan at the beginning of the thirteenth century, they too concerned themselves with Zenkōji. No extant evidence indicates that the first Hōjō shikken, Yoshitoki, patronized Zenkōji, but the two greatest of his successors, Yasutoki and Tokiyori, were deeply involved with the temple. Presumably the Hōjō leadership desired close connections with Zenkōji for both political and spiritual reasons, and the temple, for its part, would obviously seek patronage and protection from the Hōjō clan. We saw how certain activities of the Nagoe branch of the Hōjō clan at Zenkōji appear to reflect broader conflicts that existed within extended Hōjō families at mid-thirteenth century. To the extent that this argument is accurate, Zenkōji serves as something of a distant reflection of contemporary politics. During the second half of the thirteenth century Zenkōji seems to have been directly under the control of the main line of the Hōjō clan and its closest supporters.

In the course of the thirteenth century the cult of the Zenkōji Amida Triad spread rapidly through the Kantō and Tōhoku regions and also to other areas of Japan. The patronage of Zenkōji by the leaders of the bakufu undoubtedly served as an inspiration to local warriors, who contributed to the establishment of new Zenkōji temples in their own regions. Certainly the explosive growth of the Zenkōji cult during the Kamakura period would have been most unlikely without bakufu and warrior support.

Pure Land Buddhism in the Kamakura Period

Chapter 2 traced in summary form the development of Buddhism in Japan during the Nara and Heian periods, with particular reference to Shinano Province. Especially important were the attempts by the Nara government to establish a nationwide network of official temples (the Kokubunji system), the introduction of Shingon and Tendai in the Early Heian period, and the gradual rise of *Jōdo* (Pure Land) belief from the middle of the Heian period onward. Here it must be recognized that the establishment of the Kamakura bakufu, discussed in the preceding section, does not constitute a firm boundary between two types of Buddhism, one Heian, the other Kamakura, although there is an obvious temptation to take the most characteristic features of the

Buddhism of each period and formulate these into mutually exclusive categories.[39] When this is done, concepts such as "aristocratic" Buddhism of the Heian period or "popular" Buddhism of the Kamakura period are developed. Although neither of these concepts is fundamentally incorrect, "popular" Buddhism already existed in Heian times, and, of course, "aristocratic" Buddhism continued to flourish during the Kamakura.

With these ideas in mind, the following discussion describes some of the major currents in Japanese Buddhism from around 1100 until around 1300, taking into account the political transformation that occurred at the end of the twelfth century, but without giving it undue importance. This procedure should illuminate those tendencies that are of greatest significance for the development of the Zenkōji cult.

Discussions of Kamakura Buddhism usually are organized around five great sects and their founders, thought to constitute the "New Buddhism" of the Kamakura period in distinction to the "Old Buddhism" of Nara and Heian.[40] These sects are the *Jōdo Shū* (Pure Land School), associated with Hōnen (1133–1212); the *Jōdo Shin Shū* (True Pure Land School), based on the teachings of Shinran (1173–1262); the two principal Zen schools, the *Rinzai Shū* (Rinzai School) of Eisai (1141–1215) and the *Sōtō Shū* (Sōtō School) of Dōgen (1200–1253); and, finally, the *Nichiren Shū* (Nichiren School) established by Nichiren (1222–1282). Since only the first two of these schools are treated here, I would like to indicate why the other three need not be discussed. Basically, the doctrines and practices of the Zen schools had relatively limited general popularity during the Kamakura period, particularly during its earlier decades, and thus they are not directly relevant to the broader currents traced here. It is more as a Muromachi phenomenon that Zen sees its fullest expression, particularly among the military aristocracy.

Contrasting with Zen, the school of Nichiren was broadly based, but was formulated many decades after the early maturation of the Zenkōji cult, and so a consideration of the career and beliefs of Nichiren would not materially help in understanding the initial stages of the Zenkōji cult.[41] Undoubtedly, in tracing the subsequent evolution of Zenkōji belief there might be some occasion to refer to Zen or the Nichiren School, but even in the later Kamakura period there are more pertinent developments, specifically the activities of the monk Ippen and his *Ji Shū* (Ji School). Consequently, the following discussion focusses on Pure Land tendencies as they evolved in the twelfth and thirteenth centuries, for it is out of this context that Zenkōji belief grew.

Chapter Two considered the development of Pure Land Buddhism during the Heian period. These developments occurred primarily within

the Tendai School at Mt. Hiei, although there was some activity at other places as well. Through the thought and preaching of monks such as Ennin, Ryōgen, and Genshin, many of the basic doctrines and practices of Pure Land Buddhism had been formulated by the middle of the Heian period.[42] As was also noted, a monk such as Kūya was active in spreading the chanting of the Nenbutsu among the masses during the tenth century. Consequently, the teachings of Hōnen and Shinran should not be perceived as completely different from what came before, and even without their activities, the Pure Land currents would inevitably have grown into a major component of Kamakura Buddhism. This is not to say that Hōnen and Shinran failed to formulate distinctive doctrines, since they obviously contributed unique insights and teachings to Pure Land Buddhism. Excessive concentration on the doctrinal systems of these two thinkers, however, tends to distort the overall picture of Kamakura Buddhism. With this in mind, I would like to examine here some of the broader aspects of their teachings in an effort to see how they contributed to, or were congruent with, the currents that crystallized in the Zenkōji cult.

Hōnen is usually considered the central figure in the establishment of Pure Land Buddhism as a widespread movement in Japan.[43] In his long life—spanning the later Heian and early Kamakura periods—he witnessed many of the most important political and religious developments of Japanese history, and his thought obviously was affected by and responded to these developments. The need to perceive the transition from Heian to Kamakura as gradual is stressed in this study, and certainly Hōnen's career serves as a bridge between the two periods. When Hōnen was only eight his father died, and so the young boy entered the Buddhist order, where he began his studies at Enryakuji, to be ordained as a Tendai monk at the age of fifteen. In addition to his study of Tendai doctrines at Mt. Hiei, Hōnen also studied the older schools of Buddhism in Nara, but all of this learning failed to satisfy him, and he became increasingly disillusioned with orthodox teaching and practice. He withdrew from the monastery to become a mountain ascetic, gradually becoming interested in the cult of Amida. Particularly influential in the formation of his ideas was Genshin's *Ōjō Yōshū*, which convinced him that the only practical religious goal was salvation in the Pure Land of Amida. The route to this salvation was to be the Nenbutsu: the chanting of the name of Amida. Perhaps the most significant aspect of Hōnen's thought was his assertion that such salvation was available to everyone, regardless of religious or secular status.

Having formulated his belief system, Hōnen left the monastic community and established headquarters in Kyoto, where he gathered fol-

lowers and preached the Nenbutsu to commoners and aristocrats alike. Although Hōnen did not attack other religious traditions, his popularity and his strong claims for the efficacy of belief in Amida annoyed the established Buddhist schools, with the result that they agitated to have him silenced. He was finally exiled from Kyoto in 1207 and not allowed to return until 1211, the year before his death. Hōnen did not personally establish a new school, but simply formed a fellowship united in devotion to Amida through the practice of Nenbutsu. After Hōnen's death, his followers continued to be persecuted, but the belief system that he had advocated was too strong to be suppressed, and gradually increased in influence, particularly in areas outside of Kyoto. Ultimately, of course, Hōnen was enshrined as the founder of the Jōdo school, although this sect developed into an organized religious institution only after his death.

Of Hōnen's followers, the most important was Shinran.[44] He was born at the end of the Heian period and only a child when the political transformation leading to the Kamakura period occurred, so he is reasonably treated as a Kamakura figure. Like Hōnen before him, Shinran entered Enryakuji at a young age. Little is known about his first twenty years there, but at age twenty-nine he became a disciple of Hōnen, committing himself to the exclusive devotion of Amida. Both Hōnen and Shinran were exiled in 1207, but unlike Hōnen, Shinran did not return to Kyoto after being pardoned in 1211, but instead travelled to the Kantō region, where he remained until about 1235. Shinran developed some of Hōnen's ideas, and added new ones of his own. Particularly important was his rejection of celibacy, for he married and had children, thus eliminating one of the key distinctions between clergy and laity. Even more than Hōnen, Shinran was totally devoted to faith in Amida and the practice of Nenbutsu, believing that they constituted the only possible route to salvation. Like Hōnen, Shinran established a fellowship, but he did not intend to inaugurate a new school of Buddhism. However, as with Hōnen, a school later developed around Shinran's teachings, becoming the Jōdo Shin Shū.

This brief account of the activities of Hōnen and Shinran is presented in terms of the standard historiographical method referred to by James Foard as the "five founders/five schools approach." Recent analysis of Kamakura Buddhism has questioned this approach, arguing that it fails to do justice to the full richness and actual situation of the period.[45] Thus, we should strive here to incorporate Hōnen and Shinran into the larger picture. As I stressed earlier, neither Hōnen nor Shinran personally established schools; rather, the Jōdo Shū and the Jōdo Shin Shū came into existence after their deaths. Both men are best seen as participants in

a broader development of faith in salvation through Amida. The fact that their ideas subsequently were formulated into fully developed sectarian movements should not lead to a misinterpretation of the circumstances during their lifetimes. What they shared with their contemporaries—and what is important here—is the belief that salvation is available to all people, not just to the clergy who carried out various religious rituals, or to those with enough wealth to avail themselves of the services of the clergy. The revolutionary appearance of Kamakura Buddhism is based on this idea that salvation was possible for members of all classes and groups who devoted themselves to a specific deity or practice. In terms of the present study, of course, the advocacy of Hōnen, Shinran, and their followers of a cult devoted to Amida is of key importance, for this relates their thought and practice at least in some respects to the cult of the Zenkōji Amida Triad.

The single most important aspect of the religious movements considered here is that they can be classified as "popular."[46] As noted, their benefits were open to all who had faith: religious practices were greatly simplified, and missionaries travelled throughout the country preaching their messages to the masses. Broadly based movements of this type always relate to changes in the social and economic conditions, and one must see the religious developments as embedded within the overall political and cultural structure of the time. The popular Buddhism of the Kamakura period differs substantially from the scholastic Buddhism of Nara or the aristocratic Buddhism of Heian, but this is not to say that Kamakura popular Buddhism did not have roots in the Heian period, for of course it did. Clearly, a new approach to salvation evolved gradually from the mid-Heian period, to reach fruition in the Kamakura period.

The way in which the cult of the Zenkōji Amida Triad is associated with this sort of evolution will be examined presently. Two important points can be made in anticipation of the conclusion. First, the Zenkōji cult offered salvation, or lesser benefits, such as health and material prosperity, to all people, without regard to their social or clerical status. A second, and of course related, factor is that the proponents of the Zenkōji cult made great efforts to spread their beliefs throughout the country.

Shinano Zenkōji in the Kamakura Period

As discussed in Chapter 2, from the Heian period Shinano Zenkōji was controlled by Onjōji (popularly called Miidera), the great temple which was the headquarters of the Jimon branch of the Tendai School. We saw that the reference to the bettō of Zenkōji in *Chūyūki*, and the events associated with Shōshi's boating excursion de-

scribed in *Chōshūki*, made this connection with Onjōji clear. In addition, the entry in *Azuma Kagami* of 1186 documents the estates controlled by Zenkōji, and one can be certain that the authorities at Onjōji worked diligently to maintain control over these lands. In fact, Onjōji was largely successful in asserting authority over Zenkōji until about the middle of the Muromachi period. By and large, this relationship was based on a feudal structure, with Onjōji seeing Zenkōji as a source of economic resources.[47]

Earlier, we noted that the Zenkōji-bettō was a member of the Jimon lineage. Normally, the Zenkōji-bettō did not live at the temple, but maintained his permanent residence in the capital, only travelling to distant Shinano for special events. For example, in 1237 the bettō Shō-shun attended ceremonies in celebration of the completion of the pagoda. Under ordinary circumstances, the bettō delegated his authority to subordinates, paticularly to the *gon-bettō*, who did reside at Zenkōji. The gon-bettō controlled the day-to-day activities of the temple. Other officers, referred to as the *daikan* and the *zasshō*, were responsible for economic affairs, and they administered Zenkōji's estates in the typical shōen mode.[48]

Important medieval temples in Japan had their members divided into two large categories, the *gakuryo* (scholar priests) and the *dōshū* (temple workers). Although provincial temples did not necessarily adhere to this system, Ushiyama has presented evidence that suggests that such a distinction was, in fact, observed at Zenkōji. This indicates that, at least from the thirteenth century on, Zenkōji was a relatively large-scale establishment.[49]

Zenkōji and the Hijiri

No aspect of the nationwide dissemination of the cult of the Zenkōji Amida is more important than the role of the hijiri. Without the activities of these itinerant religious practitioners, the cult would not have had the growth in popularity experienced during the Kamakura period. The hijiri moved among the people, preaching at a level of understanding that was readily accessible to commoners, and the belief system associated with the Zenkōji Amida was ideal for their purposes. Consequently, to understand the spread of the Zenkōji cult, one must examine both the general role of the hijiri in Japanese Buddhism and their more specific connection with Zenkōji belief.[50]

In Chapter 2, I briefly discussed the role of the hijiri, but no attempt was made to explicate their broader significance. Such an explication involves consideration of certain important currents in Japanese Bud-

dhism from early times onward, and thus some of these currents must be examined before focusing on the specific activities of the Zenkōji-hijiri. While this material may seem remote from the subject at hand, it provides an indispensable framework for a full comprehension of the development and diffusion of the Zenkōji cult.

From its initial period in Japan, significant tension existed in Buddhism between its official and popular dimensions. The Buddhist icons and temples ordinarily studied by art historians are almost exclusively associated with official Buddhism, which is to say that they were commissioned by either the state or by members of the ruling class. A study of official Buddhist art must make distinctions as to specific patronage—that of imperial house, court aristocrat, provincial lord, etc.—but in the larger schema presented here all of these patrons can be lumped together as "official." Obviously, the sculptures, paintings, and structures made in this context were designed to further the ends of these powerful individuals and groups, be they political or spiritual; they would have had little or no connection with the vast majority of the population. Because of the prestigious auspices under which they were produced, the official monuments have had the best chances of preservation through the centuries, so that the view of Buddhist art that results is essentially elitist. This perspective is so deeply ingrained that we have a tendency to forget that it does not constitute the whole picture.[51] The present study is an effort to provide a broader assessment of the nature and character of icon production in Japan and thus focusses on the popular level.

What is denoted by popular level? In attempting to answer this question, we must recognize that there was a pervasive folk religion throughout Japan prior to the coming of Buddhism, one which continued as an important influence long after Buddhism was well established among the upper classes.[52] This folk religion tradition, which included strong shamanistic elements, became one of the foundations of what is known during the historic periods as Shinto. It is an error to subsume folk religion totally within the category of Shinto, however, since it is really a far broader phenomenon. Moreover, there is an official level of Shinto, seen in such great shrines as Ise, Izumo, and the major Hachiman shrines, which is as strongly associated with the governing classes as are the comparable Buddhist institutions.[53] Nevertheless, the more archaic rituals associated with Shinto shrines appear to provide some access to the early stages of Japanese religion as practiced in the local community.

The appearance of Buddhism in sixth-century Japan had little initial effect on the broader religious picture. At first the new religion was confined to certain powerful clans and to groups who had moved to the

Japanese islands from the Korean Peninsula.[54] As soon as the ruling classes recognized the potential value of Buddhism as a unifying ideology and a source of various powers, they made strenuous efforts to bring it under the governmental aegis. Much of the early "history" of Buddhism in Japan is, in fact, a narrative of a series of measures designed to ensure administrative control over the monks, nuns, and their temples.[55] This effort was generally successful, but, early on, governmental complaints are heard about Buddhist practitioners outside of the official sphere.[56] A small number of individuals began to function in local communities, preaching to the people and performing magical acts. The most important example is Gyōki (668?–749), an itinerant preacher who moved among the people presenting his teachings and doing good works.[57] Ultimately, he was so successful that the state co-opted him by giving him a high ecclesiastical rank. Such co-option was a standard technique for the authorities when they realized that a movement was too powerful to ignore. Another important early Buddhist practitioner who operated outside the official realm, the rather mysterious En no Gyōja, apparently lived on Mt. Katsuragi at the middle of the seventh century, performing various magical acts.[58] Residence in remote mountain regions and the practice of austerities are dominant themes in Buddhist worship outside the official structure.

Two main currents are recognizable in Nara period Buddhism: the official Buddhism of the great state temples—Tōdaiji, Yakushiji, Kōfukuji, Saidaiji, etc.—and the less visible activities of unofficial practitioners who frequently resided in remote mountainous areas but at times also preached to the people. The culmination of the official program was the erection of Tōdaiji and the establishment of a network of monasteries and nunneries, to be located in each province, called the Kokubunji and Kokubunniji system. While Tōdaiji continued to flourish over the centuries because of its prestige and central position in the development of Japanese Buddhism, the Kokubunji network had a rather ephemeral existence.[59] The fact that the vast majority of Kokubunji quite rapidly ceased to function as vital religious establishments certainly indicates that they were viewed in the provinces as symbols of central political control, rather than as places of spiritual sustenance. Although conventional viewpoints hold that the Kokubunji network was a significant vehicle for the spread of Buddhism to the provinces, this opinion is dubious. In fact, the degree to which Buddhism spread through Japan during the Nara period was really quite limited. With the exception of the state patronage of Buddhism and Buddhist belief among groups from the Korean Peninsula, the majority of the Japanese population was

largely unaffected by any type of Buddhist teaching or practice. Although there is little evidence available, one can reasonably conclude that traditional popular religion, including shamanism, was still dominant.

Substantial changes occur with the coming of the Heian period. The transfer of the capital from Nara to Kyoto left all of the old monasteries in Nara, so their function as the bulwarks of official Buddhism was largely lost.[60] Two new state monasteries were constructed in Kyoto—Tōji and Saiji—but their power was very circumscribed, and they never rivalled their eighth-century counterparts in terms of status. In fact, Saiji has ceased to exist and Tōji's great importance depends primarily on association with the great Shingon leader Kūkai.[61] As discussed in the survey of Buddhism, the Early Heian period is characterized by the introduction of two important new schools of Buddhism, Shingon by Kūkai and Tendai by Saichō. These schools, at least initially, pursued different goals from those typical of the Nara schools. Most important, in the present context, was the establishment of their headquarters on mountains, Shingon at Mt. Kōya and Tendai at Mt. Hiei. The association with mountains brought them into contact with the stratum of nonofficial Buddhist practitioners that had emerged during the preceding century. As a result, individuals who had practiced austerities in the mountains and preached to the masses came to be associated with the teachings and rituals of the new Shingon and Tendai sects, and soon began disseminating these throughout the country. In some cases their activities may have been relatively "pure" Tendai or Shingon, although one can easily imagine that the abstruse theologies of these schools would have been profoundly altered to make them comprehensible to ordinary people. Also, there were surely many itinerant preachers who lacked a real grasp of the basic principles of Shingon and Tendai.

During the Heian period the hijiri experienced substantial evolution. As noted above, there was what might be characterized as a proto-hijiri development during the seventh and eighth centuries, but it was really with the ninth and tenth centuries that a full-fledged, nationwide spread occurred. Hori has defined hijiri as:

> . . . a group of religious reformers who disregarded the existing ecclesiastical orders and institutions of their time and endeavored to establish *outside the structure of Buddhist orthodoxy* a real religious life for the common people.[62]

This definition conveys well the essential aspect of hijiri. Ordinarily they were religious practitioners who engaged in austerities to enhance their magical powers and charisma. Their teachings could combine shamanistic and Buddhist elements in a synthesis palatable to common people. As

hijiri moved from village to village, they would preach to the populace as well as offer cures of various kinds. Obviously, the hijiri was dependent on alms for his existence, and one assumes that the number active at any given time would be closely related to the economic climate. Considering the general nature of rural existence, the appearance of a hijiri would very likely provide a welcome contrast to the mundane concerns of everyday life in Heian times. Thus in some senses the hijiri can be said to have functioned as an entertainer.[63] Since hijiri were not usually members of the establishment, few of their biographies have been recorded, and thus secondary evidence must be relied on to trace their paths.

At some stage in the career of an individual hijiri, it would become necessary or desirable for him to settle down in one locale. Since many of the hijiri were not connected with an orthodox monastery, they would not have been able to use such an establishment for retirement. Consequently, a hijiri would be likely to settle down in a community where he had previously formed good connections. As a result of his religious career, he would establish a permanent religious base that would become the spiritual center of the community. Presumably these "centers" were highly syncretic, making it unwise to attempt to characterize them as simply "Buddhist" or "Shinto," for they must have comprised aspects of both.

The hijiri activity of the Early Heian period would have been connected with the Shingon and Tendai schools to the degree that it was associated with any sectarian Buddhism. However, in the Late Heian period—with the phenomenal growth of the cult of Amida—many hijiri began preaching about salvation through rebirth in Amida's Western Paradise. Given its definitiveness this message soon achieved an enthusiastic following among broad segments of the population. The paucity of evidence creates difficulties in trying to chart the activities of hijiri in the remote provinces during the Heian period, but their work in local communities was surely important in the spread of Buddhism throughout Japan. The charismatic and shamanistic powers of the hijiri, combined with the cult of Amida that many of them propagated, made their teachings highly compelling to the people.

In the preceding pages I suggested that the first broadly based dissemination of Buddhism occurred through unofficial and popular channels. Crucial to this dissemination was the work of the hijiri. Most fortunate for this study, the phrase "hijiri of Zenkōji" is found in a Late Heian text, Hōbutsushū, written by Taira Yasuyori.[64] This is extremely important in establishing an association of the hijiri movement with Zenkōji by the twelfth century. We do not know what these Late Heian Zenkōji-hijiri were doing, although it seems unlikely that they were highly active in the

widespread propagation of the Zenkōji cult at such an early stage. The fact that hijiri were connected with Zenkōji suggests, however, that, when conditions were ripe for extensive missionary activity, as in the Kamakura period, messengers of salvation were available.

The themes discussed in this chapter should now begin to coalesce. The establishment of the Kamakura bakufu contributed to the formation of a social and political environment within which a popularly based cult such as that of the Zenkōji Amida could grow. The development of Buddhism from the Late Heian to the Kamakura periods centered on the cult of Amida, which particularly stressed the promise of universal salvation. Finally, the hijiri were ideally suited to propagate such a belief system throughout the country, especially in remote areas. In order to make the activities of the Zenkōji-hijiri somewhat more concrete, let us examine a few specific cases.

Gorai has argued that temples associated with the Nagoe School of Pure Land Buddhism were particularly important for the spread of Zenkōji belief through the northern Kantō and Tōhoku regions.[65] He believes that a Nagoe presence was established by Ryōkei Myōshin at the Gekkeibō of Zenkōji. No record of the Gekkeibō survives at present-day Zenkōji, but it is described in a book by a student of Myōshin, Myōkan Ryōzan. This Nagoe School appears to have developed out of Zenkōji belief and thus was important in the dissemination of the Zenkōji cult. The four main temples of the Nagoe School were Nyoraiji, Senshōji, and Seitokuji in Fukushima, and Entsūji in Tochigi. Both Nyoraiji and Entsūji include Zenkōji Amida triads among their present icons, and Gorai provides considerable evidence to document other connections between this group of temples and Zenkōji. These four temples were themselves the centers of networks that spread to the north, and Gorai speculates that hijiri associated with them carried the Zenkōji cult to various areas. He contends that the Nagoe School must have included within its doctrines the idea of the necessity of missionary activity by the hijiri. As is the nature of the study of popular religion, much of Gorai's argumentation is based on tenuous evidence, but he nevertheless makes a rather persuasive case for the activities of Zenkōji-hijiri connected with the Nagoe School in the north. Until a better hypothesis is put forward, we can at least tentatively accept this scenario to account for the dissemination of Zenkōji belief in the northern Kantō and Tōhoku regions.

Shinchi Kakushin (1207–1298), an interesting figure of Kamakura Buddhism, seems to have had a relation with Zenkōji. Kakushin was born in Shinano Province, near present-day Matsumoto. He went as a young man to study at Mt. Kōya, where he formed a strong connection with Kuzuyama Keirin. The latter had been a close associate of Minamoto

Sanetomo (1192–1219), and after the assassination of Sanetomo, he became a Kōya-hijiri with the name Ganshō. Hōjō Masako deeply appreciated Ganshō's prayers for her son Sanetomo and as a result gave Ganshō the steward rights to Yura estate in Kii Province. Ganshō sponsored Shinchi Kakushin on a trip to China, and when Kakushin returned to Japan he was allowed to build a temple, which was called Kōkokuji, at the Yura estate; this temple became the center of a popular branch of Rinzai Zen. All of this is part of the history of Rinzai Zen, and one might wonder what relevance it has for a study of the Zenkōji cult. The answer to this question does not lie in Rinzai-school sources, but rather in sources connected with Mt. Kōya.

These sources, discussed by Gorai, relate that Shinchi Kakushin commuted between Kōkokuji and Mt. Kōya and while at the latter concerned himself with esoteric rituals and the activities of the hijiri. Gorai maintains that Shinchi Kakushin established a group of Kōya-hijiri, called the Kayadō-hijiri, who had their headquarters at the Karukayadō in the Ōjōin valley. The fact that there are Karukayadō and Ōjōji temples adjacent to Shinano Zenkōji suggests to Gorai that a branch of the Kayadō-hijiri was established there by Shinchi Kakushin. This would explain in part the relationship between Zenkōji-hijiri and Kōya-hijiri in terms of a pilgrimage route between the two important centers.[66]

In the next chapter, when the Shimane Zenkōji Amida Triad is considered, the career of Sasaki Takatsuna (?–1214) will be discussed in some detail. Here it need only be noted that he was a famous warrior who quite probably became a Zenkōji-hijiri after he became a monk at Mt. Kōya.[67]

As is well known, Ippen Shōnin, the founder of the Ji Shū, made two pilgrimages to Zenkōji, in 1271 and 1279. Evidently Ippen's experiences at Zenkōji had an important influence on the formation of his religious beliefs. As hijiri, Ippen and his followers may have spread ideas associated with the Zenkōji cult through various areas of Japan. Moreover, a number of Shin (New) Zenkōji are associated with the Ji Shū, and there is considerable evidence for the presence of Ji Shū priests at Shinano Zenkōji.[68]

The evidence presented above suggests that a number of thirteenth-century individuals associated with hijiri activity were connected to some degree with Zenkōji belief. Of course, the individuals just discussed came from a rather high social or religious stratum (which is the reason why they are recorded at all). Ryōkei Myōshin, as founder of the Nagoe School, or Ippen Shōnin, as founder of the Ji Shū, are of obvious significance. Similarly, Shinchi Kakushin and Sasaki Takasuna are well-known figures in Kamakura history. We must understand, however, that the data available provide only an extremely limited view of the broader activities

of the hijiri who were instrumental in the spread of the Zenkōji cult. These latter Zenkōji-hijiri were not prominent members of society but, rather, simple religious practitioners who carried their message to ordinary people. Although their names are now mostly forgotten, the results of their activities can be seen in the numerous triads and temples still extant throughout Japan.

The Shin Zenkōji System

The preceding pages have considered the activities of hijiri in the dissemination of Zenkōji belief. Important traces of the activities of hijiri are still extant, especially in the form of Zenkōji triads and temples associated with or reflecting the Zenkōji cult (map 2). The most important examples of the latter are those temples that bear the name Shin Zenkōji or, simply, Zenkōji, since these designations make their religious affiliations explicit. While there are quite a large number of temples with such names, there are many more which, while containing Amida triads and other evidence of the Zenkōji cult, do not have names directly related to Zenkōji. As will be seen presently, the historical development of many temples associated with the Zenkōji cult was complex, and often one must piece together assorted bits of evidence to understand their origins.[69]

Zenkōji belief centers on the Amida Triad—the Living Buddha—that is enshrined at the Shinano Zenkōji. Claims were made about this triad that convinced worshipers it could offer them salvation in the next life as well as rewards in the present world. Rather than being an aspect of an abstract conceptual system, these claims were exceedingly concrete, for they were associated with the direct, physical intervention of the Living Buddha. For pilgrims able to travel to Shinano and worship the Amida Triad in person, the desired benefits would be automatically gained, but what about those unable to make such a pilgrimage? Obviously, a visit to a local temple that was unaffiliated with the Zenkōji cult in order to worship its icon would not be effective, since that icon presumably would not partake of the powers of the Living Buddha. If the pilgrims could not get to Mecca, then Mecca had to be brought to the pilgrims, which is exactly what happened in the establishment of the Shin Zenkōji system. Religious practitioners—mostly Zenkōji-hijiri—travelled throughout Japan preaching about the Zenkōji Buddha. When they settled down in one place, they would enshrine a copy of the Zenkōji Triad in a hall, which would then become a Shin Zenkōji. Various other components of the Zenkōji cult would also be established, but the presence of the copy of the Living Buddha formed the essential element of each new temple.

In important respects the Shin Zenkōji network is quite unusual. Of course the Amida Triad is not the only example of a copied icon, for there are also numerous copies of images such as the Seiryōji Shaka. However, in the latter case there is neither a system of Shin Seiryōji nor a network of temples of the type analyzed here. For these reasons I believe that the Zenkōji cult and its distribution through the country represent a particularly significant development within the religious history of Japan.[70]

Later, in the individual descriptions of various temples, I will provide more specific information about the components of the Zenkōji cult; here only a general framework is needed within which the following analyses can be understood. Adequate evidence is unavailable for the presence of all of these components at each temple; many, perhaps the majority, of Zenkōji-affiliated temples would lack one or more of the whole range of components. This would especially be true of the more modest temples in remote provincial areas. To reiterate, the presence of a copy of the Zenkōji Amida Triad was absolutely fundamental for the establishment of a Shin Zenkōji; without that icon there could be no temple. Normally, images of the Three Founders—Yoshimitsu, Yayoi, and Yoshisuke—would also be present as reminders of the auspices under which the cult was established in Japan. Perhaps somewhat less frequent, but still important, would be an image of Prince Shōtoku in recognition of his importance in *Zenkōji Engi* and in the cult itself. Although other types of icons could also be present, those just cited are of major significance. Gorai has argued that a standard arrangement would place the shrine of the Zenkōji Amida Triad in the center flanked by the Three Founders on one side and Prince Shōtoku on the other.[71] Examples of this ideal arrangement appear to be exceedingly rare, however.

The power of the Zenkōji Amida Triad had to be transferred from Buddha to believer, and, as it was believed that this was not done directly by the icon itself, a symbolic form of transfer had to be devised. The available evidence suggests that this was accomplished by pressing a seal on the forehead of the believer.[72] A large variety of seals was used for this ritual, embodying a wide range of symbolism. Nevertheless, the basic function of the seal seems to have been constant despite variations in detail. While conceivably a specific Shin Zenkōji could lack this component, that is rather unlikely given the material emphasis of the Zenkōji cult: worshipers were not interested in abstract, philosophical messages, but instead desired a concrete and tangible guarantee of salvation. Consequently, one assumes that some sort of seal was utilized at all Shin Zenkōji as part of the basic ritual.

One of the most intriguing components of the larger Zenkōji temples, such as those in Nagano and Kōfu, is the presence of a subterranean

passage—the *kaidan meguri* (fig. 50)—under the main altar.[73] This darkened, underground passage allowed the worshipers to experience directly death and rebirth as they entered one end of the passage, descended below the altar in total darkness, and then reemerged into the light of the temple at the other end of the passage. This is a metaphorical reenactment of the salvation of Yoshisuke as described in *Zenkōji Engi*, and must have had a powerful impact on the worshipers. One feature sometimes found in kaidan meguri is a lock affixed to the wall which, if touched by the worshiper, guarantees rebirth in Amida's Western Paradise.[74] Although there is evidence for a number of these kaidan meguri, clearly not all temples associated with the Zenkōji cult were provided with one. Certainly small, rural temples would not include such an elaborate component.

Many of the Shin Zenkōji possessed textual or pictorial material elucidating the history of the Amida Triad. Kanbun versions of *Zenkōji Engi* would have been used by the temple's priest in preaching the legends of the cult. Many of these texts were expanded to include specific details related to the temple in question, thus providing a more fully articulated version of its own history. Paintings or illustrated texts, by contrast, would have served as sources to explain the cult to worshipers in a direct manner.[75] Regardless of the mode of transmission, any given Shin Zenkōji required a basic body of material adequate to allow the continued propagation of the cult.

What emerges from the preceding discussion is a complex of elements—icon, priest, ritual, texts—forming the core of Zenkōji belief. The promise of escape from hell and ultimate salvation embodied in this cult were compelling to a very high degree in medieval Japan, which explains, in part, the popularity of the Shin Zenkōji system. Of course such a high degree of popular acceptance was not found only in Zenkōji belief, for there were numerous other movements in Kamakura Buddhism that also received widespread acceptance. There are only a few other instances, however, of cults so strongly focused on a specific icon and its replication. When a number of important Shin Zenkōji throughout Japan are examined more closely, we must keep this situation in mind, for it is a key, in my view, to understanding the system.

Substantial problems of definition arise in attempting to determine just what constitutes a Shin Zenkōji. Although the presence of a Zenkōji type Amida Triad normally implies a connection at some stage with the Zenkōji cult, this is not always the case. For example, there are instances of such Triads housed in temples as "guest Buddhas," icons apparently donated to the temple when their original homes were destroyed. Even in these cases, while the present home may be unrelated to Zenkōji belief,

the very existence of an icon must imply the presence of the cult at some period in the general vicinity. The most comprehensive list of Zenkōji-related temples, compiled by Kobayashi Keiichirō, documents over 230 establishments that are definitely associated with Zenkōji belief and have Zenkōji icons (map 2).[76] In addition, there are more than 150 triads that are in other temples as "guest Buddhas" or in collections.[77] The number of specifically Zenkōji-related temples and nonaffiliated triads is close to 400, and when we take into consideration the large number of triads that must have disappeared over the centuries is considered, this is a large group indeed.

There are well over one hundred temples that are called Zenkōji or Shin Zenkōji or that include those designations in their names, although some of these are modern temples reflecting the more recent popularity of the Zenkōji cult.[78] The distribution is nationwide, with only Kōchi, Nagasaki, Saga, and Okinawa Prefectures lacking traces of Zenkōji belief. Owing to problems of temple identification and differing levels of research in specific prefectures, precise statements cannot always be made concerning the regional patterns of Zenkōji belief. The careful investigation by Takeda Kōkichi of Yamagata and Akita Prefectures does, however, allow the occurrences of Zenkōji belief in those prefectures to be studied with confidence.[79] Similarly, the research of Nishikawa Shinji and Sekine Shun'ichi on the triads in Chiba Prefecture, combined with Gorai's research in the history of Zenkōji belief there, provides a rather complete picture of the cult as it seems to have existed in Chiba.[80] On the other hand, detailed surveys of various other prefectures might expand rather substantially the number of Zenkōji-related temples known to have existed in these places. At this stage, the best that can be done is to attempt a very general analysis of regional distribution.

In terms of raw data, the largest number of temples is in Aichi Prefecture, which is, of course, adjacent to southern Nagano.[81] Moreover, there are large numbers in Gifu, Shiga, Kyoto, Nara, Osaka, and Hyōgo Prefectures, suggesting a route between the Kansai region, the center of traditional Japanese culture, and Nagano. This hypothesis is strengthened by the fact that there are relatively few occurrences of Zenkōji traces to either side of the Kansai-Aichi-Nagano axis, in prefectures such as Fukui and Toyama to the north and Shizuoka and Yamanashi to the south. This distribution directly reflects the road system of early Japan (maps 1–2). The second major axis lies to the east and north of Nagano, centering in present-day Gunma, Saitama, Tokyo, Kanagawa, Chiba, Ibaraki, and Tochigi Prefectures in the Kantō region and Fukushima, Yamagata, and Akita Prefectures in the southern part of the Tōhoku region, an axis that also reflects transportation routes. Finally, to the

north of Nagano one finds a rather significant presence of Zenkōji belief in Niigata Prefecture.

The Zenkōji cult apparently radiated in all directions from its center in Nagano, leaving its deepest concentration along the major road systems. More difficult to understand is its distribution outside of the structure just delineated. For example, an important Zenkōji presence exists in Kagawa Prefecture in Shikoku, which might perhaps be explained in terms of sea passage from the Kansai region.[82] A similar explanation might be offered for the temples in Fukuoka Prefecture.[83]

The Shin Zenkōji network covers such a wide territory and encompasses so many temples that it is difficult to present anything approaching a comprehensive survey. Such comprehensiveness is unnecessary, however, since the major tendencies can be understood through an examination of selected examples. In order to illustrate something of the regional diversity, temples from different areas of the country will be studied, beginning with Nagano itself and then moving to the Aichi-Gifu region, to Chiba Prefecture, and finally to Yamagata. Not only do these areas represent regional variation, but each has been rather well studied, thus providing us with reasonably adequate data.

In earlier sections I tried to indicate some possible circumstances under which the cult of the Zenkōji Amida Triad could have developed at the site of the present-day Shinano Zenkōji. This explanation, of course, is contrary to the legendary account, which says that the triad was brought from the capital to Shinano by Honda Yoshimitsu at the beginning of the seventh century. Various reasons were given why that account is extremely unlikely, concentrating on an analysis of the texts in order to show how the Zenkōji legend developed out of various early traditions. In the context of the Shin Zenkōji network, another aspect of the legendary account assumes importance. This holds that Honda Yoshimitsu stopped, for varying periods of time, on his way from Naniwa to the final place where the sacred icon was enshrined. For obvious reasons, these stops have been celebrated by the establishment of temples which commemorate the presence of the triad at the given location. These temples would not be called Shin Zenkōji since they are not, at least in theory, "new" with regard to the main center, the Shinano Zenkōji, but rather precede it. Consequently, the alternative designation of *Moto* (Original) *Zenkōji* was developed to indicate such precedence.

A path from the central region to distant Shinano, purported to be the very route that Yoshimitsu travelled in bringing the triad to his home, can be reconstructed, even though this "path" was formulated retrospectively, after the cult was already flourishing at the main temple. The Zenkōji-hijiri, who were largely responsible for the dissemination of the

cult, surely realized the benefits to be derived from the establishment of a Moto Zenkōji, while local inhabitants would perhaps have welcomed the prestige associated with such an important role for their temple. Since the hypothetical "route" was explicitly defined, the plausible locations for a Moto Zenkōji were limited, and occurrences departing from this basic route are not found. Needless to say, this route conforms to the Kansai-Aichi-Nagano axis of the distribution of the Zenkōji cult.

Since a movement out from the Shinano Zenkōji, rather than the opposite, has been assumed in this study, I will begin with a discussion of temples located in Nagano Prefecture (map 3). Certainly the most important representative of the Moto Zenkōji category is Zakōji, located in Iida City in southern Nagano Prefecture.[84] According to legend, the original home of Yoshimitsu was at Iida. When Yoshimitsu returned from the capital, he installed the Amida Triad in his house atop a mortar. The triad remained there for some years before issuing an oracle commanding that it be moved to what is now Nagano City.[85] Yoshimitsu's dwelling subsequently became Zakōji, and developed into an important temple.

Gorai's research into cult practices at Zakōji has revealed rich data.[86] He found that the temple contains practically all of the important components of the Zenkōji cult, but beyond that it preserves aspects that may reflect practices now lost at the Shinano Zenkōji. Most important in this regard are the ceremonies related to passage through the kaidan meguri and the pressing on the forehead of a seal called the go-inmon. At Zakōji the believer passes through the kaidan meguri, symbolically dying and then being reborn, and upon emerging goes to the seat of the zenchishiki (presiding priest) which is close to the exit from the kaidan meguri, and receives the touch of the go-inmon on the forehead. This conjunction of kaidan meguri and go-inmon is mutually reinforcing in a way that must substantially enhance the worshiper's total experience. Gorai believes that many temples, including Shinano Zenkōji, may have carried out this type of ceremony in earlier times, although the practice is now lost at other Zenkōji-related temples.

Between Zakōji, at Iida City, and Shinano Zenkōji, in Nagano City, there is another Moto Zenkōji located near Lake Suwa (map 3).[87] According to the legends of this temple, the Amida Triad came there from Zakōji as a result of an invitation by the great god of Suwa Shrine and remained for seven years before moving to its final destination. In analyzing this account, the most important factor must be the relationship of this Moto Zenkōji with Suwa Shrine, one of the two greatest religious establishments in Nagano Prefecture. What is seen here is an apparent alliance between Zenkōji and Suwa Shrine, whereby both benefit from

the idea that the Living Buddha felt it appropriate to stay at Suwa for several years.

The preceding discussion has been highly abbreviated, and yet certain basic tendencies have come to light. A glance at a map shows that Iida, in southern Nagano Prefecture, Suwa, in the center, and Shinano Zenkōji, in the northern part, are approximately equidistant (map 3). I would argue that what is observed here is a "reasonable" or "logical" distribution, from a functional perspective, of key temples. The presence of more Moto Zenkōji might have been hard to justify and would inevitably have resulted in the importance of those that did develop.

The discussion of the distribution of Zenkōji-related temples indicates that a rather large number are found in Aichi and Gifu Prefectures, particularly in the area between the present cities of Gifu and Nagoya. This should not be at all surprising, for this area is located on the main road that passes from southern Nagano through the southern part of Gifu and on to the capital. There is an additional significant feature concerning roads here, for an important branch road existed that connected the Tōsandō and Tōkaidō, leaving the Tōsandō at Kuroda (present-day Kisogawa) and joining the Tōkaidō at Atsuta. Travelers between Kamakura and Kyoto would frequently take the Tōkaidō from Kamakura as far as Atsuta and then transfer, via the branch road, to Kuroda on the Tōsandō, from there continuing to the capital (map 1). A number of important Zenkōji-related temples are found along this branch road.

The Kuroda Zenkōji is a particularly significant example of this phenomenon, and since Gorai has traced the very complex historical vicissitudes of this temple, it will serve as a useful case study.[88] At present Kuroda Zenkōji is an extremely modest temple in the city of Nagoya, but it was only moved to its current location when the previous, much more impressive establishment, also in Nagoya, was destroyed as a result of bombing during World War II. The temple had been transferred from Kuroda to Nagoya after the Battle of Kuroda, which took place during the Meitoku era (1390–1394). Thus one can see that there was a succession of moves that, if not properly understood, would obscure the original significance of the temple.

The temple's significance, however, becomes apparent in an account in the *Jinten Ainō Shō* (completed 1446), which relates how Honda Yoshimitsu and the Triad stopped for the night at Kuroda on their way from the capital to Shinano.[89] Yoshimitsu was so tired from the journey that he immediately went to sleep on the ground, and Amida, fearing that Yoshimitsu was uncomfortable, magically provided him with a pillow. Upon awakening, Yoshimitsu realized the miraculous auspices under

which the pillow had appeared and naturally cherished it as a divine gift. This legend was developed to enhance the importance of Kuroda Zenkōji, and certainly would have contributed to the temple's growth. As noted above, the original location of this temple at Kuroda was where the branch road leaves the Tōsandō for Atsuta, where it connects with the Tōkaidō. Evidence preserved at the present Kuroda Zenkōji indicates that the early temple was part of an extensive network of forty-eight temples. At present most of these temples cannot be located, but the relevant factor for this study is the existence of a major pilgrimage route associated with the Zenkōji cult in the Aichi-Gifu-Mie area during the Kamakura and Muromachi periods. Kuroda Zenkōji as a Moto Zenkōji—that is to say, as a temple where the Amida Triad stayed—must have been one of the most significant establishments in this pilgrimage network.

Traveling from Kuroda along the Tōsandō in the direction of the capital, the pilgrim comes to the Hirui Zenkōji in Ōgaki City, Gifu Prefecture.[90] The name of this temple is derived from the legend that the local villagers provided Yoshimitsu with a midday meal (*hirui*) when he was carrying the triad to Shinano. This is another example of a stop along the sort of network noted in Shinano, as the Zakōji/Suwa Zenkōji/ Shinano Zenkōji route. The geographical relationship between Hirui Zenkōji and Kuroda Zenkōji implies that Yoshimitsu carried the triad from Naniwa along the Tōsandō. A large number of Zenkōji-related temples, however, are located along the branch road from Kuroda to Atsuta and from Atsuta on to the Tōkaidō and south to the capital. From these data, we can conclude that during the Kamakura period there was no firmly established theory as to which route in this region Yoshimitsu utilized: the more southerly Tōkaidō, or the Tōsandō (map 1). As a result, temples along both roads seem to have been in a position to claim that they had been honored by a visit by Yoshimitsu and the Amida Triad. To demonstrate that the establishment of Moto Zenkōji was not totally arbitrary, one need only recall that such temples are not found east of Atsuta along the Tōkaidō in the direction of Kamakura, since it was well understood that that was not the route taken by Yoshimitsu.

Among the important Zenkōji related temples between Kuroda (Kisogawa) and Atsuta are Sobue Zenkōji and Jimokuji. The latter has a legend stating that its main icon was one of the flanking images, the Kannon, from the original Amida Triad.[91] The story explains that, at the time the triad was being brought from Paekche to Japan, the Kannon was lost in the sea and later, during the reign of Empress Suiko, pulled out by a fisherman by the name of Hadame (=Jimoku) Tatsumaro. A temple, Jimokuji, was then built to enshrine this image. This particular legend

belongs to a category involving deities who return from across the sea, several examples of which have been analyzed by Gorai in the context of the Zenkōji cult.[92] Because Jimokuji claimed to possess at least a part of the original icon, it too would be considered a Moto Zenkōji. Needless to say, this legend does not conform to other accounts, which do not mention a missing Kannon. But such consistency is not characteristic of legendary literature. Once again, what seems operative is an effort to provide a particularly impressive pedigree for an icon held by Jimokuji. Although this is no more than speculation, perhaps Jimokuji had an old, gilt-bronze image of Kannon, which, at the time that the temple was influenced by the Zenkōji cult, the resident priest "realized" was, in fact, part of the original Amida Triad.

A number of Zenkōji-related temples located along the main roads of Aichi and Gifu have been analyzed, and we have also considered the types of legends developed at some of these temples to explain either the circumstances of their foundation or the nature of their icons. Evidently, the Aichi-Gifu area evolved into a rather important center of Zenkōji belief during the Kamakura and Muromachi periods. This must have resulted from movement of Zenkōji-hijiri between Shinano and the central region. Since there does not seem to have been substantial movement of Zenkōji-hijiri along the Tōkaidō through eastern Aichi, Shizuoka, and Yamanashi prefectures, few early traces of the Zenkōji cult are found in that area. The Kantō region, however, is one of the principal centers of Zenkōji belief, and this preeminence must be accounted for in terms of direct propagation of the cult from Shinano Zenkōji through Gunma and Saitama to Kanagawa, Tochigi, Ibaraki, and Chiba Prefectures.

There are far too many instances of Zenkōji-related temples in the Kantō region to allow a general survey here, so only one prefecture will be discussed: Chiba. Chiba serves as a rather different test case in that, unlike the Aichi-Gifu area, it was not a center for important transportation routes. Instead, Chiba represents what was then a relatively backwater region. As noted earlier, there are a number of important secondary sources useful for a study of the Zenkōji cult in Chiba Prefecture.[93]

A particularly interesting situation is the existence in rather close proximity of two Zenkōji-related temples at Hikari-machi in the northeastern part of Chiba. One of these temples is called Sasamoto Shin Zenkōji, the other is Ogawadai Shin Zenkōji or Ryūdaiji, and both have Kamakura-period triads.[94] Sasamoto Shin Zenkōji has an unusual legend, which maintains it was established by a man called Honda Yoshiaki, who is said to have been the elder brother of Honda Yoshimitsu, the founder of Shinano Zenkōji.[95] Since Sasamoto Shin Zenkōji is believed

to have been established prior to Shinano Zenkōji, the "shin" of its name is written with the character meaning "true," (眞) not the usual "new" (新). Gorai's research indicates that this is an Edo-period story, but it does provide interesting insights into the types of legends that were developed to add to the prestige of specific temples. Further data relating to the Sasamoto Shin Zenkōji suggests that the temple was "restored" by a priest called Unnichi Shōnin in 1236. Unnichi Shōnin seems to have been a Kōya-hijiri and thus would have been associated with the Shingon School and with Zenkōji belief, a common combination in the thirteenth century. Gorai argues that Unnichi Shōnin established the Zenkōji cult at what is now Sasamoto Shin Zenkōji, which in the early thirteenth century perhaps survived as the remains of an earlier monastery in substantial decline. Thus, in the Edo period, Unnichi Shōnin was not treated as the "founder" of the temple, but rather as its "restorer." In a sense, of course, he was a "restorer," although he was not restoring the Zenkōji cult, but rather an old temple which he reinvigorated by introducing a new belief system.

Near Sasamoto Shin Zenkōji is Ogawadai Shin Zenkōji (official name Ryūdaiji). Gorai points out that the two temples have formal names that are very close, and he suggests that they may both relate back to an early Buddhist monastery in the area.[96] He further argues that foundation stones discovered under Ryūdaiji appear to be very old, which implies that Ryūdaiji is a successor to an ancient establishment. Legends connected with Ogawadai Shin Zenkōji relate that a person called Un'yo Shōnin was its main priest, and the obvious similarity between his name and that of Unnichi Shōnin of Sasamoto Shin Zenkōji suggests a common religious heritage.

The preceding is a brief summary of Gorai's research into these two temples. Most important for our present purposes is Gorai's utilization of a broad range of evidence—documents, extant remains, legend, and folklore—in the reconstruction, with a high degree of plausibility, of the early history of such temples as the Shin Zenkōji of Sasamoto and Ogawadai. Naturally, such a wide range of evidence is not always available, but the sort of process observed here must have occurred in many other temples as well. Basically, with the strong diffusion of Zenkōji belief during the early Kamakura period, at least two possibilities were likely in the establishment of Shin Zenkōji. In many cases the Zenkōji-hijiri may have founded an entirely new temple, but in other cases the new cult seems to have been grafted on to a previously existing temple. In the latter situation one assumes that such a temple was in decline, since, it if had been still thriving, a new cult would not have been so easily adopted. The great interest of Gorai's study of these two Shin Zenkōji at

Hikari-machi lies in the way he is able to indicate the evolutionary processes dictating this sort of transformation. For Sasamoto Shin Zenkōji a story was constructed to bridge the gap between the legendary Asuka origins of the Zenkōji cult and what apparently were the actual beginnings of Zenkōji belief at Hikari-machi in the thirteenth century. In addition, this story also accounts for the existence of an early Buddhist temple predating the origins of Zenkōji belief.

While the two temples just examined preserve considerable evidence of the Zenkōji cult, other temples in Chiba have lost most traces. In many little survives beyond a Zenkōji-type triad, or part of such a triad, to indicate the earlier presence of Zenkōji belief. During the early Edo period, Buddhist temples were required to affiliate with one of the major schools of Buddhism, and many temples that previously had been centers of the Zenkōji cult altered their religious practices to conform with their new sectarian affiliations.[97] Although a Zenkōji Amida Triad was not likely to be destroyed or removed, such an icon often would be assigned to a subordinate position within the temple, with its original significance gradually fading. Naturally, the various practices associated with the Zenkōji cult would cease as new ceremonies were adopted. In other cases, a temple associated with the Zenkōji cult would lack parishioners and thus fall into decline as a result of financial problems.

Amatsura Zenkōji (official name Saitokuji) is an example of a Chiba temple in which the new religious affiliations have overwhelmed the earlier Zenkōji beliefs.[98] Saitokuji is now a Shingon temple and emphasizes Shingon rituals, but next to the main hall is an Amidadō, and it is this structure that is referred to as Amatsura Zenkōji. According to Gorai, the people of the temple are not very enthusiastic about this Zenkōji dimension, although in earlier times the temple was an important stopping point on pilgrimages to Shinano Zenkōji.

Miyahara Zenkōji, also in Chiba, is an instance of a Shin Zenkōji which has substantially declined.[99] No legends survive about the foundation of the temple; a resident priest is lacking; and it is now supervised by a neighboring Tendai temple. At present Miyahara Zenkōji is a simple, thatched-roof structure containing a single Amida figure, the flanking Bodhisattvas having apparently been lost. This temple has no parishioners and thus lacks financial resources; moreover, its property was lost through the land reform carried out by the Allied Occupation following World War II. As a result of social and economic changes, weaker temples such as Miyahara Zenkōji were wont to fade unless they could establish new bases of support. In many cases, this would involve significant transformation of the original belief system, so that even those

temples that did flourish often did so at the expense of the earlier Zenkōji cult.

Nishikawa and Sekine have compiled a list of extant Zenkōji-related sculpture in Chiba Prefecture that includes twenty-two monuments.[100] However, the temples where most of these icons are enshrined are not now flourishing centers of Zenkōji belief. Instead, one only finds traces of the cult handed down from the Kamakura and Muromachi periods. Nevertheless, careful research of the type conducted by Gorai often provides considerable insight into the earlier circumstances of the temples where these triads are now kept. A detailed study of the history of Zenkōji belief in Chiba Prefecture would show how a prosperous network of temples was established during the Kamakura period, only to decline in later centuries, especially during the Edo period. This rather melancholy story should bring to mind the fact that all of the Zenkōji-style icons extant throughout Japan were at one time connected with a dynamic cult, even if at present few traces of this remain at their temples. For the present purposes, the Chiba data are useful in comprehending the rise and fall of Zenkōji belief, and presumably this situation can be generalized to apply to other areas of the Kantō region.

As a final case study in the diffusion of the Zenkōji cult, the evidence in Yamagata Prefecture in the far north is useful.[101] The Tōhoku region is of considerable importance for the study of the Zenkōji tradition because it had been less influenced by Buddhist movements during the Heian period and thus was perhaps more receptive to the new Zenkōji belief system. Indeed, a large proportion of early sculpture in Yamagata Prefecture consists of Zenkōji triads, clearly indicating the importance of the cult. While the number of Zenkōji monuments in Chiba and Yamagata Prefectures is similar, there are many other images of various types in Chiba, showing that the Zenkōji cult was only one of a variety of religious traditions. Consequently, I would suggest that the cult of the Zenkōji Amida Triad was of central importance to the religious life of the Yamagata area during the Kamakura and following periods.

The Zenkōji cult was highly developed in Tochigi Prefecture in the northern Kantō and Fukushima Prefecture in the southern Tōhoku region, although its very limited presence in Miyagi Prefecture, which lies directly to the east of Yamagata, is surprising. These data suggest that Zenkōji-hijiri travelled from Fukushima into southern Yamagata, perhaps to the area of present Yonezawa City, and then north to the general area of Yamagata City. The clusters of Zenkōji-related images documented along the Japan Sea coast in Yamagata and in Akita Prefecture could have resulted from either a continuation of movement through the

Yamagata area proper or, perhaps, from movement along a different route that followed the coast from Niigata.

Throughout this section, I have tried to indicate the possible routes for the spread of Zenkōji belief, although significant gaps remain. For example, even though few Zenkōji traces are found in Miyagi Prefecture, a sequence extends from the far north of that prefecture up through the center of Iwate Prefecture.[102] This situation should make obvious the dangers of a simplistic interpretation of the diffusion of the Zenkōji cult. While there are many instances of rather even distribution of centers of Zenkōji belief along major road systems, inevitably the cult proves to be absent from certain areas as a result of various local circumstances.

These observations on routes of transmission are meant to serve as a preface to an important point about the Zenkōji sculpture of Yamagata Prefecture. In a separate study, I have shown that there is a small group of images (figs. 34–39) in Yamagata with extremely consistent characteristics, suggesting that they were all made in one studio.[103] Given the fact that *all* Zenkōji triads are supposed to be exact copies of the original icon, this might not seem particularly surprising. As we will see in the next two chapters, however, through detailed analysis of the corpus, a considerable degree of diversity is apparent within the extant copies; in fact, exact resemblances are the exception. For this reason, the Yamagata group is of considerable interest. The importance of the group increases substantially because these images are directly related to a beautiful triad (fig. 33) enshrined at the Fudōin on Mt. Kōya.[104] Additionally, there is one figure in Tochigi Prefecture that relates to the Yamagata images.[105] The stylistic characteristics of this group will be discussed in Chapter 6, and so here we need only indicate that they demonstrate important connections among images in various areas of the country.

The current stage of research into the Zenkōji tradition does not allow a fully articulated account of the Shin Zenkōji system as it developed throughout the entire country. This may not be a serious limitation, however, in terms of the present study, for the variety of cases considered in the preceding pages is adequate as a survey of the principal types. The analysis of the temples in Nagano makes clear the geographical and ideological structure of those establishments near the center of the cult, while consideration of the Aichi-Gifu group shows the development of a flourishing system of temples in an intermediate zone between the cult center and the capital. A good deal of interesting data can be compiled about the Zenkōji cult in the Kansai area, although this cult does not assume as important a role in the traditional heartland of Japanese culture as it does in outlying areas.[106] Extensive Shin Zenkōji networks did not exist to the south of the Kansai region or on the islands of Shikoku

and Kyūshū, although important individual temples are found in these areas. For the Kantō region, I acknowledge that a more detailed account would have been both possible and desirable, but limitations of space allowed only a discussion of Chiba Prefecture. Nevertheless, the data available for Chiba allow a quite detailed presentation of the nature of historical and religious developments occurring in the Kantō region. Finally, in the case of Yamagata Prefecture, we note the manner in which the Zenkōji cult was diffused to the far north. Taken as a group, these cases do illustrate the major developments in the Shin Zenkōji system as seen throughout Japan during the medieval period.

The rather extensive network of temples associated with the Zenkōji Amida Triad formed an essential base for the continued popularity of the Zenkōji cult. Of course, the Zenkōji-hijiri could travel throughout Japan preaching, but without the establishment of permanent temples, the cult would not have taken root and grown. This sort of process occurs in the diffusion of any cult or school, but in the present case a quite specific belief system is operative. An exact copy of the Living Buddha, the Amida Triad of Shinano Zenkōji, would be enshrined in each branch temple, where it was believed to participate in the magical powers of the Living Buddha. In this sense, the Shin Zenkōji can be thought of as a home for its triad in the same way that Yoshimitsu's dwelling was the original home of the Living Buddha. By and large, extant Shin Zenkōji, and other temples associated with the cult, are not of great architectural distinction. Many are extremely modest structures, little more than small, private houses, although a few are larger; only the Shinano Zenkōji and the Kōfu Zenkōji, an important temple to be discussed in the next chapter, represent truly large-scale architectural complexes. While the form of the Amida Triad is specifically determined, apparently no comparable formula of construction applies to the temples. If this is in fact the case, the centrality of the icon for the Zenkōji cult becomes apparent. As I have argued, a structure to house the icon was definitely required for the maintenance of the cult, but the form of this structure seems not to have been of great importance; no tradition of architecture is associated with the Zenkōji cult. Perhaps the only significant exception to this generalization is the occasional presence of the a kaidan meguri, although this feature is not exclusively associated with Zenkōji belief.[107]

CHAPTER 5 Early Kamakura
Copies of the
Zenkōji Amida Triad

THE PRECEDING chapters were designed to
present the fullest possible context for an investigation of the extensive
production of Zenkōji icons during the Kamakura period. Separated
from the relevant religious, political, economic, and geographical fac-
tors, an individual Zenkōji Amida Triad loses most of its meaning, be-
coming a disembodied phantom rather than a symbolic manifestation of
the rich cultural and religious situation of medieval Japan. Consequently,
the present study utilizes a broad range of materials in order to allow a
deeper analysis of the cult and its icons. In this chapter I will shift the
focus from the wider situation to a small group of images made during
the early decades of the Kamakura period.

Kōfu Zenkōji Amida Triad

The Kōfu Zenkōji Amida Triad (fig. 15a–e)
is extraordinary in several respects. The icon is not only the earliest dated
example, but presumably the first of any of the copies. Rather than being
the typical small-scale sculpture, the central Buddha is life-sized, while
the flanking Bodhisattvas are also rather tall. The only triad larger than
that of the Kōfu Zenkōji is the example at Ankokuji, Hiroshima Prefec-
ture (fig. 32), but the latter is made of wood rather than bronze. Thus the
Kōfu Triad should be seen as a remarkable achievement of the bronze-
caster's art. Finally, the inscribed date (1195) of the Kōfu Triad can be
associated with the very inception of the making of copies. Combined
with what is known about the circumstances through which this triad
passed at mid-sixteenth century, to be discussed in a moment, this evi-
dence allows the monument to be placed historically with considerable
confidence. All in all, the Kōfu Zenkōji Amida Triad is arguably the most
important example of the Zenkōji tradition, and thus warrants careful
attention.

At present the triad is located at the large Zenkōji in Kōfu, Yamanashi
Prefecture (fig. 14), a temple built by the prominent warlord Takeda

Shingen during the second half of the sixteenth century. How the triad got to Kōfu is a topic that I will discuss in detail in a subsequent chapter. To anticipate briefly, we should note here that in the course of the Kawanakajima Battles, Takeda Shingen and his opponent, Uesugi Kenshin, both removed numerous treasures from Shinano Zenkōji. Takeda Shingen took his share, including this life-sized bronze triad, to his headquarters in Kōfu (map 4). The image has an inscription with a date equivalent to 1195, which can be associated with an account in *Zenkōji Engi* that relates the story of the making of the first copy by the monk Jōson in 1195. Consequently, this discussion treats the Kōfu Triad as a monument that was most likely made for Shinano Zenkōji in 1195.

Although the Kōfu Zenkōji Amida Triad is a very important monument, surprisingly few efforts at detailed stylistic analysis have been made. Before such an analysis is undertaken here, let us review the previous work. The earliest scholarly discussion of the Kōfu Zenkōji Amida Triad is an important article, "Zenkōji Nyorai Zō no Kenkyū" (Research on the Zenkōji Buddha), first published by Kobayashi Takeshi in 1931.[1] Although written in the pre-war period, Kobayashi's paper retains its significance as a fundamental contribution to the study of the Zenkōji tradition. At the time he saw the Kōfu Triad, however, Kobayashi concluded that it was a later sixteenth-century work, specifically made for Takeda Shingen's temple, and thus he rejected the traditional claims of the temple concerning the origins of its main icon in 1195. He thought that in various stylistic traits the triad could not be associated with the Kamakura period, and suggested that it related to sculpture of the fifteenth and sixteenth centuries. Naturally, Kobayashi was aware of the temple tradition that the triad was Jōson's copy of 1195, brought to Kōfu by Takeda Shingen in 1558, but he dismissed this story, pointing out that numerous Shin Zenkōji have similar legends about their icons.[2] Given the early stage in Japanese Zenkōji scholarship at which Kobayashi's research was carried out, one is not surprised that he failed to recognize the possibility of a Kamakura (1185–1333) date for the triad. When the 1195 inscription was discovered in the early 1960s, however, Kobayashi still was unwilling to change his mind, maintaining that there were "problems" with the inscription. The Kōfu Triad remained unclassified until after Kobayashi's death, at which time the image was designated an Important Cultural Property. To the best of my knowledge, all authorities now accept the triad as a sculpture of 1195. While Kobayashi's work provided a major impetus to Zenkōji research in general, it inhibited to some extent a clear understanding of the significance of the Kōfu Triad.

Kurata Bunsaku, in the early 1960s, was particularly diligent in striving

to understand the stylistic sources of the Kōfu Triad.[3] Kurata asserts that the three figures reflect the style that he refers to as the "Late Fujiwara," apparently referring to the middle decades of the twelfth century. For example, in discussing the Amida, Kurata argues that the configuration of the *ushnisha* and the form of the snail-shell curls are appropriate for Late Fujiwara or Early Kamakura. He suggests that the shape of the eyes fits into the same context, although he points out that their heaviness may be related to casting technique. While Kurata observes some early traits in the arrangement of the robes, he sees the Late Fujiwara style in the treatment of the drapery folds. Only in the case of the hands does he specifically find in favor of the Early Kamakura style, arguing that they are "sharp" and "strong" in feeling.[4] Kurata also relates the Bodhisattvas to the Fujiwara style. Although his analysis is not often specific in suggesting comparative examples, he does make comparisons when dealing with the topknots of the Bodhisattvas. They are compared to those of the Byōdōin Phoenix Hall Heavenly Beings and that of the Ōkura Museum Fugen Bosatsu.[5] He also sees the faces as relating to the Fujiwara style. In the case of the drapery elements of the Bodhisattvas, Kurata suggests that the way the two ends of the scarf cross in front of the legs should be related to the style of Late Fujiwara period.

Kurata apparently sees all three figures as deriving from a style existing at the end of the Heian period (i.e., what he calls "Late Fujiwara"). While he does not say so explicitly, presumably in his opinion the triad's appearance is very similar to that of wood triads made in the decades just prior to 1195. This is certainly a possibility, since large bronze sculptures were not made during this period, thus necessitating a prototype in wood. Kurata points out that the figures have a block-like structure, with very little sense of organic transition from one side to the next. He suggests that a lack of familiarity with the processes of bronze casting may have contributed to the slight degree of awkwardness that differentiates the large bronze triad from its wood prototype. Kurata argues that the stylistic source of the Kōfu Triad is to be found in Late Heian sculpture, and sees both the Buddha figure and the flanking Bodhisattvas as deriving from a common source.[6]

A detailed study of the Kōfu Triad was carried out in 1961, with several scholars participating, includinq Uematsu Mataji, Yoneyama Kazumasa, Kurata Bunsaku, and Tanabe Saburōsuke.[7] While Kurata published his results rather rapidly, Tanabe waited some years before presenting an analysis of the Kōfu Triad.[8] This wait enabled Tanabe to offer a more precise account of the stylistic features of the monument, presumably as a result of further study and thought. In considering the central Amida, Tanabe postulates a prototype in Early Heian (i.e., ninth–tenth century)

sculpture, arguing that the overall shape of the head, the form of ushnisha and snail-shell curls, and the articulation of the facial features all relate to the style of that period. Tanabe becomes more precise when he discusses the body forms and the treatment of the drapery, maintaining that these show traits reminiscent of provincial wood sculpture of the tenth century. Tanaka Shigehisa has argued that the first Zenkōji Amida was actually made during the tenth century, and although Tanabe is properly skeptical about this theory, he feels that one can see a tenth-century style underlying the Kōfu Amida.[9]

While differing from Kurata in his assessment of the stylistic source of the Amida, Tanabe is in agreement with Kurata in assuming a Late Heian source for the style of the flanking Bodhisattvas. Tanabe recognizes that the facial expressions of the Bodhisattvas are closely related to that of the Buddha, but believes that various traits, such as the form of the topknot and the diadem, and the treatment of the drapery are derived from twelfth-century sculpture. Thus Tanabe arrives at a mixed source for the Kōfu Triad, suggesting a tenth-century prototype for the Amida and a twelfth-century prototype for the Bodhisattvas. Presumably this hypothesis implies separate sources for the two components, rather than a single source for the entire triad.

Although several other scholars have commented briefly on the Kōfu Triad, the results summarized here constitute the most significant efforts at specific analysis of the monument.[10] Some important results have emerged from this work, but a full understanding of the stylistic lineage of the triad has not yet been achieved. Particularly distressing is the lack of concrete comparisons for the various traits seen in the Kōfu Triad. In the following pages I will present a detailed analysis of the monument, with specific comparative examples cited to buttress the argument.

Careful study of the style of these three figures, in comparison with other works of Japanese Buddhist sculpture, reveals that the triad is apparently unique in conception. Other triads that even vaguely resemble the Kōfu Triad cannot be found, and it is difficult to locate individual monuments that offer ready comparison to either the Amida or the Bodhisattvas. How should this situation be interpreted? Theoretically, at least, the Kōfu group is a more or less exact copy of the main icon of the Shinano Zenkōji—the Living Buddha—and thus should preserve as accurately as possible the traits of that monument. While definitive statements about an image that cannot be seen are risky, the suggestion that the Kōfu Triad is closely based on a triad enshrined at the Shinano Zenkōji in 1195 is most unlikely. If it is actually a fairly accurate copy of such a prototype, the situation is no better, for then we would have to explain the stylistic sources of that image. We need not follow such a

path, however, for the Kōfu Zenkōji Triad appears to be essentially an original creation. Presumably, the sculptor had some basic information concerning mudras, and probably also some idea about robes. Although it is impossible at present to determine the source of such information, probably some sort of sketch was available. Apart from this basic level, the designer seems to have been left to his own resources. The result is a pastiche, with elements taken from a variety of sources and then recombined to make a new monument.

Dogmatically arguing that an entire monument, or some aspect of it, is highly unusual, or even unique, is dangerous, since further investigation might reveal various other instances of the traits in question. While I am fully cognizant of such dangers, I believe that the Kōfu Triad has so many unusual traits that it can probably be characterized as a unique monument. Unfortunately, there are very few sculptures to serve for comparative purposes, since the Kōfu icon is the only large-scale, Zenkōji Amida Triad made of bronze. Moreover, there are few, if any, extant examples of large-scale bronze sculptures from the Heian period, so that in searching for prototypes, images made of wood must be investigated.

As noted above, Tanabe related the forms of the Kōfu Amida (fig. 15a–c) to Early Heian Buddha figures. If its proportions are compared to typical Early Heian Buddhas, such as the Yakushi figures of Jingoji or Gangōji (fig. 16),[11] one notes that the Kōfu Amida has a somewhat larger head, larger upper body, and shorter legs than the Early Heian figures, thus producing a slightly squat appearance. Nonetheless, the Kōfu Amida has a sense of powerful volume, although it does not quite match the massiveness of the Jingoji and Gangōji figures, especially in side view. And yet, even though the style of this figure can be differentiated from the Early Heian, it has closer connection to that style than to those that preceded and followed it. The face, having a rather stern, gloomy expression, is in that regard also comparable to Early Heian Buddhas. Particularly unusual is the shape of the eyes of the Kōfu Amida, with very heavy upper lids hanging over the small arcs of the lower lids. As yet no close parallels for this eye form are documented. A good deal of the chest is visible, again rendering this image comparable to the Early Heian Buddha. In contrast with the latter, however, the Kōfu Amida lacks strong, emphatic modelling in this area. There is not a very specific sense of body parts under the drapery, only a generalized feeling of volume.

In all of the aspects just noted, Tanabe's association of the Kōfu Amida with the Early Heian Buddha figure seems to work out quite well, but when the drapery system is examined problems suddenly emerge, since neither of the two Buddhas cited, or others, have a similar arrangement. I

would suggest that the outer robe is derived not from an Early Heian standing Buddha figure, but rather from one of the important types of Jizō images of the period. (Jizō is a Bodhisattva depicted wearing a monk's robe rather than the usual princely attire characteristic of other Bodhisattvas.) Kuno has demonstrated that Early Heian Jizō statues are of two basic categories, one with separate fold systems over each leg, the other with broad, sweeping folds that pass over both legs.[12] The first type of fold arrangement is seen also in most Early Heian standing Buddha figures, and is approximately equivalent to the Udayana type Buddha.[13] The second type, with broadly sweeping folds, is more frequently seen in Asuka and Hakuhō period Buddha images, and thus is normal in what was assumed to be the original source for the style of the Zenkōji Amida.[14] The Kōfu Zenkōji Amida, however, seems remote from a seventh-century prototype, and thus we must search elsewhere for the image's stylistic source. The second type of fold arrangement in Early Heian Jizō figures is seen mainly in the Tōhoku region and other areas remote from the capital, and, in fact, there is a good example very close to the main Zenkōji at Seisuiji in Matsushiro (fig. 17).[15] Other examples of this type of Jizō can be found at Shōjōji, Fukushima Prefecture and at Sōrinji, Miyagi Prefecture.[16]

A rather close comparison of the Kōfu Amida and the Seisuiji Jizō will be helpful in making these points. Of course there are important iconographical distinctions between the two, particularly the shaven monk's head of Jizō in contrast to the ushnisha and snail-shell curls of the Buddha. Also, the hand positions of the two statues are different. With these exceptions, however, there are remarkable similarities, especially in the modelling of the body and the arrangement of the drapery folds. Particularly significant are the broad shoulders, the fully articulated chest areas, and the way in which the breasts and the upper part of the belly are very prominently represented in both statues. This sense of volume, continuing down through the leg area, is apparent in side and back views. There are also close parallels between the two images in the drapery; most telling is the presence of the henzan. This element, discussed in detail by Nishikawa and Sekine, following Kuno, is a piece of fabric used to cover the right shoulder.[17] Normally, as in the present cases, the henzan is represented as being under the outer robe. The "U"-shaped section of drapery that hangs down from the right forearm and then passes up to the chest area, where it is tucked into the hem, is part of the henzan arrangement. This "U" loop motif is slightly more prominent in the Kōfu Amida because its arm and hand are held up higher, but essentially the same form is seen in both. Perhaps a more striking similarity is the closely bunched loop folds that pass across the body from the belly

down to below the knees. (This sort of dense bunching of looped folds is noted in other Jizō representations of this type as well.) The resemblances between these looped folds in the Kōfu Amida and Seisuiji Jizō extend to such minute details as the "interrupted" fold at the bottom of each figure's outer robe.[18] The under robe emerges from beneath the lower hem of the outer robe with similar forms, although that of the Amida is somewhat more detailed than that of the Jizō. Looking at the back view, a similar configuration is seen in the arrangement of the drapery, particularly in the way a hem moves obliquely from the left shoulder across the back before passing under the right arm (fig. 15c, 17a). This motif, of course, results from the presence of the henzan. The front view of the Jizō shows a considerable degree of simplification in comparison to the detail seen in the Amida, but the drapery at the backs of these two figures is essentially the same in form.

While I do not suggest a direct connection between the Seisuiji Jizō and the Kōfu Amida, evidently the latter must have been modelled on an Early Heian figure that belonged to the same tradition as that of the Seisuiji Jizō. Why would the sculptor of the Amida select this sort of prototype in designing his icon? Although speculative, the following explanation is reasonably plausible. Apparently the sculptor of the Kōfu Zenkōji Triad paid attention to certain important features of the "prototype," such as the hand positions of the flanking Bodhisattvas, while ignoring others. Since access to the original image is impossible, we do not know how its robe was arranged, but it likely had the earlier configuration seen in the Kōfu image; namely, broadly looped folds moving across both legs. This configuration, rare in Heian standing Buddhas, is seen in a certain type of Jizō, as noted above, and perhaps the sculptor of the Kōfu Amida, in seeking a life-sized source for his own life-sized image, chose just this sort of model. For this reason, the Kōfu figure looks very much like the relevant Early Heian Jizō in various respects, especially in modelling and drapery arrangement.

Both the Buddha and the Bodhisattvas are unusual, but the latter are certainly more difficult to explain than the former. The assumption of Tanabe and Kurata that the Bodhisattvas relate to a Late Heian style is reasonable, although I doubt that any comparative monument can be found as close in resemblance as the Seisuiji Jizō is to the Amida. In proportions the Bodhisattvas are similar to the Amida, being rather squat in comparison to most Heian figures, particularly in their long upper bodies and short legs. These proportions might be thought to relate the Kōfu figures to seventh-century standing Bodhisattvas,[19] except that the Kōfu images have broad shoulders and strongly modelled chests of a type not seen in the earlier period. The topknots and crowns of the

Bodhisattvas display a form frequently seen in Late Heian sculpture. In addition to the comparisons suggested by Kurata, reference should also be made to some of the Bodhisattvas in the Chūsonji Konjikidō.[20] The faces of the flanking figures are similar to Amida's face, and lack the gentleness usually associated with a Bodhisattva representation. In the same way, the modelling of the bodies of the Bodhisattvas is close to the Buddha, with even more of the chest area exposed.

We observe the most unusual characteristics in the various components of the drapery. Because of the difficulties involved in interpreting these components, detailed descriptions of their configurations are necessary.[21] The standard components of the drapery system of the Bodhisattva are the following:

1. Sash (jōhaku)
2. Scarf (tenne)
3. Skirt (mo).

The sash is a narrow strip of fabric that crosses the upper body of the Bodhisattva, usually moving from left shoulder obliquely across the chest, and then around the right hip and up the back to the left shoulder.[22] This arrangement is almost always seen in Bodhisattvas in Japanese sculpture from the Nara period onward.[23] In the Kōfu figures, however, the sash is treated in a peculiar manner, since instead of crossing the chest at an oblique angle, it falls almost vertically from the left shoulder and then passes horizontally around the body following the upper hem of the skirt. The sash is so understated that it can easily be missed on cursory inspection. Perhaps the designer of the Kōfu Bodhisattvas was concerned primarily with the modelling of the chest forms, and thus did not want the interruption of a sash. In fact, in the few Heian Bodhisattvas that totally lack the sash, the sculptor seems to have been concentrating on just such issues of modelling, and so I assume that the configuration of the Kōfu Bodhisattvas is a somewhat uneasy compromise between the sashed and sashless format.[24] As yet no Bodhisattvas with sash arrangements similar to the Kōfu figures have been documented.

Analysis of the scarf leads to equally puzzling problems. In the classic arrangement, formulated during the Hakuhō period, the scarf, which is a very long strip of fabric, passes over the shoulders, with the two ends hanging down the sides, looping across the legs and then moving up the opposite side of the body before finally passing over either arm and then descending to the ground.[25] Casual descriptions frequently refer to "scarves," in the plural, but detailed research reveals that the classic form of the scarf always consists of a single piece of fabric. At the back and over

the shoulders the scarf is much broader, assuming a configuration which might be called a "shawl." Here is where problems arise with the Kōfu Bodhisattvas, for careful inspection reveals that the shawl section of the scarf is apparently not connected with the sections that loop across the front of the legs. To a person familiar with Buddhist sculpture, this discontinuity might not be immediately evident since one might assume that there is a connection between the upper and lower sections of the scarf at either side. Such connections do not exist here and, in fact, in looking carefully at the right side one recognizes that the end of the scarf disappears under the sash![26] Moreover, the lower loop disappears under the upper loop in a totally inappropriate manner.

The configuration of the skirt is rather complex, and so a labelled diagram is useful in analyzing important elements (fig. 15e). In fully developed form, the skirt consists of three elements: the skirt proper; an apron-like element that folds over the belt and hangs down at the front, sides, and back; and the *koshinuno* (cloth wrapped around the hips).[27] These elements are all present in the Kōfu Bodhisattvas, although arranged in such a manner that confusion is apparent. The apron consists, at front, of a long narrow central section flanked by smaller pieces of fabric; it continues around the sides as a horizontal form with occasional undulations at the hem. The koshinuno is clearly visible at the two sides and the back as a large form with broadly looped folds, emerging from under the apron. At the front, however, the koshinuno is divided into two registers ("A" and "B"), by the upper loop of the scarf. Also, the koshinuno is articulated in a rather peculiar way, with interrupted folds both above and below.

The organization of the elements of the skirt, combined with the peculiar arrangement of the two loops of the scarf, suggests that the sculptor was copying something that he did not entirely comprehend. Otherwise, we have difficulty explaining how such idiosyncratic forms would emerge. If acceptable, this interpretation contributes to an understanding of why problems are encountered in searching for a prototype, since such a prototype would have to incorporate similarly eccentric elements.

Kurata has presented a detailed analysis of the casting technique used to produce the Kōfu Triad, so in the interests of space these results will be summarized only briefly here.[28] The central Amida, which is 147.2 cm tall, weighs 242 kilograms. It was cast in one pouring, including the tenons that attach the feet to the pedestal. (The right tenon is 20.5 cm long, the left 19 cm; this is in addition to the height of the statue just cited.) The hands were made separately, and then joined to the arms; some damage occurred during the casting to the section of the right hand

being attached, with the result that an additional piece had to be added. At various places on the statue, especially at the sides of the body, traces of the rods that held the molds together can be detected. The rods were removed and plugs inserted to fill the holes; since the entire image was then gilded, no unsightly scars would remain visible. Other features of the casting technique can be studied in the hollow interior of the image. As a result of his analysis of the various traits of the image, Kurata has concluded that the molds were made of clay rather than of wood. The bronze of this image is not very thick; at the base it is about 1.4 cm at the back and 1.8 cm at the front, between the legs. Also interesting is the fact that the bronze has a very high percentage of copper, approximately 94.5%; the Kamakura Great Buddha has only about 70% copper and more than 20% lead. Craftsmen report that bronze with such a high copper content is difficult to work but, of course, its utilization yields a statue of fine quality. Facial features and the hands of the Amida show the traces of finishing with a cold chisel. The *rahotsu* (snail-shell curls) and the drapery folds were produced in their basic forms by the mold and then polished after the image was removed from the mold.

The two Bodhisattvas are 95.5 and 95.1 cm tall; the right Bodhisattva weights 46 kilograms. They were cast in a technique similar to that of the Amida, except that the arms were made separately and then joined to the body. This method of joining the two arms at the shoulders is seen occasionally in twelfth-century bronze sculpture, and is also often used in wood images of the Kamakura period. Traces of the cold chisel can be seen in the locks of hair and in the facial features.

Inscriptional evidence of the Kōfu Zenkōji Triad is all found on the left Bodhisattva.[29] There are three inscriptions, each located in a different place. If the left arm is removed from the body, two characters can be seen at the back part of the area which joins the body and arm; these characters are *ren'a* (蓮阿), presumably a proper name. The other inscriptions are found on the tenons that join the feet of the image to the pedestal (fig. 15d). On the tenon under the right foot are the characters that give the date, *Kenkyū roku-nen* (建久六年) as well as the corresponding cyclical characters *kinoto-u* (乙卯). The left tenon has three characters: *gagosoku* (我伍足), which have not been interpreted. Kurata concluded that the calligraphic style of the inscriptions is appropriate for the early Kamakura period.

Particularly important in assessing the significance of the inscriptional evidence is the fact that it occurs on only one of the Bodhisattvas. While it would be foolish to reject the possibility that the inscriptions might be spurious, this is somewhat unlikely. If, for example, someone tried to give the triad an impressive pedigree at a late date, one might assume that the

name of the monk Jōson would have been included, since he was responsible for the original commission. Instead, the name of a totally unknown individual, Ren'a, is found. Furthermore, the enigmatic phrase "gagoso-ku" does not have the scent of the forger. Earlier scholars have suggested that additional inscriptions might have been incised on the original mandorla or pedestals, in which case a reference to Jōson and the auspices under which the triad was made would presumably have been present. According to this speculation, Ren'a might be thought to be another monk or perhaps an artisan. In any case, the occurrence of inscriptions on only one figure—and hidden from view—would seem to argue for their reliability rather than being suggestive of deception.

At the beginning of this discussion I made reference to the possibility of an association between the inscribed date 1195 and an account of the activities of a monk called Jōson described in *Zenkōji Engi*. The relevant section of *Zenkōji Engi* is titled, in the 1692 version, "Priest Jōson copies the form of the Zenkōji Buddha and has a new Buddha cast."[30] The story begins with a description of Jōson as a child prodigy, unique in his understanding of Buddhist teachings and practice. In due course he becomes a monk, devoting his energies to reading the *Lotus Sutra* and invoking the name of Amida. One day, in 1194, he has a vision that tells him that he must leave his home and go to Zenkōji in far-off Shinano. Jōson immediately sets out on a pilgrimage to Zenkōji and, upon arriving, sequesters himself in the Main Hall in front of the shrine of the Living Buddha, the Zenkōji Amida Triad. The icon is, of course, a secret image, but on the evening of Kenkyū fifth year (1194), tenth month, fifteenth day, the doors of the shrine magically open, the inner curtains rise, and Jōson is granted a vision of the triad. At this time the Amida gives an oracle, ordering Jōson to make copies of his holy form so that all people can worship him. A similar oracle, with greater detail, is delivered on the sixth day of the eleventh month of the same year.

Although Jōson has received oracles ordering him to make copies of the triad, he is still uncertain about the exact appearance of the icon. Consequently, in the fourth month of 1195 he requests the opportunity to see the icon again so that he can make a sketch, and various priests of Zenkōji also receive oracles urging that Jōson's wish be granted. Subsequently, on Kenkyū sixth year (1195), fourth month, twenty-eighth day, Jōson is allowed to see the icon again, and is able to make a sketch of it. Funds have already been gathered to make a life-sized copy of the triad, and on the fifteenth day of the fifth month of 1195 the Amida is cast; and by the twenty-eighth day of the sixth month the two attendant Bodhisattvas, Kannon and Seishi, are completed.

Stripped of miraculous embellishments, this is apparently an account

of the making of the first copy of the main icon of Shinano Zenkōji. The central role played by oracles clearly relates to the popular religion component of Zenkōji belief as demonstrated by Gorai.[31] There is no reason to doubt the basic historical accuracy of the story, for it takes place just when patronage by Minamoto Yoritomo and the Kamakura bakufu had peaked. As discussed earlier, reconstruction of the temple took place between 1187 and 1191. Moreover, Yoritomo announced his intention to make a pilgrimage to Zenkōji in the eighth month of Kenkyū sixth year (1195). What more appropriate time for the casting of an impressive, life-sized gilt-bronze copy of the Living Buddha? Indeed, the very expense of such an effort implies official support, although such support is not documented. The dates of the casting of the three images, in the fifth and sixth months of that year, so closely precede Yoritomo's announcement of his plan to undertake a pilgrimage that a connection seems inevitable. I would suggest that, equipped with the reconstruction of the temple's buildings and with the casting of a splendid copy of the Living Buddha, Zenkōji would have been thought ready to receive the most important political figure in the land, Minamoto Yoritomo.[32]

The Amida Figures in Zensuiji and a Private Collection

Surprisingly, two of the very few early Kamakura examples of the Zenkōji icon, date from 1206. The first is kept at Zensuiji, an important temple in Shiga Prefecture (fig. 18); the second has been in various private collections: at one time in the Noda Collection in Kōbe, and now apparently in a collection in Tokyo (fig. 19).[33] Not only is it strange to find two icons occurring in one year at the initial stage of the cult, but a specific iconographical detail seen in the images is also highly puzzling. Since the Zensuiji Amida has been carefully studied, I will consider it first and then discuss the other image.

Zensuiji, a leading temple of the Tendai school, is located in a hilly area to the south of Lake Biwa. The significance of Zensuiji is clear both from historical sources and extant remains, including a Nara period representation of the Tanjō-butsu (new-born Buddha) and an important Yakushi image dated 992.[34] In this milieu, the Zenkōji Amida of 1206 does not loom especially large, for there is no specific evidence to indicate that Zensuiji itself was a center of Zenkōji cult practices. Moreover, the image is not installed in a hall of its own, further suggesting peripheral connection to the religious life of the temple. Surely the most likely explanation for its presence at Zensuiji is as a pious donation to the temple, perhaps at the time the image's original home was destroyed. As a highly prestigious

temple, Zensuiji is a logical place for such an offering; one can probably assume that the image in question came from the general neighborhood of Zensuiji.

The Zensuiji Amida has a total height of 36.9 cm, including the lotus pedestal; the figure alone is 32.4 cm tall. These dimensions are substantially smaller than the canonical height of one shaku five sun (approx. 45 cm) seen in both the textual descriptions and in many of the later copies. The image has been through at least one fire, with the result that the surface has darkened as well as having become rough in places; naturally any gilding that may have been applied was lost. Presumably the original hands were also destroyed in the fire, for the present hands are later repairs. Even without such damage, this Amida is not an especially fine example of the bronze-caster's art: in details such as the drapery folds, a lack of the elegance seen in bronze sculpture produced both earlier and later can be observed; the pedestal is also rather ungainly in execution. These details are probably symptomatic of provincial manufacture, a topic to be addressed later.

The figure has normal proportions, with a well-rounded head and a substantial body; the heavy robes obscure specific bodily features, but the canonical folds of flesh on the neck are clearly visible. While the upper part of the chest is exposed, there is little sense of modelling in this area. The feet are crudely articulated, although there may be some fire damage evident here. The arrangement of the outer robe conforms to one of the major categories, referred to as the *tsūken* mode, wherein the upper hem of the outer robe passes across the chest with the end tossed back over the left shoulder. Above this hem can be seen the upper part of an undergarment called the *sōgishi*, but the Zensuiji Amida lacks the henzan element present in the Kōfu Zenkōji Amida.

Caution should be exercised in assessing the face, because of surface damage, but the features appear somewhat roughly articulated. In its present form, the face has a rather sweet, gentle expression. It is not the face, however, that is so fascinating, but rather the arrangement of the hair. What we see here, in contrast to the normal *rahotsu* (snail-shell curls) of the Zenkōji-tradition Amida, are the two spiral loops, one above the other, characteristic of the Seiryōji-style Shaka (fig. 20).[35] Another image from the Kamakura period with Seiryōji-type hair arrangement is the Tanjō-butsu at the Daihōonji in Kyoto.[36] Although a very unusual hair arrangement for a Tanjō-butsu, this is not illogical since the newborn Buddha is, of course, a representation of Shaka, the historical Buddha. There is certainly no iconographical justification for the presence of this element on a Zenkōji Amida, and probably there was either a confusion between the Seiryōji and Zenkōji types, or perhaps even a naive

effort to combine powerful elements of the two important traditions. Of course, the Zensuiji image could not be a Seiryōji Shaka, because the arrangement of the drapery folds across the legs does not conform to the Udayana tradition. Perhaps the designer of the Zensuiji image drew on one significant feature of the Seiryōji format, but not on others. This experiment, or perhaps mistake, seems not to have been repeated in later copies; it may be taken here as a symbol combining the two great icon traditions of Kamakura sculpture.

Before beginning a discussion of the inscription on the Zensuiji Amida, let us look quickly at the second image dated 1206 (fig. 19). This figure is 31.5 cm tall, including the pedestal, somewhat smaller than the Zensuiji Amida. In basic elements the two figures are closely related: both have Seiryōji Shaka-type hair arrangements, the faces are generally similar, and the detailing of the canonical folds on the neck is related. While the overall configuration of the robes is the same, closer inspection reveals numerous small differences in the way in which the folds are designed. Most striking is the treatment of the under-robe as seen draped over the lower part of the legs, for this section is significantly smaller in the Private Collection Amida. Moreover, the pedestals of the two images are rather different. Although the sculptors apparently paid close attention to key traits, their attention may have wavered somewhat when they were working on the lower sections. Because the Zensuiji image is associated with a very important temple, there is a natural tendency to assume that it closely resembles the prime object, and that the Private Collection Amida is a more distant replication.[37] This is certainly possible, but other scenarios can be imagined. The safest hypothesis may be to assume that there was a single model on which both examples were based. Of course, in the lost-wax technique of bronze casting, separate molds are always used. Thus the sculptor or sculptors probably employed a single model as a basis for producing subsequent copies, with slight variations almost inevitably introduced into the final forms.

The inscription on the back of the Zensuiji image is important for several reasons.[38] First—and of most obvious significance—without the reference to the image as a "Zenkōji Amida" identification would be impossible, because the repaired hands lack the normal Zenkōji mudra and the hair, as discussed above, is arranged in an idiosyncratic manner. Aside from its importance for iconographical identification, the inscription relates that the image was cast by a craftsman called Man Amitafu on Genkyū third year, tenth month, third day. The donor's name is given as Shōnin Zenkin, the first two characters in the name presumably being an indication of priestly status. Mōri Hisashi, in his analysis of the inscription, indicates that the official era designation was changed from Genkyū

to Ken'ei on the twenty-seventh day of the fourth month of Genkyū third year (1206), which shows that a "Genkyū third year, *tenth month*, third day" date is incorrect. Mōri assumes that the image was made in a provincial location, where the old era name continued to be employed, even after a change had occurred in the capital.

The Private Collection figure also bears an inscription on its back that gives precisely the same date as the Zensuiji figure, but lacks the first line of the Zensuiji inscription that provides for its identification as a Zenkōji Amida. Without this information, one could not correctly identify the Zensuiji figure. How, then, should the Private Collection figure be treated? Other than the close formal resemblances of the two images, the Private Collection piece also retains its original left hand, which forms the characteristic mudra of the Zenkōji Amida. Thus the assumption that the two were cast on the same day in the same workshop, both as Zenkōji icons, is reasonable. The name of the craftsman who made the Private Collection image is different from that of the Zensuiji Amida; Mōri has suggested that both names may refer to the same individual, one name being a religious, the other a secular, designation.[39] The last section of the inscription, giving the donor's name, is indistinct in the Private Collection image, so it is not certain whose identity is recorded. Mōri has argued that this part of the inscription may perhaps refer to the same Zenkin as seen in the Zensuiji Amida.

There is always the possibility, of course, that one or both of the images are spurious. In that case, suspicion would most likely fall on the piece in the Private Collection because of its uncertain provenance. This suspicion is mitigated by the very modest quality of both figures, for one has difficulty imagining a forger producing a fake of such limited appeal. Since literary references exist to the making at one time of multiple versions of the Zenkōji icon, I would suggest that these two figures are all that remain of one such set. Although the lack of provenance for the Private Collection image is troublesome, the fact that for a long time it was in a Kōbe collection suggests that its origin is more likely to have been in the Kansai region rather than in Kantō or Tōhoku.

The discussion of the major corpus of Zenkōji icons that begins in the next chapter will include frequent cases of incomplete triads, often consisting of only the central Amida, or the Amida and a single Bodhisattva, or even simply one or two Bodhisattvas without a Buddha. In such cases, we can assume that the set has been broken through fire or loss. Should it then be posited that the two 1206 Buddhas are all that remain of a pair of triads? While conceivable, another possibility worthy of consideration is that they were originally made as single figures. It has been stressed that their idiosyncratic Seiryōji Shaka-style hair arrangements render the two

icons so peculiar as to make even their identification as Zenkōji Amidas somewhat problematic. Possibly they were cast at a very early stage in the production of copies, at a time when a full and general awareness of the pertinent iconographical requirements was not yet current. Perhaps an energetic hijiri who was spreading the cult of the Zenkōji Amida did not have precise knowledge of the iconography, and the craftsman who cast the figures may have introduced the Seiryōji element thinking it was appropriate. Presumably such variations, or "mistakes," would not have been possible at a later stage in the development, when there was fuller information available, especially in the form of mass-produced prints purporting to represent the secret image.

Shimane Zenkōji Amida Triad

No Zenkōji Amida Triad is of greater interest than that housed at Zenkōji in Matsue City, Shimane Prefecture (fig. 21a–d).[40] This icon is unusual in format, and may be linked to the activities of one of the early Kamakura monks associated with the propagation of the Zenkōji cult. Before considering the historical circumstances, let us look carefully at the format, figural style, and iconography.

The central image of Amida, standing in front of a tall, narrow mandorla, is 53 cm tall, somewhat greater than the canonical height. At first glance, one might assume that this is a single Amida with mandorla, but closer inspection reveals that the flanking Bodhisattvas are engraved onto either side of the mandorla to complete the triad. This is a unique configuration among Zenkōji triads, causing scholars to wonder why it was employed. While a conclusive explanation cannot yet be formulated, perhaps this format relates to that discussed earlier in the analysis of Korean triads of the Three Kingdoms period (figs. 5–8). These triads usually consisted of the two Bodhisattvas cast with the mandorla, the central Buddha made separately and then attached to the mandorla.[41] Contrasting with the canonical 3:2 ratio of heights of the Zenkōji tradition, most of the Korean triads show a 2:1 ratio in the heights of Buddha and flanking Bodhisattvas, which corresponds quite closely to the ratio seen in the Shimane Zenkōji Triad. Might not the Shimane Zenkōji Amida Triad be a distant reflection of that Korean format? If so, possibly the secret image at the Shinano Zenkōji was, in actuality, a Korean Three Kingdoms Triad of the type discussed earlier. Of course one can also argue that whatever image was the prototype for the Shimane triad had traits associated with Three Kingdoms sculpture. This hypothesis places a tremendous weight on what may be accidental details of the Shimane image, and thus I would not propose to base any other arguments on it.

However, there is really no danger of this happening, for the Shimane Zenkōji Amida Triad is unique within the corpus of Zenkōji triads, an icon that apparently had no direct progeny.

The tall Buddha has rather slender proportions, and much of the chest is exposed, with fully articulated breasts. Given the normal location of the abdomen in relationship to the chest, it must be assumed that the figure is very long-legged. Seen from the sides, the figure displays a reasonable degree of modelling, creating a sense of a solid, tangible body. The small snail-shell curls are precisely carved, the ushnisha prominent, and a similar degree of sharp, precise carving delineates the facial features. Both the eyes and the mouth are wide, and the upper eyelids and the upper lip have exceedingly complex contours. The hands seem to be later repairs, while the feet are done in a schematic, lumpy manner.

The drapery system of the Amida conforms in general terms to that observed in the Kōfu Amida (fig. 15): the henzan is present, and the sōgishi can be observed at the chest. Unlike the Kōfu image, the drapery of the present figure sweeps across the front of the body in much broader, fuller folds, and there is even a suggestion of something like *honpa shiki* (rolling-wave style) in the folds over the legs. The outer robe falls to just above the ankles, with the under-robe appearing here and hanging down to the base. The lower hems of both garments are exceedingly ungainly, as if the sculptor somehow lost interest in his work in this area. This is rather surprising, for the drapery at the sides of the image, falling from the arms, is full of lively detail. Seen from the back, the image is not especially pleasing, for the overall configuration is awkward and the folds somewhat lumpy. Compared to Japanese Buddhist sculpture in general, this image displays a strange combination of well-executed passages and others that are weak and uninspired.

The tall, narrow mandorla is exceedingly unusual, worthy of detailed consideration. The halo for the head and the band that surrounds the body of the Buddha are both elaborately decorated with lotus ornamentation. Intertwining lotus stems extend out from the halo to form the lotus pedestals for the seven subsidiary Buddhas that decorate the upper third of the mandorla. These Buddhas are all shown with their hands placed in front of the body, covered with drapery. Elegantly incised flame patterns decorate the outer margins of the mandorla. The two attendant Bodhisattvas occupy the lower part of the mandorla, and although less than half as tall as the Buddha, they have rather slender, elongated proportions that correspond well to the central figure. Kannon stands to the left of Amida, Seishi to the right; both Bodhisattvas have their emblems clearly depicted in their crowns.

The modelling of the bodies of the Bodhisattvas is difficult to analyze because of the relief format. The arms and hands can be seen clearly, and in both cases the right hand is placed flat on top of the left, with no indication given that the two hands grasp a jewel; the hands are held rather high in front of the chest. Despite the Bodhisattvas' general appearance of slenderness, their legs seem rather short in comparison to the upper body. Kannon's face is slightly blurred as a result of damage, but that of Seishi can be made out quite clearly: it is round and plump, the features are precisely depicted, and the overall expression is rather stern for a Bodhisattva. The three standard elements of the drapery—scarf, sash, and skirt—all appear in fully developed form. A feature is present that is not normally found on Zenkōji Bodhisattvas: the tie-end of the belt hanging down between the legs with a bow clearly visible just below the lower loop of the scarf. Another unusual feature of these Bodhisattvas is the inclusion of considerable jewelry, especially the heavy necklaces that adorn the chest. Each figure has a halo, and stands on a lotus pedestal. At the base of the mandorla proper is a zone of upturned lotus petals that support the mandorla. (The pedestal on which the Amida stands appears to be of a later date than the rest of the monument.)

On the basis of the figural style of the Buddha, especially when it is compared to that of the Amida of the Kōfu Triad, most authorities have concluded that the Shimane icon was made early in the Kamakura period, perhaps around 1200 or a little later. As we will see in the consideration of the main corpus of Zenkōji triads—those images that fall between about 1250 and 1330—the unusual characteristics observed in the Shimane Zenkōji Triad do not appear, since the basic format was by then standardized. Thus, the peculiar features of the present icon would seem more plausible at the onset of the making of copies, i.e., toward the beginning of the Kamakura period, rather than at a later stage.

Zenkōji-tradition icons are not common along the Japan Sea coast, for reasons suggested in the previous chapter when the relationship between the spread of the Zenkōji cult and the major road systems was discussed (map 2). There is only one example in Tottori Prefecture and two, including the present image, in Shimane Prefecture. Farther south, one example, said to date to the Kamakura period, is located at Gokurakuji in Nagato City, Yamaguchi Prefecture.[42] This scanty representation of Zenkōji images within a large region calls for an explanation of the presence here of such an early example as that of Shimane Zenkōji. The following discussion offers a tentative hypothesis concerning the historical significance of the icon.

Gorai, in his research on the Zenkōji-hijiri, studied the career of an

important early Kamakura warrior mentioned in the previous chapter named Sasaki Takatsuna (?–1214), who became a monk at Mt. Kōya with the Buddhist name Ryōchi.[43] A document written by a nephew of Sasaki Takasuna, Sasaki Nobutsuna (1180–1242), states that his late uncle donated property to the monk Myōhen, leader of one of the three main groups of hijiri at Mt. Kōya. Myōhen led a group of hijiri based in the Renge Valley of Mt. Kōya, and the donation allowed Myōhen to build a temple as headquarters for his group. Gorai believes that this indicates that Ryōchi (Sasaki Takatsuna) was affiliated with the Rengedani-hijiri, which is reasonable since many samurai apparently joined this group.

There are conflicting sources on the religious activities of Ryōchi. The *Matsumoto Shōgyōji Engi* says that Ryōchi was a student of Shinran, and that he was ordered by his teacher to stay in Shinano Province to spread nenbutsu belief. As part of this campaign Ryōchi is said to have founded Shōgyōji. As Gorai notes, there are various troubling aspects to this story, including the fact that Ryōchi was considerably older than Shinran. Gorai tries to resolve the contradiction by assuming that Ryōchi was both a Kōya-hijiri and a Zenkōji-hijiri, and that Shōgyōji was used as a way station by hijiri travelling between Mt. Kōya and Shinano Zenkōji. A more plausible account of Ryōchi's activities is found in *Unshū Sasaki Yurai Yūji*, which says that Ryōchi became a monk, studied at Mt. Kōya, travelled around the country as a pilgrim, and finally settled down and died at Tomita in Izumo Province. His descendants became the Nogi clan of Izumo. A temple called Kōmyōji was supposed to have been Ryōchi's base; it subsequently was moved to Nogi-mura in the southern part of Matsue. This temple, now called Nogi Shin Zenkōji or Izumo Zenkōji, contains the icon discussed in this section. Can a plausible connection be made between the present icon and the activities of Ryōchi? Most of the datings to the early Kamakura period for the Shimane Triad apparently have been made without reference to the career of Ryōchi. This, of course, is encouraging, as one can easily decide on a specific date for a monument when that date corresponds to a particular historical event. Certainly the history of Japanese sculpture is filled with often far-fetched associations between extant monuments and specific historical circumstances. If this is not the case here, perhaps there is a connection between an individual who died in 1214 and an icon that was probably made in the early thirteenth century. Since the evidence seems to indicate that Ryōchi was associated in some way with the Zenkōji cult, I assume that the icon may have been made in some central studio, perhaps at Mt. Kōya, and was then carried around by Ryōchi during his pilgrimages, finally to be installed in his temple in Izumo Province (now Shimane Prefecture).

Summary

The monuments discussed in this chapter are extraordinarily diverse in their stylistic and iconographical characteristics. The full implications of this diversity will not be apparent until the large number of images produced between 1250 and 1330 is analyzed in the next chapter, for then we will see that a relatively consistent format characterizes the vast majority of icons. Certainly diversity is apparent in these monuments, but nothing approaching that observed amongst the Kōfu Zenkōji Amida Triad, the Zensuiji/Private Collection Amida figures, and the Shimane Zenkōji Amida Triad. A second extremely surprising trait is their geographical distribution. While the Kōfu Triad can be related to the very center of the cult, the Zensuiji Amida is in Shiga Prefecture and the Shimane Triad is in a distant location, along the Japan Sea coast, far from Shinano Province. This is not a distribution pattern that one would predict. A final peculiar feature of these icons is their clustering at the beginning of the Kamakura period, followed by a gap of several decades from which no icons remain. Some attempt at explication is necessary for all of these unusual traits.

The pattern of geographical distribution is the hardest to understand, and perhaps this is explained simply in terms of chance preservation. This explanation would suggest that numerous other copies were made during the early decades of the Kamakura period, but are now lost. Some would have been clustered in the Kantō region, and if these were now extant their location would conform more to normal expectations, given the spread of Zenkōji belief. Admittedly, a good explanation for the distribution of the Zensuiji/Private Collection and Shimane icons has not yet been proposed.

In studying the Kōfu Triad, the Zensuiji/Private Collection Amida figures, and the Shimane Triad, various unusual details are observed. Some of the more important details include the size and figure style of the Kōfu group, the Seiryōji Shaka-type hair arrangement of the Zensuiji/Private Collection Amida figures, and both the figure style and format of the Shimane image. When these traits are referred to as "unusual" there must, of course, be a standard against which they are being judged. For the Zenkōji tradition this standard is based on the large number of later Kamakura images that have relatively consistent characteristics. There are obvious difficulties, however, in projecting a later formulation backward to works made at the beginning of the tradition, then suggesting that these early works are "unusual" or even unorthodox. Some analysis of this issue is required.

The problem of the early copies' characteristics is related to assess-

ment of the status of the prototype, the Living Buddha, which is purported to be the secret main icon of Zenkōji. A hypothesis that accounts very well for the degree of diversity noted in the icons considered in this chapter might maintain that no prototype was extant at the beginning of the Kamakura period. Such being the case, the sculptors would have been forced to innovate, introducing various elements as appropriate. An approach of this type accounts rather well for the idiosyncratic Seiryōji Shaka hair arrangement of the Zensuiji/Private Collection Amida figures. A second hypothesis, which avoids heresy but has essentially the same end result, postulates that while a prototype was extant at Zenkōji at the beginning of the Kamakura period, it was considered so sacred that those responsible for making copies were not given an adequate opportunity to study it. According to this assumption, only a very general understanding of the nature of the prototype would have been possible, perhaps including only specific details, such as the mudras of the flanking Bodhisattvas. Finally, there is a possibility that the concept of a "copy" was not all that precisely defined at this early stage in the development of the Zenkōji cult. Perhaps a quite limited degree of resemblance would have been deemed sufficient.

No definitive theory about the prototype can be proposed on the basis of currently available evidence. As indicated in a previous chapter, an early icon, perhaps from the Korean Peninsula, may have existed at Zenkōji at the time of the initial formulation of the cult during the Heian period. Without such an icon, a flourishing cult is unlikely to have developed. Whether this icon survived the fire of 1179 is another question. Moreover, even if it were destroyed, there is a possibility that it was replaced by another small-scale icon in an archaic style. Nevertheless, there must have been a triad that formed the basis for the long sequence of later Kamakura copies. Whether this icon can be associated with those considered in this chapter is uncertain.

Another possibility is that the Kōfu Zenkōji Amida Triad is the prime object on which all the replications are based. While this seems unlikely, for reasons to be discussed in the next chapter, there are enough similarities between it and the Shimane Zenkōji icon to suggest a relationship. A glance at the two images makes apparent that the Shimane Amida is taller and less bulky than the Kōfu image, thus signifying different conceptions of figure style. Nevertheless, there are substantial relationships in the use of motif. In both statues the robe opens wide at the chest, revealing strongly modelled forms; the presence of the henzan may be significant. Both have broadly looped folds passing across the belly and legs, although those of the Shimane Amida are less tightly bunched and detailed than those of the Kōfu Amida. Seen from the rear, the two

figures have such strikingly similar arrangements of folds as to make it most likely they share a common prototype (fig. 15c and 21d). The two images differ from the standard Zenkōji-tradition Amida in the very respects that they resemble one another. Although a comparison of the flanking Bodhisattvas of the two triads is more difficult, one observes that neither has the standard type of crown seen in later copies. Because of the great prestige of the life-sized bronze triad, perhaps an image such as the Shimane Triad could have been based on it, at least in part.

A final problem that must be addressed is the strange clustering of icons at the beginning of the Kamakura period, followed by a paucity of extant monuments during the first half of the thirteenth century. One explanatory strategy that I used earlier, in discussing the geographical distribution, accounts for this in terms of statistical accident. This strategy, however, is not very satisfying, and an alternative should perhaps be attempted. The discussion of the Kōfu Zenkōji Amida Triad has presented evidence suggesting that it may have been made as part of a campaign of official bakufu support during the period of Yoritomo. Perhaps this approach can be extended to include the other early images, arguing that they are related to an initial spurt of patronage, followed by a period of relatively limited support for the cult. Concomitant with this, I will propose in the next chapter that the intense activity in the production of Zenkōji icons from mid-thirteenth century onward reflects to a very considerable extent a quite different level of patronage from that which was significant at the beginning of the Kamakura period.

An exceedingly interesting group of icons has been examined in this chapter. Each is worthy of detailed analysis in terms of its specific stylistic and iconographical characteristics, and some can also be placed in plausible historical contexts. Nevertheless, these are not the images that constitute the mainstream of the Zenkōji tradition. Or, stated more precisely, they cannot be associated very well with the type of popular cult which accounts for the numerous icons dating after about 1250. Before considering these images, however, a brief survey of the development of gilt-bronze sculpture in Japan will help in understanding the Zenkōji tradition.

Gilt-bronze Sculpture in Japan

The material used for the vast majority of Zenkōji icons—gilt-bronze—is of great significance in the history of Japanese Buddhist sculpture, although the most flourishing period for the making of gilt-bronze images was during the seventh century, long before the production of the Zenkōji icons considered in this study.

Quite possibly, the earliest Buddhist icon to come from Korea to Japan in the sixth century was made of gilt-bronze.[44] In the course of the Asuka period a large proportion of the images were made of this material, a tendency that continued and expanded during the following Hakuhō period, with the result that one of the glories of Japanese Buddhist sculpture is the very extensive corpus of small-scale images, apparently designed for private devotion, dating ca. 650–710.[45] For a variety of reasons, sculptural icons produced during the Nara period (710–794) utilized a wide range of materials, including wood, clay, dry lacquer, and metals such as gilt-bronze and, more rarely, gold and silver. Owing to changes in religious practice, less emphasis was placed on small gilt-bronze icons, with the focus shifting to larger images more appropriate for installation in temples. Of course, gilt-bronze imagery continued to be produced, including some small and medium-scale images, although the Nara period is most notable for a tendency toward grandiosity, culminating in the enormous Great Buddha at Tōdaiji dedicated in 752. Following this extravagant commission there seems to have been a dramatic decrease in the utilization of gilt-bronze for sculpture.[46]

The Heian period witnessed the development of what is probably the most characteristic feature of Japanese Buddhist sculpture, the extraordinary concentration on wood as the primary material. The multiplicity of materials typical of the Nara period quickly faded, with sculptors now devoting their energies to the exploration of the potentialities of wood. There is no need to outline this development here, although we should keep in mind that the corpus of wood sculpture produced from the ninth through the twelfth centuries is arguably Japan's most significant contribution to the history of Buddhist art. During these centuries, the tradition of bronze casting seems never to have died out completely, since a small number of gilt-bronze images of Heian date are extant. These images are rather unimpressive in comparison to either the Hakuhō gilt-bronze imagery or the contemporaneous Heian wood sculpture, but they are important in that they represent a degree of continuity with the "golden age" of small-scale gilt-bronze icons.[47]

Gilt-bronze sculpture experienced somewhat of a revival during the Kamakura period.[48] The Kōfu Triad of 1195 and the two single Amida figures of 1206 just considered are the earliest dated Kamakura gilt-bronze images. Dating from a little later in the thirteenth century are a small Shinto deity (1230) in Toyama Prefecture and the famous life-sized, seated Amida (1232) made by Kōshō in the Hōryūji Golden Hall.[49] The latter image is extremely interesting for our purposes, as it shows the self-conscious utilization of an archaic style so that the new Amida will complement stylistically the two older gilt-bronze icons on the main

altar of the Golden Hall, the Shaka Triad and the Yakushi, both of which date to the seventh century. Toward the middle of the century is a standing Yakushi image (1248) kept at the Ryūzen District, Obama City, Fukui Prefecture.[50] This image is a small-scale figure (50.9 cm), gracefully designed and well executed, with an inscription incised on its back that tells where it was made and its date of dedication.

As will be discussed at the beginning of the next chapter, the long series of later Kamakura Zenkōji icons is inaugurated with the Kōtokuji Amida Triad dated 1249. Consequently, the 1248 Yakushi just cited assumes considerably significance in that it was cast just the year before the Kōtokuji Triad, allowing us to place the Zenkōji image within a broader framework. From this situation, we can see that small-scale gilt-bronze imagery of the Kamakura period was not restricted to Zenkōji images, even though the majority of the extant pieces comes from the tradition. Moreover, the technical and stylistic relationship between the 1248 Yakushi and the Zenkōji images of the following years is extremely helpful in delineating the basic structure of studio practice at mid-century.

Interestingly, the middle of the thirteenth century is marked by another monumental gilt-bronze icon—the Kamakura Great Buddha— which dates almost exactly five hundred years after the Tōdaiji Great Buddha.[51] Of course, the Kamakura Great Buddha, a representation of Amida rather than Rushana, was commissioned, at least in part, either to compete with or emulate its magnificent eighth-century prototype. This degree of historical self-consciousness, which can also be seen in the Hōryūji Golden Hall Amida of 1232, is a key aspect of the Kamakura worldview, and certainly must be kept in mind when striving to determine the meanings and significance of icons in the Zenkōji tradition.

There are quite a few small-scale, gilt-bronze images from lineages other than that of the Zenkōji tradition dating between ca. 1250 and ca. 1330, including representations of a wide variety of Buddhas and Bodhisattvas, as well as Fudō-myōō, Zaō Gongen, Shinto deities, etc.[52] This body of material demonstrates quite clearly that gilt-bronze sculpture was important during the later part of the Kamakura period. While some of these icons, like those of the Zenkōji tradition, are archaistic in character, others do not seem directly based on ancient prototypes. Therefore, although the Kamakura revival of gilt-bronze sculpture cannot be understood exclusively in terms of archaism, certainly archaism is one significant component, and one especially relevant to this study.

The four Zenkōji-related monuments considered in this chapter are too diverse and isolated to allow convincing art historical generalization as to stylistic lineages and developments. In the next chapter, however, where we shall analyze a more homogeneous group, an effort must be

made to understand some of the stylistic options open to the sculptors who produced Zenkōji icons. In a few instances, I will attempt to isolate specific stylistic lineages, although in no case is it yet possible to indicate the location of the studios where such images might have been produced. Finally, it seems particularly relevant to keep in mind the revival of gilt-bronze sculpture during the Kamakura period as an essential context for the Zenkōji tradition, since the awareness of earlier traditions seen in that revival is of fundamental importance in understanding this phenomenon and its evolution.

CHAPTER 6 Later Kamakura
Copies of the
Zenkōji Amida Triad

IN THE PRECEDING chapter, a small group of
Zenkōji icons produced at the beginning of the Kamakura period was
analyzed. That discussion was motivated both by the intrinsic interest of
the monuments and by a wish to clarify the salient characteristics of the
Zenkōji-type Amida triads as represented at the onset of the production
of copies. We saw that the early Zenkōji icons are very diverse in form,
which makes identification of a "standard" type difficult. Another com-
plicating factor is the temporal isolation of the early Kamakura monu-
ments, because there are no extant images falling between 1206 and
1249. In contrast, numerous monuments date to the second half of the
thirteenth century, and other images can be ascribed to this period; these
provide the most information concerning the development of the main
Zenkōji icon tradition.

Some of the later images are fine pieces of sculpture, but many are
rather undistinguished from an aesthetic point of view, and there is little
point in providing a monument-by-monument analysis of the entire
series. Therefore, I will emphasize and analyze in detail those examples
that are especially interesting from a stylistic, iconographical, or histori-
cal perspective. Attention must also be directed, however, to less distin-
guished examples, for these, in a very important sense, represent
the broader nature of the Zenkōji cult. If only the "best" examples were
examined, this study would simply continue the paradigm of elitist schol-
arship from which it is attempting to escape.

Before addressing Zenkōji icon production from the middle of the
thirteenth century onward, a brief discussion of the various documentary
references to the making of icons during the first half of the century is in
order. In Chapter 4 a detailed account of bakufu patronage of Zenkōji
was provided, but no specific mention was made of actual commissions.
Certainly bakufu support would at times have involved the production of
icons, particularly in cases such as the establishment of the Shin Zenkōji
in Kamakura. Current documentation on the use and making of Zenkōji
icons, however, derives from sources unrelated to official government
patronage.

An important example is an entry in *Zenkōji Engi* that describes the making of a copy of the triad by the priest Jōren in 1221.[1] This account, which resembles the story about Jōson considered in some detail in the discussion of the Kōfu Zenkōji Triad, relates to the same type of religious process. If the miraculous aspects are removed, Jōren's story surely may be interpreted as a description of his activities in furthering the cult of the Zenkōji Amida Triad.

Efforts have been made by Gorai and others to associate Shinran directly with the Zenkōji cult.[2] As noted earlier, Shinran, at the time of his pardon, did not return to Kyoto but travelled to the Kantō region, where he remained for over twenty years. Scholars have suggested that on his trip from Echigo (now Niigata Prefecture) to the Kantō, Shinran stopped at Zenkōji in Nagano. This is still believed at Zenkōji, although there is no specific documentary evidence. There are, however, sources indicating that Shinran worshiped a Zenkōji Triad as his personal icon in the mid-1220s. The full implications of Shinran's possible connection with the Zenkōji cult cannot be examined here, although this particular account provides important evidence for the existence of Zenkōji icons in the Kantō region in the mid-1220s.[3]

A third account of production of a Zenkōji icon is documented in a very different source. Fujiwara Teika (1162–1241), one of the most important Japanese poets, kept a diary, called *Meigetsuki*, for over fifty years, from 1180 until 1235. These years are the crucial early decades of the Kamakura bakufu, although of course Teika wrote from the perspective of a Kyoto aristocrat. In the last year of his diary, 1235, Teika relates that a Zenkōji Triad has been made, which everybody in Kyoto is clamoring to worship. This citation indicates that the Zenkōji cult had spread to the old capital, although Teika's wording suggests there was only a single icon that people were "clamoring to worship," and not a Shin Zenkōji network of the type that developed throughout Japan at a somewhat later date.[4]

These early accounts of Zenkōji icon use and production are important because they provide a sense of the texture of Zenkōji belief in the 1220s and 1230s. The story of Jōren is perhaps best understood in the context of the internal development of the Shinano Zenkōji; the two other accounts are significant in that they show the diffusion of Zenkōji belief into the Kantō and Kansai regions. Shinran's worship of a Zenkōji icon may have broader implications, but at the very least it is important as evidence for the cult in the northern Kantō region. Similarly, the citation in *Meigetsuki* substantiates that, by Teika's day, worship of a Zenkōji Triad in Kyoto was important enough to merit inclusion in his diary. Unfortunately, no icons survive from these decades but this is perhaps not

surprising, for the period of extended Zenkōji icon production was yet to come.

The Seiryōji Parallel

There are a number of significant parallels in the patterns of icon production observed in the Seiryōji Shaka and the Zenkōji Amida Triad traditions, and these are helpful in understanding the development of the Zenkōji cult.[5] As I have noted earlier, the Seiryōji Shaka tradition constitutes another significant case in Japanese sculpture of the intensive copying of a holy icon. Of course, at Seiryōji the prime object, a figure of Shaka made in China in 985 (fig. 20), is available for inspection, which frees the investigator from the host of problems that plague the student of the Zenkōji icon.[6]

While there may be one example of a Late Heian copy of the Seiryōji Shaka,[7] this is uncertain and, in any case, not until the beginning of the Kamakura period are there unambiguous examples of Seiryōji copies. Curiously, the situation is remarkably similar at this early stage to that of the Zenkōji icon. The earliest dated Kamakura-period Seiryōji Shaka, now housed at Daienji in Tokyo, is that of ca. 1193;[8] this predates the Kōfu Zenkōji Amida Triad by only two years. From a slightly later period is the Byōdōji Shaka of 1213.[9] No other dated copies of the Seiryōji Shaka are extant before the middle of the thirteenth century. This is exactly the same situation observed in the case of the Zenkōji icon: a few icons that date from the early decades of the Kamakura period, and then a gap until about 1250. Although this coincidence may reflect an accident of preservation, such an interpretation is unlikely, and another line of reasoning is perhaps more appropriate to account for the significant expansion of the two cults from about the middle of the thirteenth century onward.

Surprisingly, each of the long sequences of dated examples in both traditions is inaugurated by a monument completed in 1249: for the Seiryōji tradition, a Shaka at Nara's Saidaiji;[10] for the Zenkōji tradition, the Amida Triad at Kōtokuji in Gunma Prefecture, to be discussed presently. Although this exact correspondence is surely coincidental, the general mid-thirteenth century date for cult expansion reflects broader historical and religious developments. The Seiryōji-style icon of 1249 was made by the sculptor Zenkei and his assistants at the order of the important Saidaiji monk, Eison (1201–1290).[11] Eison, like Myōe (1173–1232) before him, was concerned with reviving the pre-Heian schools of Buddhism and was especially devoted to the cult of the Seiryōji Shaka. One of Eison's primary goals in having this Shaka made was to shift

attention away from Amida back to Shaka, the historical founder of Buddhism.

One can construct a chronological sequence of Seiryōji-type Shaka images from the 1250s and 1260s through the end of the Kamakura period that closely parallels the contemporaneous spread of Zenkōji icons. For all intents and purposes, the cults of the Seiryōji Shaka and the Zenkōji Amida Triad as major nationwide movements are phenomena of the second half of the thirteenth century. Although the earlier Kamakura histories of both cults can be reconstructed, the later Kamakura phases of the two cults clearly saw the greatest activity. As Buddhist ideas and practices spread more widely through the population, substantial changes in attitude began to appear in regard to the nature and functions of icons. Individuals and groups with an interest in the cults of the Seiryōji Shaka and the Zenkōji Amida Triad were clearly rather successful in their efforts to propagate their cults across wide areas. Fundamental to these cults was a high degree of concern for what was thought to be an exact resemblance between copy and prototype, with much less interest directed to those aesthetic issues which had previously been of major importance in the making of icons. Despite doctrinal differences, both the Seiryōji Shaka and Zenkōji Amida Triad traditions share an intense concern with accuracy of representation.

Previous studies devoted to one of the two traditions have normally offered a brief reference to the other, as an example of a related tendency, but no effort has been made to develop a comparison. A parallel analysis of the two traditions, however, sheds a good deal of light on each component and also on more general factors in Japanese Buddhism. A consideration of some of the similarities and differences in the Seiryōji Shaka and Zenkōji Amida Triad traditions is illuminating.

1. *Origins.* The prime object for the Seiryōji Shaka tradition was made in China in 985, brought to Japan shortly thereafter by Chōnen, and installed in a temple in Kyoto in the early eleventh century. As demonstrated earlier, the history of the prime object of the Zenkōji Amida Triad is more ambiguous. It is quite possibly an icon at Shinano Zenkōji that assumed the identity of Amida sometime in the middle of the Heian period, and subsequently emerged as the central component of an important cult during the eleventh century or, at the latest, the early twelfth century.

2. *Initial growth of the cults.* In both cases the early period of development coincides with the last century or so of the Heian period. At this time the cults began to prosper and expand, but circumstances were not yet propitious for the explosive growth seen during the Kamakura period.

3. *Limited Early Kamakura-period production.* Important examples in

both traditions were made very early in the Kamakura period, followed by only a modest level of production during the early thirteenth century.

4. *Intensive Late Kamakura-period production.* For both the Seiryōji Shaka and Zenkōji Amida Triad groups, one can set up extensive sequences of dated copies from 1249 through the second half of the thirteenth century and into the early decades of the fourteenth century. In addition, a large number of undated examples can be ascribed to the same period. So many copies of both traditions belonging to the later Kamakura period are found that I have concluded that the two sequences are related to broader phenomena in Japanese religion associated with the widespread diffusion of Buddhist cult practices throughout the entire country.

The nationwide diffusion of teachings concerning these icons and their cults involved the activities of various religious professionals. For the Seiryōji Shaka, specific information exists concerning the missionary work of Eison and his followers during the second half of the thirteenth century. Much of their proselytizing centered on a revival of earlier schools of Buddhism and a concomitant focus on Shaka, the historical Buddha.[12] Less precise information is available on the spread of the Zenkōji cult, but it is indisputable that the major role was played by the humble itinerant preachers referred to as hijiri. Particularly important in both traditions is the belief that the authenticity of the central icon guarantees its efficacy.

In the following pages I will consider a number of Zenkōji icons. All are placed in the second half of the Kamakura period, most by evidence of inscription and some by that of stylistic attribution. Aside from providing dates, the inscriptions are particularly useful and interesting sources of much information: donor, sculptor, location, and even occasionally an indication of why the icon was made.[13] Although such data are not unique to the Zenkōji tradition in later Japanese Buddhist sculpture, in format and in style Zenkōji inscriptions bear a close relationship to those seen on Asuka and Hakuhō gilt-bronze images.[14] Whether this resemblance is simply coincidental or, as seems more likely, it is a conscious emulation of an earlier practice by makers and patrons of the Zenkōji icons is uncertain. Perhaps this is one more instance of an effort by those responsible for the Zenkōji cult to replicate archaic practices.

Kōtokuji Amida Triad

The long sequence of extant later Kamakura Zenkōji triads is inaugurated by a work of exceptional beauty, that found in Kōtokuji, Saitama Prefecture, dated 1249 (fig. 22a–c).[15] Although the triad lacks a mandorla, the pedestals, which were cast together with the

figures, are well preserved. The three figures are relatively close to the ca-
nonical sizes of one shaku five sun for the Buddha and one shaku for the
flanking Bodhisattvas: the Amida is 47.5 cm tall, the Kannon 34.9 cm,
and the Seishi 33.5 cm. In casting technique and in stylistic traits the
Kōtokuji Triad is clearly a work by a superb craftsman, and certainly
cannot be conceived of as "provincial" in the sense of being naive or inept
in presentation.

The Amida is relatively slender in proportions, with a large head and
gently sloping shoulders. There is little sense of volume in the modelling
of the body, although the contours of the breasts and abdomen are
indicated in the exposed section of the chest. Perhaps the most striking
feature of the Amida is its elegant yet sweet facial expression. The sculp-
tor has given the eyebrows and eyes beautifully modulated, curving con-
tours, which create the impression that Amida is gazing down benevo-
lently at the worshiper. A small, delicately modelled nose and a tiny
mouth, with corners turned down, are centered within the fleshy,
rounded planes of the cheeks. Certainly the artist took great pains to give
this face a moving spirituality, appropriate to the promise of salvation
offered by the deity.

Amida is shown in one of the standard formats for the robes, including
the outer robe, the henzan, and the under robe seen at the base. Some-
thing of the elegance of design noted in the facial features can also be
seen in the articulation of the drapery folds, especially in the area where
the end of the henzan is tucked into the main robe at the chest. An
interesting feature of the fold system over the legs is the presence of
"interrupted" folds, rather than the continuously looping folds normally
seen in this area. A second unusual feature of the drapery is the manner in
which the hem of the under-robe is turned up and back over each foot. A
glance at the back of the figure reveals that, while all of the drapery
elements are fully represented, they are quite schematic in form, as if the
sculptor lavished his attention on the more important front view.

The flanking Bodhisattvas are slender in proportion, an effect no
doubt enhanced by their bare upper bodies, which are not covered in
heavy robes of the type worn by Amida. Subtle contours, especially in the
transition from chest to abdomen, accentuate a mien of suave elegance.
The delicate placement of the arms and hands in front of the chest
further reinforces this sensibility. In their facial features the Bodhisattvas
are virtually identical to Amida, suggesting that a poignant sweetness of
expression was felt appropriate for all members of the triad.

There are some problems concerning the drapery systems of the
Bodhisattvas. Although the normal three components are present—
scarf, sash, and skirt—certain ambiguities can be seen, as in the scarf. At

the back it assumes the usual shawl configuration, and the part crossing over the right shoulder is clearly visible, but at the left side the scarf is completely hidden underneath the sash, which is a highly unusual rendering, perhaps even a "mistake." In its design, the skirt adheres to a normal format, with an apron form at top, a prominent koshinuno emerging from under the apron, and with the skirt proper then visible from about knee level. As was the case with the Amida figure, the backs of the Bodhisattvas are highly simplified in execution.

A key element in the iconography of the later Zenkōji Bodhisattva is seen for the first time in the Kōtokuji figures: the characteristic crown form. The Kōfu Zenkōji (fig. 15) and Shimane Zenkōji (fig. 21) Bodhisattvas, analyzed in the preceding chapter, bear different types of crowns than those seen in the Kōtokuji images, but their crowns do not relate to the type seen in later monuments, whereas the crown form of the Kōtokuji figures becomes the standard type. This crown is usually hexagonal, although octagonal shapes and other variants also appear. These configurations are atypical of Bodhisattva iconography. When and where this peculiar crown form first appeared in Zenkōji images is unknown, although the evidence suggests that it was not present at the initial stage. Since a crown of this type is not found in the corpus of archaic images assumed to constitute the prototype for the Zenkōji tradition, we might postulate that the hexagonal crown was introduced at a stage somewhat after the production of the earliest replications.[16] How much before 1249 it appeared will probably never be known, but once established, by the mid-thirteenth century, the hexagonal crown became by far the most common type.

The pedestals of the Kōtokuji images were cast together with the figures, as noted earlier, and thus the original appearance is preserved. The pedestal of the Amida is the largest, and it has a configuration slightly differing from that of the Bodhisattva pedestals. The upper part consists of a high, mortar-shaped element, on which the Amida stands; the lower part consists of two overlapping layers of downward-pointing lotus petals, with the entire pedestal resting on a lobed ring base. The Bodhisattva pedestals bear only one layer of lotus petals in their lower sections, but otherwise conform to the format of the center pedestal. This appears to be the canonical format. The prominent upper element perhaps alludes to the mortar on which Honda Yoshimitsu is said to have placed the original icon when he enshrined it in his house. Since in most surviving Zenkōji Triads the original pedestals have been lost, as they were cast separately, the Kōtokuji Triad provides valuable evidence for an early stage in the development of the pedestal.

Each figure bears an inscription on the back of its pedestal. The in-

scription on the pedestal of the Amida, which is the longest, includes the location where the icon was cast, Koshiro in Musashi Province; the names of three donors (the father, Eison; the mother, Saia; and the son, Saibun); and the date, Hōji third year (1249), second month, eighth day. The pedestals of the Kannon and Seishi have only the place name: Koshiro. Although short, the inscription on the Amida belongs to an important category in which an icon is presented for the sake of a family. Each person in the dedicatory inscription is referred to by a Buddhist rather than a secular name. The name of the mother seems quite specifically related to Zenkōji belief, since the first character *sai* (West, 西) probably refers to the Western Paradise, while the second, *a* (阿), is an obvious abbreviation of the name of Amida.[17]

Tokyo National Museum Amida Triad

A second very fine triad from the middle of the thirteenth century, dated 1254, is only five years later than the Kōtokuji Triad. Although the former (fig. 23a–c) is now preserved at the Tokyo National Museum (TNM), its inscription indicates that it was originally from Nasu in northern Tochigi Prefecture.[18] This monument is close in size to the Kōtokuji Triad: the Amida is 47 cm tall, and both Bodhisattvas are 36.4 cm. Unfortunately, the TNM triad has lost not only its mandorla, but also its pedestals. The absence of pedestals somewhat distorts the relative size ratios of the Amida and Bodhisattvas, since the central figure usually stands on a slightly higher pedestal that further emphasizes his elevation.

Compared to the Kōtokuji Triad, the figures of the TNM Triad are less elegant in their proportions and display a fuller, more bulky approach in their modelling. Amida has a large, solidly proportioned head and relatively broad shoulders, with heavy sculptural volume apparent in his body. This quality of heaviness is also conveyed in his robes. In contrast to the Kōtokuji Amida, the robe of the TNM Amida is arranged in the tsūken form and thus lacks the henzan element. The quite arbitrary occurrence of various drapery arrangements and elements in images as contemporaneous as the Kōtokuji and TNM Triads suggests that a fixed canonical model, which had to be adhered to in all of its details, did not exist. Consequently, certain freedoms—in figural style and selection of motifs, as well as in general expression—were allowed to the sculptor, who perhaps drew upon his general repertoire in designing a Zenkōji figure. Kurata has suggested that, in the drapery folds of the TNM Amida, the elaborate turned-back folds in the abdominal section may reflect knowledge of Seiryōji Shaka copies.[19] Although this connec-

tion seems unlikely, it is surprising that folds so different are found in the Kōtokuji and TNM figures.

Differences can also be noted in the facial expressions. While the Kōtokuji Amida's face is elegant and rather ethereal in mood, that of the TNM Amida is heavy and a bit stern. Both images show a similar treatment of ushnisha and snail-shell curls, and both have a gently arching hairline over their brows. In the TNM Amida, the cheeks are very plump and well rounded, while the eyes are small. The general expression of the Buddha is somewhat gloomy.

The Bodhisattvas of the TNM Triad are closely related in style to the Amida, and thus display rather heavy proportions. This is particularly apparent when the Bodhisattvas are compared with those of the Kōtokuji Triad. In contrast to the strongly curving contours of the Kōtokuji images, little sense of such modulation is seen in the TNM pair, which are stocky and substantial in build. Corresponding to this sense of heavy physical presence is a weighted and tangible quality in the drapery elements. Also, the placement of the hands in the TNM figures, with the right palm placed flat over the left, differs from that found in the Kōtokuji group.

A long inscription has been incised in the back of the TNM Amida, with shorter versions found on the backs of the flanking Bodhisattvas.[20] The inscription on the Amida indicates that the Triad was made for a place called Higashi Yose-mura in the Nasu shōen of Shimotsuke Province (now Tochigi Prefecture) and that the necessary funds were gathered by a priest called Sainin. It also states that Sainin, who was twenty-seven at the time, had the icon made and installed on the basis of a vision that he had experienced. The inscriptions on the Bodhisattvas simply provide the date, Kenchō sixth year (1254), first month, twentieth day, and Sainin's name.

A few more comparisons between the Kōtokuji and TNM Triads may be helpful. They are so close in date that any stylistic development occurring from 1249 to 1254 seems implausible. Although the triads are located in adjacent prefectures—Saitama and Tochigi—the TNM Triad comes from Nasu, in the far northern section of Tochigi Prefecture, which is in reality quite distant from Kōtokuji. Since we are uncertain as to where the sculptures were actually cast, however, the present locations are perhaps not overwhelmingly significant. Nevertheless, some explanation of their differences in motif and style is pertinent.

I would postulate, on the basis of the preceding analysis, that the Triads were not made by the same craftsman, and most likely not in the same studio. Variations in motif suggest that, while both artists relied on essentially the same general source, this did not preclude modification.

More basic, of course, are the profound differences in style that distinguish the monuments, for here the characteristic expressions of two quite dissimilar artists are apparent. Presumably, the two artists utilized motifs and stylistic features with which they were familiar in their general activity as image-makers. This applies in particular to the henzan element and to the general figural style. A somewhat different hypothesis is perhaps in order for the mudras of the Bodhisattvas, for in this instance it appears that the Kōtokuji figures, represented as if they are holding something in their hands, are closer to what can be assumed to be the jewel-grasping prototype than the TNM figures, which are shown with their palms pressed flat together. Perhaps in the case of the TNM Bodhisattvas it is best to assume a degeneration—a lack of understanding—of the original mudra.

Obviously, either or both of these triads may be more or less exact copies of some prototype. One can easily imagine a sequence stretching back for some years, or even for decades. However, the earlier analysis of the Kōfu and Shimane Triads indicates that Zenkōji monuments made at the beginning of the Kamakura period were different in character from those executed in 1249 and 1254. Consequently, I assume that the Kōtokuji and TNM Triads reflect developments that took place, in approximate terms, during the second quarter of the thirteenth century.

Images of the 1260s

Several images dating from the 1260s are significant in terms of stylistic features or inscriptional evidence. The extant remains suggest that production of Zenkōji-type icons increased substantially at this time, particularly in the Kantō region. Fortunately, some of the evidence encourages tentative hypotheses about patterns of distribution and even about the craftsmen and studios responsible for making the images.

Two single figures of Amida are dated to 1261: one at Jōshinji (fig. 24) in Tsuchiura City, Ibaraki Prefecture (premodern Hitachi Province); and one that is presently at Hachimanjinja (Fig. 25) in Fuchū City, Tokyo, but formerly was in an estate belonging to the Hachiman Shrine in Gunma Prefecture (premodern Kōzuke Province).[21] Both are well-designed and well-executed pieces of sculpture, the work of excellent artisans. Although sharing some features, the two works display enough differences to make apparent their derivation from slightly divergent lineages. But they both relate most closely to the TNM Amida of 1254 (fig. 23). Thus they lack the henzan element and instead have their outer

robes arranged in the tsūken form. Furthermore, both the Jōshinji and Hachimanjinja figures have the sōgishi, the "shirtlike garment" discussed earlier. However, in distinction to the TNM Amida, the Jōshinji and Hachimanjinja figures display a variant of the tsūken arrangement in which the hem that sweeps across the chest is represented as if it had been twisted over once instead of lying completely flat over the body.

The Jōshinji and Hachimanjinja images show similar treatment of the hair, expressions, related facial expressions, and nearly identical bodily proportions. Despite a general similarity in format, however, there are numerous differences in detail discernible in the drapery elements. For example, the robes of the Jōshinji Amida are rendered with many more individual folds, whereas the Hachimanjinja Amida shows a rather schematized treatment of such folds. Enumeration of such variations could continue; clearly the two images, though related in motif, are not identical. This suggests, once again, that each of the craftsmen, while following a general model, was free to introduce differing treatments of various elements.

Unfortunately, the flanking Bodhisattvas have been lost, for their presence surely would make the lineages and lineage relationships of the two images that much clearer.[22] Nevertheless, the Amida figures alone testify to the range of stylistic variation that was tolerated in such imagery, even that produced in the same year. Although no definitive statements can be made regarding possible studio relations between the Jōshinji and Hachimanjinja images, I believe that they may have been produced in the same studio, but perhaps by different craftsmen.

A number of images can be associated with the Nasu region in northern Tochigi Prefecture, which suggests that this area may have been a local center of the Zenkōji cult. In addition to the TNM triad of 1254, there are two Nasu-region monuments of the mid-1260s: the Ishikawa Collection Amida (fig. 26) of 1265 and the Senshōji Amida and Seishi (fig. 27) of 1267.[23] These Amida figures are not particularly close in style and motif, for the Ishikawa Amida has an outer robe that is arranged in the tsūken mode, while the Senshōji Amida includes the henzan; in addition, numerous other variations can be seen. Despite such dissimilarities, however, the two images may have been made—or supervised— by the same sculptor. The maker of the Senshōji Amida is recorded in the inscription as "Fujiwara Mitsutaka," while the inscription of the Ishikawa Amida provides only the given name, "Mitsutaka."[24] These could, of course, be distinct craftsmen, but, given the chronological and geographical proximity of the two figures, the more likely possibility is that

they are the same individual. If this is indeed the case, the range of stylistic variation once again provides evidence for what would appear to be a high degree of tolerance in Zenkōji imagery for differences in motif and style.

When an Amida (fig. 28) and a Kannon (fig. 29), both dated 1266, are brought into the discussion, the interconnections within the mid-1260s group becomes more complex. These figures were originally made for a temple in Yamagata Prefecture but were subsequently dispersed: the Amida is now at Senjuin in Kanagawa Prefecture; the Kannon at Seichōji in Chiba Prefecture.[25] A comparison of the Senjuin Amida with that of the Ishikawa Collection reveals that they are virtually identical in robe motifs. Both wear the outer robe in the tsūken mode, and the hem of the robe, as it passes over the chest, is twisted over in the same position on the left side. Also, the drapery folds crossing the chest conform to the same complex configuration in both images. Since such features cannot be attributed to mere chance, the Ishikawa Amida and the Senjuin Amida were certainly made in the same studio, according to the same model. (Of course this is not to assert that the two figures are identical in every detail of style and handling. The Senjuin Amida has heavy, somewhat squared-off drapery folds, while those of the Ishikawa Amida are graceful and delicate. Also, in rear view the Ishikawa figure bears schematic incised folds, whereas the Senjuin image displays the sort of fully plastic folds noted in its front view.)

The Kannon of the 1266 Triad, now at Seichōji in Chiba, has its hands clasped in prayer in front of its chest, which is inappropriate as a Zenkōji icon mudra.[26] The surface of this Kannon does not show much damage, making it difficult to explain how and why the arms came to assume their present configuration. Perhaps the arms were made separately, later damaged and, when repaired, given a new form. Nevertheless, the hexagonal crown proves that the figure was designed as a Zenkōji icon and not as an image of another type for which the present mudra might be more appropriate.

If the Kannon is compared with the Seishi of the Senshōji group, one observes that the two figures have much in common in the articulation of their crowns, their facial expressions, the modelling of their chest, and the treatment of their robes. Although this line of argumentation is perhaps overly complex, I would tentatively suggest that the stylistic relationship between the 1266 Kannon and the 1267 Seishi brings the mid-1260s group into closer cohesion than was at first supposed.

At this point a diagram of the possible connections among the Zenkōji icons of the 1260s discussed in the preceding paragraphs may be helpful.

Images identical in motif
 1265 - Ishikawa Amida (fig. 26)
 1266 - Senjuin Amida (Yamagata Triad) (fig. 28)
Images from the Nasu region
 1265 - Ishikawa Amida
 1267 - Senshōji Amida and Seishi (fig. 27)
Images perhaps made by the same sculptor
 1265 - Ishikawa Amida
 1267 - Senshōji Amida and Seishi
Stylistic relationships among Bodhisattvas
 1266 - Seichōji Kannon (Yamagata Triad) (fig. 29)
 1267 - Senshōji Seishi

On the basis of their many connections and shared characteristics, the
monuments of 1265, 1266, and 1267 must surely be directly associated.
That these monuments have more in common among themselves than
they do with other works, earlier or later, reinforces this hypothesis.

Engakuji Amida Triad

Throughout this study I have emphasized
the broader historical and religious dimensions of the cult of the Zenkōji
Amida Triad, with relatively less attention directed to the specific charac-
teristics of individual icons. The very nature of the monuments makes
this the most appropriate methodology. Yet there are a few images of
great intrinsic interest, formal or iconographical. Two such examples are
the Kōfu Zenkōji and Shimane Zenkōji triads. Two others, dating from
the early 1270s, must be considered here: the Engakuji Triad of 1271 (fig.
30), in Kamakura, and the Ankokuji Triad of 1274 (fig. 32) in
Hiroshima Prefecture. Both display a variety of intriguing traits that
demand explication and indeed justify a somewhat extended analysis as
unusual examples within the Zenkōji corpus. Certainly a presentation of
Zenkōji sculpture focusing primarily on the Kōfu, Shimane, Engakuji,
and Ankokuji triads would be rather interesting in terms of artistic and
iconographical issues. It would not do justice, however, to the broader
currents of Zenkōji belief as manifested by the more standard examples.
In this sense, monuments such as those at Kōtokuji or the Tokyo Na-
tional Museum, or the works completed in the 1260s, are more represen-
tative of the full spectrum of Zenkōji imagery.

 The Engakuji Triad earlier was mentioned in Chapter 4 in a discussion
of Hōjō patronage of the Zenkōji cult, where I suggested that the triad

may have been donated by Tokimune to his newly established Zen monastery.[27] While this is only a suggestion, the sophistication of the Engakuji Triad indicates that it was made by the best craftsmen for an important patron. Certainly we need not definitively identify this patron as Tokimune, but there is a strong possibility that the triad was made for someone at the highest level of Kamakura society. Also, some formal and iconographical details argue in favor of a rather special commission.

An important feature of the Engakuji Triad is its relative completeness. Although the original base is gone, each figure, and its pedestal has been preserved, as well as the large boat-shaped mandorla that backs the group. Among the monuments considered in earlier discussions, only the Shimane Triad displays all of the elements appropriate to Zenkōji tradition, but the Bodhisattvas of that triad are rendered in two-dimensional form incised on the mandorla. Each of the other complete triads analyzed—including those at Kōfu Zenkōji, Kōtokuji, and the Tokyo National Museum—lacks the mandorla and in some cases even the pedestals. Moreover, one frequently finds only a single figure extant from icons of the 1260s, usually the Amida or, at times, an Amida and one of the flanking Bodhisattvas. Consequently, the Engakuji Triad provides particularly valuable information about a complete ensemble, although, as will be observed presently, certain unusual characteristics may in some respects discourage generalization.

Another significant feature of the Engakuji Triad is its very fine casting technique, the specific features of which will be enumerated in the course of analysis. Clearly the excellence of craftsmanship and the complexity of detail are unusual and perhaps even unique among extant Zenkōji monuments.

The central Amida stands 42.6 cm in height, a measurement slightly shorter than the canonical one of approximately 45 cm. This figure displays the most surprising details of casting.[28] Especially unusual is the manner in which the head and the revealed portion of the chest have been fashioned in two sections, one that includes the front of the head and the chest, and the other forming the hair, which, cast like a wig, fits over the head proper. Kurata has pointed out that, in wood sculpture of the Kamakura period, examples can be found in which the head and chest area are carved from a single piece of wood. He suggests that this feature in the Engakuji Amida probably reflects influence from the Kaikei school of sculptors. Why the hair section was prepared separately is puzzling, although the craftsman clearly thought it was important, since much care was lavished on this part. The two hands of the Amida also were cast separately.

The Amida has well-balanced proportions, with the head approx-

imately one-quarter the size of the lower body. The shoulders are of reasonable breadth, giving the image a solid and stable appearance. The ushnisha is very tall and the snail-shell curls finely executed, not only at the front but also at the sides and back. The face, capped by a prominent and detailed expanse of hair, consists of smooth, planar areas. A gentle, meditative expression pervades the facial features. The eyes are wide and quite large, the nose small, the mouth tiny; the usual canonical folds are present along the neck. Only very limited modelling is visible in the part of the chest revealed by the outer robe.

An unusual aspect of the Amida is the character of this outer robe. It follows the tsūken mode, with the hem twisted over once at the right side as it crosses the chest. Although this feature is relatively standard, the manner in which the outer robe drops down to the feet on the front is most unusual, for the under-robe is no longer visible. A glance at the side or back views, however, reveals the under-robe emerging from beneath the outer robe. Also striking is the way that, at either side, the ends of the outer robe flare out strongly, a feature that is very much reminiscent of the Buddha figures of the seventh century.[29] The fluent, sweeping folds that pass over the front of the body can also be related to early sculptures, although the softness in facial expression and the general treatment of the drapery elements obviously belong within the stylistic category of Kamakura sculpture. An extremely rare trait is seen in the left foot, where the big toe is shown as slightly raised; while this feature may be the result of damage, I assume that it is intended to create the impression that the Buddha is moving forward toward the worshiper.[30]

Of the flanking Bodhisattvas, the Kannon is 33.2 cm in height, the Seishi 32.5 cm. In contrast to the unusual casting technique employed for the Amida, these figures were each made in a single casting that includes their pedestals. They are essentially identical in motif, except that, while the Seishi holds his right hand cupped over his left, the Kannon does the opposite. The hands are depicted as if they were holding a jewel, directly relating to an iconographical configuration frequently seen in Asuka and Hakuhō sculpture. Interestingly, in the majority of Zenkōji Bodhisattvas the hands are held flat, palm to palm, as if the original significance of the mudra had been forgotten. Following iconographical rules, the Seishi bears a water vase emblem in his crown, while the Kannon is provided with a standing Amida.

The Bodhisattva figures are rather short and stocky, with quite narrow shoulders. There is a limited sense of modelling in their chests, while their arms have a general feeling of sculptural volume; both their hands and feet are schematic in form. Their faces wear a sweet, gentle expression paralleling that of the Amida. Most interesting are the hair style,

crown, and drapery elements. In contrast to the standard hexagonal/octagonal crown type observed in the Kōtokuji and Tokyo National Museum Bodhisattvas, the Engakuji figures have a curved, single-unit crown type harking back to the Asuka period.[31] This form contributes strongly to the archaic flavor of the images, although an examination of the decorative elements of the crown reveals that they are Kamakura rather than Asuka in form. Reinforcing this later attribution are the topknots of the two Bodhisattvas, which—in the complex treatment of intertwining locks of hair—reflect the influence of Sung forms that entered Japan in the later part of the Heian and the early part of the Kamakura periods.[32] This type of elaborate topknot was of some importance to the sculptor, who directed considerable attention to it despite its location at a point virtually hidden behind the crown in front view.

The drapery elements are orthodox: scarf, sash, and skirt. The two-register arrangement of the scarf, making it cross over the front of the legs, is encountered occasionally in other Zenkōji Bodhisattvas. A highly unusual feature is the manner in which the scarf-ends, which hang down each side of the pedestal, have been cast as part of the main fabric. Although this arrangement is frequent in Asuka and Hakuhō sculpture, it is extremely rare in Zenkōji images.[33] (The scarf-ends of the Shimane Zenkōji Triad's Bodhisattvas are *represented* as if they are falling to the sides of the pedestal, but this is a different matter.) Sash and skirt can be associated with standard types, although both display a higher degree of complexity in detail than is common.

Differences can be noted between the pedestal of the Amida and those of the Bodhisattvas. The pedestal of the Amida bears a prominent upper element, the *renniku* with the stamens distinctly represented. (The renniku is the pod or torus of the lotus, usually hidden by the lotus petals, which is depicted by vertical striations. The image stands on this element.) This upper section fits into a lower part consisting of two registers of downward-pointing, overlapping lotus petals. The base of the pedestal is formed by a ring. In the Bodhisattvas, the upper renniku element is very small, while the lower section consists of a single layer of rather long, narrow lotus petals. Curiously, there is no base supporting the lotus petals. With the exception of the latter "omission," all other features of the pedestals of the Buddha and Bodhisattvas are essentially the same as those of the Kōtokuji Triad (fig. 22), although there are significant variations in rendering. The formats of the 1249 (Kōtokuji) and 1271 (Engakuji) pedestals appear to have been considered standard.

The large, boat-shaped mandorla gives the Engakuji Triad a particularly archaic flavor. This type of mandorla was popular in Three Kingdoms and Asuka sculpture, as noted in a previous chapter, and must have

been present in the original icon at Zenkōji. The Engakuji mandorla bears a representation of the head and body halos of Amida, indicated with double, raised bands, among which numerous lotus blossoms were originally placed, most of which are now lost. There is no evidence of halos for the flanking Bodhisattvas on the mandorla, nor do they appear to have been provided with separately attached halos. The main surface of the mandorla contains independent pieces of the cloud-flame motif, affixed to the surface, with several sections now lost. The principal loss is that of the group of seven subsidiary Buddhas that originally decorated the upper portion of the mandorla. Their earlier presence is evinced by the rather large holes by which they were affixed to the surface, as well as by discolorations showing traces of seated-Buddha silhouettes.

In our analysis of extant Zenkōji monuments, only the mandorla of the Shimane Zenkōji Triad (fig. 21a) has been appropriate for discussion. As noted, the long narrow shape and the depictions in relief of the Bodhisattvas render it most uncharacteristic. Nevertheless, many of the same features, albeit in three-dimensional format, are present in the Engakuji mandorla. The Engakuji mandorla is also quite close to that of the Ankokuji Amida Triad, to be considered next.

The Amida figure bears an inscription that provides the date and the name of the sculptor.[34] The inscription is located in a rather unusual place that is not visible when the sculpture is fully assembled. When the image is taken apart, one can see that it was cast in two sections: the lower pedestal with lotus blossoms; and the Amida proper plus the upper part of the pedestal in one unit. The inscription is found on the tenon that attaches the Amida/upper pedestal section (including the renniku) to the lower pedestal (fig. 30e). This inscription records that the icon was cast and dedicated on Bun'ei eighth year (1271) tenth month, nineteenth days, and that the sculptor's name was Enji, an individual otherwise undocumented; no indication of donor or reason for commission is seen at present.

We have noted several ancient elements of the Engakuji triad, which can be summed up as follows:

1. The shape of the mandorla.
2. The arrangement of the robe of the Amida.
3. The crowns of the Bodhisattvas.
4. The distinct, jewel-holding hands of the Bodhisattvas.
5. The treatment of the scarf-ends along the sides of the pedestals of the Bodhisattvas.

In toto, the Engakuji Triad is certainly the most archaic in appearance of the body of surviving Zenkōji Amida Triads. An explanation for this

phenomenon is surely warranted, if by nature tenative. Some scholars, presumably influenced by the account in *Zenkōji Engi*, have loosely referred to the style of the Engakuji Triad as related to that of the Asuka period. Clearly this is impossible, for the two-register arrangement of the scarf, in which it crosses in front of the legs, does not appear prior to the Hakuhō period. Moreover, there is evidence that the sash is an element that normally does not occur until the Nara period. Although the third, fourth, and fifth items probably derive from Asuka sculpture, the arrangement of the drapery of the Bodhisattvas represents a somewhat later developmental stage, while the elaborate top-knots are much later. (Of course this analysis is advanced only in terms of motif; in style, the monument clearly reveals its Kamakura date.)

What accounts for these seemingly archaic elements in a monument of 1271, a year well into the evolution of Zenkōji-type images? I was tempted to conclude, at an initial stage of this research, that the Engakuji Triad somehow reflects the prototype at Shinano Zenkōji more accurately than other copies. If true, this would be a wonderfully attractive situation since direct access would be provided to the enigmatic secret image. Unfortunately, numerous difficulties arise when an attempt is made to defend this position, particularly because virtually no earlier or later copies look much like the Engakuji Triad. Thus, were it in fact an accurate copy of the Living Buddha, it would have the doubly unique status of never having been recognized as such by contemporary patrons and artists.

Because of such problems I now assume that the various archaic elements were introduced into the Engakuji Triad of 1271 as a result of a specific request by the patron. While this hypothesis assumes the collaboration of a highly sophisticated patron and a knowledgeable artisan, there certainly are no factors that preclude this. A particularly relevant example of such a collaboration is provided by the seated bronze image of Amida that was cast for the Hōryūji Kondō in 1232.[35] This image was executed in the archaic style of the seventh century, which is seen in various versions in the Shaka Triad and Yakushi image of the same hall. Evidently the patrons who commissioned the 1232 Amida asked the sculptor, Kōshō, to render it in the manner of archaic works, which he did, although his success is more on the level of motif than style. Nevertheless, if this sort of historical awareness existed by the 1230s, there is no reason that the Engakuji Triad of a few decades later could not have resulted from a similar level of self-conscious historicism. Certainly, further study of archaism in thirteenth-century sculpture is warranted.

The implications of this hypothesis are worth further thought. It postulates the existence of a patron who was aware of the general character

of seventh-century sculpture and an artisan who was capable of translating this into the appropriate iconographical format. Various stylistic discrepancies in the Engakuji monument are easily understood within this context. As demonstrated earlier, Korean sculptures of the Three Kingdoms period contain the prototype for a triad form in which all figures stand before a large, boat-shaped mandorla. Such a prototype, including the mudras of the figures, was surely known to the Engakuji sculptor. But in attempting to make the icon look more archaic, he seems to have introduced early elements, such as the Asuka crown and the characteristic early seventh-century arrangement of the scarf ends.

Ankokuji Amida Triad

The other monument of the 1270s requiring extended consideration is the Ankokuji Amida Triad of 1274 (fig. 32a–e).[36] Of all Zenkōji-related temples, Ankokuji has perhaps the most beautiful site (fig. 31). Located at Tomonoura, in eastern Hiroshima Prefecture near Fukuyama City, it commands a spectacular view over the Inland Sea (Setonaikai) toward distant Shikoku. Because the temple now called Ankokuji has passed through various transformations since its establishment in the thirteenth century, a brief outline of the history of the temple is necessary.

"Ankokuji" is a common designation that refers to the system of provincial temples established by Ashikaga Takauji at the beginning of the Muromachi period, following the precedent of the Kokubunji network of Nara times.[37] Since the main hall of Ankokuji—the Shakadō—and several of the extant images date to the Kamakura period, evidently an earlier temple was transformed into an Ankokuji in the fourteenth century. Fortunately, deposits within the Amida Triad provide the information necessary for reconstructing the early history of the temple.[38]

According to the documents placed inside the image, the Amida Triad was made in 1274 for a temple called Kinhōji that had been established in the previous year. People have often been puzzled as to why a large Zenkōji-type Amida Triad would be associated with a temple of the Rinzai School of Zen, housed in a Shakadō, and moreover located in a region far from the centers of Zenkōji belief. Gorai has answered this question through his analysis of the career of Shinchi Kakushin (1207–1298), summarized in an earlier chapter.[39] Shinchi Kakushin received the high Buddhist title of Hottō Kokushi, and one of the most important treasures of Ankokuji is a Kamakura-period statue of Kakushin as Hottō Kokushi.[40] At first glance the presence of an image of a high Zen prelate seated in front of a monumental Zenkōji Amida Triad seems somewhat

incongruous, but until relatively recently, the Amida iconography of the triad had been forgotten, and it was thought to be a Shaka Triad, which is completely appropriate for a Shakadō and certainly more relevant to the usual expectations for a Zen establishment.

As Gorai has elucidated, Kakushin pursued a multifaceted career that included both a commitment to Rinzai Zen and support for the cult of the Zenkōji Amida Triad. Consequently, there is absolutely nothing surprising about the association between the monk portrait and the Amida Triad now enshrined at Ankokuji. Of the three Zenkōji-hijiri recorded to have made the Ankokuji Triad, one was named Kūzōbō Kankaku, and Gorai has argued that the "Kaku" (覚) syllable may refer to the same character in Kakushin's name.

Earlier, in discussing the Shin Zenkōji system, I noted that many temples associated with Zenkōji belief in the Kamakura period subsequently declined and lost their cult dimension. Probably by the early Muromachi period Kinhōji was no longer a flourishing center of Zenkōji belief, and thus Takauji could conveniently incorporate the temple into his broader Ankokuji network. At some indefinite time, the identity of the monumental triad was forgotten (or perhaps even suppressed), and it became a Shaka Triad. A photo taken prior to repairs in 1950 reveals very substantial damage to the hands of all three figures, obscuring considerably the original mudras.[41] The sutras found deposited in the image, however, are devoted to Amida Buddha, including one specifically related to the Zenkōji Amida, so there can be no doubt that from its inception the Ankokuji icon was a Zenkōji-type Amida Triad. Moreover, despite the damage to the hands of the Bodhisattvas, both wear the characteristic crown of the main lineage of the Zenkōji Triad.

There are a number of striking features of size and material in the Ankokuji Amida Triad. It is by far the largest extant triad, with the mandorla reaching a total height of 315.7 cm. The Amida stands 230 cm in height, the flanking Bodhisattvas each about 170 cm (these dimensions include the pedestals). Moreover, the triad is constructed of wood, a most unusual selection for a Zenkōji-related icon. Like the Engakuji Triad, this monument preserves the original format very well, including the monumental mandorla as well as the pedestals, and thus provides valuable evidence about how a Kamakura Triad was supposed to appear.

The Amida is a well-carved, strongly modelled figure, and wears one of the standard types of robes associated with the Zenkōji Amida. In contrast to the Engakuji Amida of just a few years earlier, which wears robes of an archaic type, the Ankokuji Amida has robes closely resembling those of the Tokyo National Museum Triad of 1254 (fig. 23). This applies to both the front and back views. Moreover, the Bodhisattvas,

with their hexagonal crowns, are very similar to those of the TNM Triad. Obviously, the Ankokuji Triad relates to the lineage that emerges in well-established form in the mid-thirteenth century, as seen in the Kōtokuji and TNM Triads. A key feature of the Ankokuji Triad is the relatively good condition of the mandorla. Analysis of this mandorla, in association with those of the Shimane Zenkōji and Engakuji Triads, indicates a consistent ensemble of characteristics. Although the overall shapes of the three mandorlas reveal variations in compositional factors, the general configurations are nearly identical: the boat-shaped form, the seven subsidiary Buddhas, the cloud-flame motifs, and the intertwined lotus ornamentation in the divisions between the head and body halos. (As at Engakuji, the subsidiary Buddhas of the Ankokuji mandorla have been lost, and only their silhouettes remain.)

The large scale of the Ankokuji Triad presents a difficult problem. Analysis of the figures and mandorla has indicated that the monument is faithful to one of the main lineages of the Zenkōji tradition. Clearly, the patron and sculptor would have known that the standard size was very much smaller. Various possibilities come to mind. One, of course, is that the work was intended as a copy of Jōson's life-sized triad of 1195 at the Shinano Zenkōji. If this is the case, then the Kōfu Zenkōji Amida Triad is not Jōson's triad, but something else. However, certain features of the Buddha's robes, as well as the hexagonal crowns of the Bodhisattvas, suggest that the prototype for the Ankokuji Triad was an image of the middle of the thirteenth century and not one of earlier date. Perhaps the Ankokuji image was meant to be a metaphorical copy of Jōson's image, rather than an exact copy. I would also suggest that the life-size scale of the Amida may be a reference to the Living Buddha concept discussed earlier.

Also strange, for a Zenkōji icon, is the selection of wood as the material. In general terms, wood, with the exception of precious types such as sandalwood, is less expensive than bronze, and there would be little significant discrepancy in cost between a normal, small-scale bronze and the larger-than-life-sized wooden Ankokuji Triad. Perhaps the patron who commissioned this monument desired the scale associated with Jōson's triad but was unable, or unwilling, to have it executed in bronze. Possibly there were other large wooden triads made during the Kamakura period that were lost though fire; certainly, a small-scale bronze triad had a much better chance of surviving than a monumental wood sculpture. In the case of the Ankokuji Triad, the main reason for its survival into the present lies in the Shakadō, the Kamakura-period structure within which it is enshrined, and which has had the great good fortune to escape destruction over the centuries.[42] To date, no other

Zenkōji-type triads that are enshrined in Kamakura-period buildings have been documented, and thus all other extant monuments from that period have moved at least once, if not much more frequently.

The Ankokuji Amida Triad is unique in a number of respects: its large size, unusual material, and direct association with the religious activities of Hottō Kokushi. While it is one of the most interesting Zenkōji sculptures, it must, like the Engakuji triad, be considered a profoundly uncharacteristic monument within the Zenkōji corpus. By and large, the Zenkōji tradition is highly conservative in the production of icons, and we can see that the patrons who commissioned the Engakuji and Ankokuji triads ordered unusual, even unorthodox, icons. Fascinating as they are, these two monuments are very much off the mainstream of Zenkōji production. Why two of the most unusual extant triads were made within three years of each other remains a tantalizing question.

A Group of Undated Images

A glance at the list of dated Zenkōji monuments reveals a paucity of examples from the later 1270s through the 1280s, with production picking up again in the 1290s. The reasons for this sort of gap are not clear, although the Zenkōji cult is not likely to have suddenly declined for fifteen or twenty years, only to revive around 1295. Perhaps the extensive preparations against the Mongol invasion of 1274 and 1281 adversely affected the making of Zenkōji icons during these years, but this is uncertain. Thus far this chapter has considered dated images; indeed, the only undated Triad considered in the preceding chapter was that of Shimane Zenkōji. There are, however, a number of other significant Zenkōji images lacking inscribed dates, and we must not ignore them entirely in favor of the more securely dated examples. Therefore, we will examine next an interesting group of undated images that can be ascribed on stylistic grounds to the general period of the 1270s and 1280s.

One of the most important Zenkōji Amida Triads is that of the Fudōin on Mt. Kōya (fig. 33).[43] Classified as an "Important Cultural Property") —one of about a dozen Zenkōji sculptures so designated—it has been frequently illustrated but not much analyzed or discussed. Probably this state of affairs originates in the work's lack of an inscription and the resulting deficiencies in contextual evidence. Also, the tremendous range of important Buddhist monuments at Mt. Kōya tends to overwhelm the Fudōin Triad, which in this light seems somehow an insignificant aspect of the total picture. This benign neglect is easy enough to understand. Since much of the research devoted to Zenkōji sculptures has been car-

ried out by regional historians concerned with the local cultures of specific prefectures largely limited to the Kantō or Tōhoku areas, there would have been no immediately apparent reason for a specialist in the history and art of Wakayama Prefecture to concentrate on the Fudōin Triad. The Fudōin work does, however, indeed possess considerable historical significance, which will become clear after a preliminary description of the figures in the triad.

Although there is no mandorla, all the figures retain their original pedestals, and all are quite well preserved and include traces of their original gilding. The Amida has a height of 50.4 centimeters; the flanking Bodhisattvas, 33.8 and 32.8 centimeters. The Amida, a very solid and massively proportioned figure, is characterized by a striking width across the chest, in the belly area, and down through the legs. In comparison with the Amida figures from the Kōtokuji (1249) or Tokyo National Museum (1254) Triads, the Fudōin Amida seems indeed frontally broad, even stout. As if compensating for the width, the drapery folds loop across the front of the body in rather shallow arcs. The most important feature in the arrangement of the robes is the henzan. The figure also wears the sōgishi. An under robe covers the lower part of the body; its folds loop emphatically over either leg.

The Bodhisattvas are virtually identical in motif, and thus can be treated as one stylistic unit. Although they are not as massive as the Amida, they are solidly modelled. Their hands are held flat, palms together, with the right hand over left, which is the most common arrangement. Their most striking trait is the high topknot, used instead of the more typical hexagonal or octagonal crown. The Bodhisattvas lack the usual scarf covering the back and both shoulders, which leaves their right shoulders completely bare; the sash, however, covers the left shoulders before passing diagonally across the chest and looping around the right hip. The skirt area is rendered as a tightly composed structure: the apron feature is depicted as small and downward-pointing, with the kushinuno emerging from the tip of the apron and moving out diagonally to either side. The edges of the apron and koshinuno produce a sort of "X" pattern. Over each leg is a series of five forcefully articulated loop folds.

There are a number of images in Yamagata Prefecture that are closely related to the Fudōin Amida Triad.[44] Perhaps the most important member of this group is one at Tachikawa-machi (fig. 34).[45] This triad has lost both the boat-shaped mandorla and the pedestals, and the hands of the Amida have been repaired, with the result that the mudras are incorrect. There can be no doubt, however, that it is a Zenkōji-type Amida Triad. This can be determined by the use of bronze for the images, by the dimensions, and, most importantly, by the mudras of the flanking

Bodhisattvas. The Tachikawa-machi Amida is virtually identical to the Fudōin Amida in its massiveness, its breadth across the front, and its utilization of the henzan element. A glance at the contours of the outer robe and the treatment of the folds over the lower section of the legs makes the similarities even more apparent. Moreover, the flanking Bodhisattvas in both triads share the characteristic topknot without a crown, the bare right shoulder, and identical arrangements of the skirt. Particularly noteworthy are the five loop folds over each leg: exactly the same number is seen in both groups.

In addition to the complete Tachikawa-machi Triad, several other figures in Yamagata Prefecture, in addition to one in Tochigi Prefecture, belong to the same lineage. These include Buddha figures at Amidaji (fig. 35) and Hōsenji (fig. 36) and Bodhisattva figures at Jōman Kō-minkan (fig. 37) and Higashine City.[46] Possibly the Bodhisattvas were originally a pair, and, of course, one or both of them may once have flanked either the Amidaji or Hōsenji Amida figures. Thus at least three triads in the Fudōin lineage (Tachikawa-machi, Amidaji, and Hōsenji) and hypothetically as many as five (supposing that the two independent Bodhisattvas were never related to any other members of the group) are found in Yamagata.

The Tochigi member of this category is a single Bodhisattva in a temple called Sōgonji in Mōka City (fig. 38). At present there is a central Amida figure and a flanking Bodhisattva identified as Seishi. Mizuno Keizaburō, who has studied the pair, dates the Amida to the fourteenth century.[47] Certainly it is quite different from the Amida figures in the Fudōin group. Mizuno states that the Amida and Seishi are not related to each other, which is a key observation, since the Seishi clearly belongs to the Fudōin group. In its present form, the figure holds its hands in prayer before its chest; this is presumably a later repair, however. Nevertheless, in every important respect—including topknot, bare right shoulder, and skirt arrangement—the Sōgonji Bodhisattva is identical to the other members of the Fudōin group (fig. 39), even so far as the five folds over each leg.

The analysis of the Fudōin Triad and the Zenkōji images in northern Japan clearly indicates a specific relationship among the monuments in question. This seems to be evidence for a stylistic diffusion from Shinano Zenkōji both to Mt. Kōya and to the northern Kantō region and, further, to Yamagata Prefecture. The Zenkōji-hijiri had strong connections with Mt. Kōya, so that the presence of a triad there is not surprising. The exact route of transmission is not clear, but traces of a Mt. Kōya/Shinano Zenkōji/Yamagata axis are apparent and of particular value in under-standing the spread of the Zenkōji cult during the Kamakura period.

Many Zenkōji images in Yamagata and in adjacent Akita Prefecture do not belong to the specific lineage discussed here as the Fudōin group, and certainly the spread of Zenkōji belief in this region did not come from a single source.[48] Rather, over the course of at least two centuries, the Zenkōji cult seems to have been propagated by various hijiri connected with several traditions. Furthermore, the emergence of an important center of Zenkōji belief at Hōonji in Yonezawa City is directly related to the treasures brought there from the Shinano Zenkōji by the Uesugi clan after the Kawanakajima Battles in the sixteenth century. This topic will be considered in more detail in Chapter 7 in the discussion of the later history of Zenkōji.

Monuments of the Later Kamakura Period

A number of Zenkōji icons bear dates from 1290 to the end of the Kamakura period in 1333, with small groups clustered in the years 1295–1296 and 1309–1311; and, as is frequently the case, I am not certain whether these clusters have any statistical significance. There are surprisingly few images dated after 1311, with one example from 1316, two examples from 1325, and one example from 1328, at the very close of the Kamakura period. Current research has uncovered relatively few Zenkōji monuments dating after the Kamakura period, although further investigation may turn up additional examples. Apparently the main period for the production of Zenkōji Triads was from about 1250 to 1310, and I assume that the majority of undated icons also fits into this time span. Our survey of Kamakura monuments will conclude with a few examples of Zenkōji images dated after 1290, as well as some undated examples which can be generally attributed to the late Kamakura period.

One of the dated examples is a complete triad of 1290 that is enshrined in Shūtokuin, Chiba Prefecture (fig. 40).[49] Although the mandorla is gone and the Amida has lost his right hand, the figures are generally well preserved and possess characteristic Zenkōji-type pedestals. The central Amida figure is well proportioned and wears the outer robe in the tsūken mode with the hem twisted over once at the left. Nishikawa and Sekine have suggested that this image derives from the lineage represented by the Jōshinji Amida of 1261 (fig. 24).[50] Buddha figures that might be thought to correspond to the Shūtokuin Amida include those of Eimyōji in Saitama Prefecture (fig. 41) and Hōshōji in Kanagawa Prefecture (fig. 42).[51] These linkages suggest a relatively consistently defined group that may provide some hints as to modes of production. The flanking Bodhisattvas of the Shūtokuin Triad can also be related to a

number of images that appear to date to the later part of the Kamakura period.

The Hōshōji Triad (fig. 42) is a particularly important member of this later group despite the fact that it lacks an inscribed date. As with other members of the group, the outer robe of the Amida is worn in the tsūken mode, and the hem is twisted over at left; the drapery folds are very precisely carved. Similar treatment of the drapery can be seen in the two Bodhisattvas. All three figures are well proportioned, and each has a beautifully rendered face.

Two monuments bear dates of 1295: a complete triad at Manpukuji in Ibaraki Prefecture (fig. 43) and a single figure of Amida at Kōmyōji in Saitama Prefecture (fig. 44).[52] The Buddha figures are generally related in style and motif, and both correspond to the Shūtokuin Amida of 1290. The flanking Bodhisattvas of the Manpukuji Triad have some features in common with the Hōshōji Bodhisattvas, which further suggests a late Kamakura date for that important triad.

Dating from the year 1300 is a triad at Seikōji in Chiba Prefecture (fig. 45).[53] Here the figures manifest a modest level of craftsmanship, perhaps indicating manufacture in a provincial studio. All three are short and squat, and the robes of the Amida show very simplified treatment of the folds, utterly lacking in the variety seen in most other images. While the Bodhisattvas display a similar degree of schematization, one observes that the scarf is arranged in a format whereby it crosses in front of the legs rather than hanging straight to the feet.

A rather fine work from the beginning of the fourteenth century is the triad of 1304 enshrined at Nyoraiji in Fukushima Prefecture (fig. 46).[54] This is one of the rare instances of a complete composition, where a mandorla, three figures, and original pedestals remain; only the base that supports the pedestals and mandorla is missing. Although the figures are well designed, there is a good deal of simplification in the articulation of details. For example, the emblems of Kannon and Seishi are incised in a most summary manner into the fronts of the crowns. A similar linear schematization can be seen in the folds of skirts of the Bodhisattvas. This sort of simplification is generally associated with later Kamakura triads, and thus the style conforms well to the 1304 date.

At this stage I would like to attempt a more synthetic account of what may have been perceived as the standard features of a Zenkōji Amida Triad toward the end of the Kamakura period. For this analysis, an undated triad at Gyōtokuji in Chiba Prefecture (fig. 47)[55] will be examined in relation to the Nyoraiji Triad. Like the Nyoraiji Triad, that of Gyōtokuji is essentially complete, including a large boat-shaped mandorla, pedestals, and all three figures. (Interestingly, from pictorial

evidence—see fig. 48a–c—we must conclude that, in the fully complete Zenkōji icon, the mandorla and three pedestals of the triad were meant to be supported by a box-like base, but there appear to be no extant examples of this type of base in sculptural form.) To make analysis as comprehensive as possible, other such "complete" monuments addressed in earlier discussions—those at Shimane Zenkōji (fig. 21), Engakuji (fig. 30), Ankokuji (fig. 32), and Nyoraiji (fig. 46)—and a number of depictions in pictorial form (figs. 48a–c) also will be examined.

The mandorla of the Gyōtokuji Triad displays the basic components seen in other extant Zenkōji mandorlas: a boat-shaped contour, a head and body halo for the Amida, seven subsidiary Buddhas (now mostly lost), and cloud-flame decor along the outer margins. At present the Gyōtokuji mandorla lacks the lotus base element seen in some of the other examples, but this may result from damage and loss, since a row of nail holes along the bottom seems to be evidence of its once having had lotus-petal supports. An analysis of the contours of the extant examples is instructive. The mandorla of the Shimane Zenkōji Triad is, of course, unusual in various respects, and one notes that it assumes a rather tense, dynamic shape culminating in a sharp point. Similarly, the Engakuji (1271) mandorla is also quite strongly articulated in shape but is naturally much wider as is common for the orthodox triad configuration. That of the Ankokuji Triad, completed three years later, in 1274, is tall with a rather sharp point, but the sides lack the subtle contours seen in the Engakuji mandorla, perhaps because this effect is more difficult to achieve in wood. In the Nyoraiji mandorla (1304) a more slack, unemphatic shape prevails, and this tendency is also noted in the Gyōtokuji mandorla, although in the latter instance the designer has included a slight point at the top. The margins of all of the mandorlas are decorated with cloud-flame elements rendered in low relief and then attached to the surface. Only in the case of the Shimane Zenkōji mandorla are these elements incised and seen to resemble quite closely the traditional flame pattern of seventh-century sculpture.

Nishikawa and Sekine point out one illuminating detail in the design of the pedestals for the seven subsidiary Buddhas on the mandorlas of Zenkōji images.[56] Since this feature can be best seen in a graphic form, pictorial representations from Tōshōdaiji and elsewhere (fig. 48a–b) are useful for elucidation. In the case of the lowest subsidiary Buddha at either side, the long stalks that support the pedestals emerge out of the halo and then take the form of a trumpet-shaped element, which gives rise to two stalks: the shorter stalk points directly upward and ends in a lotus blossom; the longer stalk travels outward, then gently turns upward before ending in the Buddha's lotus pedestal. Essentially the same config-

uration appears to have been present in the Engakuji and Ankokuji man-
dorlas, although damage has made it much less apparent. In the Nyoraiji
and Gyōtokuji mandorlas, however, this configuration is far more evi-
dent: for each subsidiary Buddha (now lost) the trumpet-shaped motif
out of which two stalks emerge is clearly visible, as are the two stalks, the
upper culminating in a lotus bud, the other originally having ended in a
lotus pedestal for the Buddha. Why such a specific motif is seen on all
examples of extant mandorlas remains something of a mystery, although
clearly this cannot be mere coincidence. On the other hand, numerous
other motifs in the Triads that are quite different. For instance, the
drapery elements of the Buddha and Bodhisattvas of the Engakuji, An-
kokuji, Nyoraiji, and Gyōtokuji Triads show a great deal of variety, which
must indicate that they were less closely copied from the putative original
than was the mandorla detail under discussion.

The open-work head and body halos are quite consistently designed in
all examples. Each shows lotus tendrils twining through the bands, and
most have blossoms emerging from the sides below the upper zone
where the subsidiary Buddhas are placed. With the exception of the
Gyōtokuji mandorla, all sculptural examples depict a lotus flower at the
center of the head halo; thus, Nishikawa and Sekine suggest that this
element has been lost in the Gyōtokuji example.[57] As iconographic prints
also depict the head lacking the halo lotus flower, however, perhaps one
cannot be certain about its importance. Finally, as Nishikawa and Sekine
also point out, the lotus ornamentation at the base of the mandorla is an
element not seen in the hypothetical seventh-century prototypes of the
Zenkōji-type mandorla.[58] This motif is noted in the mandorlas of the
Shimane Zenkōji, Ankokuji, and Nyoraiji triads, as well as in numerous
pictorial representations, but it is lacking in the Engakuji and Gyōtokuji
mandorlas. The reason for this absence is uncertain, but perhaps it was
part of the original composition and, as suggested earlier, is now lost.

Many more Zenkōji pedestals than mandorlas are extant, but for the
sake of clarity, I think the best procedure is to consider only those pedes-
tals belonging to essentially complete triads as a means of delineating
which elements are displayed consistently. There is a basic differentia-
tion between the pedestals of the Buddha figures and those of the flank-
ing Bodhisattvas. The former are invariably larger; in addition, they
almost always exhibit two layers of downward-pointing lotus petals as
their lower part, with a tall renniku element above. Bodhisattva pedestals
have the renniku upper section and a single layer of downward-pointing
lotus petals below. The only exception to these "rules" is the pedestal of
the Gyōtokuji Amida, which contains only one layer of lotus petals. The
presence or absence of a ring base for the Buddha and Bodhisattva pedes-

tals seems somewhat arbitrary; it is most commonly seen on the pedestal of a Buddha, and it is frequently absent on those of the Bodhisattvas.

A key insight emerges out of this analysis of mandorlas and pedestals: certain highly distinctive features are very frequently represented in essentially the same way. There is a greater degree of consistency in some of these "minor" details than there is among the figures. Only the mudras and the most general features of drapery arrangement are standard; in the details, substantial variation appears. For example, the Buddhas of the Engakuji and Ankokuji Triads have virtually nothing in common in terms of drapery forms. If one looks at the Nyoraiji and Gyōtokuji Buddhas, it is noteworthy that, while the former has the tsūken arrangement, the latter displays the henzan. Similar variety is observed in the Bodhisattvas, particularly in features such as the crowns and drapery systems.

What accounts for the relative consistency of forms in mandorlas and pedestals, and the considerable diversity seen in figural components? Clearly this is not a question of style, but rather one of motif. Apparently in the later Kamakura period there were common iconographical sources—such as the prints cited earlier—that conveyed the essential information to the sculptor. Simple motifs, such as details of mandorla or pedestal configurations, presumably were easily copied from such graphic images. Details of costume, on the other hand, were more freely designed by individual craftsmen, perhaps in keeping with respective studio practice. For a detail such as the crowns of the Bodhisattvas, a degree of uncertainty may have existed as to the proper configuration, thereby leading to the frequent occurrence of hexagonal and octagonal variants.

Conclusion

The main corpus of Zenkōji icons, namely those made between the middle of the thirteenth century and the first decades of the fourteenth, has been surveyed in the preceding pages. Most of these images are found in the Kantō and Tōhoku regions, but some are from more southern locations, such as Mt. Kōya and Hiroshima Prefecture. This distribution indicates in a concrete manner the very substantial geographical diffusion of Zenkōji belief during the later Kamakura period. Considerable variety in design and style exists, and yet some lineage traditions can be distinguished. More research is necessary, however, before a comprehensive understanding of the various lineages can be achieved.

A crucial issue in the context of this study is the status assigned the

more "interesting" examples of Zenkōji sculpture. Of the twelve or so monuments that are currently classified as "Important Cultural Properties," I have shown that several are unique in various respects: the Kōfu Zenkōji (fig. 15), Zensuiji (fig. 18), and Shimane Zenkōji (fig. 21) images examined in Chapter Five; and the Engakuji (fig. 30) and Ankokuji (fig. 32) triads addressed in the present chapter. All are fascinating subjects for study, and yet none is entirely orthodox, in that each is unusual and diverges from the mainstream. Comprehension of the broader significance of the Zenkōji cult and its icons requires a sympathetic consideration of a large number of sculptures which would not normally be thought of as works of the highest aesthetic value. This is not to denigrate the quality of numerous examples in the corpus, for icons such as those of the Kōtokuji (1249; fig. 22), Tokyo National Museum (1254; fig. 23), Fudōin (undated; fig. 33), and Nyoraiji (1304; fig. 46) are certainly fine works. Nevertheless, an even larger category of images exists that is only of limited interest stylistically. And it is precisely here that a search for the core of Zenkōji belief must be undertaken. Without the main icon at the Shinano Zenkōji and all of its replications there would certainly be no cult, and yet the spiritual force attributed to the Living Buddha animates the entire corpus from sophisticated to pedestrian. A fundamental aim of this study, as an analysis of Buddhist sculpture, is to broaden the focus of scholarly attention so that issues of aesthetic concern, while important, are addressed within the larger context of the spiritual and social meaning of specific icons.

The Later History of
Zenkōji and Its Icon

THE TWO PRECEDING chapters analyzed the
large number of Zenkōji Amida Triads produced during the Kamakura
period, emphasizing the relevant stylistic and iconographical issues.
Here the focus will shift to key events in the history of the Zenkōji cult
during the post-Kamakura centuries. These episodes are not simply of
intrinsic interest but, rather, profoundly illuminate some of the essential
features of the cult of the Zenkōji Amida Triad. In this chapter our
attention will return to the nexus of Zenkōji belief, the Shinano Zenkōji
and its icon.

Shinano and Zenkōji in the
Muromachi Period

To best understand the political develop-
ment of Shinano Province, one must remark the absence of a native clan
able to exercise general authority over the province. Of course, there
were strong families who had considerable local authority, but none was
powerful enough to act effectively on a wider stage. As I noted in the
discussion of the Kamakura period, the Hōjō clan was dominant in Shi-
nano during the thirteenth century, and thus its members were the main
patrons of Zenkōji. Without Hōjō support, Zenkōji and its cult would
probably not have grown to the extent that they did. Of course, Hōjō
patronage was not the only significant factor, for the internal dimensions
of the cult were also of great importance.

A detailed account of the decline and fall of the Kamakura bakufu is
unnecessary here. It is well known that the financial burdens assumed by
the Hōjō rulers in preparing the defenses against the Mongol invasions
of 1274 and 1281 put them in very difficult straits. Their fortunes further
declined in the late thirteenth century and during the first decades of the
fourteenth, until the bakufu was finally eliminated in 1333.[1] The imme-
diate successor to Hōjō rule was the curious Kenmu Restoration,
whereby the emperor, Godaigo, and his advisors attempted to reassert
direct imperial rule.[2] Lacking an adequate power base, this "restoration"

was exceedingly short-lived and was soon followed by a new bakufu, established by the Ashikaga clan and led by Takauji.

Shinano experienced a serious power vacuum as a result of the fall of the Hōjō clan. It is surely no coincidence that the most important attempt to revive Hōjō fortunes arose in Shinano Province. This event is referred to by historians as the Nakasendai Disturbance.[3] After the fall of the Hōjō clan in 1333, Godaigo attempted to initiate a new governmental system, but at the same time Ashikaga Takauji was striving to form a traditional bakufu embodying the power and policies of the military class. During this period of political uncertainty and strife, the old governmental structures of the Hōjō regime were subjected to great pressure since they now lacked the validation of central government authority. The extensive holdings of the various branches of the Hōjō clan in Shinano Province were particularly vulnerable to threats from both local warriors, as well as those from representatives of the national political forces. The Nakasendai Disturbance, which began in Kenmu second year (1335), seventh month, under the leadership of Hōjō Tokiyuki, can be seen as a response by the Hōjō to the strong threat to their power. The Hōjō began to campaign from the fourteenth day of the seventh month first in Shinano Province and then in the Kantō region, and after defeating an Ashikaga army on the twenty-fifth day of the same month, they moved into the old bakufu capital of Kamakura. Their administration lasted less than a month, however, for the Ashikaga soon counterattacked and defeated the Hōjō. This defeat effected the end of Hōjō power on a national scale, and with the collapse of Godaigo's regime in the next year, the Ashikaga clan became dominant.

The Ashikaga and Ogasawara carried out "mopping-up" actions in Shinano Province in later 1335 and early 1336, which eliminated the last remnants of the Nakasendai forces, with the result that the Hōjō clan lost control of Shinano. Particularly active in these campaigns was the shugo of Shinano Province, Ogasawara Sadamune (1291–1347). As we will see presently, the Ogasawara clan was of great importance in Shinano during the subsequent period, and yet it should be noted that they lacked the strong national power base that the Hōjō clan had enjoyed. Consequently, they were not able to provide a level of support for Zenkōji comparable to the patronage of the Hōjō clan during the Kamakura period. Zenkōji assumed a somewhat less prominent position during the Muromachi period than it had occupied during the Kamakura, presumably because of the lack of a strong patron.

During the approximately sixty years of the Nanbokuchō Period (Period of the Northern and Southern Courts) the various warrior families of Shinano Province allied themselves to both the Southern Court and to

the Ashikaga bakufu.[4] Those allied to the Southern Court tended to come from the clans earlier associated with the Hōjō, while the pro-Ashikaga side was led by the Ogasawara clan in its position as shugo. Naturally, such divisions led inevitably to strife and conflict within the province as the two sides competed for dominance. At the time of the final conflict between the first Ashikaga shogun, Takauji, and his brother Tadayoshi, the Southern Court faction allied with Tadayoshi, while the Ogasawara clan and their allies fought for Takauji. This included a battle near Zenkōji on Shōhei sixth year (1351), eighth month, tenth day.[5] With the assassination of Tadayoshi in Kamakura in 1352 and the triumph of Takauji, Southern Court supporters declined, and Shinano Province came under the rule of the shogunate. This does not mean that the authority of the Ashikaga bakufu went unchallenged, for the local warrior families retained considerable power and were frequently unwilling to follow the orders of the shugo.

In the late fourteenth century, Shinano was under the authority of the Kamakura branch government, but in ca. 1384 it was transferred back to direct bakufu control, under the *bakufu kanrei* (Deputy Shogun), Shiba Yoshimasa (1350–1410) and then his brother Yoshitane.[6] During this period, the local warrior clans continued to threaten the established authorities, increasingly asserting their own interests. The Ogasawara clan recovered the position of Shinano shugo in 1400 when Ogasawara Nagahide was appointed to the office.[7]

Ogasawara Nagahide, raised in the capital, exemplified the attitudes of the aristocracy. On Ōei seventh year (1400) seventh month, third day he departed from Kyoto and on the twenty-first day of the same month, he and his party arrived at the residence of Ōi Mitsunori, where they carried out consultations concerning the governance of the province. At the beginning of the eighth month, Nagahide, accompanied by a splendid group of retainers, proceeded to Zenkōji. This was not a pilgrimage, since the shugo headquarters was located here. The party was greeted by the provincial warriors who had assembled at the Nandaimon (Great South Gate) of Zenkōji. They were extremely impressed by the grandeur of Nagahide's procession, and expressed their respect, but Nagahide and his retainers treated the locals with scorn. Nevertheless, the provincial warrior groups indicated their willingness to accept Nagahide's authority as shugo, and thus he established his administration near the temple.[8]

Peaceful conditions did not last long. Nagahide overestimated the extent of his power and underestimated the resistance of the local warriors to incursions into their land. The provincial landholders had grown accustomed to autonomy, and were unwilling to recognize the authority of the shugo, or that of his deputies, to enter their territory. When

attempts to exercise administrative control were made, a rebellion occurred almost immediately. This outbreak, which began on the twenty-fifth day of the ninth month of that year, is referred to as the Ōtō Battle.[9] Nagahide was defeated and fled to Shiozaki Castle. A large portion of his army, cut off by the enemy, was forced to seek shelter in an old fort at Ōtō. They were immediately besieged, and because it lacked adequate provisions, Ōtō fort fell on the seventeenth day of the tenth month, with all of its defenders slaughtered. Nagahide withdrew to Kyoto and resigned his position of shugo, thus ending, for the time being, Ogasawara rule in Shinano Province. Once more the central government was having great difficulty in asserting its authority over Shinano.

Interesting traditions connect the Ōtō Battle and Zenkōji. One tells of a brave young warrior of the Ogasawara forces, Banzai Nagakuni, who perished in the defeat at Ōtō fort. Two courtesans of the quarter in front of the gates of Zenkōji, Tamagiku and Kaju, had been intimate with Nagakuni and bitterly lamented his death. They went to the battlefield, located his remains, which they returned to Zenkōji, and disguising themselves in black robes, mourned for Nagakuni.[10] Other stories tell of monks attached to Zenkōji going to the battlefield and burying the remains of the dead, and also of informing the survivors of the tragic fate of their loved ones.[11]

The Ōtō Battle and the defeat of Ogasawara Nagahide must have had profound significance for Zenkōji. If Nagahide had been successful in his efforts to establish a powerful administration as shugo, one assumes Zenkōji would have benefitted from a relatively stable governmental structure in its region, perhaps analogous to that administered by the Hōjō clan. With the defeat of the Ogasawara clan, however, the local political situation lapsed into an uneasy truce among various provincial families contending for influence. Within such an environment, Zenkōji could hardly have been expected to receive the protection and support of one dominant clan. For this reason, perhaps, the legends relating the Ōtō Battle and Zenkōji have a tragic, melancholy character, for with the collapse of the Ogasawara, the temple faced an uncertain, frightening future.

After the defeat of the Ogasawara, Shinano Province was once again placed directly under the authority of the Ashikaga bakufu.[12] This led inevitably to conflict between the Shinano warrior clans, the bakufu authorities in Kyoto, and the Kantō Headquarters (*Kantō kubō*) in Kamakura. At this point a new leader of the Ogasawara clan, Ogasawara Masayasu (ca. 1380–1442), appeared on the scene. In 1416–1417 a leading warrior, Uesugi Zenshū, rebelled against the Kantō Headquarters, which was then under the authority of Ashikaga Mochiuji. In response to

requests for help, Ogasawara Masayasu assisted the bakufu in quelling this revolt.[13] In 1425, perhaps as a reward for these services, Shinano Province was returned to the Ogasawara clan, with Masayasu appointed as shugo.[14] He appears to have had the usual difficulties in bringing the province under his authority because of the resistance of powerful local warriors.

Not much is known about Zenkōji during these years, but in 1427 the entire temple was destroyed by fire. The fire started at the East Gate, spreading to other structures until nothing was left.[15] Legend records that the Living Buddha escaped the flames by flying to a nearby structure called the Yokoyama Dōjō. Since the Main Hall was not reconstructed until 1465, almost forty years later, apparently only limited financial support was available to maintain Zenkōji.

Ogasawara Masayasu continued to be a central actor in political military affairs until his death. During the Eikyō Disturbance (1438), he assisted the bakufu forces in defeating the now-rebellious Ashikaga Mochiuji in Kamakura. When Yuki Ujimoto subsequently aided Mochiuji in reestablishing his forces, Masayasu led the troops that defeated this party in Kaikitsu first year (1441), fourth month. These were trying days for the bakufu, since the shogun, Ashikaga Yoshinori, had been assassinated by Akamatsu Mitsusuke in the sixth month of that year. The kanrei, Hosokawa Mochiyuki, informed Masayasu of these events, but by this stage Masayasu was becoming inactive, and he died in the next year somewhat over the age of sixty.[16]

The assassination of Ashikaga Yoshinori plunged the bakufu into crisis, while the death of Ogasawara Masayasu produced an uncertain political situation in Shinano Province. Turmoil and chaos ensued there, culminating in the Urushida Battle (1446), which resulted in the division of the Ogasawara clan into two main branches.[17] One branch, under Masayasu's son, Mitsuyasu, established its base in the Ina region of southern Shinano; the other branch, under a nephew of Masayasu, Mochinaga, set itself up at Fuchū, or present-day Matsumoto. The decisive battle was fought at Urushida, near Zenkōji, at the place assumed to have been the headquarters of the shugo. As a result of this battle, both factions of the Ogasawara abandoned the Zenkōji Plain, establishing themselves much to the south. Consequently, in the rich Zenkōji Plain region, the local warrior clans increased their power substantially, and this important area became a lost cause as far as the Ogasawara clan was concerned. Once more, Zenkōji found itself in a rather tenuous situation, unable to depend on any single great clan for protection and support.

Onjōji appears to have maintained authority over Zenkōji until the time of the Ōnin War (1467–1477), but the near total disruption of

society that resulted from that civil war ended the long-lasting Onjōji administrative role at Shinano Zenkōji. A local warrior clan, the Kurita, then assumed control of Zenkōji, thus basically transforming fundamental aspects of the administrative structure. One branch of the Kurita clan, the *Yama-Kurita* (Mountain Kurita) had long held the position of Togakushi-bettō, while a second branch, the *Sato-Kurita* (Village Kurita), who resided near Zenkōji, took the position of Zenkōji-bettō. While bettō is often a religious title, and members of the Kurita clan took priestly names, they also had lay titles and names, and consequently should be thought of as lay bettō. For the rest of the fifteenth and through the sixteenth century, the Kurita clan played a central role in connections with Zenkōji and the Living Buddha, as we shall see presently.[18]

The general situation in Shinano Province after the Ōnin War and during the Sengoku Period ("The Period of the Warring States," 1477–1568) was characterized by instability and chaos. The Ogasawara clan was able to maintain a tenuous hold over southern Shinano, and small warrior clans continued to dominate the Zenkōji Plain. Shinano Province was threatened, however, by the increasing power of the Takeda clan of adjacent Kai Province (now Yamanashi Prefecture) to the south and the Uesugi clan of Echigo Province (now Niigata Prefecture) to the north (map 3). The lack of a dominant group in Shinano—and the power vacuum that developed in the Zenkōji Plain—resulted in a series of battles that fill this void and lead to a extraordinary chain of events in the history of Zenkōji and its icon.[19]

The Kawanakajima Battles and the Establishment of Kōfu Zenkōji

During the Sengoku Period, a fundamental reordering of the political, economic, religious, and cultural institutions of Japan took place, culminating in the unification of the country under the Tokugawa bakufu (1615–1868).[20] The Ōnin War marked the end of any pretensions on the part of the Ashikaga bakufu to govern the country in an effective manner, even though Ashikaga shoguns continued in their putative role as the political heads of state. Reality was different: various great lords—the *daimyō*—governed their own domains, often extending to a whole province or more, as independent rulers, and the hold of the Ashikaga family on the shogunate continued only because the relative power of the greatest of the daimyō produced a situation in which they tended to cancel each other out. The political history of the Sengoku Period is largely an account of shifting alliances, battles, and intrigue, as one faction fought it out with another. At the conclusion of the period,

three military leaders—Oda Nobunaga (1534–1582), Toyotomi Hide-yoshi (1536–1598), and Tokugawa Ieyasu (1542–1616)—succeeded in turn in asserting control over their peers, with the last establishing a family dynasty that was to last some 250 years.

Here the key decades are the 1550s and 1560s, just prior to the ascendancy of Oda Nobunaga.[21] Certainly at mid-century there would have been no indication that Nobunaga was to be the victor and, in fact, several of the most prominent daimyō may have seemed more plausible candidates, among them Imagawa Yoshitomo (1519–1560), Takeda Shingen (1521–1573), and Uesugi Kenshin (1530–1578). The latter two are particularly important for the present study. Takeda Shingen was the lord of Kai Province; Uesugi Kenshin the lord of Echigo Province.[22] Both were remarkably effective generals, with powerful military forces at their disposal and the inclination and ambition to utilize these resources. Shingen and Kenshin both formed numerous alliances with other leaders, including Oda Nobunaga and Imagawa Yoshitomo, as the political situation shifted and turned at mid-century, but most important here are the relations that they maintained with each other. A glance at the map reveals that between Shingen's Kai Province and Kenshin's Echigo Province lies the large province of Shinano (map 3). Not only does Shinano lie between Kai and Echigo, but at the time under consideration it lacked a powerful daimyō ruler able to exercise overall control. Not surprisingly, Shingen and Kenshin hastened to fill this void, with the result that a series of battles were fought there between 1553 and 1564, designated by historians as the Kawanakajima Battles. Takeda Shingen was particularly aggressive in his campaign against Shinano Province, actively threatening the northern part of the province. In 1553, reacting to this pressure, the lords of northern Shinano, including Murakami Yoshikiyo, called upon Uesugi Kenshin for assistance. Kenshin used this request as a pretext for entering Shinano, thus beginning the Kawanaka-jima Battles. At first the Kurita clan, under their leader Kurita Kakuju, fought on the side of the Uesugi, but it quickly shifted its allegiance to the Takeda clan.[23]

In terms of the broader political and military situation, the Kawanaka-jima campaign was of particular significance in that it kept two of the most powerful generals occupied with each other, rather than with the forces that were gathering around Oda Nobunaga. Kawanakajima—literally, "island between the rivers"—refers to the stretch of land between the Sai and Chikuma rivers on the Zenkōji Plain. Here Shingen and Kenshin fought at least five battles, some involving large numbers of troops and extensive campaigns. During the second battle of the series, in 1555, Zenkōji was destroyed by fire and its treasures taken by the forces

of Uesugi Kenshin and Takeda Shingen. The evidence suggests that the latter got the larger and more important portion of the booty, which perhaps is not surprising, as he was aided by Kurita Kakuju and by the nun Kyōkū of the Daihongan, the main subtemple of Zenkōji at that time. The Kurita clan accompanied the Zenkōji treasures to Kōfu, and in 1568 Shingen gave the leader of the clan, Kurita Kakuju, general authority over Kōfu Zenkōji. Shingen first moved his spoils to Netsu Village, Saku County in Shinano Province and then, in 1558, to his headquarters in Kōfu, Kai Province (map 4). Kenshin took his share to Kasugayama Castle in Echigo, where it remained until the Uesugi clan was later transferred to the Aizu region of Fukushima Prefecture. (These objects subsequently were transferred to Yonezawa in Yamagata Prefecture, and are now in Yonezawa.)[24] In late 1555, Imagawa Yoshitomo served as an intermediary between the Takeda and Uesugi sides and a truce was concluded, although it was subsequently broken and fighting resumed. Ultimately Takeda Shingen triumphed and took control of the Zenkōji Plain. Despite this victory, however, the treasures of the Zenkōji were not returned to their rightful home.

What precisely did Takeda Shingen take to Kōfu? Textual sources refer to the main icon of Shinano Zenkōji and so it can be assumed that the original small gilt-bronze triad—the Living Buddha—was brought along. Other treasures are mentioned, without specific detail being given in all cases. It is a reasonable assumption that the early objects extant at Kōfu Zenkōji today must have been brought there by Shingen as a result of the Kawanakajima Battles. These would have included, in addition to the Living Buddha, the large, gilt-bronze Amida Triad dated 1195 (fig. 15), the temple bell dated 1313, and the statues of members of the Minamoto clan, including Yoritomo (fig. 12) and Sanetomo.[25] Presumably many other objects came as well.

Documentary evidence provides substantial detail regarding the building of Kōfu Zenkōji.[26] The treasures arrived in Kōfu on Eiroku first year (1558), ninth month, twenty-fifth day, and work began on the new temple in the next month. The columns were erected by the following year, with the ridge poles in place the year after that, and there was a ceremony celebrating the completion of the Golden Hall on Eiroku eighth year (1565), third month, twenty-seventh day. That work continued on other buildings can be seen from an entry of Eiroku eleventh year (1568), eleventh month, tenth day, which records a request to a subtemple (the Daihongan) to gather lumber for construction. These activities culminated in a ceremony celebrating the installation of the Living Buddha, which was held during Genki third year (1572). Since the work was supervised by Kyōkū, the important nun from Shinano Zenkōji men-

tioned earlier, one can assume that the new temple in Kōfu followed traditional practices. Takeda Shingen must have been proud of his new temple, enshrining the Living Buddha of Zenkōji, and he may have felt that it would be an enduring monument to his conquest of Shinano. Ultimately it did become just such a symbol, as will be seen presently, but in the short term, Shingen's aspirations were bitterly frustrated.

Takeda Shingen died in 1573, at the relatively early age of fifty-three, still at the height of his power. Without his leadership the clan declined rapidly, and at the battle of Nagashino (1575) the Takeda forces, under Takeda Katsuyori (1546–1582), were soundly defeated by an Oda-Tokugawa army. Katsuyori and Kurita Kakuju continued to hold out, but, in 1581, a key fort fell, and Kakuju died in battle. Upon the death of his father, Kurita Eiju was confirmed in the management of Kōfu Zenkōji by Takeda Katsuyori. The end was now near for the Takeda clan, and, after a string of defeats, Takeda Katsuyori committed suicide on Tenshō tenth year (1582), third month, eleventh day. This was the end of a once-powerful and proud clan.[27]

With the demise of the Takeda clan, the status of Kōfu Zenkōji and its treasures became uncertain. Oda Nobutada (1557–1582), the son of Nobunaga, transferred the Zenkōji Amida Triad to his base in Mino Province, and the temple where the triad was kept subsequently became the Gifu Zenkōji (map 4).[28] The leaders of the Oda clan, however, were only to enjoy possession of the image for a few months, for in the middle of 1582 Nobunaga and Nobutada were assassinated in Kyoto.

The Zenkōji Amida Triad and Toyotomi Hideyoshi

After the assassinations of Oda Nobunaga and Oda Nobutada, Nobutada's younger brother, Nobukatsu (1558–1630), moved the Zenkōji Amida Triad from Gifu and installed it at Jimokuji in Owari Province (now Aichi Prefecture) (map 4).[29] The administrators of Kōfu Zenkōji, however, wished to have the icon returned and, as a result of orders by Tokugawa Ieyasu, it was sent back to Kōfu in the middle of 1583.[30] Although its stay at Jimokuji was very short (less than a year), there were important consequences, as will be shown presently. On the journey from Jimokuji to Kōfu Zenkōji the triad stopped briefly at various places, including Kamoedera in Hamamatsu. Then, for the next fourteen years, it remained enshrined at Kōfu Zenkōji.

With the death of Oda Nobunaga, Toyotomi Hideyoshi quickly gathered the reins of power, so that by the mid-1580s his rule was secure.[31] His authority consolidated, Hideyoshi embarked on various building

projects, including a monumental temple in Kyoto called Hōkōji (fig.
49).[32] Central to this establishment was an enormous hall—the Daibu-
tsuden (Great Buddha Hall)—designed to house a gigantic Great Bud-
dha that was planned to be even larger than the Great Buddha at Tōdaiji
in Nara. In view of Hideyoshi's megalomania, one might find it amusing
that his Great Buddha was not constructed of bronze, as was its eighth-
century predecessor at Tōdaiji, but of more economical wood. Nev-
ertheless, this must have been a highly impressive icon, even if its later
sixteenth-century patron was not willing to make the sort of pious invest-
ment characteristic of the Nara court.

On Keichō first year (1596), seventh month, thirteenth day, a great
earthquake hit the Kyoto area, and one of the fatalities was Hideyoshi's
Great Buddha, which was reduced to rubble.[33] Hideyoshi must surely
have been distraught by such a terrible and frightening event. Shortly
after this tragedy Hideyoshi had a dream in which the Zenkōji Amida
Triad appeared, informing him of its desire to be moved to Kyoto.[34] As
discussed in an earlier chapter, dream-oracles in which the icon gives
orders are an important aspect of the Zenkōji tradition. Doubtlessly
Hideyoshi had learned from some person about the great powers of the
Zenkōji Amida Triad, and its tendency to deliver dream-oracles. In
searching for a source of this information, a very likely candidate is the
nun Chikei Shōnin of Jimokuji, who was a successor to Kyōkū. Not only
was Chikei associated with Jimokuji at the time that Nobukatsu en-
shrined the Zenkōji Amida Triad there, but she was also closely con-
nected with important immediate vassals of Hideyoshi, including
Fukushima Masanori (1561–1624).[35] Thus there are strong grounds to
believe that people in Hideyoshi's immediate circle could have convinced
him of the desirability of summoning the Living Buddha to Kyoto.

In the sixth month of Keichō second year (1597), Hideyoshi ordered
Asano Nagamasa (1544–1611) to go to Kōfu in order to receive the
Zenkōji Amida Triad and escort it back to Kyoto.[36] Nagamasa had been
appointed lord of Kai Province in 1593, and thus he was designated to
attend the triad on its journey. Accompanied by 500 soldiers and 236 post
horses, Nagamasa led a grand procession from Kōfu into Suruga Prov-
ince (now Shizuoka Prefecture), with a stop at Hamamatsu and then
traveled on through modern Aichi, Mie, and Shiga Prefectures. At each
major stop the icon was guarded by local daimyō. The penultimate stop
was at Ōtsu, where the procession waited for a large party coming from
the capital to meet the Zenkōji Amida Triad and escort it to the city
(map 4).[37]

Hideyoshi was very excited about the prospect of receiving the Zenkōji
Amida Triad, and he ordered Mokujiki Shōnin Ōgo to ensure that the

monks of Mt. Kōya participate in the welcome. Ōgo contacted the leaders of Kongōbuji, the main temple on Mt. Kōya, and arranged for 150 monks in ceremonial robes to come down from the mountain for the occasion. Although the triad was supposed to have arrived on the fifteenth day of the seventh month, it did not actually appear until the eighteenth day. The welcoming party, which went out to Ōtsu, included 150 Tendai monks, 150 Shingon monks, as well as the prince-abbots of several important temples. The procession that entered the city was led by Mokujiki Shōnin Ōgo, followed by musicians and horsemen and then the shrine of the icon, flanked by men carrying banners. Bringing up the rear was the responsible daimyō, Asano Nagamasa.[38]

The most detailed account of the events surrounding the installation of the Zenkōji Amida Triad at the great hall of Hōkōji is found in *Rokuon Nichiroku* in an entry of Keichō second year (1597), seventh month, eighteenth day.[39] After explaining Asano Nagamasa's role in bringing the icon to Hōkōji, the text refers to the building of the Daibutsuden and the destruction of the Great Buddha by the earthquake of the previous year. It describes Hideyoshi's unhappiness about the lack of power apparent in his Great Buddha, and his resolve to replace it with a more appropriate icon. The theme of the dream-oracle appears once more, this time in the form of dreams occurring on three successive nights, in which the Zenkōji Amida Triad orders that it be enshrined in the Daibutsuden. With the installation of the icon, the name of the hall is changed from Daibutsuden to Zenkōji Nyoraidō. Observations are made in the *Rokuon Nichiroku* about the tendency of the small to excel the great, referring to the collapse of the original Great Buddha and its replacement by the tiny triad. The narrative reaches its denouement when the Zenkōji Amida Triad is equated with Hideyoshi and the wooden Great Buddha with Nobunaga, and the 1596 earthquake is symbolically interpreted as the traitor Akechi Mitsuhide striking down Nobunaga. This fabulous story allows all of the details to be fitted into a powerful account of the demise of the Great Buddha and the ascendancy of the Zenkōji Amida Triad that directly parallels the fall of Nobunaga and the rise of Hideyoshi.

This optimistic scenario did not proceed as anticipated. Shortly after the Zenkōji Amida Triad was enshrined at Hōkōji, Hideyoshi's plans began to unravel: his efforts to conquer Korea did not reach fruition; he became increasingly ill, and he was plagued by worries about the prospects for his heir, Hideyori (1593–1615), at the time a boy of four. By the middle of 1598 Hideyoshi was in very poor health, and on the fifth day of the eighth month of that year he presented to the Five Elders his request that the regency be established for Hideyori. People of Hideyoshi's household may have begun to have second thoughts about the benefits of

having the Zenkōji Amida Triad, especially when recalling that ill luck
had befallen both the Takeda and Oda clans after they took possession of
the triad. Presumably as a result of such considerations, the icon was
abruptly sent back to Shinano on the seventeenth day of the eighth
month. The *Tōdaiki* account states that it was transported from Kyoto
to Shinano by post-horse, and that in the course of the journey the
flanking Bodhisattvas were severely damaged.[40] Hideyoshi died the next
day in Fushimi Castle, shortly after the icon left Hōkōji, and certainly
long before it arrived back in Shinano (map 4).

During the years from 1555 until 1598 the Zenkōji Amida Triad was
transported from place to place with some regularity without the ap-
proval of its home temple. To date no other instance of this sort of
situation has been documented in the history of Japanese Buddhist icons,
although perhaps the tradition of sangoku denrai may offer a partial
justification for the triad's peripatetic habits. In considering just exactly
what was on the move during these decades, the following hypotheses
can be advanced:

1. The original Living Buddha from India was still extant; those without
strong religious faith will be highly doubtful about this possibility.

2. An old icon, of the type reconstructed in Chapter Three, was still
extant, and it was the one taken here and there. This posits that this image
survived the numerous fires between 1179 and 1475, which is somewhat
unlikely.

3. An icon made after one of the disastrous fires was assumed to be the
original, and it was the one that traveled. Certainly this is the most plausi-
ble suggestion.

If these hypotheses are analyzed in more depth, we see that what really
travelled around was a *concept*, the concept of the "Living Buddha" who
could offer salvation to believers. Consequently, the status of the icon
hidden deep within its shrine was primarily theoretical, since its powers
were accepted by the faithful and its tradition as a hidden icon was well
established.[41]

Naturally, the absence of the Living Buddha—either as tangible icon
or abstract concept—had a devastating impact on Shinano Zenkōji. The
outcome of the Kawanakajima Battles was that Shinano Province came
under the control of the Takeda clan, and one can hardly imagine that the
remaining priests at Zenkōji would have had much success petitioning
Takeda Shingen to return the icon now installed at Kōfu Zenkōji. After
the fall of the Takeda clan, Oda Nobunaga appointed Mori Nagayoshi as
lord of the Kawanakajima region.[42] The son of Uesugi Kenshin, Uesugi
Kagekatsu (1555–1623), now lord of Echigo Province, urged the warrior

families of northern Shinano to rebel against their new lord, Mori Nagayoshi. This rebellion was unsuccessful, however, and Nagayoshi destroyed both rebels and their families in a particularly harsh manner. Nevertheless, Nagayoshi's period of supremacy turned out to be short, for with the assassination of Oda Nobunaga in 1582, he lost his patron and fled from Shinano. Uesugi Kagekatsu then became lord of northern Shinano Province, a position that he retained until 1598.[43] Ironically, as a result of the Kawanakajima Battles, the Takeda clan gained the area around Zenkōji, but with the death of their leader, Takeda Katsuyori, they lost the territory to the leader of their old enemy, the Uesugi clan. Kagekatsu appointed Myōkan'in as abbot of the Daikanjin, one of the two main subtemples, with orders for him to revive Zenkōji. This must have been an essentially futile task given that the temple's *raison d'être*— the Living Buddha—was still absent.[44]

Early in 1598, Hideyoshi transferred the Uesugi clan to the Aizu region in present-day Fukushima Prefecture, and Uesugi Kagekatsu was enfeoffed with holdings of almost 1,000,000 *koku*, one of the richest holdings in the land.[45] The warrior clans of Echigo and northern Shinano provinces were required to accompany the Uesugi to Aizu. Hideyoshi appointed new lords to the major castles of the Zenkōji Plain, and at the same time took a large proportion of the available land for his own family. Since Hideyoshi died shortly thereafter, however, these new administrative arrangements probably did not have much impact on the Zenkōji region. With the rise of Tokugawa Ieyasu to supreme power, Hideyoshi's retainers were removed from office, and Ieyasu appointed Mori Tadamasa lord of Kaizu Castle in 1600.[46] Tadamasa retained this position until 1603, when Ieyasu made his sixth son, Matsudaira Tadateru, lord of Matsushiro (Kaizu Castle).[47] Since Tadateru was only twelve years old at this time, he was obviously not in a position to govern the large area himself, and Ieyasu designated Ōkubo Nagayasu as overall administrator, with other warriors to control Kaizu and Naganuma Castles. Tadateru retained Matsushiro until 1616, and then after two short periods when other lords were in charge, Sanada Nobuyuki was transferred in 1622 from Ueda to Matsushiro. The Sanada clan kept control of Matsushiro *han* until the Meiji Restoration, thereby assuring reasonable political stability in the Zenkōji Plain for over two hundred years.[48]

Zenkōji in the Edo Period

With the return of the Living Buddha to Shinano Zenkōji in late 1598, the temple was once more in a position to flourish as a religious center. There is a tradition that a donation given in

the name of Toyotomi Hideyori enabled the rebuilding of the Main Hall in 1599, although this is not certain.[49] In 1601, Tokugawa Ieyasu granted Zenkōji estates valued at 1,000 koku, thus providing the temple with an appropriate level of support.[50] These developments imply the beginning of a period of prosperity, but on Genna first year (1615), third month, thirteenth day, the Nyoraidō was destroyed by fire caused by lightning, and the Living Buddha was just barely removed at the last moment. A temporary hall was then constructed, but in 1642 it also succumbed to fire.[51]

Although Zenkōji as a whole is not affiliated with a specific sect of Buddhism, it is administered by two subtemples that do have sectarian affiliations: the Daihongan, headed by an abbess, is of the Jōdo sect; the Daikanjin, headed by an abbot, is Tendai. The available evidence suggests that the Daihongan was established earlier than the Daikanjin, although ultimately the latter became the more powerful of the two. When, for example, Ieyasu granted the 1,000 koku just noted to Zenkōji the Daikanjin received 100 koku, while the Daihongan got only 50 koku, a clear indication of lesser status.[52] There has been ill will between these two units since at least the seventeenth century. A pattern of quarreling emerged after the fire of 1642, when the Daihongan and the Daikanjin argued over which should have responsibility for rebuilding the destroyed Main Hall. The Daihongan asserted that since ancient times it had the responsibility for rebuilding, while the Daikanjin presented evidence suggesting that in the past the two had cooperated in construction projects. Since the two sides could not reach agreement, the bakufu official responsible for religious institutions, the *jisha bugyō* (Administrator of Temples and Shrines), stepped in and ordered them to cooperate; the result of this effort was a temporary hall completed in 1650.[53]

The hall completed in 1650 was not intended to be permanent, and Zenkōji was granted permission in 1661 to seek funds throughout Shinano Province to finance the building of a new Main Hall. Construction was completed and a ceremony held to install the Living Buddha in 1666.[54] This structure, referred to as the Kanbun-era Nyoraidō, was essentially the same in size and design as the present Main Hall; unfortunately, it was poorly built and by the late seventeenth century it, and other structures at Zenkōji, were in bad condition. That a hall completed in the 1660s should have significantly deteriorated by the early 1690s is strange, but perhaps the general prosperity of the Genroku period (1688–1704) motivated the authorities at Zenkōji to attempt a substantial enhancement of their facilities.

In the course of the seventeeth century the authority of the Tendai sect at Zenkōji, represented by the Daikanjin, became increasingly strong.

The monk Tenkai established a direct connection with Tendai in 1643, forming an affiliation with Kan'eiji in Edo. Originally the three groups of subtemples at Zenkōji had a variety of sectarian affiliations: the *Shuto* was Tendai, the *Nakashū* was Jōdo, and *Tsumadoshū* was Ji. In 1685–1686, however, the Nakashū and Tsumadoshū were required to become Tendai, under the authority of the Daikanjin, and to abide by the regulations of Kan'eiji. Although the Daihongan authorities protested these actions, their wishes were not heeded, and the Daikanjin became the dominant institution at Zenkōji. Ushiyama has argued that this process can be interpreted in the context of the development of a characteristic feudal structure within Tokugawa society, one unwilling to tolerate equality between male and female entities.[55]

The vicissitudes surrounding the construction of the present Main Hall provide both an engaging story as well as important data regarding building projects during the Edo period. The process can be divided into two phases: a period between 1692 and 1700, when Zenkōji endeavored to carry out the project alone; and one after 1700, when the bakufu realized that the temple could not manage such a vast effort on its own.[56]

Fundamental to any construction project is the raising of necessary funds, and because the Main Hall of Zenkōji was planned on a very large scale, this was a serious problem, indeed. There was no single patron in a position to finance the project alone, nor was it feasible to raise the money locally, so other options had to be explored. The means chosen constitute one of the most significant religio-economic phenomena of Edo Buddhism.

In many ways the most effective fundraising technique available to a Buddhist temple is careful control of access to its most important icon. If people can see and worship the icon at any time they wished, the spiritual resonance of this activity would be devalued. Consequently, most of the important icons in Japan, except those of extremely large scale, are kept in closed shrines, behind curtains. Such images are known as *hibutsu* (Secret Buddha), and the Zenkōji Amida Triad is, of course, an example of this phenomenon; in fact, it is probably the most secret of all Japanese icons. In the case of a normal hibutsu, the image is revealed to the faithful periodically, often once a year. At that time, the doors of the shrine are opened and the curtains within unrolled to reveal the icon in a ceremony called *kaichō* (opening the curtains).[57] This, of course, is a time when the temple can hope for substantial donations. Zenkōji must have utilized this practice continually over the centuries, although what was actually revealed to the faithful was the *Maedachi Honzon*, the "Image that Stands in Front," rather than the Living Buddha. Because of the tremendous expenses involved in the construction project, it was unlikely that ade-

quate funds could have been collected from only those who visited the temple in person, and so an alternative strategy was necessary.

A variation on the kaichō, popular during the Edo period, was the *degaichō* (Transporting [the icon] and Opening the Curtains). This involved taking the icon in its shrine to another locale, where it was then displayed to people who may not have had the opportunity to worship it at the home temple. There are several icons that were particularly associated with degaichō activity, including the Shaka of Seiryōji, the Zenkōji Amida Triad, and the Fudō of Narita. One can easily see why the Seiryōji and Zenkōji images would have lent themselves to this sort of effort, since both were strongly associated with transmission from one country to another. While the present Seiryōji Shaka is documented as having been made in 985 in China, medieval Japanese widely believed that the icon was actually the original image of Shaka made during his lifetime in India. Similarly, the legendary accounts of the Zenkōji Amida Triad describe a journey from India to Paekche and then to Japan. In both cases, this was and is referred to as sangoku denrai (Three Kingdom Transmission), although the three in question are different in these two instances.[58]

Perhaps in the case of many holy icons the priests of the temple would have been reluctant to move the image. However, both the Seiryōji and Zenkōji images have such strong traditions of movement that there would seem to have been no reluctance to exploit this situation and transport the images around in order to raise funds.

Zenkōji petitioned the jisha bugyō in Genroku fifth year (1692), fourth month, to carry out a degaichō in the "Three Cities" (Edo, Kyoto, Osaka).[59] Permission was granted for a sixty-day display, beginning on the fifth day of the sixth month of that year, at Ekōin in Fukagawa. The Maedachi Honzon, the *Nehan Shaka* (a representation of the historical Buddha at the time of his entry into Nirvana), and other temple treasures were accompanied to Ekōin by the abbot of the Daikanjin, the abbess of the Daihongan, and other people connected with the temple. The sources suggest that it was not the most secret image, the "Living Buddha," that travelled, but instead the Maedachi Honzon, an icon that, as we saw above, is still at times revealed to the faithful, although only on special occasions. A study of the early sources does not always indicate whether a specific statement refers to the Living Buddha or to the Maedachi Honzon, and one can assume that such ambiguity is at times intentional. For instance, during the degaichō, presumably not a great deal of effort was devoted to explaining that the object of worship was not actually the Living Buddha. The Three Cities degaichō was so extremely

successful, with numerous worshipers attending, that it took only fifty-five days to complete.[60] On Genroku fifth year (1692), eighth month, fourth day, in accordance with the wishes of Keishōin, the mother of Shogun Tsunayoshi, the Maedachi Honzon was taken into Edo Castle, where it could be worshiped by the shogunal court. Keishōin, a very pious lady, made a large donation of 100 ryō to pay for the making of a new shrine for the image.[61] After this sign of the highest respect, the Maedachi Honzon was taken to the mansions of the various daimyō in Edo.

There was a year interval before the degaichō proceeded to the Kansai region. During 1694 it was first at Shinnyoin in Kyoto and then at Tennōji in Osaka.[62] During the Kyoto-Osaka degaichō, in addition to the Maedachi Honzon and the Nehan Shaka, paintings representing the Three Founders (Honda Yoshimitsu, Yayoi, and Yoshisuke), as well as an image of Prince Shōtoku, were also displayed. This last, of course, was especially appropriate for Tennōji, a temple said to have been founded by Prince Shōtoku at the end of the sixth century.

The proceeds from the Three Cities degaichō, after expenses had been deducted, were 13,000 ryō, an extremely large sum.[63] These funds were intended to finance the construction of a grand Main Hall. A new site, slightly to the north of the previous location, was selected, apparently because the authorities thought that earlier fires were caused in part by close proximity of the Main Hall to other buildings. Purchase of this land cost 119 ryō, and an additional 53 ryō were paid in compensation to those required to move. A team of officials and carpenters was assembled, and work began in Genroku tenth year (1697), second month. Considerable efforts were required to obtain the necessary lumber, at a cost of about 5,300 ryō. The project seemed to be proceeding satisfactorily when, on Genroku thirteenth year (1700), seventh month, twenty-seventh day, a fire spread from the town, destroying various buildings and most of the lumber that had been gathered.[64]

Throughout the first phase of construction, the Daihongan and the Daikanjin had not cooperated effectively, and with the disastrous fire of 1700, the bakufu authorities realized that Zenkōji would have difficulty carrying out the reconstruction on its own. As Shogun Tsunayoshi and Keishōin were eager to see the project completed, Yanagisawa Yoshiyasu, a leading bakufu official, was ordered to assist.[65] This begins the second phase of construction. Late in 1700 the incumbent Daikanjin abbot, Mikai Hōin, was removed from office and a new Daikanjin abbot, Keiun, was appointed.[66] Since Keiun had a strong relationship with Yanagisawa Yoshiyasu, he could count on the full backing of the bakufu in carrying

out the project. In addition, the abbess of the Daihongan was Yanagisawa's daughter Chizen, which further concentrated authority within one group.

Keiun was, from all accounts, a formidable character. At the time he was appointed Daikanjin Abbot, he was thirty-eight years old and was serving as the chief priest of Daihofukuji and Kan'ōji, both in Edo. Because of the failure of the previous administrative efforts at Zenkōji, those involved in that phase were totally discredited, and Keiun assumed absolute authority. Upon coming to Zenkōji, Keiun first audited the financial records and, finding discrepancies, attempted to recover the lost funds. Nevertheless, he realized that substantial efforts at fundraising would be necessary in order to achieve success, and petitioned the bakufu for permission to carry out a *kaikoku kaichō* (Kaichō throughout the Provinces). Permission was granted, and the Genroku kaikoku kaichō took place between 1701 and 1706, covering during these years many regions of Japan (map 5).[67]

The kaikoku kaichō, as planned by Keiun, was intended to be as efficient as possible as the group travelled around the country. On the other hand, it could not be too modest, for then the appropriate dignity and impressiveness required to elicit donations would be lacking. About thirty people accompanied the Zenkōji treasures. At the head of the party was the leader, followed by the donation chest carried by two men. Then came the palanquin of the go-inmon (the seal used to confer the blessings of the icon), carried by four men, and the palanquin of the Maedachi Honzon, carried by six men. Other treasures followed in the rear, including portraits of the Three Founders.

The kaikoku kaichō began in Genroku fourteenth year (1701) in Edo; the treasures were first displayed at one of Keiun's temples, Kan'ōji, from the tenth day of the third month until the tenth day of the fifth month. In the sixth month it began circulating through the Kantō provinces of Kazusa, Shimōsa, and Awa, all corresponding to modern Chiba Prefecture. The party, with its treasures, then spent the end of the year at the other of Keiun's Edo temples, Daihofukuji. Not only was this an appropriate time to rest, but the go-inmon was, in addition, required at Shinano Zenkōji for the ceremonies greeting the New Year. In 1702 the group visited other provinces in the Kantō and once more wintered at Daihofukuji. The next year it moved along the Tōkaidō, ending up at Oyama Zenkōji in Osaka. In 1704 it traveled down along the Inland Sea, crossing over to Kyūshū and going as far south as Kagoshima. It then crossed over to Shikoku, visiting Uwajima and Tokushima before sailing for Osaka. The year 1705 saw the party travelling south along the Japan Sea to Matsue and Tottori, and then back to the Shiga, Gifu, and Fukui

area. The final year, 1706, consisted of the trip north along the Japan Sea, passing through Kanazawa, Itoigawa, and Kashiwazaki before heading inland to Nagaoka; then south to Iiyama in Shinano and finally returning to Zenkōji on Hōei third year (1706), eighth month, sixteenth day (map 5).

Keiun was very strict concerning the money collected. Members of the party were not allowed to go out at night, and funds not needed for expenses were immediately forwarded to the Matsushiro han offices for safekeeping. The amount collected over the five years was not revealed, but since the construction of the Main Hall was financed primarily by this effort and, in addition, the Daikanjin used some of the money for its own building projects, the returns were probably more than 30,000 ryō.[68]

The construction process did not have to await the completion of the kaikoku kaichō, because funds were deposited to the Zenkōji account each year as the kaichō progressed. In the winter of 1702, Keiun invited a bakufu construction foreman, Kōra Buzen Nyūdō Shūga, to Daihofukuji and entrusted him with the rebuilding of the Main Hall of Zenkōji.[69] Kōra did not draw up new plans for the structure, but rather produced a somewhat simplified version of the earlier plan of 1694.[70] In the summer of 1703 Kimura Manbei went to Shinano to begin gathering the necessary lumber, always a difficult task. Construction began on Hōei first year (1704), ninth month, fifteenth day, and was completed on Hōei fourth year (1707), eighth month, thirteenth day, at a cost of almost 25,000 ryō. Of this amount, more than 50% was the cost of lumber. The building completed in 1707, one of the largest wooden structures in Japan, is the present Main Hall of Zenkōji.[71]

Throughout its history, Zenkōji was an important goal for pilgrims. As noted in earlier chapters, knowledge of Zenkōji and its icon was spread through the entire country by hijiri and other religious practitioners. In addition, local centers for the cult—Shin Zenkōji—were ubiquitous. Naturally, the opportunity to worship the actual Living Buddha enshrined at the Shinano Zenkōji always remained a primary goal of the devout. Moreover, for the slightly less pious, pilgrimage was the main form of tourism during the Edo period, since it provided an acceptable justification for travel. Various sources provide information about the routes taken by pilgrims to reach Zenkōji, generally following the major roads. Inns located at convenient points serviced the travelers and these inns, in turn, derived substantial portions of their incomes from such business.[72]

The majority of pilgrims traveled to Zenkōji as members of formal religious entities called kō.[73] These were devotional societies affiliated

with specific temples or deities, and they were organized in such a manner that believers in a given area could join together in group pilgrimage for the purposes of economy, safety, and communal spirit. In the case of Zenkōji kō, women were particularly numerous since the temple offered special guarantees of salvation to them. Frequently, the kō would be guided on its pilgrimage by priests referred to as *oshi* or *onshi*.[74]

The situation at Zenkōji proper provides us with interesting data regarding the practicalities of an important pilgrimage center during the Edo period. There was, of course, no such city as Nagano at this time; rather, the area around the temple was called Zenkōji-machi. This must be seen as primarily a temple town, in distinction to the castle town, for it had no specific political function and much of the population was associated with activities relating to Zenkōji.

When the pilgrim arrived at Zenkōji-machi, a decision had to be made about lodging. There were two main possibilities: outside of the temple precincts numerous inns catered to travelers; and within the precincts a large number of subtemples lodged pilgrims. Conflicts often broke out between these two groups as they competed for customers. Even within one category, such as the subtemples of Zenkōji, discord arose concerning the sharing of patrons. In the latter case, a decision was finally reached whereby individual subtemples housed pilgrims from specific regions of the country, thereby spreading the pool of customers among the whole group.[75]

We should not conceive of Zenkōji-machi and of the temple itself in overly pious terms. While the principal aim of most of the pilgrims was undoubtedly to worship the Living Buddha, this did not preclude other, less elevated, activities. Tea houses and drinking establishments, shops selling various goods, and entertainers of all types, catered to the desires of the visitors. Solemnity was appropriate at certain stages of the pilgrimage, but lively high spirits also had a place. Those who followed the cult of the Zenkōji Amida Triad were normally not philosophical in spirit, nor were they inclined toward an ascetic approach to salvation. Rather, such pilgrims represented a cross-section of the Japanese population who saw their specific religious devotions as only one aspect of a total range of activities. Nothing could be more natural than enjoying oneself while at the same time taking highly effective steps to ensure both good fortune in this life and a guarantee of rebirth in paradise in the next life.[76]

After settling down in lodgings, the pilgrim normally bathed and rested. However, he or she did not necessarily spend the first night in an inn, for the most important aspect of the Zenkōji pilgrimage was *o-komori*, the custom of remaining for the entire night within the Main

Hall of Zenkōji. At dusk the faithful gathered at the temple and then settled down for the night, grouped in accordance with the region from which they hailed. Individuals rested or even napped at the beginning, but at the sounding of the midnight bell, everyone promptly sat up straight as the officiating priest commenced the evening service. Since all the doors of the temple were closed, it was quite dark, creating a properly mysterious atmosphere. The flickering light of the eternal lamps dimly illuminated the altar on which the Living Buddha is enshrined, while the solemn chanting of the priest enhanced the spiritual impact of the experience. At this stage, the worshiper could enter the kaidan meguri, the subterranean passage under the altar and circumambulate below the shrine of the Living Buddha. As discussed earlier, the kaidan meguri symbolizes death and resurrection, and obviously combined with the general ambience of o-komori, it must have been supremely potent in producing a powerful religious effect.[77]

The pilgrimage and religious activities just described constitute the core of Zenkōji belief as known primarily from Edo sources. Pilgrims had as their central object of devotion the small gilt-bronze triad that is the subject of this study. As suggested above, the "original" icon was probably not still extant at the temple after the numerous fires over the centuries. But, clearly, this is not the relevant point. Rather, what was important was the concept of the Living Buddha, an icon so infused with spiritual force that the believers were convinced that it guaranteed rebirth in paradise. The ceremonies and practices at the main Zenkōji were evidently so impressive, and presumably effective, that they motivated numerous people to recommend that their relatives and friends also make the pilgrimage, thus ensuring a constant stream of worshipers. The magnificence of the ritual and the overall ambience of Shinano Zenkōji have been stressed in order to make clear the religious foundations of the cult. At a certain stage in the development of the cult the actual presence of the icon was no longer necessary, since the ritual activity alone sufficed to maintain the tradition. And yet we must always return to the foundations of the system, which are based on a deep belief in the efficacy of a tangible icon. To put it in the plainest terms, "No icon, no cult!" Of course, the icon and cult are dialectically interactive, and one could not exist without the other. The powerful tradition within the history of Buddhism of belief in miraculous icons established the framework for the development of the cult of the Zenkōji Amida Triad, and this cult was sustainable long after the original icon was unavailable for direct worship. The fact that the sanctity of the Zenkōji Amida Triad at Shinano was such that it was never shown to the worshipers does not mean that its replications were also not shown. While the images enshrined in the

Shin Zenkōji were not ordinarily visible to the worshipers, they were shown often enough that there was no doubt about their actual, physical presence.[78]

Zenkōji was fundamentally a religious center, devoted to the furthering of specific cult practices, but of course existed within the broader secular world of Edo-period Japan. Since the temple controlled a quite large amount of land in the Zenkōji Plain, administrative structures were required to manage its properties and gather needed revenue. The land of the Zenkōji Plain was divided into estates (*ryō*) under the control of various authorities, including the bakufu itself, local han authorities (Naganuma, Ueda, and Matsushiro), and Zenkōji. Legal rights for the land of Zenkōji were vested in the two subtemples, the Daikanjin and the Daihongan, each of which had the same status as a daimyō. Although the temple and its property were under the protection of Matsushiro han, the latter did not administer the temple's land; rather, the temple assumed this responsibility for itself. The religious position of the leaders of the Daikanjin and the Daihongan made it inappropriate for them to be directly involved in administrative matters. Moreover, the Daihongan, as a nunnery under an abbess, was seen as especially remote from secular affairs. Consequently, the management of the temple lands was delegated to officials associated primarily with the Daikanjin. In particularly important matters, there were discussions between representatives of the Daihongan and the Daikanjin, but generally speaking, the latter managed day-to-day affairs.[79]

In the early part of the Edo period the Takahashi clan was responsible for the administration of the Zenkōji properties. They apparently utilized very old-fashioned administrative systems reflecting those of the medieval era, when the Kurita clan was dominant at Zenkōji. Frequent complaints about the archaic practices of the Takahashi clan led to their removal in 1678–1679, and a number of other families, including the Yamazaki, Imai, Nakano, and Kubota, were involved in the management of Zenkōji properties during the rest of the Edo period.[80]

Various administrative structures were devised to govern the Zenkōji territories. At the top were the representatives of the two subtemples, who were called the *daikan*. These individuals were temple samurai (*terazamurai*) and were full-time officials. Below the temple authorities were men referred to as *hikan*. They were usually wealthy members of the community but not of samurai background, although they were given honorary samurai status in recognition of their services to the temple. Normally there were about ten hikan associated with both the Daikanjin and the Daihongan. These men could be relied on to come to the aid of

the temple in times of difficulty, and they thus performed an important function in the administration of Zenkōji. Thus, there were both full-time, professional managers (daikan) and a group of individuals (hikan) who worked for the good of the temple on a voluntary basis. Clearly, the latter group was motivated primarily by the prestige that its members received as a result of their position.[81]

A specific chain of command connected the temple to the local people. The daikan would normally communicate directly with the *machidoshi-yori*, the chief administrative officer of the people. There were three or four machidoshiyori, each of whom took a turn serving for a one-month period. The machidoshiyori would convey orders to the *shōya* (village headmen), who would in turn pass it down to the *kumi gashira* (group leaders), representing the bottom level of the administrative structure.[82]

Territory controlled by Zenkōji was divided into various units. Directly associated with the temple were the *ryō gomonzen* (the two areas in front of the temple gate): Yokozawa-machi was connected with the Dai-kanjin, Tatsu-machi with the Daihongan; both were controlled by the daikan. Living in these areas were people who worked for the temple itself, rather than having an association with agriculture. The balance of Zenkōji territory was divided into eight towns (*machi*) and three villages (*mura*), which were primarily agricultural, and were administered by the shōya.[83]

The information provided in the preceding paragraphs helps us understand the operation of a large-scale temple in the pre-modern period. We must avoid an overly pious view of Zenkōji, for there was a strong intermingling of the sacred and the secular. Many people were involved in the administration of the temple and its property. At times, the religious dimension would be central, but at other times, secular activities would be primary. Naturally, these realms would call on the services of different individuals, although these groups formed a single constituency, ultimately dependent on the cult of the Living Buddha for their livelihood.

The nineteenth century was a tumultuous period for Shinano Zenkōji. The area was struck by a large earthquake in 1847, causing great damage to the temple and its surroundings. Some 2,400 homes were destroyed, and over 2,000 people perished. Tragically, the earthquake hit during a time when special ceremonies were going on at Zenkōji, so many pilgrims suffered. Although the Main Hall of the temple was saved, the very extensive damage to other structures necessitated considerable repair work, which was difficult to finance. Additionally, pilgrims became reluctant to visit the temple on account of the fear of earthquakes, thus

decreasing revenues at an especially bad time. However, the buildings were eventually repaired through the cooperation of bakufu and the local authorities.[84]

The coming of the Meiji Restoration (1868), and the resultant modernization of Japan, had profound implications for Buddhist temples. When the old feudal structure was abolished in 1871, Zenkōji lost its lands, thus experiencing tremendous financial problems. The opening of a railroad line connecting Nagano City with Tokyo in 1893 greatly facilitated travel, however, and since that time Nagano Prefecture has been one of the most important tourism centers in Japan. Not surprisingly, Zenkōji has shared in this good fortune, now being one of the wealthiest temples in the country.[85]

CHAPTER 8 Conclusion

For centuries, the cult of the Zenkōji Amida Triad has occupied an extremely important position in the religious life of the Japanese people. The aim of the preceding six chapters has been to trace in as much detail as practical the origins and development of the cult, from its legendary beginnings through recent times. The sheer complexity of the issues and the enormous body of pertinent data require a treatment that at times may have seemed overly detailed and technical. For a full comprehension of all dimensions of the Zenkōji cult, however, the broadest range of methodologies must be employed, thereby bringing diverse approaches to bear upon specific aspects of the problem.

Here I will shift from a general presentation of data, as developed in Chapters 2 through 7, to a broader discussion of the most significant issues associated with the cult of the Zenkōji Amida Triad. Although the secondary literature on Zenkōji is quite extensive, this material is generally uncritical, lacking in analytic depth, and deficient in efforts at synthesis and cross-cultural comparison. Individual studies have offered excellent accounts of specific images and certain aspects of the history of Zenkōji; what we still need is a probing analysis of the broader contexts of the cult. Since little guidance can be expected from previous scholarship, the following discussion is necessarily tentative; nevertheless, we must move beyond specificity and detail to greater generalization and a more theoretical explication if we hope to understand the nature of Zenkōji and its icon.

The Icon at Zenkōji

This study is founded on the notion that the cult of the Zenkōji Amida Triad is in essence an icon cult. Thus, each aspect of the discussion has been designed to elucidate critical contextual material concerning the status of the icon(s). I would like to emphasize this point, since the Living Buddha can no longer be seen in its shrine at Zenkōji in Nagano. Therefore, as discussed above, in the present case there is the somewhat unusual situation of an icon cult devoted to what is, for all intents and purposes, an invisible image.[1]

Since the present usage of the terms "icon" and "icon cult" is not

entirely standard, some clarification is needed. In common parlance the word icon usually refers to a pictorial representation, most frequently to the painted panels so central to Byzantine and Russian Orthodox Christianity. While three-dimensional objects are not excluded from the normal definition, the emphasis is certainly on two-dimensional, graphic representations of a deeply sacred nature. In designating a three-dimensional object of religious practice, a number of terms come to mind: sculpture, statue, idol, fetish, image; but objections can be raised to each. A sculpture may be either religious or secular, as can a statue, so that neither of these terms captures fully the sacred dimensions so essential for the purposes here. Quite the opposite problems arise with the words "fetish" and "idol": these concepts are redolent with religious and magical implication, but there are such strongly pejorative overtones to both that their employment in serious religious discourse is highly questionable. The last word cited—"image"—is unobjectionable from the latter point of view, and is very frequently used for three-dimensional objects. Like "statue" and "sculpture," however, image is quite neutral in connotation; the sacred and mysterious qualities of the Zenkōji Amida Triad seem inadequately conveyed by "Zenkōji and its Image." In addition, image is now frequently employed in theoretical investigations of various types, and has taken on meanings that may not be entirely suitable for the present study. For these reasons, icon is the most appropriate term for the Zenkōji Amida triads, since it captures fully the intense religious resonances of the objects under consideration. The term "iconicity" is employed to convey the mode by which this religious resonance is conveyed.[2]

In the interests of clarity a few observations are in order regarding the term "icon cult." Worship of sculptural icons is ubiquitous in Japanese Buddhist practice, and so, in a very general sense, virtually all schools and temples can be associated with icon cults. In the present context, however, something more specific is implied: an icon cult is here defined as a case when devotion is directed to images that are very precisely delineated and which are replicated, at least in theory, as exact copies of a canonical central prototype. In this limited sense, one of the few other important icon cults in Japan is that associated with the Seiryōji Shaka, since all replications in that tradition theoretically go back to the prime object housed at Seiryōji in Kyoto. This is not to say that other sculptures, or sculptural lineages, are not based on well-defined traditions, for of course they are. Extensive collections of iconographical drawings were utilized by both priest and sculptor, and reference was of course made to extant objects, as is characteristic of image production at all times throughout the world. Most Buddhist statues in Japan, however, are not

normally conceptualized as being exact replications of a prototype, but rather as relating directly to the characteristics of the deity which they represent.[3]

The reader should by now be convinced that this study really is concerned with an icon cult even though within the slightly peculiar context of a totally hidden main image. Since the worshipers believed and still believe that a tangible icon is enshrined at Zenkōji, and since there are numerous replications of the original icon spread throughout Japan, there can be no doubt that "iconicity" is fundamental to this religious system.

Given the overwhelming importance of the concept of iconicity to the Zenkōji cult, I would like to try to place this specific instance within a broader analysis of the theory and practice of the icon in Buddhist worship. While the cult of the Zenkōji Amida Triad has certain unusual features, it obviously shares many characteristics with other types of Buddhist icon cults seen in Japan as well as in other areas of Asia. The following discussion will treat icons in the context of three-dimensional, sculptural images, since in important respects such images are significantly different from two-dimensional pictorial images. At least three conceptions of the meaning of the icon are valid, as follows:

1. The icon as representation or likeness of the deity.
2. The icon as symbol of the deity.
3. The icon as the deity.

These formulations are not intended to be exhaustive, and of course they overlap in certain cases, but they are broad enough to provide a basis for discussion.

Clearly "icon as representation of the deity" is the basic conception in Buddhist religious art, indicating the most common way of viewing images. In the early, "aniconic" phase of Buddhist art in India, the Buddha was represented by various symbols such as his footprints, a throne, a wheel, or a column.[4] Later, in a subsequent stage of Buddhist religious thought and practice, actual depictions of the Buddha in essentially anthropomorphic form replaced the symbolic representations. These depictions included a number of specific iconographical markers, but more important than such details is the sense of idealization that the sculptors aimed at in producing their images. Initially developed in the early Indian schools of Mathura and Gandhara, the idealized formulation of the Buddha exerted great influence on subsequent developments in India as well as in Central Asia, Southeast Asia, and East Asia.[5]

Numerous legends account for the way in which specific icons or icon lineages relate to the form of an actual Buddha.[6] Most illuminating in the

present context, of course, is the tradition of the Seiryōji Shaka, discussed in an earlier chapter. A monarch of ancient India, King Udayana, who lived at the time of the historical Buddha, Shaka, is believed to have had an actual portrait sculpture made of the Buddha in sandalwood. The holy image was copied and recopied over the centuries, thus perpetuating the actual physical likeness of the historical Buddha. How literally this account is accepted undoubtedly depends on circumstances, with humble worshipers seeing the representation as exact and true and more sophisticated viewers perhaps assuming a less "exact" representation. In either case, the fundamental belief is that this type of icon gives the worshiper some sort of direct access to the Buddha whose appearance is depicted.

The second category, the "icon as symbol of the deity," is more complex in theological terms. It relates to the notion that an icon does not, and cannot, literally represent the deity, but rather serves as a symbolic substitute for that deity. Since the Buddha is assumed to be a transcendent being, totally beyond the comprehension of the human mind, obviously in this perspective representation in concrete form is impossible. But even within this conceptual framework, with its acknowledgement of the imperfect quality of the icon, there is a belief that the icon can serve as a direct stimulus and as an aid to meditation that, in turn, may lead to spiritual progress.

The third category, "the icon as the deity," delineates, of course, the situation of the Zenkōji Amida Triad. This conception necessarily entails category (1) inasmuch as the image must be an exact representation of the deity, but goes far beyond the usual parameters of (1) in claiming that in some mysterious manner the deity is incarnated in the icon itself, the icon literally becoming the deity. This idea directly contradicts category (2), since it is not content with an abstract symbolic explanation of the icon, but insists that the object of worship is alive. David Freedberg has traced in detail numerous examples of icons, primarily Christian, that manifest animate characteristics, and, of course, this phenomenon is also frequently seen in Buddhist practice.[7] The desire to worship a living icon, very deeply rooted in human psychology, is expressed in an especially direct manner in the cult of the Zenkōji Amida.

These three categories can and do overlap, and of course, a single icon can be interpreted in terms of different conceptualizations at various times or by diverse individuals. For example, a religious professional may ascribe primarily symbolic meanings to a specific icon, while at the same time this very icon is seen by laymen as an accurate representation of the Buddha. The latter viewpoint can easily begin to move toward an ascription of powers to the icon, which inevitably involves an association between concrete image and the superhuman deity it is thought to repre-

sent. From this point, only one step is needed to reach the assumption that the power of the deity—even the deity itself—is incarnated in the actual icon.

An important benefit of a careful study of the Zenkōji Amida Triad is the insight provided about one point on the spectrum of religious opinion, a point diametrically opposed to conceptions of the deity as ineffable and transcendent. A clear understanding of the concrete, tangible nature of Zenkōji belief should alert the reader to phenomena fundamental to icon cults throughout the world. At the very least, this information will serve as a salutary warning against too ready acceptance of theologically sophisticated but exceedingly abstract conceptions of the significance of the icon, conceptions of a type that can never have had much influence on the majority of worshipers.

I would like to examine a little more closely some of the ways in which icons are designed and function. No matter which of the three perspectives is operative, clearly veracity is essential to the production of an icon. This is self-evident in the context of the "icon as representation," while in the case of the "icon as symbol" there are almost always precisely specified prescriptions as to how the image is to be made.[8] Obviously, in the third category the conception that the icon is "living" logically entails its exact resemblance to the deity "represented" or, better, "manifested." In all three cases, this belief in accuracy is fundamental, whether it is that the icon (a) somehow or other depicts the form of the deity; (b) represents its essential qualities symbolically; or (c) is an actual incarnation of the deity.

In the usual parlance of art history, the preceding analysis would be classified as "iconographical" since it strives to categorize the fundamental components necessary to recognize the nature of a specific icon; if the pertinent traits are present, the icon will be identified. Within given iconographical parameters, however, an exceedingly wide range of stylistic variation is possible, although that seldom hinders the process of identification. This study has not emphasized stylistic development for reasons explained earlier. Nevertheless, to place the Zenkōji Amida Triad tradition properly within the conceptual structure of the icon as proposed here, some attention must be given to the stylistic dimensions of both icons in general and the Zenkōji icon in particular.

For the sake of analytical clarity, I will assume that all icons have been conceived and made by human agents; regardless of other claims, we must explain why the icons manifest the stylistic traits that they do. Generally speaking, icons embody aesthetic qualities such as beauty, power, spiritual resonance, and the like. A study of mainstream Buddhist sculpture inevitably grapples with these matters, striving to isolate and

describe regional, sectarian, and individual stylistic manifestations, as well as those of historical period. Clearly, the sculptor seeks to produce an icon to satisfy the iconographic and stylistic requirement of his time and place. The patron who contributes the necessary funds and the religious professional who offers advice both tend to motivate the sculptor to excel. While this paradigm is critical to any analysis of elite art production, it has less utility in the case of a more popular tradition such as the Zenkōji Amida Triad group, a canonically defined form that, at least in theory, must be exactly replicated in the copies. While such iconographically strict requirements do not totally preclude stylistic experimentation, they certainly tend to inhibit it to a significant degree. Moreover, virtually all Zenkōji icons were made outside of the realm of elite production, with the result that the social and economic factors which normally motivate stylistic evolution were not important.

The Myth (The Engi)

I have tried to present a relatively full analysis of the nature and function of icons, as these topics are central to the present study. In particular, I have been concerned to probe the implications of the "living icon" concept, a subject often slighted by historians of religion and art, as Freedberg has pointed out so vividly.[9] Less detail is required for the consideration of the myth since there is a very extensive and well-developed literature devoted to this subject.[10] The function of myth in expressing on an archetypal level central concerns of human experience can be observed in virtually all cultures, and this role is clear in *Zenkōji Engi*. Most important, of course, are those aspects of the myth that respond to innate fears concerning death and the nature of the afterlife, articulating persuasive and satisfying solutions to these overwhelming problems.

To recapitulate briefly, the Zenkōji myth begins in ancient India, with the marvelous events surrounding the sickness and death of Princess Nyoze, the daughter of the wealthy man Gakkai; the intercession of Amida Buddha and the revival of the princess; and the subsequent making of the holy icon representing the Amida Triad. The account then shifts to the ancient Korean Kingdom of Paekche in the sixth century, with Gakkai reincarnated as the famous King Song, and the Amida Triad flying magically from the Indian subcontinent to the Korean Peninsula to urge the king to change his ways. Finally, the icon travels to Japan, where the Gakkai/King Song reincarnation sequence culminates in Honda Yoshimitsu, who is responsible for bringing the icon to Shinano Province and establishing there the cult of the Zenkōji Amida Triad.

This is an edifying tale, but is also highly entertaining, guaranteed to capture the attention of those who heard it.

The dramatic climax of the entire myth is reached when Honda Yoshisuke, the son of Yoshimitsu and his wife Yayoi, tragically dies, leaving his parents bereft. While this death is functionally equivalent to that of Princess Nyoze at the beginning of the engi, included is the far more significant dimension of Yoshisuke's descent to hell, his experiences there, and his rescue by the Living Buddha and reentry into the human world. This is an archetypal version of the "Otherworld Journey" as seen throughout history: an individual "dies," leaves the body, travels to the otherworld, most frequently a graphically described hell, and then returns to this world, where an account is given of both the general nature and the specific details of the experience. Of course, the salvation of Yoshisuke described here guarantees that those who are devoted to the Zenkōji Amida Triad will be saved from hell, thus insuring a rebirth in paradise.[11]

Although Yoshisuke's death, travels in hell, and salvation are the culmination of the myth, an additional dimension is provided when Empress Kōgyoku rewards father and son with governorships, and accedes to their request for funds to build a grand temple to house the icon. Here the profound gift of salvation is not stressed, but mundane rewards designed to make earthly existence more pleasant.[12] There are concluding sections of Zenkōji Engi of a more or less historical nature, including the accounts of the icons made by Jōson and Jōren, mention of various pilgrims who travelled to Zenkōji, and descriptions of halls built at the temple (as well as references to the frequent fires), but such material falls outside of the usual category of myth.

Relationship of Icon and Myth

In the two preceding sections, icon and myth were analyzed separately, but they must also be discussed together because an awareness of their relationship and interaction is fundamental for an understanding of the nature of the cult and its great popularity over the centuries. A consideration of both of these aspects reveals that the Zenkōji cult goes beyond traditional ideas associated with abstract or symbolical visualization of the deity or the otherworld. This is not a situation of "icon as symbol" or "faith in salvation," but a far more tangible belief system that, at least to a wide range of believers, was and still is extremely convincing and powerful.

Thus the main icon of the cult is not conceived of as an inanimate symbol, but as an actual living presence.[13] This conceptualization of the

icon as Living Buddha is basic to one central dimension of the cult. Similarly, the believer does not have to accept on faith an account of the otherworld, be it hell or paradise; but is instead provided with a vivid eyewitness description based on the "real" experiences of Yoshisuke. The highly concrete and tangible characteristics of these two dimensions of the Zenkōji cult generate the underlying structural foundation on which the entire belief system is erected. In the following pages I will discuss several other extremely important aspects of the cult, but we must bear in mind that the icon-myth complex always remains as the central component.

The Priesthood

The nature of religious practitioners at Shinano Zenkōji in the early stages is uncertain, although one assumes that at proto-Zenkōji, the situation would have been similar to what was found at other provincial temples. While there was probably a priesthood that ministered to the needs of local worshipers, presumably there would not have been monks and nuns concerned primarily or exclusively with their own personal spiritual exercises. A fundamental transformation probably took place when a largely shamanistic, popular religion propagated by the hijiri became the dominant current at the temple.[14] We have already studied the activities of the hijiri in spreading Zenkōji belief throughout Japan, so this need not be reconsidered here. In the present context, however, we should keep in mind the new ideas and practices that hijiri must have contributed to the cult of the Living Buddha.

In addition to hijiri, who by definition are itinerant, a resident priesthood would have been living in the temple as soon as it was a well-established institution. Some of these resident priests would also have had careers as hijiri, and some may have combined both roles, although it is likely that a non-hijiri priesthood would have quickly developed. In previous chapters, we considered the administrative organization of Zenkōji from the Heian through the Edo period. The temple was supervised by the Jimon branch of the Tendai School during the Heian, Kamakura, and early Muromachi periods, but after the Ōnin War direct Jimon control apparently lapsed. In the Edo period, however, Tendai authority was reasserted, although the development of a dual structure of the Tendai Daikanjin, with an abbot, and the Jōdo Daihongan, with an abbess, resulted in some bifurcation of religious authority. Presumably, the pairing of abbot and abbess at Zenkōji ultimately reflects the shamanistic practice of a male/female couple receiving oracles, which harks

back to the shamanistic roles of Yoshimitsu and his wife Yayoi, as described in *Zenkōji Engi*.

While the Daikanjin and the Daihongan are still the dominant subtemples in the Zenkōji complex, there are numerous other small subtemples of various sectarian affiliations.[15] These latter subtemples have served over the centuries primarily as lodgings for pilgrims, but of course each is headed by a priest and in theory has its own religious life. In this context, I would like to point out that the central locus of the cult—the Hondō, or Main Hall—has not been affiliated with any sect and does not have its own priesthood. Consequently, the religious ceremonies carried out in the Hondō are performed by priests and priestesses from the Daihongan, the Daikanjin, and the other subtemples.

When the Shin Zenkōji network is examined, far more modest organizational structures are apparent. A few of the larger establishments such as Kōfu Zenkōji, had, in former times, numerous priests, but normally there would have been a single priest who served the needs of the local worshipers. Perhaps in some cases his wife served as a partner in receiving oracles. As discussed in an earlier chapter, the Shin Zenkōji were not formally affiliated with Shinano Zenkōji, so the priests of these temples were not subject to the authority of the main temple, an egalitarian structure somewhat unusual in Japanese Buddhism.

In addition to organizational matters, we must examine the character of the Zenkōji priesthood. As should be evident by this point, I am avoiding the designations monk-monastery/nun-nunnery as inappropriate for the Zenkōji cult, and instead utilize the terms priest/priestess and temple. Basically, an amalgamation of two currents is apparent that might be diagrammed as shown below.

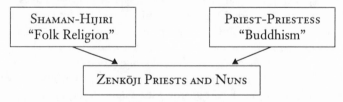

While certainly not unique, this combination is somewhat unusual, and it is basic to an understanding of Zenkōji belief and practice.[16] The priesthood mediated between Living Buddha and worshiper, ensuring that benefits guaranteed by Yoshisuke's salvation from hell would be available to those who participated in the cult. The rituals performed by the priesthood, as we will see in the next section, are structurally related to the basic icon/myth complex in that they tend to be physical and active

rather than meditative and passive. The worshiper is not interested in, nor does the priesthood provide, an emphasis on moral or ethical precepts; rather, the focus is on direct, concrete actions which transfer powers from Living Buddha to devotee.

As soon as permanent centers were established, a professional priesthood would arise, leading to significant economic factors that must be included in a discussion of the Zenkōji system. Each member of the priesthood had to acquire the resources to sustain himself, and in some cases dependents as well. Consequently, the priesthood had a vested interest in maintaining both the cult in general and each local manifestation in particular. While this process is usually presented in terms of piety—and obviously in many cases piety is present—the economic dimension must also be kept in mind. The very nature of the Zenkōji belief system resulted inevitably to a direct exchange of wealth as the worshiper paid the priest for performing rituals that were believed to guarantee salvation and other benefits.

Ritual

Throughout this study, I have made sporadic references to ritual, and now we must look more carefully at the ritual dimensions of the Zenkōji cult.[17] Certain types of ritual are an absolutely fundamental component of Zenkōji belief, although complete data are difficult to gather and, in any case, there were undoubtedly significant variations over time and locale. Consequently, the most that I can do here is to indicate some of the more important varieties of ritual activity, with the hope that these examples will illuminate the nature of the cult.

Earlier I demonstrated that the belief system and practices of the Zenkōji cult are "mixed," and consequently the ritual activities are similarly diverse in origin and expression. An amalgamation of these two strands must have taken place over the centuries, but for the sake of analytical clarity, they can be usefully distinguished.[18]

The shamanistic stratum is best considered first.[19] Clearly, the whole issue of oracles is a specifically shamanistic manifestation that is a fundamental defining feature of the shaman throughout the world, and as we noted in the discussion of the priest/priestess complex at Zenkōji, the phenomenon of a male/female pair receiving messages from the otherworld is generally important in Japanese religion. In *Zenkōji Engi* there are descriptions of Honda Yoshimitsu and others, including Jōson and Jōren, receiving oracles from the Living Buddha. These messages tend to be related to wishes of the Living Buddha himself, and thus are of a somewhat elevated character; the fact that the Living Buddha of Zenkōji

is capable of giving messages through the medium of the priesthood to the worshiper results inevitably, however, in requests for intercession or information of a more personal nature. In particular, the desire to communicate with deceased relatives is natural, and Gorai has recorded examples of this practice.[20]

Other ritual activities that have been mentioned also seem to have a strong shamanistic or popular religion component. For example, the practice of o-komori—sequestering oneself in the temple for an entire night—appears to be a "rite of passage" activity closely related to those seen in various religious traditions. As a result of spending the night in the darkness of the Hondō, before the Living Buddha, the believer hopes to be transformed from an individual still at risk of hell to one destined for paradise. More graphic, in the context of rite of passage thought, is the practice of kaidan meguri (fig. 50), symbolizing death, movement through the underworld, and then rebirth-salvation. The utilization of the go-inmon (fig. 51) and other seals to convey the blessing of the Living Buddha to the believer by pressing it on the forehead also can be related to practices of popular religion.[21]

There are, of course, numerous other ritual activities carried out at Zenkōji that are more typical of orthodox Buddhist practice. These include the recitation of sutras, prayer and chanting, and various types of music. While these are certainly important, they seem less basic to the Zenkōji cult than the popular religion and shamanistic practices just mentioned. Obviously if worshipers were interested in more standard Buddhist ritual, other temples could provide this in orthodox form; what distinguishes Zenkōji is the specific ritual that concretely conveys the grace of the Living Buddha by means of acts performed by priest and worshiper.

The Worshiper

There are, of course, two basic loci of Zenkōji practice: Shinano Zenkōji, the main center, and the numerous temples of the Shin Zenkōji network. In analyzing the relationship of worshipers to these establishments, various factors must be taken into account. At both the great Shinano Zenkōji and the modest Shin Zenkōji, a group of believers in the immediate environs could have been depended upon for support. More interesting, of course, are those who come from a distance to worship. While this on occasion would have involved a lesser temple, the case of Shinano Zenkōji is most pertinent, since this is a temple which in the past drew an enormous number of pilgrims, as it still does today.

Women have always been extremely important participants in the worship of the Zenkōji Amida Triad. In *Zenkōji Engi*, as we have seen, Princess Nyoze is a key protagonist, and Honda Yoshimitsu's wife, Yayoi, is central to the Japanese development of the story, as is Empress-Regnant Kōgyoku, who fell into hell, later to be rescued by Yoshisuke. A variety of spirited women visited or lived at Shinano Zenkōji during the Kamakura period, including Tora, Senju, and Nijō. This pattern of pilgrimage continued in later centuries, and during the Edo period a very substantial portion of the visitors was female. As we noted, the important role of the Abbess of the Daihongan is highly significant in understanding the attraction of the Zenkōji cult for women. In short, Shinano Zenkōji cannot be interpreted properly without a strong focus on the centrality of women in the cult both as religious practitioners and as worshipers.[22]

The entire topic of pilgrimage in the context of Zenkōji belief deserves close analysis. Ample evidence exists for the journeys of numerous important pilgrims over the centuries, including such famous individuals as Kakuchū, Chōgen, Ippen, Lady Nijō, Mujū Ichien, Gyōe, etc., and in some cases there is information about their motivations and experiences. An application of Victor Turner's analysis of pilgrimage to the situation of Shinano Zenkōji may illuminate important dimensions.[23]

As Turner indicates, the pilgrim leaves his or her normal environment and the social structure within which he or she lives, and through travel, voluntarily enters a liminal dimension totally different from the everyday world. The travel associated with pilgrimage usually involves a substantial investment of time, energy, and wealth, and is frequently associated with hardship, or even suffering. These challenges, of course, are ordinarily believed to enhance the efficacy of the pilgrimage. Shinano Zenkōji's location in a remote area of central Japan, surrounded by high mountains, guaranteed that some difficulties would be encountered in getting there.

Upon arrival at the pilgrimage goal—the main liminal space—the pilgrim has specific expectations as to what services the religious institution should provide. Turner's analysis of Catholic Christian pilgrimage stresses the performance of two sacraments, Penance and Eucharist. The functional equivalents at Zenkōji are:

1. Worship before the Living Buddha (o-komori).
2. Symbolic death, passage through the underworld, and rebirth (kaidan meguri).
3. Ritual acts performed by the priesthood: e.g., application of the go-inmon.
4. Purchase of holy objects and charms.

The merit accrued through the rigors of travel now achieves full fruition in the ritual activity at church or temple. Zenkōji, like many pilgrimage goals throughout the world, is an impressive architectural complex located in beautiful surroundings. Moreover, in addition to specifically religious aspects, it, like other pilgrimage sites, provided in the past and continues to provide various types of entertainment.

Following the religious activities and secular pleasures at Zenkōji, the pilgrim returned home, reentering a familiar social environment. While individual experiences would vary widely, for the pilgrimage process to be sustained certainly a large majority of the participants must have left confident about their prospects for escape from hell and ultimate salvation—and, in some sense, even reinvigorated, ready to face effectively the travails of daily existence.

A diagram of the results achieved thus far might be as shown below.

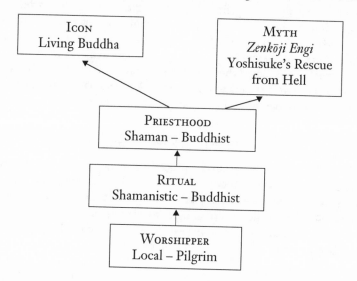

Only by integrating these manifold dimensions and components can one explicate the total context of Zenkōji belief.

The preceding paragraphs have concentrated on Shinano Zenkōji; earlier, I have made reference to supporters of local temples in the Shin Zenkōji network. There were other important categories of worshipers, however, discussed in Chapter 7: first, those who came in contact with the Living Buddha during the decades of its movement from 1555 until 1598 (map 4); and second, those who experienced the Zenkōji cult during the degaichō or kaikoku kaichō activities carried out during the Edo period (map 5). While the first case is significant in terms of

sixteenth-century political history, undoubtedly the second was more important in terms of the diffusion of Zenkōji belief throughout Japan.

In particular, the ambitious kaikoku kaichō of 1701–1706 covered most of the country, and judging from the vast revenues obtained, an enormous number of people must have participated. While concepts of "exclusive affiliation" are not usually relevant when examining Japanese religion, in the case of pilgrimages to Shinano Zenkōji or actual worship in a regional Shin Zenkōji, one can assume at least a minimal degree of conscious commitment to the cult of the Zenkōji Buddha. Those drawn to the degaichō and kaikoku kaichō venues, however, probably manifested attitudes ranging from simple curiosity and mild interest through various levels of piety which motivated them to come to see and/or worship the cult objects. Just about everybody showed up at these exciting events, thus insuring substantial profits; after all, there was nothing to lose and everything to gain. I would suggest that the near-universal recognition of the name of Zenkōji throughout Japan is partially the result of the kaikoku kaichō of the beginning of the eighteenth century. While there is an extremely wide spectrum of concern and belief, a substantial proportion of the Japanese population participates, at least in a certain sense, in the cult of the Zenkōji Amida Triad. This is a rather unusual occurrence in the history of Japanese religion.[24]

Nature of the Zenkōji Cult

In the preceding sections I made an effort to isolate the major components of the Zenkōji cult, analyzing, in each instance, the significance of a specific component for the total complex. Certain reasons for the wide popularity of Zenkōji belief should naturally have surfaced in the course of these discussions. The Zenkōji cult can be described in terms of the following characteristics:

1. It is nonphilosophical.
2. It has a strong magical dimension.
3. It is very materialistic.
4. It stresses the merit of a tangible, living icon rather than being articulated through abstract symbolism.

These traits are, of course, embodied in the cult of the Living Buddha and its associated ritual activities.

Before concluding this analysis, we should confront directly one problem associated with the status of the Living Buddha at Shinano Zenkōji. I have stressed the concrete, nonphilosophical characteristics of the cult, but the situation becomes somewhat confusing when we recall that the

Main Icon, the Living Buddha of the cult, cannot be seen. This might be explained best by saying that if the worshiper *believes* that the icon is living, then it will naturally be conceived of in concrete and highly tangible terms, not as an abstract symbol. If such a belief structure were not operative, then the triad would presumably lose its ascribed status.

The basis for the extraordinary success of the cult of the Zenkōji Amida Triad in medieval Japan must be found in the broader social milieu. Through the Heian period, society was organized, at least in theory, in terms of a central aristocracy that dominated the local populations, but this system gradually crumbled with the establishment of warrior government during the Kamakura period. While orthodox Buddhism obviously had had some impact throughout the country, traditional popular religion was still dominant in most areas. With the coming of new political, economic and social structures, the traditional belief systems apparently were no longer adequate to the changing situation. The significant transformations in Japanese life called for different answers to the questions that the new environment posed. Evidently the Zenkōji cult was extremely well suited to respond, for it had developed to such an extent during the Late Heian period that all of its major components were in place when they were needed. Those characteristics of the Zenkōji cult that I enumerated provided the foundation for a movement that was able to flourish among large groups over a broad area for many centuries.

In an assessment of the factors that led to the development of the Zenkōji cult, close attention must be paid to both the popular-shamanistic and Buddhist dimensions of the belief system; certainly those who adhered to the Zenkōji cult desired both a standard Buddhist structure *and* the more immediate popular/shamanistic elements with which they had long been familiar. Clearly, this powerful synthesis resulted in a coherent set of beliefs and practices suitable to the needs of the sociopolitical groups that came to the forefront during the Kamakura period. In the case of the spread of the cult of the Zenkōji Amida Triad, the way in which a small-scale, easily replicated icon type was utilized by newly empowered social classes to manifest their own religious aspirations is of central importance. The mode chosen—and necessary—was, of course, distinct from the aristocratic-individualistic mode characteristic of earlier stages of Buddhist image making in Japan. Meanings encoded in the Living Buddha of the Shinano Zenkōji and the numerous replications throughout the country simultaneously expressed and formed the essential religious system of a very large group of believers. The new social and political institutions forged during the Kamakura period retained much of their validity in subsequent centuries, and this goes a long way toward

explaining the continuing vitality of the Zenkōji cult. Understandably, Muromachi, Momoyama, and Edo manifestations of the cult varied in character, but underlying the entire historical development was a system based on a unique combination of profound political/societal changes, popular/shamanistic elements, and more orthodox expressions of Amidist belief. The growth of Zenkōji-related institutions during the last one hundred years suggests that the cult continues to speak in a meaningful voice to many people.

A Note on Chronology

1. Generally, a single year—e.g., "1195"—is given in this form, with no indication of the Japanese era.

2. The same form for the years of a period, reign, etc. is also employed—e.g., 1185–1225.

3. Standard chronological scheme in Japanese: Era name Year. Month. Day. I have adopted the following format:

Eikyu second year (1114), fifth month, ninth day

4. *Eikyu* 2.5.9. This form might be confusing to the nonspecialist, but it has the advantage to the specialist of allowing easy access to the original documentary source. I will sometimes employ this form in the notes.

5. Problems in chronology:

Era names—of course, they do not correspond to Western years, and also do not necessarily (or usually) begin on the first day of the month of the lunar year. Ordinarily mark the beginning of a reign, or an auspicious event within a reign.

Year—first year begins at an arbitrary day within the year in question, but the second and following years begin on the first day of the first month of the lunar year. (Thus, if a new era begins near the end of the year, it might consist of only a few weeks, or even days.) All years after the first, assuming that it is not the last, consist of an entire lunar year. The last year of an era can end at any time during the lunar year, and therefore does not necessarily consist of a whole year.

Month/day—because the East Asian lunar calendar does not correspond to the modern Western calendar, the first day of the first month is later than our January 1. Consequently, the last part of a given lunar year corresponds to the next year from what the first part of the year corresponds.

Names
with Japanese Equivalents

Akamatsu Mitsusuke—赤松満祐
Akashinahaiji—明科廃寺
Akechi Mitsuhide—明智光秀
Amaterasu—天照大神
Amatsura Zenkōji—天面善光寺
Amida—阿弥陀
Amidadō—阿弥陀堂
Amidaji—阿弥陀寺
Ankokuji—安国寺
Asano Nagamasa—浅野長政
Ashikaga Clan—足利氏
 Mochiuji—持氏
 Tadayoshi—直義
 Takauji—尊氏
 Yoshinori—義教
Asuka—飛鳥
Asukadera—飛鳥寺
Atsuta—熱田
Azuma Kagami—吾妻鏡

Bakufu—幕府
Bakufu Kanrei—幕府管領
Banzai Nagakuni—坂西長国
Bettō—別当
Bidatsu, Emperor—敏達天皇
Bishari—毘舎離国
Byōdōin—平等院
Byōdōji—平等寺

Chidō Shōnin—智導上人
Chiisagatagōri—小県郡
Chiisagata-gun—小県郡

Chikei Shōnin—智慶上人
Chikuma-gawa—千曲川
Chikumagōri—千曲郡
Chizen—智善
Chōfukuji—長福寺
Chōgen—重源
Chōnen—奮然
Chūsonji—中尊寺
 Konjikidō—金色堂
Chūyūki—中右記

Daibutsuden—大仏殿
Daienji—大円寺
Daihofukuji—大保福寺
Daihongan—大本願
Daihōonji—大報恩寺
Daikan—代官
Daikanji—大勧寺
 Hōin—法印
Daimyō—大名
Dai Nihon Bukkyō Zensho—大日本仏教全書
Daiō—大黄
Degaichō—出開帳
Dōgen—道元

Edo—江戸
Eikyō Disturbance—永享の乱
Eimyōji—永明寺
Eisai—栄西
Eison (Saidaiji)—叡尊
Eison (Kōtokuji)—栄尊
Ekōin—回何院
Engakuji—円覚寺
Engi—緣起
Engi Shiki—廷喜式
Enji—廷寺
Enma, King—閻魔王
Ennin—円仁
En no gyōja—役行者
Enryakuji—廷暦寺
Entsūji—円通寺

Fudōin—不動院
Fujii Yūrinkan—藤井有鄰館
Fujiwara Capital—藤原京
 Clan—氏
 Mitsutaka—光高
 Munetada—宗忠
 Teika—定家
Fukada Gō—深田郷
Fukushima Masanori—福島正則
Fushimi Castle—伏見城
Fusō Ryakki—扶桑略記

Gakkai-chōja—月蓋長者
Gangōji—元興寺
Gangōji Engi—元興寺縁起
Ganshō—願性
Gekkei-bō—月形坊
Genpei War—源平合戦
Genroku Gonen-ban Zenkōji Nyorai Engi—元禄五年版善光寺如来縁起
Genshin—源信
Giba—耆婆
Gō—郷
Go-Daigo, Emperor—御醍醐天皇
Go-inmon—御印文
Gokurakuji—極楽寺
Gorai Shigeru—五来重
Gōri—評
Gunji—郡司
Gyōe—堯恵
Gyōgi—行基
Gyōtokuji—行徳寺

Hachiman—八幡
Hachimanjinja—八幡神社
Hadame Tatsumaro—甚目龍麻呂
Hakoshimizu—箱清水
Hakuhō—白鳳
Han—藩
Handen—班田
Hasedera—長谷寺
Hata no Kose Maetsukimi—秦巨勢大夫
Heian—平安

Heiankyō—平安京
Heiji Disturbance—平治の乱
Heijōkyō—平城京
Henzan—偏衫
Hibutsu—秘仏
Hiei, Mt.—比叡山
Higashiyose-mura—東与世村
Higashine City—東根市
Hijiri—聖
Hikan—被官
Hikari-machi—光町
Hiki Yoshikazu—比企能員
Hirui Zenkōji—昼飯善光寺
Hōbutsushū—宝物集
Hōgen Disturbance—保元の乱
Hōjō Clan—北条氏
 Masako—政子
 Masamura—政村
 Nagatoki—長時
 Shigetoki—重時
 Takatoki—高時
 Tokimasa—時政
 Tokimune—時宗
 Tokiuji—時氏
 Tokiyori—時頼
 Tokiyuki—時行
 Tomotoki—朝時
 Tsunetoki—経時
 Yasutoki—泰時
 Yoshitoki—義時
Hōkōji—方広寺
Honda Yayoi—本田弥生
 Yoshiaki—善明
 Yoshimitsu—善光
 Yoshisuke—善佐
Hondō—本堂
Hōnen—法然
Honpa-shiki—翻波式
Honshi-nyorai—本師如来
Hori Ichirō—堀一郎
Horikawa, Emperor—堀河天皇
Hōryūji Kondō—法隆寺金堂

Hōsenji — 宝泉寺
Hōshōji — 宝生寺
Hosokawa Mochiyuki — 細川持之
Hosshōji — 法勝寺
Hottō Kokushi — 法燈国師

Ikimi — 生身
Imagawa Yoshimoto — 今川義元
Imai Clan — 今井家
Imoi Village — 芋井郷
In — 院
Ina County — 伊那郡
Inoue Clan — 井上氏
Ippen — 一遍
Iroha Jirui Shō — 色葉字類抄
Ise Shrine — 伊勢神宮
Ishikawa Collection — 石川錦司蔵
Izumo — 出雲

Jibutsudō — 持仏堂
Jimon — 寺門
Jimokuji — 甚目寺
Jingoji — 神護寺
Jinmu, Emperor — 神武天皇
Jinshin Disturbance — 壬申の乱
Jinten Ainō Shō — 塵添壒嚢鈔
Jisha Bugyō — 寺社奉行
Ji Shū — 時宗
Jitō — 地頭
Jizō — 地蔵
Jōdo — 浄土
Jōdo Shū — 浄土宗
Jōdo Shin Shū — 浄土眞宗
Jōgyō-zanmai — 常行三昧
Jōman Kōmin-kan — 常万公民館
Jōmon — 繩文
Jōren — 浄蓮
Jōshinji — 浄眞寺
Jōson — 定尊
Jūichimen Kannon — 十一面観音

Kaichō — 開帳

Kaidan meguri—戒壇めぐり
Kaikei—快慶
Kaikoku Kaichō—回国開帳
Kaizu Castle—海津城
Kaju—花寿
Kakuchū—覚忠
Kamakura—鎌倉
Kamoedera—鴨江寺
Kanasashi Clan—金刺氏
Kanazawa Bunko—金沢文庫
 Clan—金沢氏
 Sanetoki—実時
Kanbun—漢文
Kanbun Hachinen-ban Zenkōji Engi—寛文八年版善光寺縁起
Kannon—観音
Kannondō—観音堂
Kan'ōji—感応寺
Kanrei—管領
Kanshōin—観松院
Kansong Museum—澗松美術館
Kantō—関東
Kantō Kubō—関東公方
Karukayadō—刈萱堂
Kasugayama Castle—春日山城
Katsuragi, Mt.—葛城山
Kawanakajima Battles—川中島の戦
Kayadō-hijiri—萱堂聖
Keiun—慶運
Keishōin—桂昌院
Kenkyū Rokunen—建久六年
Kenmu Restoration—建武新政
Kii—紀伊
Kim Collection—金東鉉氏蔵
Kimura Manbei—木村万兵衛
Kin (weight)—斤
Kinhōji—金宝寺
Kinmei, Emperor—欽明天皇
Kiso Yoshinaka—木曾義仲
Ko—戸
Kobayashi Ichirō—小林一郎
 Keiichirō—計一郎
 Takeshi—剛

Kōen—皇円
Kōfu—甲府
Kōfukuji—興福寺
Kofun—古墳
Kōgyoku, Empress—皇極天皇
Kojiki—古事記
Kōkokuji—興国寺
Kokon Chomonjū—古今著聞集
Koku (weight)—石
Kokubunji—国分寺
Kokubunniji—国分尼寺
Kōmyōji—光明寺
Kongōbuji—金剛峰寺
Kōra Buzen Nyūdō Shūga—甲良豊前入道宗賀
Koshinuno—腰布
Koshiro—小代
Kōshō—康勝
Kōshō-Jōchō—康尚 - 定朝
Kōtokuji—向徳寺
Kōya, Mt.—高野山
Kōya-hijiri—高野聖
Kūkai—空海
Kumi gashira—組頭
Kuni no kami—国守
Kuni no miyatsuko—国造
Kuno Takeshi—久野健
Kurahashi-be Hiroto—倉橋部広人
Kurata Bunsaku—倉田文作
Kurita Kakuju—栗田鶴寿
Kuroda Zenkōji—黒田善光寺
Kūya—空也
Kūzōbō Kankaku—空蔵房寛賞
Kuzuyama Keirin—葛山景倫
Kyōkū—鏡空

Machi—町
Machidoshiyori—町年寄
Maedachi Honzon—前立本尊
Man Amitafu—万アミタフ
Manpukuji—万福寺
Man'yōshū—万葉集
Matsudaira Tadateru—松平忠輝

Matsukawa Village—松川村
Matsumoto—松本
Matsumoto Shōgyōji Engi—松本正行寺縁起
Meigetsuki—明月記
Miidera—三井寺
Mikai Hōin—見海法印
Minamoto Clan—源氏
　　Sanetomo—実朝
　　Yoritomo—頼朝
Minochi County—水内郡
Mitsutaka—光高
Miwa Clan—神氏
Miyahara Zenkōji—宮原善光寺
Mizu Kagami—水鏡
Mizuno Keizaburō—水野敬三郎
Mokkan—木簡
Mokujiki Shōnin Ōgo—木食上人応其
Mokuren—目連
Mononobe no Moriya—物部守屋
　　Okoshi—尾輿
Mōri Hisashi—毛利久
Mori Nagayoshi—森長可
　　Tadamasa—忠政
Moto Zenkōji—元善光寺
Mujū Ichien—無住一円
Mukuhara—向原
Mura—村
Murakami Clan—村上氏
Muromachi—室町
Muroga Gō—室賀郷
Myōe Shōnin—明恵上人
Myōhen—明遍
Myōkan Ryōzan—妙観良山
Myōkan'in—妙観院

Nagano—長野
Naganuma Castle—長沼城
Naganuma Munemasa—長沼宗政
Nagoe—名越
Nagoshi—名越
Nagoshi Mitsutoki—名越光時
Nakano Clan—中野家

Nakasendai Disturbance—中先代の乱
Nakatomi no Kamatari—中臣鎌足
Nanbokuchō—南北朝
Naniwa—難波
Narita Fudō—成田不動
Nasu—那須
Nehan Shaka—涅槃釈迦
Nenbutsu—念仏
Nenbutsudō—念仏堂
Nenbutsu-zanmai—念仏三昧
Nichiren—日蓮
Nichiren Shū—日蓮宗
Nihon Shoki—日本書紀
Nijō, Lady—二条
Nishikawa Kyōtarō—西川杏太郎
　　Shinji—新次
Nishikigōri—錦織郡
Nishina Clan—仁科氏
Noda Collection—野田吉兵衛氏蔵
Nogi Clan—乃木氏
Nogi Zenkōji—乃木善光寺
Nyoraidō—如来堂
Nyoraiji—如来寺
Nyoze-hime—如是姫

Ōan Zenkōji Engi—応安善光寺縁起
Oda Nobukatsu—織田信雄
　　Nobunaga—信長
　　Nobutada—信忠
Ōei Zenkōji Engi—応永善光寺縁起
Ogasawara Clan—小笠原氏
　　Masayasu—政康
　　Mitsuyasu—光康
　　Mochinaga—持長
　　Nagahide—長秀
　　Sadamune—貞宗
Ogawadai Shin Zenkōji—小川台新善光寺
Oharida—小治田
Oharida no Ason Yakamochi—小治田朝臣宅持
Ōi Mitsunori—大井光矩
Ōiso no Tora—大磯の虎
Ōjōin—往生院

Ōjōji—往生寺
Ōjō Yōshū—往生要集
O-komori—おこもり
Ōkubo Nagayasu—大久保長安
Ōkura Museum—大倉美術館
Omi Village—麻績村
Ōmuro—大室
Ōnin War—応仁の戦
Osada Clan—他田氏
Ōshū Fujiwara—奥州藤原氏
Ōtō Battle—大塔合戦
Oyama Zenkōji—小山善光寺

Paekche—百済

Rahotsu—螺髪
Ren'a—蓮阿
Rengedani-hijiri—蓮花谷聖
Renniku—蓮肉
Rikushōji—六勝寺
Rinzai—臨済
Ritsuryō—律令
Rokuon Nichiroku—鹿苑日録
Ryō (cash)—両
Ryō (estate)—領
Ryōchi—了智
Ryōgen—良源
Ryō Gomonzen—両御門前
Ryōkei Myōshin—良慶明心
Ryūdaiji—隆台寺

Saia—西阿
Saibun—西文
Saichō—最澄
Saidaiji—西大寺
Sai-gawa—犀川
Saiji—西寺
Sainin—西忍
Saitokuji—西德寺
Sanada Clan—眞田氏
　　Nobuyuki—信之
Sangoku Denrai—三国伝来

Sanzenji—山千寺
Sasaki Nobutsuna—佐々木信綱
 Takatsuna—高綱
Sasamoto Shin Zenkōji—篠本新善光寺
Seichōji—清澄寺
Seikōji—清光寺
Seishi—勢至
Seisuiji—清水寺
Seitokuji—成徳寺
Sekine Shun'ichi—関根俊一
Sengoku Period—戦国時代
Senjuin—千手院
Senshōji—専称寺
Sensōji—浅草寺
Shaka—釈迦
Shaku—尺
Shiba Yoshimasa—斯波義将
 Yoshitane—義種
Shigeno Clan—滋野氏
Shigisan Engi—信貴山縁起
Shikken—執権
Shimane Zenkōji—島根善光寺
Shin ("new") Zenkōji—新善光寺
Shin ("true") Zenkōji—眞善光寺
Shinano—信濃
Shinchi Kakushin—心地覚心
Shingon Shū—眞言宗
Shinnyodō—眞如堂
Shinran—親鸞
Shinshō Hōshi—信生法師
Shinshō Hōshi Shū—信生法師集
Shinto—神道
Shiozaki Castle—塩崎城
Shirakawa, Emperor—白河天皇
Shitennōji—四天王寺
Shō Kannon—聖観音
Shō Kanzeon Bosatsu Shōfuku Dogugai Darani Ju Kyō
 —請観世音菩薩消伏毒害陀羅尼呪経
Shōen—荘園
Shogun—将軍
Shōgyōji—正行寺
Shōjōji—勝常寺

Shoku Nihongi—続日本紀
Shōmyōji—称名寺
Shōnin Zenkin—聖人善金
Shōtoku Taishi—聖徳太子
Shōya—庄屋
Shugo—守護
Shūtokuin—修徳院
Silla—新羅
Sobue Zenkōji—祖父江善光寺
Soga Clan—蘇我氏
 Iname—稲目
 Umako—馬子
Soga no Sukenari—曾我祐成
 (Soga Jūrō)—曾毛十郎
Sōgishi—僧祇支
Sōgonji—荘厳寺
Song, King—聖王
Sōrinji—双林寺
Sōtō Shū—曹洞宗
Suiko, Empress—推古天皇
Sui-mei, King—推明王
Sumitomo—住友
Sun—寸
Suwa Clan—諏訪氏
 Shrine—神社

Tachibana Shrine—橘夫人厨子
Tachikawa-machi—立川町
Taika Reform—大化改新
Taira Masakado—平将門
 Yasuyori—康頼
Takahashi Clan—高橋氏
Takai County—高井郡
Takeda Katsuyori—武田勝頼
 Shingen—信玄
Takeda Kōkichi—武田好吉
Tamagiku—玉菊
Tanabe Saburōsuke—田辺三郎助
Tanjō-butsu—誕生仏
Tatsu-machi—立町
Tendai—天台
Tennōji—天王寺

Terazamurai—寺侍
Toba, Emperor—鳥羽天皇
 Prince—鳥羽宮
Tōdaiji—東大寺
Tōdaiki—当代記
Tōhoku—東北
Tōji—東寺
Tōkaidō—東海道
Tokoyo—常世
Tokugawa Clan—徳川氏
 Ieyasu—家康
 Tsunayoshi—綱吉
Tokuichi—徳一
Tokusō—得宗
Tomonoura—鞆ノ浦
Tōsandō—東山道
Tōshōdaiji—唐招提寺
Toyotomi Hideyori—豊臣秀頼
 Hideyoshi—秀吉
Tsūken—通肩

Uematsu Mataji—植松又次
Uesugi Clan—上杉氏
 Kagekatsu—景勝
 Kenshin—謙信
 Zenshū—禅秀
Unnichi Shōnin—吽日上人
Unshū Sasaki Yurai Yūji—雲州佐々木由来有事
Un'yo Shōnin—吽誉上人
Urushida Battle—漆田の戦

Yakushi—薬師
Yakushiji—薬師寺
Yamato—大和
Yamazaki Clan—山崎氏
Yanagisawa Chizen—柳沢智善
 Yoshiyasu—吉保
Yayoi—弥生
Yokoyama Dōjō—横山道場
Yokozawa-machi—横沢町
Yoneyama Kazumasa—米山一政
Yūki Ujitomo—結城氏朝

Zenkōji Icons Dated
to the Kamakura Period

1. 1195 Zenkōji, Yamanashi Amida Triad (fig. 15)
2. 1206 Zensuiji, Shiga Amida (fig. 18)
3. 1206 Private Collection Amida (fig. 19)
4. 1249 Kōtokuji, Saitama Amida Triad (fig. 22)
5. 1253 Tokyo Geijutsu Daigaku Amida
6. 1254 Tokyo National Museum Amida Triad (fig. 23)
7. 1261 Jōshinji, Ibaraki Amida (fig. 24)
8. 1261 Hachimanjinja, Tokyo Amida (fig. 25)
9. 1264 Private Collection, Mie Amida
10. 1265 Ishikawa Collection, Saitama Amida (fig. 26)
11. 1265 Tokyo National Museum Amida
12. 1266 Senjuin, Kanagawa Amida (fig. 28)
13. 1266 Seichōji, Chiba Kannon (fig. 29)
14. 1267 Senshōji, Tochigi Amida/Seishi (fig. 27)
15. 1271 An'onji, Fukushima Amida
16. 1271 Engakuji, Kanagawa Amida Triad (fig. 30)
17. 1274 Ankokuji, Hiroshima Amida Triad (fig. 32)
18. 1276 Hōdōji, Fukushima Amida Triad
19. 1288 Rin'ōji, Tochigi Monk's Staff (Triad)
20. 1290 Shūtokuin, Chiba Amida Triad (fig. 40)
21. 1295 Manpukuji, Ibaraki Amida Triad (fig. 43)
22. 1295 Manpukuji, Ibaraki Amida Triad (fig. 43)
23. 1296 Sekitani Collection, Nagano Amida
24. 1300 Seikōji, Chiba Amida Triad (fig. 45)
25. 1304 Nyoraiji, Fukushima Amida Triad (fig. 46)
26. 1309 Enkōji, Chiba Amida
27. 1309 Saigōji, Nagano Amida Triad
28. 1310 Jōtokuji, Saitama Amida
29. 1310 Zentsūji, Kagawa Amida Triad
30. 1311 Tanibō, Saitama Seishi
31. 1316 Amidadō, Chiba Amida
32. 1325 Yakushidō, Fukushima Amida Triad
33. 1328 Shōganji, Iwate Amida

Notes

ABBREVIATIONS USED IN NOTES

Gorai, *Kōya-hijiri*	Gorai Shigeru, *Kōya-hijiri* (Tokyo, 1965).
Gorai, *Zenkōji-mairi*	Gorai Shigeru, *Zenkōji-mairi* (Tokyo, 1988).
Kobayashi Ichirō, *ZNE*	Kobayashi Ichirō, *Zenkōji Nyōrai Engi: Genroku Gonen-ban* (Nagano, 1985).
Kobayashi, *Zenkōji San*	Kobayashi Keiichirō, *Zenkōji San*, 2nd. ed. (Nagano, 1979).
Matsunaga and Matsunaga	Daigan Matsunaga and Alicia Matsunaga, *Foundation of Japanese Buddhism*, 2 vols., (Los Angeles and Tokyo, 1974 & 1979).
Nagano	*Nagano*, the Journal of the Nagano Regional Historical Society.
NK-s	Nagano Ken-shi Kankōkai, ed., *Nagano Ken-shi: Tsūshi-hen*, 10 vols. (Nagano, 1986–1992).
N-sS	Kobayashi Keiichirō, *Nagano-shi Shikō: Kinsei Zenkōji-machi no Kenkyū* (Tokyo, 1969).
Nishikawa & Sekine	Nishikawa Shinji and Sekine Shun'ichi, "Zenkōji Amida Sanzon Zō no Keishiki o megutte: Chiba Kenka no Ihin o Chūshin ni" (Concerning the Style of the Zenkōji Amida Triad Images: Centering on the Monuments Preserved in Chiba Prefecture), *Miura Kobunka* 32 (1982): 9–42.
Sakai, *Zenkōji-shi*	Sakai Kōhei, *Zenkōji-shi*, 2 vols. (Tokyo, 1969).
Takeda	Takeda Kōkichi, *Dewa no Zenkōji-shiki Sanzon-zō* (Yamagata, 1970).

CHAPTER 1

1. Helen Craig McCullough, *The Tale of the Heike* (Stanford, 1988), p. 88.

2. The term used is *shōjin* or *ikimi* (生身). For a general discussion see Yoshihara Hiroto, "Zenkōji Honzon to Shōjin Shinkō" (The Main Image of Zenkōji and Belief in Living Images) in Nishikawa Kyōtarō and Tanaka Yoshiyasu eds., *Butsuzō o Tabisuru: Chūō-sen* (Tokyo, 1990), pp. 61–64.

3. David Freedberg, *The Power of Images: Studies in the History and Theory of Response* (Chicago and London, 1989).

4. This monograph is part of an ongoing research project devoted to replication traditions in East Asia, especially Japan. In the present volume I intend to

provide comparisons within the Zenkōji tradition primarily from representations of the Seiryōji Shaka, since I believe the latter group is the manifestation closest to the situation of the Zenkōji images, in terms of the process of replication. The next volume in the series, entitled *Seiryōji and Its Icon*, will investigate the Udayana Shaka lineage, which is said to have originated in India at the time of the historical Buddha, passed to China in the Six Dynasties period, and ultimately to Japan in the later tenth century. In the case of the Seiryōji Shaka, the actual Chinese "prime object," dated 985, is available for inspection at Seiryōji in Kyoto. For that reason, I propose to discuss prime object/replication developments in more detail in that study, since the existence of the prime object greatly facilitates analysis. There are, of course, a variety of important replication traditions in Japan, such as the Hasedera Eleven-headed Kannon. (See Kobayashi Takeshi, "Hasedera no Honzon Jūichimen Kannon Zō" [The Main Image of Hasedera, the Eleven-headed Kannon] in *Yamato Bunka Kenkyū* 5.2 (1960): 9–15, which includes a list of 105 temples located throughout Japan that are directly associated with the Hasedera cult. For more detail consult Tsuji Hidenori, *Kodai Sangaku Jiin no Kenkyū* 1, *Hasedera-shi no Kenkyū* [Research on Ancient Mountain Temples 1, Research on the History of Hasedera], [Kyoto, 1979].) Other sculptural replication lineages include the Kiyomizu Eleven-headed Kannon as well as less specifically defined traditions such as those associated with Shōtoku Taishi and Tobatsu Bishamonten. In addition, there are replication traditions in painted icons as well, most important the Taima Mandara. (See Elizabeth ten Grotenhuis, "Rebirth of an Icon: The Taima Mandala in Medieval Japan," *Archives of Asian Art* 36 [1983]: 59–87, idem, "Chūjōhime: The Weaving of Her Legend," in J. Sanford, W. LaFleur, and M. Nagatomi, eds., *Flowing Traces: Buddhism in the Literary and Visual Arts of Japan*, (Princeton, 1992), pp. 180–200. Ten Grotenhuis notes [p. 182], "The first copies of the tapestry seem to have been made in the Kenpō era [1213–1218]. Hundreds of painted and woodblock printed copies have been created through the centuries, often on a greatly reduced scale.") Other examples of painted replication lineages include works associated with the Kasuga cult (Susan Tyler, *The Cult of Kasuga Seen Through Its Art* [Ann Arbor, 1992]). For reasons that I intend to develop in the next volume, I do not include more general iconographical or stylistic lineages within the replication category, since ordinarily such lineages do not refer to a specific prime object, but instead relate in a theological sense to the deity in question.

5. Surveys of Kamakura sculpture usually refer specifically in their titles to this period. For example, Mōri Hisashi, *Unkei to Kamakura Chōkoku* (Unkei and Kamakura Sculpture) (Tokyo, 1964). Interestingly, when this volume was translated into English, the title was changed to *Sculpture of the Kamakura Period* (New York and Tokyo, 1974); Miyama Susumu, *Kamakura no Chōkoku-Kenchiku: Unkei to Kaikei* (Sculpture and Architecture of the Kamakura Period: Unkei and Kaikei) (Tokyo, 1979); Mizuno Keizaburō, et al., eds., *Unkei to Kaikei: Kamakura no Kenchiku-Chōkoku* (Unkei and Kaikei: Architecture and Sculpture of the Kamakura Period) (Tokyo, 1991).

6. For a succinct account of these developments see Jeffrey P. Mass, "The Kamakura bakufu," especially "The road to Jōkyū" (pp. 66–70) and "The Jōkyū

Disturbance and its aftermath" (pp. 70–80) in Kozo Yamamura, ed., *Medieval Japan*, vol. 3 of *The Cambridge History of Japan* (Cambridge, 1990), pp. 46–88.

7. My understanding of the development of nonelite culture in medieval Japan has been greatly facilitated by two articles of Barbara Ruch, "Medieval Jongleurs and the making of National Literature" in John Whitney Hall and Toyoda Takeshi, eds., *Japan in the Muromachi Age* (Berkeley and Los Angeles, 1977), pp. 279–309; and "The Other Side of Culture in Medieval Japan" in Yamamura, *The Cambridge History of Japan*, vol. 3: 500–543.

8. A brilliant demonstration of this sort of process is Peter Brown, *The Cult of the Saints: Its Rise and Function in Latin Christianity* (Chicago, 1981).

9. For the statues of Muchaku and Seshin see Mōri Hisashi, *Unkei and Kamakura Sculpture*, figs. 16, 48, 149 (Muchaku) and 54, 59, 149 (Seshin), and *Nara Rokudaiji Taikan* 8, *Kōfukuji* II (Tokyo, 1970).

10. A book that has had a great impact on my conceptualization of the Zenkōji cult is Carol Zaleski, *Otherworld Journeys: Accounts of Near-Death Experiences in Medieval and Modern Times* (Oxford, 1987). Zaleski's work enabled me to move from a somewhat remote view of the material to a realization that it could be associated with pervasive, near-universal human concerns.

11. Ōsumi Kazuo, "Buddhism in the Kamakura Period," in Yamamura, *The Cambridge History of Japan*, vol. 3: 544–582. Ōsumi's treatment can be instructively compared with the essay by Ruch, cited above, in the same volume.

CHAPTER 2

1. Fujimori Eiichi and Kirihara Takeshi, *Shinano Kōkogaku Sanpo* (Visits to Shinano Archaeology) (Tokyo, 1968), pp. 67–68. My study of the history of Zenkōji has been very much aided by Ushiyama Yoshiyuki's essay, "Zenkōji Sōken to Zenkōji Shinkō no Hatten" (The Establishment of Zenkōji and the Development of the Zenkōji Cult), in Itō Nobuo, et. al., eds., *Zenkōji: Kokoro to Katachi* (Zenkōji: Spirit and Form) (Tokyo, 1991), pp. 131–151.

2. *NK-s* 1: 204–286.

3. *Nagano* 119 (1985): 15. Of approximately fifty-two large-scale keyhole tombs in Nagano, in addition to the twenty-three located in the Zenkōji Plain, most of the rest are to be found in Ina County, much to the south.

4. Inoue Mitsusada, *Asuka no Chōtei* (The Asuka Court), vol. 3 of *Nihon no Rekishi* (Shōgakkan) (Tokyo, 1974), provides an orthodox analysis of this period.

5. This fundamental transformation can perhaps be best symbolized by the commencement of work on the Asukadera by the Soga clan from 588. The literature concerning Asukadera is voluminous. Good surveys of the issues are Tamura Enchō, "Hōkōji no Sōken" (The Establishment of Hōkōji), in Ienaga Saburō Kyōju Tokyo Kyōiku Daigaku Taikan Kinen Ronshū Kankō Iinkai, eds., *Kodai-Chūsei no Shakai to Shisō* (Tokyo, 1979), pp. 99–115; and Matsuki Hiromi, "Asukadera no Sōken Katei" (The Process of the Establishment of Asukadera), in Kokugakuin Daigaku Shigakuka, eds., *Sakamoto Tarō Hakase Shōju Kinen, Nihon Shigaku Ronshū*, vol. I (Tokyo, 1983), pp. 237–271.

6. *NK-s* 1: 284.

7. *NK-s* 1: 241–254. See also Imai Tainan, *Shinshū no Torai Bunka*, (Immigrant Culture in Shinshū) (Nagano, 1985). For an interesting discussion of this topic see Ōwa Iwao, *Shinano Kodai-shi Kō* (Studies of the Ancient History of Shinano) (Tokyo, 1990), pp. 119–185.

8. Nomura Tadao, *Kenkyū-shi: Taika Kaishin* (Historiography: The Taika Reform), expanded edition (Tokyo, 1978). Inoue Mitsusada, et al., *Taika Kaishin to Higashi Ajia* (The Taika Reform and East Asia) (Tokyo, 1981). For a traditional account of the Taika Reform and Shinano see *NK-s* 1: 327–339.

9. Fujimori Eiichi, "Zenkōji no Tabi" (Trip to Zenkōji), *Nagano* 29 (1970): 2–3. I will refer to this hypothetical early temple in subsequent pages as "proto-Zenkōji."

10. Yamaguchi Jun'ichi, "Wakatsuki Shutsudo no iwayuru Zenkōji Kawara ni tsuite" (Concerning the so-called Zenkōji Tiles from the Wakatsuki Excavations), *Nagano* 134 (1987): 39–51. Kobayashi Yūjirō, "Zenkōji no Jūkomen Nokihira-gawara ni tsuite" (Concerning the Double-circle Eave Tiles of Zenkōji), *Nagano* 147 (1989): 1–14, provides a detailed examination of the problems associated with the tiles found at Zenkōji and related sites, but compare Ushiyama, p. 131.

11. Very early dates are given for the introduction of Buddhism into Koguryo (372) and Paekche (384), with a later date given for Silla (528). It is not until well into the sixth century, however, that a substantial number of Buddhist monuments can be seen. See Ki-baik Lee, *A New History of Korea* (Cambridge, Mass., 1984), pp. 59–61.

12. *NK-s* 1: 349–461. For a general account in English see William Wayne Farris, *Population, Disease, and Land in Early Japan, 645–900* (Cambridge, Mass., 1985).

13. Hoshino Ryōsaku, *Kenkyū-shi: Jinshin no Ran* (Historiography: The Jinshin Disturbance), expanded edition (Tokyo, 1978). For a discussion of the Jinshin Disturbance and Shinano see *NK-s* 1: 340–343.

14. For the period covered in this paragraph see Hayakawa Shōhachi, *Ritsuryō Kokka* (The Ritsuryō State), vol. 4 of *Nihon no Rekishi* (Shōgakkan) (Tokyo, 1974).

15. Donald L. Philippi, trans., *Kojiki* (Tokyo, 1968), pp. 133, 220, 244. W. G. Aston, *Nihongi; Chronicles of Japan from the Earliest Times to 697*, (Tokyo, 1972), vol. II: 404 (hereafter abbreviated to "Aston"); Sakamoto Tarō, et. al., *Nihon Shoki* I & II, vols. 67 and 68 of *Nihon Koten Bungaku Taikei* (Iwanami Shoten) (Tokyo, 1980), vol. II: 501–502.

16. For a detailed discussion of the appearance of Shinano in *Man'yōshū*, see *NK-s* 1: 848–854.

17. Niino Naoyoshi, *Kenkyū-shi: Kuni no Miyatsuko* (Historiography: Kuni no Miyatsuko) (Tokyo, 1974). For *kuni no miyatsuko* in Shinano, see *NK-s* 1: 295–321.

18. Tsukada Masatomo, *Nagano-ken no Rekishi* (History of Nagano Prefecture) (Tokyo, 1977), p. 35.

19. For a general discussion of the wooden tablets, see Kano Hisashi, *Mokkan* vol. 160 of *Nihon no Bijutsu* (Tokyo, 1979). For those connected with Shinano, see

NK-s 1: 444–448; the one considered here is illustrated and discussed on pp. 442–443.

20. A basic discussion of the political organization of early Shinano and its early clans is *NK-s* 1: 406–429. See also Kirihara Takeshi, "Zenkōji Sōken ni Kakkatta Shizoku-tachi" (Aristocrats connected with the Establishment of Zenkōji), *Nagano* 103 (1982): 19–28, for an analysis of some of the important clans in Shinano.

21. Ushiyama, p. 134. For the texts, see Hayashi Rokuro, ed., *Shoku Nihongi*, vol. 5 (Tokyo, 1988), pp. 40, 65.

22. *NK-s* 1: 408–429.

23. Ushiyama, p. 133.

24. For a recent study, with full bibliography, see Miyagi Yōichirō, "Kokubunji no Sōken" (Establishment of the Provincial Temples) and "Kokubunji Zōei Undō to sono Tenkai" (Development of the Mobilization of the Masses in the Establishment of the Provincial Temples), in *Nihon Kodai Bukkyō Undō-shi Kenkyū* (A Study in the History of Buddhist Mass Movements in Ancient Japan) (Kyoto, 1985), pp. 52–147.

25. Naito Masatsune, "Shinano Kokubunji no Iseki" (Remains of the Provincial Temple of Shinano), *Kobijutsu* 17 (1967): 71–78. *NK-s* 1: 543–555 provides considerable information on Shinano Kokubunji. For a good general study of the Kokubunji remains, see Miwa Yoshiroku, *Kokubunji*, vol. 171 of *Nihon no Bijutsu* (Tokyo, 1980).

26. *NK-s* 1: 555, 708–711. *Masakado-ki*, which describes this event, is illustrated in fig. 167, p. 710.

27. Ushiyama (pp. 134–135) argues that the proto-Zenkōji may have had a semi-official status in the Nara period. By this he means that the temple would have received some government support.

28. *NK-s* 1: 482.

29. Tokyo Kokuritsu Hakubutsukan, ed., *Tokubetsu-ten Zuroku: Kondō-butsu—Chūgoku, Chōsen, Nihon* (Special Exhibition Compilation: Small Gilt-bronze Buddhist Deities—China, Korea, Japan) (Tokyo, 1988) cat. entry 32: 118–119, 402–403. This is probably a representation of the Bodhisattva Maitreya (J. Miroku).

30. Kuno Takeshi, *Zoku Nihon no Chōkoku: Chūbu* (Sculpture of Japan, Continuation: The Chūbu Region) (Tokyo, 1964), pls. 1–3, p. 44. (This image is frequently referred to as being in the Maruyama Collection.)

31. As note 29, cat. entry 120: 224–225, 435.

32. For the occurrence of early images in adjacent prefectures see Kuno Takeshi, *Kodai Shō Kondō-butsu* (Small Gilt-bronze Buddhist Deities of the Ancient Period) (Tokyo, 1982), especially section 7, "Chūbu-chihō no Shō Kondō-butsu" (Small Gilt-bronze Buddhist Deities of the Chūbu Region), pp. 212–223, and section 8, "Kantō-Tōhoku-chihō no Shō Kondō-butsu" (Small Gilt-bronze Buddhist Deities of the Kantō and Tōhoku Regions), pp. 224–231.

33. *NK-s* 1: 615–655, provides detailed information about horses and horse ranches in Shinano.

34. For Shingon, see Minoru Kiyota, *Shingon Buddhism: Theory and Practice*, (Los Angeles and Tokyo, 1978). For Tendai, see Matsunaga and Matsunaga I: 139–171. Also Tamura Yoshiro, "Tendaishū," *The Encylopedia of Religion*, vol. 14: 396–401.

35. For a detailed discussion of the road system, see *NK-s* 1: 487–530.

36. The move from Chiisagatagōri to Chikumagōri is discussed in *NK-s* 1: 558–567.

37. Elizabeth Sato, "The Early Development of the Shōen," in John W. Hall and Jeffrey Mass, eds., *Medieval Japan: Essays in Institutional History* (New Haven and London, 1974), pp. 91–108. For the early development of *shōen* in Shinano, see *NK-s* 1: 693–700.

38. *NK-s* 1: 431–432. For the text, see Hayashi, *Shoku Nihongi* 4: 154.

39. Tsukada, *Nagano-ken no Rekishi*, p. 82.

40. Donald F. McCallum, "Buddhist Sculpture of the Seisuiji, Matsushiro," *Oriental Art* N.S. 25.4 (1979–1980): 462–470.

41. Donald F. McCallum, "The Evolution of the Buddha and Bodhisattva Figures in Japanese Sculpture of the Ninth and Tenth Centuries" (Ph.D. diss., New York University, 1973), pp. 27–38.

42. For the Pure Land School, see Hamashima Masaji, ed., *Zusetsu Nihon no Bukkyō*, vol. 3, *Jōdokyō* (Tokyo, 1989); Matsunaga and Matsunaga I: 215–218.

43. Robert T. Paine and Alexander Soper, *The Art and Architecture of Japan* (Baltimore, 1975), pls. 15–16 (Tachibana Shrine), pl. 19 (Hōryūji Wall Painting).

44. For Tendai developments, see Hamada Takashi, "Hieizan no Nenbutsu to Tendai Jōdokyō," in Hamashima, *Jōdokyō*, pp. 49–120.

45. Ibid., pp. 67–68.

46. Ibid., pp. 75–81. Also Allan A. Andrews, *The Teachings Essential for Rebirth: A Study of Genshin's Ōjōyōshū* (Tokyo, 1973).

47. Iwanami Shoten has brought out a magnificent three-volume set that provides comprehensive coverage of all aspects of the Byōdōin. See Midorikawa Atsushi, ed., *Byōdōin Taikan*, vol. I, *Architecture* (Tokyo, 1988); vol. II, *Sculpture* (Tokyo, 1987); vol. III, *Painting* (Tokyo, 1992).

48. Toshio Fukuyama, *Heian Temples: Byodo-in and Chuson-ji* (Tokyo and New York, 1976).

49. Melanie Hall Yiengpruksawan, "The Buddhist Sculpture of Chūsonji: The Meaning of Style at the Hiraizumi Temples of the Ōshū Fujiwara" (Ph.D. diss., UCLA, 1987).

50. Hamada, as in note 44, pp. 69–75; Hori Ichirō, *Kōya* (Tokyo, 1963); Matsunaga and Matsunaga I: 217–218. (Note that the pronunciation is given as "Kūya" or "Kōya.")

51. Donald F. McCallum, "Heian Sculpture at the Shinano Art Gallery," *Oriental Art* N.S. 24.4 (1978–1979): 445–453.

52. Sansom, "The Growth of the Warrior Class," pp. 234–263. Jeffrey P. Mass, *Warrior Government in Early Medieval Japan: A Study of the Kamakura Bakufu, Shugo, and Jitō* (New Haven, 1974).

53. For these rebellions see Kitayama Shigeo, *Heian-kyō*, vol. 4 of *Nihon no Rekishi* (Chūō Kōron) (Tokyo, 1965), pp. 382–446; Sansom, pp. 244–246 (Masakado) and pp. 145–146 (Sumitomo).

54. See Takeuchi Rizō, *Bushi no Tōjō*, vol. 6 of *Nihon no Rekishi*, (Chūō Kōron) (Tokyo, 1965), pp. 198–259.

55. Ibid., pp. 316–417; Sansom, pp. 255–288.

56. Jeffrey P. Mass, *The Development of Kamakura Rule, 1180–1250* (Stanford, 1979).

57. *Nagano* 119 (1985): 50–52. See also *NK-s* 1: 817–829.

58. Zōho Shiryō Taisei Kankō, ed., *Zōho Shiryō Taisei*, vol. 12, *Chūyūki* 4 (Kyoto, 1975), p. 303.

59. C. Cameron Hurst, *Insei: Abdicated Sovereigns in the Politics of Late Heian Japan, 1086–1185* (New York, 1976), pp. 262–265.

60. For the *Chōshūki* text, see Zōho Shiryō Taisei Kankōkai, ed., *Zōho Shiryō Taisei*, vol. 16 (Kyoto, 1965), p. 160.

61. I have presented the standard opinion concerning the compilation of *Fusō Ryakki*. However, Ushiyama (p.138) refers to interesting research suggesting that the text may have been produced in the circle of Ōe no Masafusa (1041–1111). This attribution would indicate a somewhat earlier date of compilation, and in that respect relates closely to the basic argument presented here as to the establishment of the Zenkōji cult.

62. For *Fusō Ryakki*, see Kurosaka Katsumi, ed., *Shintei Zōho Kokushi Taikei*, vol. 12, pp. 28–29.

63. For a discussion of Kakuchū's poem, see Ushiyama, pp. 136–137 and *NK-s* 1: 862, 873–874, 888. The poem can be found in Shinpen Kokka Taikan Henshū Iinkai, ed., *Shinpen Kokka Taikan Dai Ikkan: Chokusenshū Hen* (Tokyo, 1983), p. 336, poem 876. (This book is also referred to as the *Shoku Kokinshū*.) For a reference to the possibility of Kakuchū continuing to Zenkōji, see James H. Foard, "The Boundaries of Compassion: Buddhism and National Tradition in Japanese Pilgrimage," *Journal of Asian Studies* 41.2 (1982): 233.

64. For Chōgen's pilgrimages to Zenkōji, see Ushiyama, p. 137.

65. For *Azuma Kagami*, see Kurosaka Katsumi, ed., *Shintei Zōho Kokushi Taikei* vol. 32, pp. 266–267 (Bunji 3.7.28).

66. Ushiyama, p. 135.

67. Ushiyama, pp. 137–138.

CHAPTER 3

1. An engi is a text that describes the establishment of a temple, miracles that may have occurred there, the deities worshiped at the temple, and related matters. See Sakurai Tokutarō, "Engi no Ruikei to Tenkai" (Types of *Engi* and their Development), in Sakurai et. al., eds., *Jisha Engi*, vol. 20 of *Nihon Shisō Taikei* (Tokyo, 1975), pp. 445–478. Valuable material concerning engi is included in Royall Tyler, *The Miracles of the Kasuga Deity* (New York, 1990), especially pp. 40–

41. For a discussion of the development of the medieval engi, see Yoshihara Hiroto, "⟨Chūsei-teki⟩ Jisha Engi no Keisei" (Formation of the ⟨Medieval Type⟩ of Jisha Engi), *Kokubungaku: Kaishaku to Kanshō* 51.6 (1986): 122–127. For illustrations, see Nara Kokuritsu Hakubutsukan, ed., *Shaji Engi-e* (Illustrated Tales of Shrines and Temples), Tokyo, 1975.

2. An interesting discussion of these scrolls is Yoshiaki Shimizu, "The *Shigisan-engi* Scrolls, c. 1175," in Herbert L. Kessler and Marianna Shreve Simpson, eds., *Pictorial Narrative in Antiquity and the Middle Ages*, (Washington, 1985), pp. 115–129. (Myōren, the central character of *Shigisan-engi*, is said to be a *hijiri* from Shinano.)

3. The most extensive discussion of the *Zenkōji Engi* is found in Sakai, *Zenkōji Shi*, which, however, is somewhat dated. A different approach can be found in Gorai, *Zenkōji-mairi*. See also Shimaguchi Yoshiaki, "Jisha Engi to Minzoku: *Zenkōji Engi* o Chūshin ni" (Jisha Engi and the People: Centering on *Zenkōji Engi*), in Ōtani Daigaku Kokushi Gakkai, eds., *Ronshū: Nihonjin no Seikatsu to Shinkō* (Studies on the Lives and Beliefs of the Japanese) (Kyoto, 1979), pp. 577–605.

4. Kobayashi Ichirō, *ZNE*, pp. 15–40; Ushiyama, pp. 138–140.

5. *Kokushi Taikei*, vol. 12, pp. 1–336.

6. Tamura Enchō, "Kinmei Tennō Jūsan-nen Bukkyō Denrai Setsuwa no Seiritsu" (Formation of the Legends Concerning the Transmission of Buddhism in the 13th year of Emperor Kinmei) in *Asuka Bukkyō-shi Kenkyū* (Tokyo, 1969), pp. 166–177

7. Aston, vol. II, pp. 65–67; Sakamoto, vol. II, pp. 100–103.

8. *Kokushi Taikei*, vol. 12, pp. 28–29. The full versions of each text considered will be cited here, but it should be noted that the specific accounts of the Zenkōji Buddha's arrival in Japan are all contained in *Shinano Shiryō*, vol. 2, pp. 18–23.

9. This section of *Fusō Ryakki* does not deal specifically with the Zenkōji Amida Triad, but is, rather, an account of the original introduction of Buddhism into Japan as a result of the gift of King Song of Paekche to Emperor Kinmei of Japan. See the article by Tamura cited in note 6, above.

10. The detail of the image "floating" in to Japan may be related to an account in the next year (553) that describes a magical log floating into Kawachi harbor: *Nihon Shoki*, Aston II, pp. 67–68; Sakamoto II, pp. 103–105; *Fusō Ryakki, Kokushi Taikei*, vol. 12, p. 29.

11. This is the *Ch'ing Kuan-shih-yin P'u-sa Hsiao-fu Tu Hai T'o-li-ni Chou Ching, Taishō Shinshū Daizōkyō*, vol. 20, text 1043, pp. 34–38. Alexander C. Soper has rendered the title in English as "Dharani Spell Sutra that Implores the Bodhisattva Avalokitesvara to Counteract Evil Influences." See *Literary Evidence for Early Buddhist Art in China* (Ascona, 1959), pp. 150–151. See also Robert F. Campany, "Notes on the Devotional Uses and Symbolic Functions of *Sutra* Texts as Depicted in Early Chinese Buddhist Miracle Tales and Hagiographies," *The Journal of the International Association of Buddhist Studies* 14.1 (1991): 33 and p. 62, note 33.

12. Yoneyama Kazumasa, "Zenkōji Ko Engi ni tsuite" (Concerning the Old Zenkōji Engi), *Shinano* 9.6 (1957): 356–368. Shimaguchi, "Jisha Engi to Minzoku," pp. 584–585.

13. The *Mizu Kagami* is a three-volume work attributed to Nakayama Tadachika, dated to about the end of the twelfth century. It is not considered very reliable. See *Kokushi Taikei*, vol. 21A, pp. 35–36. The *Iroha Jirui Shō* is a Late Heian work by Tachibana Tadakane, with additions made in the Kamakura period. It is the first dictionary using the Japanese syllabic system. For the reference to Zenkōji, see *Shinano Shiryō*, vol. 2, p.19.

14. McCullough, *Heike*, p. 88.

15. In two articles, Kanai Kiyomitsu points out interesting relationships between *Heike Monogatari* and Zenkōji-hijiri. See "Zenkōji-hijiri to Sono Katarimono" (Zenkōji-hijiri and Their Tales) in *Jishū Bungei Kenkyū* (Tokyo, 1967), and "Nagatabon *Heike Monogatari* no Itsukushima Engi," in *Jishū to Chūsei Bungaku*, (Tokyo, 1975). A full discussion of other textual references to Zenkōji would be an enormous undertaking. Important works translated into English include *Shasekishū*, Robert E. Morrell, *Sand and Pebbles (Shasekishū): The Tales of Mujū Ichien, A Voice for Pluralism in Kamakura Buddhism* (Albany, 1985), p. 200, "The Girl Who Became a Serpent Through Delusive Attachments"; *Jinnō Shōtōki*, H. Paul Varley, *A Chronicle of Gods and Sovereigns: Jinnō Shōtōki of Kitabatake Chikafusa* (New York, 1980), pp. 123–124, "Emperor Kimmei"; *Towazugatari*, Karen Brazell, *The Confessions of Lady Nijō* (New York, 1973), pp. 185, 195–197. A good survey of literary references to Zenkōji is Takizawa Sadao, "Monogatari-Bungaku no Naka no Zenkōji" (Zenkōji in Tales and Literature) in Itō Nobuo, et al., eds. *Zenkōji: Kokoro to Katachi* (Zenkōji: Spirit and Form) (Tokyo, 1991), pp. 224–228.

16. Part of this text is published in *Shinano Shiryō*, vol. 2, pp. 22–24. I was allowed to make a photocopy of the entire text at the Kanazawa Bunko by Mr. Manabe Shunshō. For a general discussion of the material at this library, see Nōdomi Jōten, *Kanazawa Bunko Shiryō no Kenkyū* (Research on the Historical Documents of Kanazawa Bunko) (Kyoto, 1982).

17. Ōta Toshirō, ed., *Zoku Gunsho Ruijū*, Tokyo: Zoku Gunsho Ruijū Kansei Kai, vol. 28, text 814, pp. 136–193. The reference to the fire of Ōan 3.4.4 is on p. 191b.

18. *Dai Nihon Bukkyō Zensho*, vol. 120 of *Jishi Sōsho* 4: 233–279. The reference of the fire of Ōei 34.3.6 is on p. 277b.

19. See *Nagano* 121: 54. The "Kanbun" of this title refers to a chronological era of the later seventeenth century and should not be confused with *kanbun* referring to Chinese characters.

20. Kobayashi Ichirō, *ZNE*, provides the entire text, with notes, and a translation into modern Japanese.

21. For example, *Zenkōji Nyorai E-kotoba Den*, published in 1856, provides a complete version of the legend illustrated with numerous woodblock pictures.

22. An interesting survey of the relationship between illustrated texts and

storytelling is Victor Mair, *Painting and Performance* (Honolulu, 1988). For an illustration of a priest preaching with the aid of pictures, see *Nagano* 121: 55. See also the studies by Barbara Ruch cited in note 7, Chapter 1.

23. This is the Japanese romanization of the Sanskrit name *Vaishali*.

24. Nyoze-hime is not, strictly speaking, a princess, although this seems like an appropriate translation to capture the meaning.

25. For this story, see Kobayashi Ichirō, *ZNE*, p. 31.

26. Giba (Sanskrit "Jivaka") was a famous doctor in ancient India. For full details, see *Bukkyō Daijiten* I, pp. 535–536.

27. Stories about returning from death are frequent in Japan. See, for example, Royall Tyler, *The Miracles of the Kasuga Deity*, pp. 197–198, for an interesting account about an individual's descent to hell, sightseeing tour, and return to this world.

28. Stephen F. Teiser, *The Ghost Festival in Medieval China* (Princeton, 1988), provides a detailed account of the role of Mokuren (Ch., Mu-lien, Sanskrit, Maudgalyayana) in medieval Chinese Buddhism. See also Victor H. Mair, "Notes on the Maudgalyayana Legend in East Asia," *Monumenta Serica* 37 (1986–1987): 83–93.

29. The motif of diving into the water can be seen in a different manifestation in *Kegon Engi Emaki, Gishō Scroll* III, where the woman Zenmyō jumps into the sea after the ship to follow the monk Gishō. *Nihon Emakimono Zenshū*, vol. 7 (Tokyo, 1959), pl. 19. Perhaps both legends share common roots.

30. The *Nihon Shoki* account does not provide the detail of King Song's image arriving at Naniwa, although this account of the debate between the opponents of Buddhism and its advocates closely follows *Nihon Shoki*'s discussion of King Song's gift.

31. *Nihon Shoki* omits the detail about melting, although it does refer to throwing the image into Naniwa canal. Numerous illustrations indicate that visual artists found this scene interesting to depict.

32. *Nihon Shoki* does not contain the statement that the demons predicted the death of the emperor and Mononobe no Okoshi, but this is not surprising since it was written to praise the imperial line. It does, of course, refer to the fire that destroyed the palace.

33. In terms of orthodox chronology, a lot of time has elapsed here, since the gift of King Song was supposed to have been in 552 while the death of Emperor Kinmei was nineteen years later in 571. There is no documentary evidence to indicate when Okoshi died, although at the beginning of the reign of Kinmei's successor, Bidatsu, Okoshi's son Mononobe no Moriya is referred to as his father's successor as O-muraji.

34. It is stated in *Nihon Shoki* that Emperor Bidatsu was not a believer in Buddhism, which suggests, in the context, that he was actively opposed to it. This is probably why he is singled out here as becoming ill as a result of the curse of the Amida Buddha. Orthodox history maintains that Mononobe no Moriya carried on the opposition to Buddhism of his father, and *Nihon Shoki* records that in 585 he threw the Buddha image belonging to Soga no Umako into Naniwa Canal.

Subsequently, a plague struck the country that was attributed to the mistreatment of Umako's image. Umako petitioned Emperor Bidatsu to be allowed to practice Buddhism, and although this wish was granted, Bidatsu died later in the same year.

35. There is an enormous literature on Prince Shōtoku. See Takemitsu Makoto, *Shōtoku Taishi: Nihon Shisō no Genryū* (Tokyo, 1984) for a recent account.

36. This detail is intended to show that Prince Shōtoku was associated with the pro-Buddhist side.

37. For the black horse mythology and Prince Shōtoku, see Gorai, *Zenkōji-mairi*, pp. 153–157.

38. The victory of the pro-Buddhist forces, led by Soga no Umako, is here attributed to Prince Shōtoku.

39. The writing of the Constitution and the dedicating of temples are part of orthodox history, but of course the account of Prince Shōtoku going to Naniwa Canal to rescue the Buddha is specific to *Zenkōji Engi*.

40. The name "Yoshimitsu" in Chinese-style pronunciation is "Zenkō," from which the temple gets its designation. There has been a good deal of speculation as to where the surname "Honda" comes from, one suggestion being that it is derived from "Hata." See Kobayashi Ichirō, *ZNE*, pp. 25–26. Ina-gun Omi is equivalent to present day Iida City in southern Nagano Prefecture. The term for national labor service given in the text is one that was in use during the Heian period.

41. Gorai has considered the significance of the mortar in the Zenkōji cult in *Zenkōji-mairi*, p. 97. For an illustration of a medieval mortar, see Shibusawa Keizō, *Emakimono ni yoru Nihon Jōmin Seikatsu Ebiki* (Illustrations of the Lives of Japanese People according to Picture Scrolls) vol. 4 (Tokyo, 1967), pp. 200–201, pl. 633 (showing *Kasuga Gongen Genki-e*).

42. The name "Yayoi" does not occur in the Ōan or Ōei *Engi*, although it appears by the early Edo period. See Kobayashi Ichirō, *ZNE*, p. 30.

43. This story emphasizes the family context of the Zenkōji Buddha.

44. The text says that the oracle was given in the first year of Empress Kō-gyoku, or 642. According to this chronology, forty years have passed since the image left the capital and arrived in Shinano Province. Empress Kōgyoku will be encountered in an extremely interesting context in a moment.

45. This is supposed to have occurred in the second year of Kōgyoku, or 643.

46. She lived from 594 until 661, reigning first as Kōgyoku, 642–645, and then as Saimei, 655–661. See Yoshihara Hiroto, "Kōgyoku Tennō no Dajigoku Dan: *Zenkōji Engi*" (The Story of Empress Kōgyoku's Fall into Hell: *Zenkōji Engi*), *Kokubungaku: Kaishaku to Kanshō* 55.8 (1990): 74–78; Nishiyama Katsu, "⟨Jotei⟩ no Dajigoku: Zenkōji Sankei Mandara o Tekisuto ni shite" (The Fall of the ⟨Empress⟩ into Hell: Using the Zenkōji Sankei Mandara as Text), *Shinano* 39.11 (1987): 21–43; Shimaguchi, "Jisha Engi to Minzoku," pp. 594–599.

47. The proposal by Yoshisuke to substitute himself for Empress Kōgyoku is identical to Mokuren's offer to take the place of his suffering mother in hell, and

probably was influenced by it. See Teiser, *The Ghost Festival in Medieval China*, pp. 87–91.

48. Takada Ryōshin, "Zenkōji Nyorai Gosho-bako no Roman" (The Story of the Letter Box of the Zenkōji Buddha), in *Horyuji 1: Rekishi to Ko Bunken*, vol. 1 of *Nihon no Koji Bijutsu* (Tokyo, 1987), pp. 166–172. Kobayashi Keiichirō, "Zoku Gunsho Ruijū Shoshū Zenkōji Engi Maki-yon ni tsuite," (Concerning Book Four of the Zenkōji Engi in the Zoku Gunsho Ruijū), *Nagano* 29 (1970): 22–41, has translated into modern Japanese Book 4 of *Zenkōji Engi*, which contains all of these events. For the Shōtoku Taishi account, see pp. 23–24.

49. *Nagano* 29 (1970): 24–25.

50. Ibid., pp. 28–29.

51. Ibid., pp. 30–34.

52. Ibid., pp. 34–35.

53. Ibid., pp. 38–40.

54. It is interesting to note that this text does not refer to Princess Nyoze's sickness as the motivation for Gakkai-chōja's having the Triad made. See Kobayashi Ichirō, *ZNE*, p. 18.

55. An instance of Sangoku Denrai that includes India, China, and Japan is that of the transmission of the Seiryōji Shaka.

56. Kobayashi Ichirō has suggested that one reason for the association of the Zenkōji Buddha with the Kingdom of Paekche is the possibility of settlers from the Korean Peninsula bringing an icon from Korea to Nagano, *ZNE*, pp. 19–20.

57. Gorai devotes a whole section of his monograph to the relationship between Prince Shōtoku and Zenkōji. See *Zenkōji-mairi*, section 3, "Zenkōji Nyorai to Shōtoku Taishi" (The Zenkōji Buddha and Prince Shōtoku), pp. 145–183. Of course, many temples claim a connection with the prince in order to enhance their prestige.

58. Gorai deals with the concept of Tokoyo in *Zenkōji-mairi*, pp. 68–69. See also Shimaguchi, "Jisha Engi to Minzoku," pp. 579–584. For a more general discussion, see Carmen Blacker, *The Catalpa Bow: A Study of Shamanistic Practices in Japan* (London, 1975), pp. 73–75.

59. For Honda Yoshimitsu as a hijiri, see Gorai, *Zenkōji-mairi*, pp. 114–124. Needless to say, Honda Yoshimitsu also has the characteristics of a house-holder in that he is married with children.

60. Gorai's monograph, *Zenkōji-mairi*, presents a detailed analysis of Shamanism in *Zenkōji Engi*. My understanding of Japanese shamanism has been strongly influenced by Blacker, *The Catalpa Bow*.

61. Gorai, *Zenkōji-mairi*, pp. 98–107.

62. For a good account of Sensōji, see Kanaoka Shūyū, ed., *Koji Meisatsu Daijiten* (Dictionary of Famous Old Temples) (Tokyo, 1981), pp. 259–263. Another interesting example of a temple founded by laypeople is Kokawadera; see Hyōdō Hiromi, "Kokawadera" in *Kokubungaku: Kaishaku to Kanshō* 47.3 (1982): 140–141.

63. As I indicated in Chapter 1, my thinking on this subject has been strongly influenced by Carol Zaleski, *Otherworld Journeys: Accounts of Near-Death Experi-*

ence in Medieval and Modern Times. There are, of course, numerous accounts of this type in traditional Japanese tales.

64. There are interesting structural relations between the Indian and the Japanese families:

Gakkai-chōja	Wife	Nyoze-hime
Honda Yoshimitsu	Yayoi	Yoshisuke

Kobayashi Ichirō has suggested that the female "Nyoze-hime" may have been transformed into the male "Yoshisuke" as part of a process of spiritual advancement in which the reincarnated being moves from the lesser female state to the higher male one, thus getting closer to salvation. Kobayashi Ichirō, *ZNE,* pp. 15–16.

65. Much recent research has been concerned with the entertainment, or story, aspect of religious narratives. See particularly three books by Victor H. Mair: *Tun-huang Popular Narratives* (Cambridge, 1983), *Painting and Performance* (Honolulu, 1988), and *T'ang Transformation Texts* (Cambridge, Mass., 1989). For Japanese discussions of tale-telling, see Kawaguchi Hisao, "Waga-kuni ni okeru Etoki: Tonkō henbun kara no Shōsa" in *Etoki no Sekai: Tonkō kara no Kage* (Tokyo, 1981), pp. 1–111; Hayashi Masahiko, *Zōho Nihon no Etoki: Shiryō to Kenkyū* (Tokyo, 1984).

66. George Kubler, *The Shape of Time* (New Haven, 1962).

67. *Fusō Ryakki,* p. 28.

68. Lena Kim, "Samguk sidae ui pongji pojuhyong posal ipsang yon'gu: Paekche wa Ilbon ui sang ul chungsim uro" (Bodhisattva Images Holding Cintamani from the Three Kingdoms Period: With an emphasis on Images of Paekche and Japan), *Misul Charyo* 37 (1985): 1–39. For a Japanese version of this article, see "Hōju Hoji Bosatsu no Keifu" (The Lineage of the Jewel-clasping Bodhisattva) in Mizuno Keizaburo, ed., *Nihon Bijutsu Zenshū,* vol. 2, *Hōryūji kara Yakushiji e: Asuka-Nara no Kenchiku-Chōkoku* (Tokyo, 1990), pp. 195–200. A recent article that includes a discussion of the jewel-clasping Bodhisattva in East Asia is Lucie R. Weinstein, "The Yumedono Kannon: Problems in Seventh Century Sculpture," *Archives of Asian Art* 42 (1989): 25–48.

69. For example, the gilt-bronze shrine dated 524 in the Metropolitan Museum, or the steles in the Nelson Gallery and the Museum of Fine Arts, Boston, Sickman and Soper, *The Art and Architecture of China,* pls. 66–68.

70. For the Kondō Shaka Triad, see Seiichi Mizuno, *Asuka Buddhist Art: Horyuji* (New York and Tokyo, 1974), pl. 18. For the Tachibana Shrine, see ibid., pl. 114. For the Yakushiji Yakushi Triad, see Takeshi Kobayashi, *Nara Buddhist Art: Todaiji* (New York and Tokyo, 1975), pls. 79–83.

71. For the Asukadera Great Buddha, see Mizuno, *Asuka Buddhist Art,* pl. 13, and for the 628 Triad, ibid., pl. 15. In its present form, the Asukadera Great Buddha is a single seated image, but the pedestal indicates that originally flanking Bodhisattvas were also present.

72. A detailed publication of this triad can be found in Tokyo Kokuritsu Hakubutsukan, ed., *Hōryūji Kennō Hōmotsu Tokubetsu Chōsa Gaihō* V (Tokyo, 1983–

1984); *Kondō-butsu* 1, pp. 4–14. In the recent exhibition at the Tokyo National Museum the Triad was labelled "Asuka or Korean, Three Kingdoms," *Tokubetsu-ten Zuroku: Kondō-butsu—Chūgoku, Chōsen, Nihon*, no. 20: 99–100, 397–398.

73. For Korean Buddhist sculpture see Hwang Su Young, *Buddhist Art*, vol. 3 of *The Arts of Korea* (Seoul, 1979) (hereafter cited as Hwang). Kim Chewon and Kim Won-yong, *Treasures of Korean Art* (New York, 1966), pp. 109–172.

74. Hwang, pl. 9.

75. Ibid., pl. 3.

76. Ibid., pl. 12.

77. Mizuno, *Asuka Buddhist Art*, pl. 170.

78. For example, Hwang, pls. 17 and 20.

79. For the Fujii Yūrinkan stele, see Matsubara Saburō, *Chūgoku Bukkyō Chōkoku-shi Kenkyū* (Research in Chinese Buddhist Sculpture) (Tokyo, 1966), pl. 105.

80. The major exceptions, of course, are the two bronze images of Maitreya in the National Museum of Korea. See Hwang, pls. 23–24.

81. Hwang, pls. 11, 22. Kim and Kim, *Treasures of Korean Art*, pls. 64a–b.

82. In addition to the references in note 72, above, see Satō Akio, *Hōryūji Kennō Kondō-butsu* (Gilt-bronze Images Donated by Hōryūji) (Tokyo, 1975), pls. 15–16, 74–76, and p. 223.

83. Nara Kokuritsu Bunkazai Kenkyūjō, Asuka Shiryō-kan, ed., *Asuka-Hakuhō no Zaimei Kondō-butsu* (Asuka and Hakuhō Gilt-bronze Buddhist Images with Inscriptions), first edition (Nara, 1976), pls. 32–38, pp. 80–83, 105–110; second edition (Nara, 1979), pls. 80–102, pp. 156–159, 182–186.

84. I have presented a general survey of this issue in a paper given at the Annual Meeting of the Association for Asian Studies, Washington, D.C., 1984, entitled "East Sea/Japan Sea: A Neglected Area for Early Korean-Japanese Relations in Buddhist Sculpture."

85. Ishida Mosaku, "Asuka ni nokoru Zenkōji-nyorai no Densetsu to Jittai" (Tradition and Actual Circumstances of Zenkōji Images Preserved in the Asuka Region) in *Asuka Zuisō* (Tokyo, 1972), pp. 223–247.

86. Gorai, *Zenkōji-mairi*, pp. 76–81, demonstrates the dual nature of the Zenkōji Buddha, which incorporates aspects of both Shaka and Amida even though it is officially identified as the latter.

CHAPTER 4

1. Jeffrey C. Mass, *Warrior Government in Early Medieval Japan: A Study of the Kamakura Bakufu, Shugo, and Jitō*; idem, *The Development of Kamakura Rule, 1180–1250*; idem, "The Kamakura Bakufu"; Ishii Susumu, *Kamakura Bakufu*, vol. 7 of *Nihon no Rekishi* (Chūō Kōron) (Tokyo, 1965).

2. *NK-s* 2: 48–83.

3. *NK-s* 2: 114–125.

4. Yumoto Gun'ichi, "Hōjō-shi to Zenkōji" (The Hōjō Clan and Zenkōji), *Nagano* 121 (1985): 1.

5. *Azuma Kagami* I: 266–267 (Bunji 3.7.27–28).

6. Ibid., I: 450 (Kenkyū 22.10.22).

7. *Ōan Zenkōji Engi*, pp. 185–187. It is possible that the making of the life-sized image was motivated by the desire to provide the icon with a greater sense of animation than would be the case with the typical small-scale form. See Yoshihara Hiroto, "Zenkōji Honzon to Shōjin Shinkō," as cited in Chapter 1, note 2.

8. Kurata Bunsaku, *Butsuzō no Mikata* (Looking at Buddhist Sculpture) (Tokyo, 1965), p. 260, has suggested that there may have been *bakufu* support behind this commission.

9. *Azuma Kagami* I: 546 (Kenkyū 6.8.2).

10. Ibid., I: 548 (Kenkyū 6.8.23). Ushiyama (p. 140) provides an interesting discussion of the evidence for Yoritomo's pilgrimage.

11. Kurosaka Katsumi, ed., *Kokon Chomonjū, Shintei Zōho Kokushi Taikei*, Vol. 19 (Tokyo, 1930), Book 2, p. 45.

12. Yamada Yasuhiro, "Kōfu Zenkōji no Shōzō Chōkoku: Minamoto Yoritomo Zō Nado" (The Portrait Sculpture of Kōfu Zenkōji: The Image of Minamoto Yoritomo and Others), *Miura Kobunka* 29 (1981): 14–21.

13. *Azuma Kagami* I: 493 (Kenkyū 4.6.18).

14. Ibid., I: 652 (Jōgen 4.8.12).

15. Ibid., I: 719 (Kenpō 3.12.20).

16. Watanabe Tamotsu, *Hōjō Masako* (Tokyo, 1961).

17. Martin Collcutt, *Five Mountains: The Rinzai Zen Monastic Institution in Medieval Japan* (Cambridge, Mass., 1981), pp. 57–58.

18. Tsukada, *Nagano-ken no Rekishi*, p. 78, has argued that Tokimasa was granted estates in Shinano, but *NK-s* 2: 108, dismisses this theory. Consequently, it is not certain when the Hōjō Clan got its foothold in the province.

19. This paragraph is based on the research of Yumoto Gun'ichi, "Hōjō-shi to Shinano no Kuni" (The Hōjō Clan and Shinano Province), *Shinano* 19 (1967): 841–860, and "Shinano no Kuni ni okeru Hōjō-shi no Shoryō" (Hōjō Clan Estates in Shinano Province), *Shinano* 24 (1972): 800–813. For a general discussion of Hōjō government see Yasuda Motohisa, *Kamakura Shikken Seiji: Sono Tenkai to Kōzō* (Government by the Kamakura Shikken: Its Development and Structure) (Tokyo, 1979). Also, Okutomi Takayuki, *Kamakura Hōjō-shi no Kisoteki Kenkyū* (Fundamental Research on the Hōjō Clan) (Tokyo, 1980). In English there is H. Paul Varley, "The Hōjō Family and Succession to Power," in Jeffrey P. Mass, ed., *Court and Bakufu in Japan: Essays in Kamakura History* (New Haven, 1982), pp. 143–167, and Andrew Goble, "The Hōjō and Consultative Government," ibid., pp. 168–190.

20. Yumoto, "Hōjō-shi to Zenkōji," p. 1.

21. *Ōan Zenkōji Engi*, p. 192.

22. See Donald Keene, "The Diary of the Priest Shunjo," in *Travelers of a Hundred Ages* (New York, 1989), pp. 121–125. For a reference to this event, see Kawazoe Shoji, *Kamakura Bunka* (Kamakura Culture) (Tokyo, 1982), p. 58. Ushiyama, p. 140. (I use the romanization "Shinshō.")

23. Kobayashi, *Zenkōji San*, p. 50.

24. For Hōjō Shigetoki, see Carl Steenstrup, *Hōjō Shigetoki (1198–1261)* (Copenhagen, 1979).

25. *Ōan Zenkōji Engi*, p. 192.

26. *Azuma Kagami* II: 244–246 (En'ō 1.7.15).

27. *Hōjō Kyūdai Ki*, in *Zoku Gunsho Ruijū* 855 (Tokyo, 1925): 413.

28. *Ōan Zenkōji Engi*, p. 191; Ushiyama, p. 141.

29. Yumoto, "Hōjō-shi to Zenkōji," p. 3.

30. Gorai discusses Nagoe Zenkōji in *Zenkōji-mairi*, p. 322. This was a temple founded by the Nagoe line, devoted to the Zenkōji cult. See also Ushiyama, p. 141.

31. *Azuma Kagami* II: 359 (Kangen 4.3.14).

32. Gorai, *Zenkōji-mairi*, p. 322. Okutomi, *Kamakura Hōjō-shi*, pp. 162–163, discusses the fall of the Nagoe line. In 1250 Kujō Michiie, the father of the fourth Shōgun, and an ally of the Nagoe line, gave a donation to Zenkōji; see Ushiyama, p. 141.

33. *Azuma Kagami* II: 560–561 (Kenchō 5.4.26).

34. Ibid., II: 820–822 (Kōchō 3.3.17).

35. Yumoto, "Shinano Kuni ni okeru Hōjō shi no Shoryō," pp. 58, 65–67.

36. Collcutt, *Five Mountains*, pp. 72–73.

37. Yumoto, "Hōjō-shi to Zenkōji," p. 4, quoting *Zenkōji Bettō Denryaku*. (I have not seen this text.)

38. See Kanagawa Kenritsu Kanazawa Bunko, ed., *Kanazawa Bunko Meihin Zuroku*, (Catalogue of the Famous Works of the Kanazawa Bunko) (Yokohama, 1981), pl. 31 and p. 100. Nōdomi Jōten, *Kanazawa Bunko Shiryō no Kenkyū*.

39. For general references to Kamakura Buddhism, see Tokoro Shigemoto, *Kamakura Bukkyō*, (Kamakura Buddhism) (Tokyo, 1967), and Tanaka Hisao, *Kamakura Bukkyō* (Tokyo, 1980). For a lengthy discussion in English, see Matsunaga and Matsunaga II. The most recent detailed treatment is Ōsumi, "Buddhism in the Kamakura Period," cited in Chapter 1, note 11.

40. See James H. Foard, "In Search of a Lost Reformation: A Reconsideration of Kamakura Buddhism," *Japanese Journal of Religious Studies* 7.4 (1980): 261–291, especially pp. 261–262.

41. Nichiren was particularly opposed to the belief in Amida, and the following comment by him should be seen in this context: "Here it must be pointed out in passing that the most appalling fraud in the world today is the statue of Amida Buddha, allegedly the original object of worship of Zenko-ji Temple." In Nichirin Shōshū International Center, ed., *The Major Writings of Nichiren Daishōnin*, vol. 3 (Tokyo, 1985), p. 253. Original text in *Shōwa Teihon Nichiren Shōnin Ibun*, vol. 2, p. 1381.

42. Particularly important is the rise of Pure Land Buddhism within the Tendai School during the Heian period. See Allan A. Andrews, *The Teachings Essential for Rebirth: A Study of Genshin's Ōjōyōshū*.

43. For a good discussion of Hōnen and extensive bibliographical information, see James C. Dobbins, *Jōdo Shinshū: Shin Buddhism in Medieval Japan* (Bloomington, 1989), pp. 11–20. Also Allan A. Andrews, "Hōnen" in *The Encyclopedia of*

Religion 6: 453–455. For recent Japanese discussion, see Itō Yuishin, "Hōnen to Senju Nenbutsu," in Hamashima, *Jōdokyō*, pp. 286–296.

44. For Shinran, see Dobbins, *Jōdo Shinshū*, pp. 21–46. Also Alfred Bloom, "Shinran" in *The Encyclopedia of Religion* 13: 278–280. For a recent Japanese discussion, see Yamada Yasuhiro, "Shinran to Jōdo Shinshū" in Miyama Susumu, ed., *Zusetsu Nihon no Bukkyō*, vol. 4, *Kamakura Bukkyō* (Tokyo, 1988), pp. 50–57.

45. Foard, "In Search of a Lost Reformation."

46. For an extremely informative discussion of the nature of popular or folk religion, see Teiser, *The Ghost Festival in Medieval China*, pp. 215–217. Also interesting is Catherine Bell, "Religion and Chinese Culture: Toward an Assessment of 'Popular Religion'" *History of Religions* 29.1 (1989): 35–57.

47. Chapter 2, pp. 36–37.

48. Ushiyama, pp. 141–142.

49. Ibid. The term *dōshū* is difficult to translate. It refers to lower-level priests who carried out the routine tasks at the temple.

50. For general discussions of hijiri, see Gorai, *Kōya-hijiri*, and Ichirō Hori, "On the Concept of Hijiri (Holy-Man)," *Numen* 5 (1958): 128–160 and 199–232.

51. Virtually all of the architecture, sculpture, and painting in the temples of Nara, Kyoto, and Kamakura can be directly associated with the elite classes, as can the majority of monuments located elsewhere. Two significant exceptions, of the Edo period, are the works of the sculptor-monks Enkū and Mokujiki.

52. Ichirō Hori, *Folk Religion in Japan: Continuity and Change* (Chicago, 1968). See also Bell, as in note 46.

53. Christine Guth Kanda, *Shinzō, Hachiman Imagery and Its Development* (Cambridge, Mass. 1985). An interesting viewpoint on the nature of Shinto is Kuroda Toshio, "Shinto in the History of Japanese Religion," *The Journal of Japanese Studies* 7.1 (1981): 1–21.

54. It seems likely that the acceptance of Buddhism in early Japan was dependent largely on the role of the Soga Clan. I am preparing a monograph dealing with this topic, entitled *The Soga Clan and Early Buddhist Art in Japan*.

55. Inoue, "Sōni no Tōsei" (Control of Monks and Nuns) in *Asuka no Chōtei*, pp. 215–216.

56. Kuno Takeshi, "Daibutsu Igo" (After the Great Buddha) in *Heian Shoki Chōkoku-shi no Kenkyū* (Research into the History of Early Heian Buddhist Sculpture) (Tokyo, 1974), pp. 26–30.

57. For Gyōki, see Hori, "Hijiri," p. 134, note 18.

58. For En no Gyōja, see Matsunaga and Matsunaga I: 242–245, and Blacker, *The Catalpa Bow*, pp. 96–98.

59. Miwa, *Kokubunji*.

60. For the move from Nara to Kyoto see Sansom: 99–101; Kitayama Shigeo, *Heiankyō*, pp. 33–37, 69–70.

61. For Saiji and Tōji, see *Kyoto no Rekishi* (History of Kyoto) (Kyoto, 1970), 1: 366–368.

62. Hori, "Hijiri," p. 131. (Emphasis in the original.) For a good discussion of the Zenkōji-hijiri, see Ushiyama, pp. 143–146.

63. For the entertainment aspect of such storytellers, see Victor Mair, *Painting and Performance*. See also Masao Yamaguchi, "Kingship, Theatricality, and Marginal Reality in Japan," in Ravindro K. Jain, ed., *Text and Context: The Social Anthropology of Tradition* (Philadelphia, 1977), for a valuable discussion of marginal individuals in Japanese society. Naturally, this entertainment activity has to be seen in the context of the gathering of funds, or *kanjin*.

64. Koizumi Hiroshi and Yoshida Yukikazu, eds., *Hōbutsushū* (Tokyo, 1968), pp. 324–325. The textual history of this book is complicated, and some scholars have questioned the Heian date for this entry. See Ihara Kesao, "Chūsei Zenkōji no Ichi-kōsatsu" (One Theory concerning Medieval Zenkōji), *Shinano* 40.3 (1988): 202–205. For a general discussion of *Hōbutsushū*, see Ishida Mizumaro, "Hōbutsushū Zakkō: Mitsu no Mondai" (Hōbutsushū Miscellany: Three Problems) in *Nihon Bukkyō Shisō Kenkyū 5, Bukkyō to Bungaku* (Research into Japanese Buddhist Thought 5, Buddhism and Literature) (Kyoto, 1987), pp. 7–55. For the activities of Zenkōji-hijiri, see Kanai Kiyomitsu, "Zenkōji-hijiri to sono Katarimono" (The Zenkōji-hijiri and Their Tales) in *Jishū Bungei Kenkyū* (Research in the Arts of the Ji School) (Tokyo, 1967).

65. Nagoe Sect: Gorai, *Zenkōji-mairi*, pp. 232–247; "Jōdo-shū Nagoe-ha to Zenkōji Shinkō" (The Nagoe School of Jōdo and Zenkōji Belief), *Nagano* 108 (1983): 59.

66. Gorai, *Kōya-hijiri*, pp. 227–240; idem, *Zenkōji-mairi*, pp. 257–261.

67. Gorai, *Kōya-hijiri*, pp. 152–154.

68. Ōhashi Shunnō, *Ippen Shōnin* (Tokyo, 1983). See also Kanai Kiyomitsu, "Zenkōji Shinkō to Ji Shū" (Belief in Zenkōji and the Ji School), *Nagano* 29 (1970): 9–21, and Imai Masaharu, "Zenkōji to Zenkōji Shinkō" (Zenkōji and the Zenkōji Cult) in *Ji Shū Seiritsu-shi no Kenkyū*, (Research on the History of the Formation of the Ji School) (Tokyo, 1981). In English, see James H. Foard, "Ippen," in *The Encyclopedia of Religion*, vol. 7: 274–275.

For discussions dealing with Ippen and the scroll illustrating his life, see Laura S. Kaufman, "Nature, Courtly Imagery, and Sacred Meaning in the *Ippen Hijiri-e*" in J. Sanford, W. LaFleur, and M. Nagatomi, eds., *Flowing Traces: Buddhism in the Literary and Visual Arts of Japan* (Princeton, 1992), pp. 47–75; and James H. Foard, "Prefiguration and Narrative in Medieval Hagiography: The *Ippen Hijiri-e*" in J. Sanford et al., eds., *Flowing Traces* (Princeton, 1992), pp. 76–92.

69. Gorai, "Zenkōji Shinkō to Shin Zenkōji" (Belief in Zenkōji and the New Zenkōji) in *Zenkōji-mairi*, pp. 277–326.

70. I am preparing a study entitled *Seiryōji and Its Icon*, which contains a full bibliography on this topic.

71. Gorai, *Zenkōji-mairi*, p. 289.

72. For a discussion of the seals referred to as the *O-tehan, O-kechimyaku*, and *Go-inmon*, see Gorai, *Zenkōji-mairi*, pp. 177, 278–285.

73. For the *kaidan meguri*, see Gorai, *Zenkōji-mairi*, pp. 49–50, 172–183. Mt. Shigi is also provided with a kaidan meguri.

74. For a photograph of the present lock, see Gorai, *Zenkōji-mairi*, p. 174.

75. A convenient source for paintings is the Shinano Art Museum exhibition catalogue, *Zenkōji Eden-ten* (Nagano, 1973). For the practice of using pictorial works in preaching, see Tokuda Kazuo, *Egatari to Monogatari* (Illustrated Stories and Tales) (Tokyo, 1990).

76. Kobayashi Keiichirō has worked for many years on compiling a comprehensive list of Zenkōji-related temples. See "Shin Zenkōji/Zenkōji-shiki Sanzon Zō Ichiran" (A Catalogue of Shin Zenkōji and Zenkōji Style Triads), *Nagano* 108 (1983): 11–20, and "Kakuchi no Shin Zenkōji" (The Shin Zenkōji of Various Regions), ibid., pp. 26–57.

77. Kobayashi Keiichirō has provided a detailed list in *NK-s* 2, "Appendix," pp. 1–19.

78. It is beyond the scope of the present study to attempt a presentation of recent developments in the cult of the Zenkōji Buddha. See the various articles by Yamanoi Daiji cited in the bibliography.

79. Takeda.

80. Nishikawa and Sekine, pp. 9–42.

81. Gorai, *Zenkōji-mairi*, pp. 290–298.

82. Kobayashi, *Nagano* 108: 19.

83. Ibid., pp. 19–20. Also important in Kyūshū is Shibahara Zenkōji in Usa City, Ōita Prefecture, ibid., p. 57.

84. Ibid., p. 36.

85. For oracles, see Gorai, *Zenkōji-mairi*, pp. 124–132.

86. Gorai, *Zenkōji-mairi*, pp. 285–290.

87. Kobayashi, *Nagano* 108: 36–37; and Ono Sumio and Ono Mitsuo, "Zenkōji Nyorai Ibun: Suwa ni kita Zenkōji Nyorai" (An Unusual Story Concerning the Zenkōji Buddha: The Zenkōji Buddha Comes to Suwa), ibid., 67–69; Gorai, *Zenkōji-mairi*, p. 288.

88. Sakai, *Zenkōji Shi*, pp. 253–257. Gorai, *Zenkōji-mairi*, pp. 290–293.

89. *Jinten Ainō Shō* as quoted by Gorai, *Zenkōji-mairi*, pp. 292–293.

90. Kobayashi, *Nagano* 108: 47; Sakai, *Zenkōji Shi*, p. 250.

91. Kobayashi, *Nagano* 108: 44–45; Sakai, *Zenkōji Shi*, pp. 257–260.

92. Gorai, *Zenkōji-mairi*, pp. 68–69.

93. See Gorai, *Zenkōji-mairi*, pp. 298–308; Nishikawa and Sekine; Kuno, *Kantō Chōkoku no Kenkyū*, pp. 212–229: Kobayashi, *Nagano* 108: 6–7.

94. Ibid., p. 30. For illustrations of the images, see Nishikawa and Sekine, pls. 12, 13, 28, 29.

95. Sakai, *Zenkōji Shi*, pp. 264–267, 589–590.

96. For Ryūdaiji, see Gorai, *Zenkōji-mairi*, pp. 302–303.

97. For Edo requirement that temples affiliate with sects, see Udaka Yoshiaki, *Edo Bakufu no Bukkyō Kyōdan Tōsei* (The Control of Buddhist Organizations by the Edo Bakufu) (Tokyo, 1987).

98. For Saitokuji, see Gorai, *Zenkōji-mairi*, p. 306.

99. For Miyahara Zenkōji, Gorai, *Zenkōji-mairi*, pp. 303–304.

100. Nishikawa and Sekine, pp. 24–26.

101. Takeda.

102. Takeda. Kobayashi, *Nagano* 108: 3–4.

103. Donald F. McCallum, "Yamagata Kennai no Zenkōji-shiki Sanzon Zō no Ichi-keitō: Kōyasan Fudōin Zō to no Kankei ni tsuite" (One Tradition of Zenkōji Style Triads in Yamagata Prefecture: Concerning the Connections with the Image in Fudōin, Mt. Kōya), *Uyō Bunka*, 122 (1986): 3–21.

104. Nara Kokuritsu Hakubutsukan ed., *Amida Butsu Chōzō* (Tokyo, 1975), pl. 129, pp. 303–304. Mitsumori Masashi , *Amida Nyorai-zō* (Images of Amida Buddha), vol. 241 of *Nihon no Bijutsu* (Shibundō) (Tokyo, 1986).

105. Kuno, *Kantō Chōkoku no Kenkyū*, p. 163.

106. Yoshiko Kainuma, "Shin Zenkōji in the Kinki Region," (M.A. thesis, UCLA, 1987); Kawakatsu Masatarō, "Nishi Nihon ni okeru Zenkōji-shiki Sanzon-zō o Chūshin to shite" (Centering on the Zenkōji type Triads in Western Japan), *Shiseki to Bijutsu* 407 (1970): 246–262.

107. It is not possible to deal in detail with the architectural history of Shinano Zenkōji in this monograph. For a good survey of the issues, see Kobayashi Keiichirō, "Zenkōji Hondō no Kenchiku Yōshiki no Hensen" (Transformations in the Architectural Style of the Main Hall of Zenkōji), *Nagano* 149 (1990): 1–8.

CHAPTER 5

1. This study is included in Kobayashi's collection of articles, *Nihon Chōkoku-shi Kenkyū*, (Research in the History of Japanese Buddhist Sculpture) (Nara, 1947), pp. 357–385. It first appeared in *Bukkyō Bijutsu* 18 (1931).

2. Ibid., p. 377.

3. Kurata, *Butsuzō no Mikata*, pp. 263–267; idem, "Zenkōji Nyorai Kō" (Study of the Zenkōji Buddha), *Kokka* 866 (1964): 8–14; idem, "Kōshu Zenkōji no Amida Sanzon in tsuite" (Concerning the Zenkōji Amida Triad in Kōfu), *Shinano* 16.3 (1964): 162–166.

4. Kurata, *Butsuzō no Mikata*, p. 266.

5. Ibid.

6. Ibid.

7. Uematsu Mataji, "Shingen no Shinano Keiei to Zenkōji: Toku ni Zenkōji Nyorai ni tsuite" (The Activities of Takeda Shingen in Shinano and Zenkōji: Especially Concerning the Zenkōji Buddha), *Kai-ji* 17 (1970): 22.

8. In Matsubara and Tanabe, *Shō Kondō-butsu*, pp. 314–315.

9. See Tanaka Shigehisa, "Shinano Zenkōji Nyorai Genzō no Dōzō Tōshin Setsu" (Theory that the Original Zenkōji Buddha of Shinano was a Life-sized Bronze Image), *Bukkyō Geijutsu* 82 (1971): 11–46.

10. For examples, see Nishikawa Kyōtarō, *Bunkazai Kōza: Nihon no Bijutsu 7, Chōkoku (Kamakura)* (Tokyo, 1977), p. 215; or Kuno Takeshi, *Hokuriku-Shinano no Ko-ji* (Old Temples of the Hokuriku Region and Shinano Province) in *Zenshū Nihon no Ko-ji*, (Tokyo, 1984), p. 85.

11. See Uehara Shōichi, *Kokuhō Chōzō* (National Treasure Sculpture) (Tokyo, 1967), vol. 3, pls. 326–331 (Jingoji Yakushi) and pls. 338–343 (Gangōji Yakushi).

12. Kuno Takeshi, "Heian Shoki no Jizō Bosatsu Zō ni tsuite" (Concerning the Images of Jizō Bosatsu in the Early Heian Period), *Museum* 247 (1971): 4–14.

13. See Gregory Henderson and Leon Hurvitz, "The Buddha of the Seiryō-ji," *Artibus Asiae* 19.1 (1956): 5–55, for a discussion of the Udayana type Buddha as seen in the famous Chinese example enshrined at Seiryōji.

14. Matsubara and Tanabe, *Shō Kondō-butsu*, pls. 11–12, 38.

15. McCallum, "Buddhist Sculpture of the Seisuiji, Matsushiro," pp. 466–467.

16. Kuno Takeshi, *Tōhoku Kodai Chōkoku-shi no Kenkyū*, (Research on the Sculpture of the Ancient Period in the Tōhoku Region) (Tokyo, 1971), pls. 42–45 (Shōjōji) and pls. 87–89 (Sōrinji).

17. See Nishikawa and Sekine, pp. 28–31. Kuno Takeshi, "East Asian Buddhist Sculpture and the Henzan" in *International Symposium on the Conservation and Restoration of Cultural Property: Inter-regional Influences in East Asian Art History* (Tokyo, 1981), pp. 15–27. Japanese version in *Kodai Shō Kondō-butsu*, pp. 242–249.

18. By "interrupted fold" I refer to those folds that loop in from either side but do not join at the center.

19. See, for example, Matsubara and Tanabe, *Shō Kondō-butsu*, pls. 27–29 (Hōryūji images), pl. 44 (Nagano image), and various standing Bodhisattvas from the Forty-eight Buddhist Deities group, Tokyo National Museum, figs. 143–168.

20. Kuno, *Tōhoku Kodai Chōkoku-shi no Kenkyū*, pls. 212–215.

21. I have discussed the Bodhisattva's costume at length in "Heian Sculpture at the Shinano Art Gallery," pp. 445–453, and in "Buddhist Sculpture of the Seisuiji, Matsushiro."

22. The sash can be seen clearly in Kuno Takeshi, *Heian Shoki Chōkoku-shi no Kenkyū*, pls. 210–216 (Kōgenji Jūichimen Kannon), and pls. 549–555 (Hokkeji Jūichimen Kannon).

23. The only instance of a sash that I know of in Hakuhō sculpture is on the Kakurinji Kannon. (Matsubara and Tanabe, *Shō Kondō-butsu*, pls. 59a–c.) In this case it is not really apparent at the front, although it is clearly visible at back. It is my impression that the sash results from T'ang influence on Japanese sculpture of the eighth century, although it is possible that this form appears at the end of the seventh century in Japan.

24. For Heian Bodhisattvas lacking the sash, see Kuno, *Heian Shoki Chōkoku-shi no Kenkyū*, pls. 36–41 (Shō Buraku Bosatsu), pls. 440–443 (Reizanji Jūichimen Kannon), pls. 520–523 (Matsushiro Seisuiji Shō Kannon. Note that this image has a representation of the sash at back, but not at front.)

25. The scarf, as represented in Early Heian sculpture, can be seen in the two images cited in note 22, above.

26. Indicated on the drawing of the side view of the Bodhisattva.

27. The best discussion of the skirt elements will be found in Nishikawa and Sekine, pp. 29–31. For a very clear view of the koshinuno, see Kuno, *Heian Shoki Chōkoku-shi no Kenkyū*, pls. 486–489 (Hiyoshi-jinja Bosatsu).

28. See Kurata's articles cited in note 3, above.

29. Illustrations of the inscriptions will be found in Kurata, "Zenkōji Nyorai Kō," p. 13.

30. Kobayashi Ichirō, *ZNE*, pp. 230–237; *Ōan Zenkōji Engi*, pp. 185–187; *Ō'ei Zenkōji Engi*, pp. 271–273.

31. Gorai Shigeru, *Zenkōji-mairi*, pp. 124–132.

32. Kurata, *Butsuzō no Mikata*, p. 260, has suggested that there may have been bakufu support behind this commission.

33. Mōri Hisashi, "Zensuiji no Dōzō Amida Zō" (The Bronze Amida Image of Zensuiji) in *Nihon Butsuzō-shi Kenkyū* (Research in the History of Japanese Buddhist Images) (Kyoto, 1980), pp. 291–295. [Originally published in *Yamato Bunka Kenkyū* 14 (1955)]. Matsubara and Tanabe, *Shō Kondō-butsu*, pl. 118 (Zensuiji) and pl. 119 (private collection).

34. Ibid., pl. 98 (Tanjō-butsu). Maruo Shōzaburō, et al., *Nihon Chōkoku-shi Kiso Shiryō Shūsei: Zōzō Meiki Ban*, vol. 1 (Tokyo, 1966), pp. 66–70 (text) and pls. 76–78 (Yakushi). Other Zensuiji images are illustrated in the appendix of the text volume, pp. 5–12.

35. The arrangement can also be seen in Northern Wei images. Matsubara, *Chūgoku Bukkyō Chōkoku-shi Kenkyū*, pls. 12–13 (443), pls. 32–33 (477).

36. Tanaka Yoshiyasu, *Tanjō-butsu*, (New-born Buddhas), vol. 159 of *Nihon no Bijutsu* (Tokyo, 1979), pls. 16, 99; pp. 80–81. Another Kamakura example is at Ryūfukuji, Nara. Ibid., pl. 97.

37. Here I am utilizing George Kubler's terminology. See *The Shape of Time*.

38. Mōri, "Zensuiji no Dōzō Amida Zō," p. 293.

39. Ibid., p. 294.

40. Kobayashi Keiichirō, "Kakuchi no Shin Zenkōji no Gaiyō" (Survey of New Zenkōji in Each Region), *Nagano* 108 (1983): 56–57.

41. See the Triads in the Kansong Museum (563) and the Kim Collection (571), discussed in Chapter 3, pp. 57–58.

42. Kobayashi, as in note 40, p. 19.

43. Gorai Shigeru, *Zenkōji-mairi*, pp. 261–262.

44. The significance of King Song's gift of a Buddha figure was discussed above, Chapter 3, pp. 47–48.

45. For gilt-bronze sculpture of the Asuka and Hakuhō periods see, Matsubara and Tanabe, *Shō Kondō-Butsu*; Kuno Takeshi, *Kodai Shō Kondō-butsu*; Tokyo Kokuritsu Hakubutsukan, *Tokubetsu-ten Zuroku: Kondō-butsu—Chūgoku, Chōsen, Nihon.*

46. For gilt-bronze sculpture of the Nara period, see Matsubara and Tanabe, *Shō Kondō-butsu*, and Tokyo Kokuritsu Hakubutsukan, *Tokubetsu-ten Zuroku, Kondō-butsu*. For the Tōdaiji Great Buddha, see *Nara Rokudaiji Taikan*, vol. 10 (Tokyo, 1968), *Tōdaiji* II: 49–57.

47. For Heian gilt-bronze sculpture, in addition to Matsubara and Tanabe and Tokyo Kokoritsu Hakubutsukan, especially important is Nara Kokuritsu Hakubutsukan, ed., *Heian-Kamakura no Kondō-butsu* (Gilt-bronze Buddhist Sculpture of the Heian and Kamakura periods) (Nara, 1976).

48. Ibid. See also Tanabe Saburōsuke, "Kamakura-jidai no Kondō-butsu" (Gilt-bronze Sculpture of the Kamakura Period), *Kōen-kai Shiriizu* 2 (Kanazawa Bunko, 1971). This study has a list of dated gilt-bronze images, from 1195 until

1392, many of which are Zenkōji icons, a list of 165 Zenkōji icons throughout the country, and an extensive bibliography.

49. For the Shinto deity, see the Nara Kokuritsu Hakubutsukan catalogue, pl.

56. For the Hōryūji Amida see *Nara Rokudaiji Taikan*, vol. 2, *Hōryūji* II (Tokyo, 1968), pls. 15, 76–81; pp. 38–43 (Kurata Bunsaku).

50. Nara Kokuritsu Hakubutsukan catalogue, pl. 48.

51. Shimizu Mazumi, *Kamakura Daibutsu: Tōgoku Bunka no Nazo* (The Kamakura Great Buddha: The Riddle of the Culture of the Eastern Regions) (Tokyo, 1979).

52. Illustrated and discussed in the Nara Kokuritsu Hakubutsukan catalogue.

CHAPTER 6

1. *Ōan Zenkōji Engi*, pp. 187–188.

2. Gorai, *Zenkōji-mairi*, pp.186–225. Shinran's relationship with the Zenkōji cult is discussed in Hiramatsu Reizō, *Shinshū-shi Ronkō* (Essays on the History of the Shin School) (Kyoto, 1988), pp. 41–54, 66–67, 97–107.

3. For Shinran at Zenkōji see Kobayashi, *Zenkōji San*, pp. 61–64.

4. Fujiwara Teika, *Meigetsuki*, Katei 1.6.17.

5. Shimizu Zenzō, "Seiryōji-shiki Shaka Zō" (Seiryōji Style Shaka Images), *Nihon Bijutsu Kōgei* 440 (1975): 15–21.

6. Maruo Shozaburō, et. al., *Nihon Chōkoku-shi Kiso Shiryō Shūsei: Zōzō Meiki Ban*, vol. 1, text, pp. 42–65; plates, pp. 43–75.

7. The Mimurododera Shaka is fully illustrated in Nara Kokuritsu Hakubutsukan, ed., *Nihon Bukkyō Bijutsu no Genryū* (The Origins of Japanese Buddhist Art) (Kyoto, 1984), vol. 1, pls. 93a–e.

8. Nishikawa Shinji, "Daienji no Seiryōji-shiki Shaka Zō" (The Seiryōji Style Shaka at Daienji), *Museum* 100 (July 1959): 20–23.

9. Nara Kokuritsu Hakubutsukan, eds., *Nihon Bukkyō Bijutsu no Genryū*, pls. 95a–d.

10. See *Nara Rokudaiji Taikan*, vol. 14, *Saidaiji* (Tokyo, 1973), pls. 12–13, 50–53 and pp. 41–46 (Tanabe Saburōsuke).

11. The basic biographical source for Eison is Wajima Yoshio, *Eison-Ninshō* (Tokyo, 1959). A series of essays devoted to his thought and career will be found in Nakao Takashi and Imai Masaharu, eds., *Chōgen, Eison, Ninshō* (Tokyo, 1983), pp. 212–334.

12. Wajima, *Eison-Ninshō*, pp. 37–55. Yoshida Fumio, "Saidaiji Eison no Tōgoku Gekō" (The Trip to the Kantō Region of Eison of the Saidaiji) in Nakao and Imai, *Chōgen, Eison, Ninshō*, pp. 221–248.

13. The classic compilation of inscriptions in Japanese Buddhist sculpture is Kōkogaku Kai, ed., *Zōzō Meiki* (Tokyo, 1936).

14. Kuno Takeshi, "Shō Kondō-butsu no Zōzō no Riyū" (Reasons for Making Small Gilt-bronze Buddhist Images) in *Kodai Shō Kondō-butsu*, pp. 107–121. Originally published in *Bijutsu Kenkyū* 309 (1979): 172–186, and *Bijitsu Kenkyū* 310 (1979): 1–10.

15. Kuno, *Kantō Chōkoku no Kenkyū*, no. 32, p. 204.

16. The most frequently seen occurrences of the hexagonal crown are on Heian-period representations of the deity Tobatsu Bishamonten. See Mainichi Shinbunsha, ed., *Genshokuban Kokuhō*, vol. 4, *Heian* II (Tokyo, 1967), pls. 52–53, for excellent illustrations of the T'ang image, which was brought to Japan and served as the model for subsequent copies. Although it would seem rather unlikely that such a crown would be transferred from a guardian figure, such as Tobatsu Bishamonten, to the Bodhisattvas Kannon and Seishi, it is worth noting that the Tobatsu Bishamonten is an iconic tradition deriving from a continental source just like the Seiryōji and Zenkōji traditions. Moreover, there are well-known examples of Tobatsu Bishamonten wearing the hexagonal crown in both Seiryōji and Zensuiji. See *Jūyō Bunkazai*, vol. 4, *Chōkoku* 4, no. 173 (Seiryōji) and no. 171 (Zensuiji). Nishikawa and Sekine, pp. 31–32, discuss the configurations of the crown in Zenkōji Bodhisattvas.

17. For a discussion of this image, see Shinozaki Shirō, "Zenkōji-shiki Sanzon" (Zenkōji Style Triads), *Hoshioka* 119 (1940): 3–5.

18. See Donald F. McCallum, "Tokyo Kokuritsu Hakubutsukan Hokan Zenkōji-shiki Amida Sanzon Zō ni tsuite" (A Zenkōji Triad in the Tokyo National Museum), *Museum* 441 (1987): 21–28, for a detailed consideration.

19. Kurata, *Butsuzō no Mikata*, pp. 269.

20. McCallum, "Tokyo Kokuritsu Hakubutsukan," pp. 24–26.

21. Kuno, *Kantō Chōkoku no Kenkyū*, no. 40, p. 149 (Jōshinji) and no. 14, p. 300 (Hachimanjinja).

22. In the discussion of the two Buddha figures dated 1206 (Zensuiji and private collection), it was suggested that they may never have had attendant Bodhisattvas. Perhaps the same situation holds here as well, although one cannot be certain. Presumably in the case of a functioning Zenkōji cult situation, the loss of the Buddha would be devastating, with the attendant Bodhisattvas no longer having any significant role to play.

23. Shinano Bijutsukan, ed., *Zenkoku Zenkōji Nyorai-ten*, (Exhibition of Zenkōji Buddhas from the Entire Country) (Nagano, 1967), p. 14 (Ishikawa Collection); Kuno, *Kantō Chōkoku no Kenkyū*, no. 30, p. 164 (Senshōji).

24. Kuno Takeshi, ed., *Butsuzō Jiten* (Dictionary of Buddhist Sculpture) (Tokyo, 1975), p. 450.

25. Takeda, pp. 98–103.

26. Presumably this transformation was intended to give the image a *raigō* aspect.

27. See Collcutt, *Five Mountains*, pp. 57–58, for the founding of Engakuji, and Nuki Tatsuto, *Engakuji* (Tokyo, 1964), pp. 17–19.

28. Kurata, *Butsuzō no Mikata*, pp. 269–272.

29. Tokyo Kokuritsu Hakubutsukan, ed., *Tokubetsu-ten Zuroku: Kondō-butsu— Chūgoku, Chōsen, Nihon*, nos. 28–29.

30. See the famous Early Heian Jūichimen Kannon at Hokkeji, Kuno, *Heian Shoki Chōkoku-shi no Kenkyū*, pls. 549–555.

31. As note 29, nos. 22–23.

32. Shimizu Zenzō, "Kamakura Chōkoku ni okeru 'Sō-fū' ni tsuite: Joron-teki Kōsatsu" (Concerning the "Sung Style" in Kamakura Sculpture: An Introductory Analysis), *Bijutsu-shi* 75 (1969): 75–88.

33. As note 29, nos. 25, 60, 65.

34. Kurata, "Zenkōji Nyorai Kō," pp. 20–22.

35. *Nara Rokudaiji Taikan*, vol. 2, *Hōryūji II*, pls. 15, 76–81, pp. 38–43 (Kurata Bunsaku).

36. Ogura Toyobumi, "Zenkōji Nyorai Zō Shōkō: Toku ni Bingo-kuni Ankokuji Honzon ni tsuite" (Study of the Zenkōji Nyorai, with Particular Reference to the Main Image of the Bingo Ankokuji), *Bukkyō Geijutsu* 37 (1958): 37–53.

37. For the Ankokuji network, see Satō Kazuhiko, *Namboku-chō Nairan* (Internal Disturbances of the Nanbokuchō Period), vol. 11 of *Nihon no Rekishi* (Shōgakkan) (Tokyo, 1974), pp. 139–142.

38. Mr. Nishikawa Kyōtarō, Director of the Nara Kokuritsu Hakubutsukan has provided me with copies of these documents, which he obtained when surveying the monument.

39. For Shinchi Kakushin, see Gorai, *Zenkōji-mairi*, pp. 257–261, and idem, *Kōya-hijiri*, pp. 227–240.

40. For the Ankokuji Hottō Kokushi, see Mōri Hisashi, *Japanese Portrait Sculpture* (Tokyo and New York, 1977), pls. 84–85, p. 88. There is an interesting example of this iconography in the Cleveland Museum of Art. See Donald Jenkins, *Masterworks in Wood: China and Japan* (Portland, 1976), pp. 90–91.

41. Ogura, "Zenkōji Nyorai Zō Shōkō," frontispiece.

42. For the date of the Shakadō at Ankokuji, see Ogura Toyobumi, "Ankokuji Sōzō Shōkō: Bingo-kuni no Baai o Chūshin to shite" (A Study of the Establishment of the Ankokuji Network: Centering on the Ankokuji of Bingo Province), *Hiroshima Daigaku Bungakubu Kiyō* 12 (1957): 1–21.

43. Nara Kokuritsu Hakubutsukan, ed., *Amida-butsu Chōzō*, pl. 129 (color) and details, pp. 303–304.

44. Donald F. McCallum, "Yamagata Kennai no Zenkōji-shiki Sanzon Zō no Ichi-keitō: Kōya-san Fudōin Zō to no Kankei ni tsuite," pp. 3–21.

45. Takeda, pp. 129–136.

46. Takeda, pp. 95–98 (Amidaji), pp. 87–89 (Hōsenji), and pp. 137–139 (Jōman Kōmin-kan).

47. Kuno, *Kantō Chōkoku no Kenkyū*, no. 28, p. 163.

48. See Takeda, for other images.

49. Kuno, *Kantō Chōkoku no Kenkyū*, no. 339, p. 228. Nishikawa and Sekine, figs. 10, 23.

50. Nishikawa and Sekine, p. 30.

51. Kuno, *Kantō Chōkoku no Kenkyū*, no. 24, p. 200 (Eimyōji); no. 93, p. 277 (Hōshōji).

52. See Shinano Bijutsukan, ed., *Zenkoku Zenkōji Nyorai-ten*, p. 17 (Manpukuji); and Kuno, *Kantō Chōkoku no Kenkyū*, no. 40, p. 207 (Kōmyōji).

53. Ibid., no. 28, p. 225. For a color illustration and a discussion in English, see

Victor Harris and Ken Matsushima, *Kamakura: The Renaissance of Japanese Sculpture, 1185-1333* (London, 1991), no. 38, pp. 124-125.

54. Miura Katsuo, ed., *Kamakura Kokuhō-kan Zuroku*, vol. 27, *Kamakura no Zaimei Chōkoku I* (Inscribed Sculpture of the Kamakura Region) (Yokohama, 1985), pp. 33-35. For a color illustration, see Miyama Susumu, *Kamakura no Chōkoku-Kenchiku: Unkei to Kaikei* (Sculpture and Architecture of the Kamakura Period: Unkei and Kaikei), vol. 17 of *Nihon Bijutsu Zenshū* (Tokyo, 1978), pl. 72.

55. Nishikawa and Sekine, frontispiece.

56. Ibid., p. 27.

57. Ibid.

58. Ibid.

CHAPTER 7

1. Sansom, pp. 459-461, "The Decline of the Hōjō Regents". Kuroda Toshio, *Mōko Shūrai* (The Mongol Invasions), vol. 8 of *Nihon no Rekishi* (Chūō Kōron) (Tokyo, 1965), pp. 485-509. Amino Yoshihiko, *Mōko Shūrai* (The Mongol Invasions), vol. 10 of *Nihon no Rekishi* (Shōgakkan) (Tokyo, 1974), pp. 386-406. For a recent survey in English, see Ishii Susumu, "The Decline of the Kamakura bakufu" in Kozo Yamamura, ed., *Medieval Japan, The Cambridge History of Japan* (Cambridge, 1990), pp. 128-174.

2. H. Paul Varley, *Imperial Restoration in Medieval Japan*, (New York, 1971).

3. *NK-s* 3: 12-20. Okutomi, *Kamakura Hōjō-shi*, pp. 244-245.

4. *NK-s* 3: 23-55. For general discussions of the Nanbokuchō, see Satō Shin'ichi, *Nanbokuchō no Dōran* (Disturbances of the Nanbokuchō Period), vol. 9 of *Nihon no Rekishi* (Chūō Kōron) (Tokyo, 1965), and Satō, Kazuhiko, *Nanbokuchō Nairan*.

5. *NK-s* 3: 43-44.

6. *NK-s* 3: 73-82. At this time the *shugo* headquarters was at Funeyama (present Togura), not far from Zenkōji. Ushiyama, pp. 146-147.

7. *NK-s* 3: 88-92.

8. *NK-s* 3: 92-96.

9. *NK-s* 3: 96-101. For the *Ōtō Monogatari*, see Kanai Kiyomitsu, "Zenkōji-hijiri to sono Katari-mono" (The Zenkōji-hijiri and the Legends that they tell) in *Jishū Bungei Kenkyū* (Research on the Arts of the Ji School) (Tokyo, 1967), pp. 187-190.

10. *NK-s* 3: 102.

11. Kobayashi, *Zenkōji San*, pp. 98-100.

12. *NK-s* 3: 105-108.

13. *NK-s* 3: 124-126.

14. *NK-s* 3: 127.

15. Kobayashi, *Zenkōji San*, pp. 108-109.

16. For the events in Shinano, see *NK-s* 3: 132-137; for the assassination of Ashikaga Yoshinori, see Sasaki Ginmi, *Muromachi Bakufu* (The Muromachi Bakufu), vol. 13 of *Nihon no Rekishi* (Shōgakkan) (Tokyo, 1975), pp. 77-83.

17. For the Urushida Battle, see Kobayashi Keiichirō, *Waga Machi no Rekishi:*

Nagano (History of Our Town: Nagano) (Tokyo, 1979), pp. 54–57. For the splitting of the Ogasawara see *NK-s* 3: 141–145.

18. Ushiyama, pp. 147–149. For an extended discussion of the Kurita clan, see Kobayashi Keiichirō, "Kurita-shi ni tsuite" (Concerning the Kurita clan) in *Shinano Chūsei Shikō* (Tokyo, 1982), pp. 225–285.

19. For Shinano after the Ōnin War, see *NK-s* 3: 156–222.

20. Detailed treatments of this period can be found in Sugiyama Hiroshi, *Sengoku Daimyō* (Daimyō of the Sengoku Period), vol. 11 of *Nihon no Rekishi* (Chūō Kōron) (Tokyo, 1965), and Nagahara Keiji, *Sengoku no Dōran* (Disturbances of the Sengoku Period) vol. 14 of *Nihon no Rekishi* (Shōgakkan) (Tokyo, 1975).

21. For a discussion of Oda Nobunaga, particularly with reference to his relations to Buddhism, see Neil McMullin, *Buddhism and the State in Sixteenth Century Japan* (Princeton, 1984), pp. 59–94.

22. See Inoue Toshio, *Kenshin to Shingen* (Kenshin and Shingen) (Tokyo, 1964). For greater detail on Takeda Shingen, see Isogai Masayoshi, *Takeda Shingen no Subete* (Everything concerning Takeda Shingen) (Tokyo, 1983).

23. Kobayashi Keiichirō, *Kawanakajima no Tatakai* (The Kawanakajima Battles) (Tokyo, 1963).

24. See *Shōwa Daishūri Kanjin Zenkōji-ten* (Exhibition of Zenkōji at the time of the Shōwa Reconstruction) (Tokyo, 1986), section 3–3 for illustrations of the objects now kept at Hōonji, Yonezawa.

25. Ibid. See also Yamada, "Kōfu Zenkōji no Shōzō Chōkoku: Minamōto Yoritomo Zō Nado," and Yamada Yasuhiro and Yoshihara Hiroto, *Kai Zenkōji* (Kōfu, 1982), for numerous illustrations. A good discussion of the movements of the Zenkōji Buddha is Sasamoto Shōji, "Zenkōji no Iten" (The Movement of Zenkōji) in *Takeda-shi Sandai to Shinano: Shinkō to Tōchi no Hazama* (Three Generations of the Takeda Clan and Shinano: The Interval between Faith and Rule) (Matsumoto, 1988), pp. 179–198.

26. Yamada and Yoshihara, *Kai Zenkōji*, p. 35. An excellent compilation of documents relating to all aspects of Kōfu Zenkōji is Udaka Yoshiaki and Yoshihara Hiroto, *Kai Zenkōji Monjo*, (Documents of the Zenkōji of Kai Province), vol. 5 of *Kinsei Jiin Shiryō Sōsho* (Collection of Historical Records of Early Modern Temples) (Tokyo, 1986).

27. *NK-s* 3: 342–359.

28. Kobayashi, *Zenkōji San*, pp. 117–118.

29. Kobayashi, *Zenkōji San*, p. 118.

30. Kobayashi, *Zenkōji San*, p. 118.

31. Mary Elizabeth Berry, *Hideyoshi* (Cambridge, Mass., 1982).

32. See Miki Seiichirō, "Hōkōji Daibutsuden no Zōei ni kansuru Ichi-kōsatsu" (A Theory Concerning the Construction of the Great Buddha Hall of Hōkōji) in Nagahara Keiji, et al., *Chūsei-Kinsei no Kokka to Shakai* (The State and Culture in the Medieval and Early Modern Periods) (Tokyo, 1986), pp. 185–213.

33. For the earthquake of 1596, see ibid., note 61, p. 212, which cites an unpublished document kept at Tokyo University.

34. Tsuji Zennosuke, ed., *Rokuon Nichiroku* (Tokyo, 1936), II: 358. For transla-

tions into modern Japanese, see Kobayashi, *Zenkōji San*, pp. 121–122, or Yoneyama Kazumasa, "Sengoku Bushō to Zenkōji Nyorai" (Warriors of the Sengoku Period and the Zenkōji Buddha) in *Shinano-ji* 39 (1982): 77. The *Rokuon Nichiroku* is a collection of diaires, dating 1487–1651, by the top administrators of the Zen School, who resided at Rokuon'in, built by Ashikaga Yoshimitsu. Considered to be a very good source for the politics and literature of the period.

35. *Nagano* 108 (1983): 44–45.

36. Kobayashi, *Zenkōji San*, pp. 119–120.

37. Kobayashi, *Zenkōji San*, pp. 119–120. For the text, see Yamada and Yoshihara, *Kai Zenkōji*, pl. 22 (p. 16) and p. 88 where it is transcribed as "Zenkōji Nyorai Daibutsu Dono e Senza Koto" (Concerning the Moving of the Zenkōji Buddha to the Great Buddha Hall [=Hōkōji]); Udaka and Yoshihara, *Kai Zenkōji Monjo*, pp. 2–3; Udaka Yoshiaki, *Edo Bakufu no Bukkyō Kyōdan Tōsei*, pp. 292–293.

38. For the arrival of the image in Kyoto see Kobayashi, *Zenkōji San*, p. 120, and Miki, "Hōkōji Daibutsuden no Zōei," p. 203.

39. As note 34.

40. Hayakawa Junsaburō, ed., *Shiseki Zassan*, vol. 2 (Tokyo, 1911), p. 70. The *Tōdai Ki* is tentatively attributed to Matsudaira Tadaoki and records events in the sixteenth century. Sasamoto, *Takeda-shi Sandai to Shinano*, has a good map showing the travels of the Zenkōji Buddha during the second half of the sixteenth century.

41. For a penetrating analysis of some of these issues, see Roger Goepper, "Some Thoughts on the Icon in Esoteric Buddhism of East Asia," *Münchner Osasiatische Studien* 25 (1979): 245–254.

42. For the rule of the Takeda Clan, see *NK-s* 3: 280–341. For Mori Nagayoshi, see pp. 366–367.

43. *NK-s* 3: 369–370.

44. Kobayashi, *Zenkōji San*, p. 126; Ushiyama, p. 149.

45. *NK-s* 4: 18–23.

46. *NK-s* 4: 70–73.

47. *NK-s* 4: 91–96.

48. *NK-s* 4: 250–251.

49. *NK-s* 4: 311.

50. *NK-s* 4: 136–137.

51. *NK-s* 5: 311.

52. Ushiyama, pp. 149–150; Kobayashi, *Zenkōji San*, pp. 127–128.

53. Kobayashi, *Zenkōji San*, pp. 127–128.

54. Kobayashi, *Zenkōji San*, p. 128.

55. Ushiyama, p. 150.

56. Kobayashi, *Zenkōji San*, pp. 129–131.

57. Hiruma Hisashi, *Edo no Kaichō* (Displaying the Icon in the Edo Period) (Tokyo, 1980); idem, "Edo no Kaichō" and "Edo Kaichō Nenpyō" in Nishiyama Matsunosuke, ed. *Edo Chōnin no Kenkyū* (Research into the Townsmen of the Edo Period) vol. 2, (Tokyo, 1983), pp. 273–472 and 473–548.

58. Hiruma, *Edo no Kaichō*, pp. 39–41. The term *degaichō* is difficult to translate literally and so my rendering is an effort to indicate what actually happens. Hiruma deals with the various temples as follows: pp. 48–54 (Zenkōji), pp. 55–63 (Seiryōji), pp. 149–159 (Narita Fudō).

59. Kobayashi, *Zenkōji San*, pp., 129–130, 138–141. *NK-s* 5: 315–316.

60. Kobayashi, *Zenkōji San*, pp. 138–139.

61. Kobayashi, *Zenkōji San*, p. 129.

62. Kobayashi, *Zenkōji San*, p. 130. One result of the various degaichō was that the Zenkōji cult became very widely known. Ushiyama, p. 151.

63. Kobayashi, *Zenkōji San*, p. 130.

64. *NK-s* 5: 312.

65. *NK-s* 5: 312.

66. Kobayashi, *Zenkōji San*, pp. 131–134.

67. Kobayashi, *Zenkōji San*, pp. 149–151.

68. Kobayashi, *Zenkōji San*, p. 151.

69. *NK-s* 5: 312–313.

70. *NK-s* 5: frontispiece. See also Itō Nobuo, "Shinshutsu no Zenkōji Sanmon Hoka Tatechi Warizu ni tsuite" (Concerning the Newly Discovered Architectural Plans of the Zenkōji Sanmon and other Buildings), *Nagano* 134 (1987): 1–13, and "Zenkōji Zōei-zu Setsumei Sho" (Explanatory Text for the Architectural Drawings of Zenkōji), *Nagano* 146 (1989): 39–44.

71. Kobayashi, *Zenkōji San*, pp. 134–136. Of course, the Great Buddha Hall of Tōdaiji, Nara, is the largest wooden hall in Japan. It was completed the year before the Main Hall of Zenkōji. Interestingly, the Tōdaiji Hall was recently repaired, followed by a similarly ambitious repair of the Main Hall of Zenkōji.

72. For an interesting discussion of the pilgrimage process, see Victor Turner, "Death and the Dead in the Pilgrimage Process," in Frank E. Reynolds and Earle H. Waugh, eds., *Religious Encounters with Death: Insights from the History and Anthropology of Religion* (University Park and London, 1973), pp. 24–39. For pilgrimages to Zenkōji, see *N-sS*: 530–570. Numerous illustrations of the Zenkōji pilgrimages can be found in Kodama Yukita and Haga Noboru, *Edo-jidai Zushi* (Pictorial Records of the Edo Period), vol. 10, *Nakasendō* I (Tokyo, 1977), pp. 75–100.

73. For the *kō* see, Shinjo Tsunezō, *Shaji Sankei no Shakai Keizai Shiteki Kenkyū* (Historical Research on the Social and Economic Aspects of Pilgrimage to Shrines and Temples) (Tokyo, 1964), pp. 244–289.

74. For *oshi*, see ibid., pp. 146–210; Winston Davis, "Pilgrimage and World Renewal: A Study of Religion and Social Values in Tokugawa Japan," Part II, *History of Religions* 23.3 (1984): 210–213.

75. For lodging, *N-sS*: 530–555. Similar discord was apparently frequent at Mt. Kōya.

76. For entertainment, *N-sS*: 614–651.

77. For o-komori, Kobayashi, *Zenkōji San*, pp. 173–176.

78. I have discussed the issues in "The Deity Depicted," a review of Christine Guth Kanda, *Shinzō: Hachiman Imagery and Its Development*, (Cambridge, 1985) in *Monumenta Nipponica* 41.4 (1986): 477–488.

79. For the administrative structure of Zenkōji and its territories, see *N-sS*: 38–71; Ushiyama, p. 150.

80. For the role of the Takahashi Clan at Zenkōji, *N-sS*: 72–96; for the other clans, ibid., pp. 100–109.

81. *N-sS*: 97–141.

82. For the *machidoshiyori*, *N-sS*: 142–180.

83. *N-sS*: 20–37.

84. Ibid., p. 151.

85. Ibid., p. 151.

CHAPTER 8

1. The conceptualization of this chapter has been strongly influenced by David Freedberg, *The Power of Images*.

2. There is not yet, to my knowledge, an adequate account of what I am calling "iconicity." By this term I refer to that quality or character of icons that enable them to convey meaning to those who view them. I am distinguishing these meanings from the narrative meanings that are frequently encoded in pictorial art. While two-dimensional icons are plentiful, there is something about the three-dimensional, sculptural icon that is especially compelling, and that constitutes the fundamental aspect of iconicity.

3. I stated my general approach to this problem in Chapter 1, note 4.

4. For the aniconic phase in India see Benjamin Rowland, *The Art and Architecture of India*, 3d. ed. (Harmondsworth, 1967), pp. 59–119, and J. C. Harle, *The Art and Architecture of the Indian Subcontinent*, (Harmondsworth, 1986), pp. 21–53. The article "Images and Iconoclasm" (various authors) in *Encyclopedia of World Art*, VII, (New York, 1963), cols. 798–822, presents a good deal of interesting material on the issues of iconic and aniconic art.

5. See David L. Snellgrove, ed., *The Image of the Buddha*, (Tokyo, 1978), for the development of the Buddha figure throughout Asia. For a stimulating discussion of the nature of the Buddha's presence, see Gregory Schopen, "Burial 'Ad Sanctos' and the Physical Presence of the Buddha in Early Indian Buddhism: A Study in the Archaeology of Religions," *Religion* 17 (1987): 193–225.

6. Alexander C. Soper, "Representations of Famous Images at Tun-huang," *Artibus Asiae* 27.4 (1965): 349–364.

7. Freedberg, *Power of Images*, especially Chapter 2 and Chapter 5.

8. Alex Wayman, "Contributions Regarding the Thirty-two Characteristics of the Great Person," *Liebenthal Festschrift, Sino-Indian Studies* 5 (1953): 234–260.

9. Freedberg, *Power of Images*, pp. xix–xxv.

10. For myth, see Kees W. Bolle, "Myth: An Overview," pp. 261–273, and Paul Ricoeur, "Myth and History," pp. 273–282, in vol. 10 of *The Encyclopedia of Religion*.

11. Zaleski, *Otherworld Journeys*, pp. 75–94, has dealt in detail with this issue in western medieval Christianity.

12. This aspect of the cult must be considered in terms of the concept *genze-riyaku* (worldly rewards).

13. Of course, this conceptualization is not limited to the Zenkōji Amida Triad, since other icons, in Japan and elsewhere, manifest animate characteristics of various types.

14. Further research and clarification is required before an adequate formulation of Japanese folk religion and shamanism is possible. Pertinent general studies include Ichirō Hori, "Penetration of Shamanic Elements into the History of Japanese Folk Religion," *Festschrift für Adolf E. Jensen*, ed. by Eike Haberland, et al. (Munich, 1964), 1: 245–265; and Carmen Blacker, *The Catalpa Bow*. An enormous amount of stimulating material can be found in Tsuji Nobuo, ed., *Zusetsu Nihon no Bukkyō 5, Shomin Bukkyō* (Popular Buddhism) (Tokyo, 1990).

15. Kobayashi, *Zenkōji San*, pp. 220–225.

16. It must be stressed here that in this analysis, the term "priesthood" is used to include male and female practitioners, since both men and women were important to the development of the Zenkōji cult. Consequently, in the Shaman-Hijiri category it should be understood that both men and women were essential to the religious practices.

17. For ritual, see *The Encyclopedia of Religion*, vol. 12, "Ritual," pp. 405–422 (Evan M. Zuesse), "Ritual Studies," pp. 422–425 (Ronald L. Grimes). A recent historiographical survey is Catherine Bell, "Discourse and Dichotomies: The Structure of Ritual Theory," *Religion* 17 (1987): 95–118. For the daily rituals of present Shinano Zenkōji see Yamanoi Daiji, "Zenkōji no Nenjū-gyōji" (The Annual Rituals at Zenkōji), in Itō, pp.210–223.

18. The degree to which the Zenkōji cult was associated with the worship of kami is uncertain. However, given the general nature of medieval Japanese religion, it seems likely that kami worship was a component of the cult.

19. Of course Gorai, *Zenkōji-mairi*, devotes a great of attention to the shamanistic aspects of Zenkōji practice.

20. Gorai, *Zenkōji-mairi*, p. 173.

21. Gorai, *Zenkōji-mairi*, pp. 172–183.

22. The role of women in Japanese Buddhism has received increasing attention in recent years. See, for example, the four volumes edited by Ōsumi Kazuo and Nishiguchi Junko, *Shiriizu Josei to Bukkyō* (Women and Buddhism Series), especially vol. 1, *Ama to Amadera* (Nuns and Nunneries) (Tokyo, 1989).

23. Victor Turner, "Death and the Dead in the Pilgrimage Process," pp. 24–39.

24. Inokuchi Shoji, *Nihon no Sōshiki* (The Japanese Funeral) (Tokyo, 1965), pp. 65–68, provides interesting examples of the wide spread of Zenkōji belief in Japanese funerary practice.

Glossary

Bakufu—Lit. "tent government." Refers to the military governments established during the Kamakura, Muromachi, and Edo periods.

Bettō—Director of the administrative headquarters of a religious or political institution.

Daikan—A local administrator in premodern Japan. Often rendered "intendant."

Daimyō—The feudal lords who ruled the largest territories, often an entire province, during the later middle ages.

Degaichō—The term used when a secret icon (*hibutsu*) is taken from its home temple to be displayed for worship at another place. See *kaichō*.

Engi—A text giving the legends surrounding the establishment and history of a temple or shrine, or of the associated images.

Go-inmon—A seal used in ceremonies to transfer the power of the Buddha to the worshiper.

Henzan—A piece of fabric, worn under the main robe, used to cover the right shoulder of the Buddha figure.

Hibutsu—A secret Buddhist image, revealed only on special occasions.

Hijiri—A religious practitioner, normally outside of traditional Buddhist institutions, who travels throughout the country preaching to the people.

Jitō—A steward who managed an estate and collected taxes, under the authority of the bakufu.

Jimon—The Onjōji branch of the Tendai school of Buddhism; it is one of the two main branches of that school.

Jōhaku—A sash like band of cloth worn diagonally across the chest of a Bodhisattva.

Kaichō—Lit. "opening the curtains." Refers to the ceremony whereby a secret icon (*hibutsu*) is revealed to the faithful on special occasions.

Kaikoku kaichō—The showing of an icon for worship around the various provinces of Japan. See *kaichō*.

Kaidan meguri—A subterranean passage under the main altar of a Buddhist temple. Movement through it symbolizes a descent to the underworld and then a return to this world, guaranteeing future salvation.

Koku—A measurement, used generally for rice, in the premodern period. One koku of rice was theoretically adequate to feed one person for a year. The value of land holdings was given in koku.

Koshinuno—A piece of fabric wrapped around the hips of a Bodhisattva, over the usual skirt.

Maedachi honzon—Lit. "the icon that stands in front." Refers to an icon that is usually placed in front of a secret icon (*hibutsu*) to substitute for one that is less frequently, or never, shown to the faithful.

Mudra—(J. *inzō*). Refers to the symbolic hand and finger positions of Buddhist icons.

Nenbutsu—The ritual chanting of the name of the Buddha Amida.

Rahotsu—The curls of the Buddha, which assume a spiral configuration, often referred to as "snail-shell curls" on the basis of their form.

Renniku—The torus of the lotus. Refers to the upper part of the lotus pedestal, on which the image stands or sits.

Ritsuryō—A system of legal codes, derived from China, which formed the basis for early Japanese government, especially during the eighth century.

Sangoku denrai—Lit. "three kingdom transmission." Refers to the transmission of Buddhism, and Buddhist icons, from India to East Asia. Normally the three kingdoms are India, China, and Japan, but in the case of the Zenkōji cult, the Korean kingdom of Paekche is substituted for China.

Shaku—A traditional unit of measurement. The length has varied over the centuries, but it is usually about 30 cm.

Shikken—The position of regent for the shogun during the Kamakura period. The office was held by members of the Hōjō family.

Shōen—A landed estate, usually belonging to absentee owners. Formed one of the key structures of premodern economic life.

Shōgun—The leader of a military government (bakufu).

Shugo—A 'constable' appointed by the bakufu to supervise a province.

Sōgishi—(Sanskrit *sankaksika*). An undergarment, worn under the main robe, covering the right shoulder and passing under the left underarm.

Sun—A traditional unit of measure, approximately 3 cm, equal to one-tenth of a shaku.

Tenne—Lit. "heavenly scarf." A long strip of fabric worn by a Bodhisattva in various arrangements, usually covering the back and shoulders, and then passing in front of the legs.

Tokusō—A term referring to the leader of the main branch of the Hōjō clan.

Tsūken—A way of arranging the outer robe of the Buddha whereby the upper hem of the robe passes across the front of the body, hiding the chest, and then with the end draped over the left shoulder.

Udayana Buddha—(J. *Udenō shibo zō*). A canonical representation of the historical Buddha, Shaka, believed to have been made as a portrait at the time Shaka was living in this world. Seen, in Japan, in the Seiryōji Shaka (985), which was brought from China to Japan by Chōnen.

Urna—(J. *byakugō*). A tuft of white hair between the eyebrows of a Buddhist deity, usually represented in sculpture by a jewel.

Ushnisha (J. *nikkei*). The protuberance on the head of a Buddha signifying wisdom.

Bibliography

THE BIBLIOGRAPHY relating to Zenkōji is unusual in certain respects, necessitating a few comments here. There is not yet a modern, research monograph devoted to the major elements of the temple, its icon, and the cult. The most useful studies, Kobayashi's *Zenkōji San*, and Gorai's *Zenkōji-mairi*, are both quite popular, and neither is provided with the type of scholarly apparatus that aids further investigation. Sakai's *Zenkōji-shi*, written in the 1930s, but not published until 1969, contains important material, but is somewhat outdated. Recently a large picture book, with interesting essays appeared: Itō Nobuo, et al., eds., *Zenkōji: Kokoro to Katachi* (Zenkōji: Spirit and Form).

Much of the periodical literature is published in hard-to-find local journals, and these articles manifest the usual strengths and weaknesses of regional history: they are strong on local detail, but weak in interpretation and synthesis. There are a few important art-historical studies, such as those of Kurata and of Nishikawa and Sekine, but these tend not to examine the broader religious issues. Takeda's *Dewa no Zenkōji-shiki Sanzon-zō* is the only effort at a more comprehensive regional discussion.

Scholars of Japanese religion have generally ignored the Zenkoji tradition, although a few recent studies have begun to address the issues. Especially useful are the studies of Tokuda, Yamanoi, and Yoshihara, although a great deal more remains to be done.

From a historical perspective, the most useful recent addition to the bibliography is the ten-volume *Nagano Ken-shi: Tsūshi-hen*, since it provides an extremely detailed account of the history of Nagano Prefecture from prehistory through the modern period.

Amino Yoshihiko. *Mōkō Shūrai* (The Mongol Invasions). Vol. 10 of *Nihon no Rekishi* (Shōgakkan). Tokyo, 1974.
Andrews, Allan A. *The Teachings Essential for Rebirth: A Study of Genshin's Ōjōyōshū*. Tokyo, 1973.
———. "Hōnen." In Mircea Eliade, et al., eds. *The Encylopedia of Religion*. Vol. 6, pp. 453–455. New York, 1987.
Aston, W. G. *Nihongi: Chronicles of Japan from the Earliest Times to 697*. 2 vols. Tokyo, 1972.
Bell, Catherine. "Discourse and Dichotomies: The Stucture of Ritual Theory." *Religion* 17 (1987): 95–118.
———. "Religion and Chinese Culture: Toward an Assessment of Popular Religion." *History of Religions* 29.1 (1989): 35–57.
Berry, Mary Elizabeth. *Hideyoshi*. Cambridge, Mass., 1982.

Blacker, Carmen. *The Catalpa Bow: A Study of Shamanistic Practices in Japan*, London, 1975.

Bloom, Alfred. "Shinran." In Mircea Eliade, et al., eds. *The Encyclopedia of Religion*, Vol. 13, pp. 278–280. New York, 1987.

Bolle, Kees W. "Myth: An Overview." In Mircea Eliade, et al., eds. *The Encyclopedia of Religion*. Vol. 10, pp. 261–273, New York, 1987.

Brazell, Karen, trans. *The Confessions of Lady Nijō*. New York, 1973.

Brown, Peter. *The Cult of the Saints: Its Rise and Function in Latin Christianity*. Chicago, 1981.

Campany, Robert F. "Notes on the Devotional Uses and Symbolic Functions of *Sutra* Texts as Depicted in Early Chinese Buddhist Miracle Tales and Hagiographies." *The Journal of the International Association of Buddhist Studies* 14.1 (1991): 28–72.

Collcutt, Martin. *Five Mountains: The Rinzai Zen Monastic Institution in Medieval Japan*. Cambridge, Mass., 1981.

Comstock, W. Richard. "The Study of Religion and Primitive Religions." In Comstock, et. al. *Religion and Man: An Introduction*. New York, 1971.

Davis, Winston. "Pilgrimage and World Renewal: A Study of Religion and Social Values in Tokugawa Japan." *History of Religions*, Part I, 23.2 (1983): 97–116; Part II, 23.3 (1984): 197–221.

Dobbins, James C. *Jōdo Shinshū: Shin Buddhism in Medieval Japan*. Bloomington, 1989.

Ferris, William Wayne. *Population, Disease, and Land in Early Japan, 645–900*. Cambridge, Mass., 1985.

Foard, James H. "In Search of a Lost Reformation: A Reconsideration of Kamakura Buddhism." *Japanese Journal of Religious Studies* 7.4 (1980): 261–291.

———. " The Boundaries of Compassion: Buddhism and National Tradition in Japanese Pilgrimage." *Journal of Asian Studies* 41.2 (1982): 231–251.

———. "Prefiguration and Narrative in Medieval Hagiography: The *Ippen Hijiri-e*." In J. Sanford, W. LaFleur, and M. Nagatomi, eds. *Flowing Traces: Buddhism in the Literary and Visual Arts of Japan*. Princeton, 1992, pp. 76–92.

Freedberg, David. *The Power of Images: Studies in the History and Theory of Response*. Chicago and London, 1989.

Fujimori Eiichi and Kirihara Takeshi. *Shinano Kōkogaku Sanpo* (Visits to Shinano Archaeology). Tokyo, 1968.

Fujimori Eiichi. "Zenkōji no Tabi" (Trip to Zenkōji), *Nagano* 29 (1970): 1–8.

Fukuyama Toshio. *Heian Temples: Byodo-in and Chuson-ji*. Tokyo and New York, 1976.

Goble, Andrew. "The Hōjō and Consultative Government." In Jeffrey P. Mass, ed. *Court and Bakufu in Japan: Essays in Kamakura History*. New Haven, 1982.

Goepper, Roger. "Some Thoughts on the Icon in Esoteric Buddhism of East Asia." *Münchner Osasiatische Studien* 25 (1975): 245–254.

Gorai Shigeru. *Kōya-hijiri* (The Hijiri of Mt. Kōya). Tokyo, 1965.

———. *Zenkōji-mairi* (Pilgrimage to Zenkōji). Tokyo, 1988. This study was first published in the *Shinano Mainichi Shinbun*, Nagano City, every Tuesday, be-

tween May 1, 1984 and December 31, 1985. The book is somewhat different than the newspaper version.

Grimes, Ronald L. "Ritual Studies." In Mircea Eliade, et al., eds. *The Encyclopedia of Religion*. Vol. 12, pp. 422–425. New York, 1987.

Harle, J. C. *The Art and Architecture of the Indian Subcontinent*. Harmondsworth, 1986.

Harris, Victor and Ken Matsushima. *Kamakura: The Renaissance of Japanese Sculpture, 1185–1333*. London, 1991.

Hayakawa Shōhachi. *Ritsuryō Kokka* (The Ritsuryō State). Vol. 4 of *Nihon no Rekishi* (Shōgakkan). Tokyo, 1974.

Henderson, Gregory and Leon Hurvitz. "The Buddha of the Seiryōji." *Artibus Asiae* 19.1 (1956): 5–55.

Hirabayashi Moritoku. *Ryōgen*. Tokyo, 1976.

Hiramatsu Reizō. *Shinshū-shi Ronkō* (Essays on the History of the Shin School). Kyoto, 1988.

Hiruma Hisashi. *Edo no Kaichō* (Displaying the Icon in the Edo Period). Tokyo, 1980.

———. "Edo no Kaichō" and "Edo Kaichō Nenpyō" (Chronology of Displaying the Icon in the Edo Period). In Nishiyama Matsunosuke, ed. *Edo Chōnin no Kenkyū* (Research into the Townsmen of the Edo Period). Vol. 2. Tokyo, 1983, pp. 273–548.

Hori, Ichirō. "On the Concept of Hijiri (Holy-Man)." *Numen* 5 (1958): 128–160, 199–232.

———. *Kōya*. Tokyo, 1963.

———. *Folk Religion in Japan: Continuity and Change*. Chicago, 1968.

———. "Penetration of Shamanic Elements into the History of Japanese Folk Religion." *Festschrift für Adolf E. Jensen*, edited by Eike Haberland, et al. Munich, 1964, pp. 245–265.

Hoshino Ryōsaku, *Kenkyū-shi: Jinshin no Ran* (Historiography: The Jinshin Disturbance). Expanded ed., Tokyo, 1978.

Hurst, C. Cameron. *Insei: Abdicated Sovereigns in the Politics of Late Heian Japan, 1086–1185*. New York, 1976.

Hwang, Su Young. *Buddhist Art*. Vol. 3 of *The Arts of Korea*. Seoul, 1979.

Hyōdō Hiromi. "Kowaradera." In *Kokubungaku: Kaishaku to Kanshō* 47.3 (1982): 140–141.

Ihara Kesao. "Chūsei Zenkōji no Ichi-kōsatsu" (One Theory Concerning Medieval Zenkōji). *Shinano* 40.3 (1988): 19–30.

Imai Tainan. *Shinshū no Torai Bunka* (Immigrant Culture in Shinshu). Nagano, 1985.

Inokuchi Shōji. *Nihon no Sōshiki* (Japanese Funerals). Tokyo, 1965.

Inoue Mitsusada. *Asuka no Chōtei* (The Asuka Court). Vol. 3 of *Nihon no Rekishi* (Shōgakkan). Tokyo, 1974.

Inoue Mitsusada, et al., *Taika Kaishin to Higashi Ajia* (The Taika Reform and East Asia). Tokyo, 1981.

Inoue Toshio. *Kenshin to Shingen* (Kenshin and Shingen). Tokyo, 1964.

Ishida Mizumaro. "Hōbutsushū Zakkō: Mitsu no Mondai" (Hōbutsushū Miscellany: Three Problems). In *Nihon Bukkyō Shisō Kenkyū* 5, *Bukkyō to Bungaku* (Research into Japanese Buddhist Thought 5, Buddhism and Literature). Kyoto, 1987, pp. 7–55.

Ishida Mosaku. "Asuka ni nokoru Zenkōji Nyorai no Densetsu to Jittai" (Traditions and Actual Circumstances of Zenkōji Images Preserved in the Asuka Region). In *Asuka Zuisō*. Tokyo, 1972.

Ishii Susumu. *Kamakura Bakufu*. Vol. 7 of *Nihon no Rekishi* (Chūō Kōron). Tokyo, 1965.

———. "The Decline of the Kamakura Bakufu." In Kozo Yamamura, ed. *The Cambridge History of Japan*. Vol. 3, *Medieval Japan*. Cambridge, 1990.

Isogai Masayoshi. *Takeda Shingen no Subete* (Everything concerning Takeda Shingen). Tokyo, 1983.

Itō Nobuo. "Shinshutsu no Zenkōji Sanmon Hoka Tatechi Warizu ni tsuite" (Concerning the Newly Discovered Architectural Plans of the Zenkōji Sanmon and other Buildings). *Nagano* 134 (1987): 1–13.

Itō Nobuo, et al., eds. *Zenkōji: Kokoro to Katachi* (Zenkōji: Spirit and Form). Tokyo, 1991.

Jenkins, Donald. *Masterworks in Wood: China and Japan*. Portland, 1976.

Kainuma, Yoshiko. "Shin Zenkōji in the Kinki Region." Unpublished Master's thesis, University of California, Los Angeles, 1987.

Kanai Kiyomitsu. "Zenkōji-hijiri to sono Katarimono" (The Zenkōji-hijiri and Their Tales). In *Jishū Bungei Kenkyū* (Research in the Arts of the Ji School). Tokyo, 1967.

———. "Zenkōji Shinkō to Jishū" (Belief in Zenkōji and the Ji School). *Nagano* 29 (1970): 9–21.

Kanaoka Shūyū, ed. *Koji Meisatsu Daijiten* (Dictionary of Famous Old Temples). Tokyo, 1981.

Kanagawa Kenritsu Kanazawa Bunko, ed. *Kanazawa Bunko Meihin Zuroku* (Catalogue of Famous Works of the Kanazawa Bunko). Yokohama, 1981.

Kanda, Christine Guth. *Shinzō: Hachiman Imagery and Its Development*. Cambridge, Mass., 1985.

Kano Hisashi. *Mokkan*. Vol. 160 of *Nihon no Bijutsu* (Shibundō). Tokyo, 1979.

Kaufman, Laura S. "Nature, Courtly Imagery, and Sacred Meaning in the Ippen Hijiri-e." In J. Sanford, W. LaFleur, M. Nagatomi, eds. *Flowing Traces: Buddhism in the Literary and Visual Arts of Japan*. Princeton, 1992, pp. 47–75.

Kawakatsu Masatarō. "Nishi Nihon ni okeru Zenkōji-shiki Sanzon-zō o Chūshin to shite" (Centering on the Zenkōji Type Triads in Western Japan). *Shiseki to Bijutsu* 407 (1970): 246–262.

Kawazoe Shōji, *Kamakura Bunka*. (Kamakura Culture). Tokyo, 1982.

Keene, Donald. *Travelers of a Hundred Ages*. New York, 1989.

Kim, Chewon and Kim Won-yong. *Treasures of Korean Art*. New York, 1966.

Kim, Lena. "Samguk sidae ui pongji pojuhyong posal ipsang yon'gu: Paekche wa Ilbon ui sang ul chungsim uro" (Bodhisattva Images Holding Cintamani from the Three Kingdoms Period: With an emphasis on Images of Paekche and

Japan). *Misul Charyo* 37 (1985): 1–39. For a Japanese version of this article, see "Hōju Hōji Bosatsu no Keifu" (The Lineage of the Jewel-clasping Bodhisattva). In Mizuno Keizaburō, ed. *Nihon Bijutsu Zenshū 2, Hōryūji kara Yakushiji e: Asuka-Nara no Kenchiku-Chōkoku.* Tokyo, 1990.

Kirihara Takeshi. "Zenkōji Sōken ni Kakatta Shizoku-tachi" (Aristocrats Connected with the Establishment of Zenkōji). *Nagano* 103 (1982): 19–28.

Kitagawa Hiroshi and Bruce Tsuchida, trans. *The Tale of Heike.* Tokyo, 1975.

Kitayama Shigeo. *Heiankyō.* Vol. 4 of *Nihon no Rekishi* (Chūō Kōron). Tokyo, 1965.

Kiyota, Minoru. *Shingon Buddhism: Theory and Practice.* Los Angeles and Tokyo, 1978.

Kobayashi Ichirō. *Zenkōji Nyorai Engi: Genroku Gonen-ban* (The Zenkōji Nyorai Engi: The Version of Genroku 5). Nagano, 1985.

Kobayashi Keiichirō. "Zoku Gunsho Ruijū Shoshū Zenkōji Engi Maki-yon ni tsuite" (Concerning Book Four of the Zenkōji Engi in the Zoku Gunsho Ruijū). *Nagano* 29 (1970): 22–41.

———. "Shin Zenkōji/Zenkōji-shiki Sanzon Zō Ichiran" (A Catalogue of Shin Zenkōji and Zenkōji Style Triads). *Nagano* 108 (1983): 11–57.

———. "Zenkōji Hondō no Kenchiku Yōshiki no Hensen" (Transformations in the Architectural Style of the Main Hall of Zenkōji). *Nagano* 149 (1990): 1–8.

———. *Waga Machi no Rekishi: Nagano* (The History of Our Town: Nagano). Tokyo, 1979.

———. *Kawanakajima no Tatakai* (The Kawanakajima Battles). Tokyo, 1963.

———. *Zenkōji San,* 2nd ed. Nagano, 1979.

———. *Nagano-shi Shikō: Kinsei Zenkōji-machi no Kenkyū* (History of Nagano City: Research into Early Modern Zenkōji-machi). Tokyo, 1969.

Kobayashi, Takeshi. *Nara Buddhist Art: Tōdaiji.* New York and Tokyo, 1975.

———. "Hasedera no Honzon Jūichimen Kannon Zō" (The Main Image of Hasedera, the Eleven-headed Kannon). *Yamato Bunka Kenkyū* 5.2 (1960): 9–15.

———. "Zenkōji Nyorai Zō no Kenkyū" (Research on the Zenkōji Buddha). In *Nihon Chōkoku-shi Kenkyū* (Research on the History of Japanese Sculpture). Tokyo, 1947, pp. 357–385.

Kobayashi Yūjiro. "Zenkōji no Jūkomen Nokihira-gawara ni tsuite" (Concerning the 'Double-circle' Eave Tiles of Zenkōji). *Nagano* 147 (1989): 1–14.

Kodama Yukita and Haga Noboru. *Edo-jidai Zushi* (Pictorial Records of the Edo Period). Vol. 10, *Nakasendo* I. Tokyo, 1977.

Koizumi Hiroshi and Yoshida Yukikazu, eds. *Hōbutsushū.* Tokyo, 1968.

Kokogaku Kai, ed. *Zōzō Meiki.* Tokyo, 1936.

Kubler, George. *The Shape of Time.* New Haven, 1962.

Kuno Takeshi. *Zoku Nihon no Chōkoku* (Sculpture of Japan: Continuation). Tokyo, 1964.

———. *Kodai Shō Kondō-butsu* (Small Gilt-bronze Buddhist Deities of the Ancient Period). Tokyo, 1982.

———. "Daibutsu Igo" (After the Great Buddha). In *Heian Shoki Chōkoku-shi no Kenkyū* (Research into the History of Early Heian Buddhist Sculpture). Tokyo, 1974, pp. 21–37.

———. "Heian Shoki no Jizō Bosatsu Zō ni tsuite" (Concerning the Images of Jizō Bosatsu in the Early Heian Period). *Museum* 247 (1971): 4–14.

———. *Hokuriku-Shinano no Ko-ji (Zenshū Nihon no Ko-ji)*, (Old Temples of the Hokuriku and Shinano Districts). Tokyo, 1984.

———. *Tōhoku Kodai Chōkoku-shi no Kenkyū* (Research on the Sculpture of the Ancient Period in the Tōhoku Region). Tokyo, 1971.

———. "East Asian Buddhist Sculpture and the Henzan." *International Symposium on the Conservation and Restoration of Cultural Property: Inter-regional Influences in East Asian Art History*. Tokyo, 1981, pp. 15–27.

———. *Kantō Chōkoku no Kenkyū* (Research on the Sculpture of the Kanto Region). Tokyo, 1964.

———. *Butsuzō Jiten* (Dictionary of Buddhist Sculpture). Tokyo, 1975.

Kurata Bunsaku. *Butsuzō no Mikata* (Looking at Buddhist Sculpture). Tokyo, 1965.

———. "Zenkōji Nyorai Kō" (Study of the Zenkōji Buddha). *Kokka* 866 (1964): 8–14.

———. "Kōshū Zenkōji no Amida Sanzon ni tsuite" (Concerning the Zenkōji Amida Triad in Kōfu). *Shinano* 6.3 (1964): 162–166.

Kuroda Toshio, *Mōkō Shūrai* (The Mongol Invasions). Vol. 8 of *Nihon no Rekishi* (Chūō Kōron). Tokyo, 1965.

———. "Shinto in the History of Japanese Religion." *The Journal of Japanese Studies* 7.1 (1981): 1–21.

Lee, Ki-baik. *A New History of Korea*. Cambridge, Mass., 1984.

Mainichi Shinbunsha, ed. *Genshokuban Kokuhō*. Vol. 4, *Heian* II, Tokyo, 1967.

Mair, Victor. *Painting and Performance*. Honolulu, 1988.

———. *Tun-huang Popular Narratives*. Cambridge, 1983.

———. *T'ang Transformation Texts*. Cambridge, Mass., 1989.

Maruo Shōzaburō, et al. *Nihon Chōkoku-shi Kiso Shiryō Shūsei: Zōzō Meiki Ban*. Vol. 1, Tokyo, 1966.

Mass, Jeffrey P. *Warrior Government in Early Medieval Japan: A Study of the Kamakura Bakufu, Shugo, and Jitō*. New Haven, 1974.

———. *The Development of Kamakura Rule, 1180–1250*. Stanford, 1979.

———. "The Kamakura Bakufu." In Kozo Yamamura, ed., *The Cambridge History of Japan*. Vol. 3, *Medieval Japan*. Cambridge, 1990.

Matsubara Saburō and Tanabe Saburōsuke. *Shō Kondō-butsu* (Small Gilt-bronze Buddhist Images). Tokyo, 1979.

Matsubara Saburō. *Chūgoku Bukkyō Chōkoku-shi Kenkyū* (Studies of the History of Chinese Buddhist Sculpture). Tokyo, 1966.

Matsuki Hiromi. "Asukadera no Sōken Katei" (The Process of the Establishment of Asukadera). In Kokugakuin Daigaku Shigaku, eds. *Sakamoto Tarō Hakase Shōju Kinen, Nihon Shigaku Ronshū*. Vol. 1. Tokyo, 1983.

Matsunaga, Daigan and Alicia Matsunaga. *Foundation of Japanese Buddhism*. 2 vols. Los Angeles and Tokyo, 1974 and 1979.

McCallum, Donald F. "Buddhist Sculpture of the Seisuiji, Matsushiro." *Oriental Art* N.S. 25.4 (1979–1980): 462–470.

———. "Heian Sculpture at the Shinano Art Gallery." *Oriental Art* N.S. 24.4 (1978–1979): 445–453.

———. "The Evolution of the Buddha and Bodhisattva Figures in Japanese Sculpture of the Ninth and Tenth Centuries." Ph.D. diss., New York University, 1973.

———. "Yamagata Kennai no Zenkōji-shiki Sanzon Zō no Ichi-keitō: Kōyasan Fudōin Zō to no Kankei ni tsuite" (One Tradition of Zenkōji Style Triads in Yamagata Prefecture: Concerning the Connections with the Image in Fudōin, Mt. Kōya). *Uyō Bunka* 122 (1986): 3–21.

———. "Tokyo Kokuritsu Hakubutsukan Hokan Zenkōji-shiki Amida Sanzon Zō ni tsuite" (A Zenkōji Triad in the Tokyo National Museum). *Museum* 441 (1987): 21–28.

McCullough, Helen, trans. *The Tale of the Heike.* Stanford, 1988.

McMullin, Neil. *Buddhism and the State in Sixteenth Century Japan.* Princeton, 1984.

Midorikawa Atsushi, ed. *Byōdōin Taikan.* 3 vols. Tokyo, 1987–1992.

Miki Seiichirō. "Hōkōji Daibutsuden no Zōei ni kansuru Ichi-kōsatsu" (A Theory Concerning the Construction of the Great Buddha Hall of Hōkōji). In Nagahara Keiji, et al. *Chūsei-Kinsei no Kokka to Shakai,* (The State and Culture in the Medieval and Early Modern Periods). Tokyo, 1986.

Mitsumori Masashi, *Amida Nyorai-zō* (Images of Amida Buddha). Vol. 241 of *Nihon no Bijutsu* (Shibundō). Tokyo, 1986.

Miura Katsuo, ed. *Kamakura Kokuhō-kan Zuroku.* Vol. 27, *Kamakura no Zaimei Chōkoku* I (Kamakura Sculpture with Inscriptions). Yokohama, 1985.

Miwa Yoshiroku. *Kokubunji.* Vol. 171 of *Nihon no Bijutsu* (Shibundō). Tokyo, 1980.

Miyagi Yōichirō. *Nihon Kodai Bukkyō Undō-shi Kenkyū* (A Study in the History of Buddhist Mass Movements in Ancient Japan). Kyoto, 1985.

Miyama Susumu. *Kamakura no Chōkoku-Kenchiku: Unkei to Kaikei* (Sculpture and Architecture of Kamakura: Unkei and Kaikei). Vol. 17 of *Nihon Bijutsu Zenshū.* Tokyo, 1978.

Mizuno Keizaburō, et al., eds. *Unkei to Kaikei: Kamakura no Kenchiku-Chōkoku* (Unkei and Kaikei: Architecture and Sculpture of the Kamakura Period). Tokyo, 1991.

Mizuno, Seiichi. *Asuka Buddhist Art: Horyuji.* New York and Tokyo, 1974.

Mōri Hisashi. "Zensuiji no Dōzō Amida Zō" (The Bronze Amida Image of Zensuiji). *Nihon Butsuzō-shi Kenkyū* (Studies of the History of Japanese Buddhist Sculpture). Kyoto, 1980.

———. *Unkei to Kamakura Chōkoku* (Unkei and Kamakura Sculpture). Tokyo, 1964. Translated as *Sculpture of the Kamakura Period.* New York and Tokyo, 1974.

———. *Japanese Portrait Sculpture.* Tokyo and New York, 1977.

Morrell, Robert A., trans. *Sand and Pebbles (Shasekishū): The Tales of Mujū Ichien: A Voice for Pluralism in Kamakura Buddhism.* Albany, 1985.

Nagahara Keiji. *Sengoku no Dōran* (Disturbances of the Sengoku Period). Vol. 14 of *Nihon no Rekishi* (Shōgakkan). Tokyo, 1975.

Nagano Ken-shi Kankōkai, ed. *Nagano Ken-shi: Tsūshi-hen* (History of Nagano Prefecture: Comprehensive Edition). 10 vols. Nagano, 1986–1992.

Naitō Masatsune. "Shinano Kokubunji no Iseki" (Remains of the Provincial Temple of Shinano). *Kobijutsu* 17 (1967): 71–78.

Nakao Takashi and Imai Masaharu, eds. *Chōgen, Eison, Ninshō.* Tokyo, 1983.

Nara Kokuritsu Bunkazai Kenkyūjo, Asuka Shiryō-kan, ed. *Asuka-Hakuhō no Zaimei Kondō-butsu* (Asuka and Hakuhō Gilt-bronze Buddhist Images with Inscriptions). 2d ed. Nara, 1979.

Nara Kokuritsu Hakubutsukan, ed. *Amida Butsu Chōzō* (Sculpture of Amida Buddha). Tokyo, 1975.

————. ed. *Shaji Engi-e* (Illustrated Tales of Shrines and Temples). Tokyo, 1975.

————. ed. *Heian-Kamakura no Kondō-butsu* (Gilt-bronze Buddhist Sculpture of the Heian and Kamakura Periods). Nara, 1976.

————, ed. *Nihon Bukkyō Bijutsu no Genryū* (The Origins of Japanese Buddhist Art). Kyoto, 1984.

Nara Rokudaiji Taikan Kankōkai, eds. *Nara Rokudaiji Taikan* (Survey of the Six Great Temples of Nara). 14 vols. Tokyo, 1969–1973.

Niino Naoyoshi. *Kenkyū-shi: Kuni no Miyatsuko* (Historiography: Kuni no Miyatsuko). Tokyo, 1974.

Nishikawa Kyōtarō. *Bunkazai Kōza: Nihon no Bijutsu 7, Chōkoku (Kamakura).* Tokyo, 1977.

Nishikawa Shinji and Sekine Shun'ichi. "Zenkōji Amida Sanzon Zō no Keishiki o megutte: Chiba Kenka no Ihin o Chūshin ni" (Concerning the Style of the Zenkōji Triad Images: Centering on the Monuments Preserved in Chiba Prefecture). *Miura Kobunka* 32 (1982): 9–42.

Nishikawa Shinji. "Daienji no Seiryōji-shiki Shaka Zō" (The Seiryōji Style Shaka at Daienji). *Museum* 100 (1959): 20–23.

Nishiyama Katsu. "⟨Jotei⟩ no Dajigoku: Zenkōji Sankei Mandara o Tekisuto ni shite" (The Fall of the ⟨Empress⟩ into Hell: Using the Zenkōji Sankei Mandara as Text). *Shinano* 39.11 (1987): 21–43.

Nōdomi Jōten. *Kanazawa Bunko Shiryō no Kenkyū* (Study of the Historical Documents in the Kanazawa Library). Kyoto, 1982.

Nomura Tadao. *Kenkyū-shi: Taika Kaishin* (Historiography: The Taika Reform). Expanded ed. Tokyo, 1978.

Nuki Tatsuto. *Engakuji.* Tokyo, 1964.

Ogura Toyobumi. "Zenkōji Nyorai Zō Shōkō: Toku ni Bingo no kuni Ankokuji Honzon ni tsuite" (Study of the Zenkōji Buddha, with Particular Reference to the Main Image of the Bingo Ankokuji). *Bukkyō Geijutsu* 37 (1958): 37–53.

————. "Ankokuji Sōzō Shōkō: Bingo no kuni no Baai no Chūshin to shite" (A Study of the Establishment of the Ankokuji Network: Centering on the Ankokuji of Bingo Province). *Hiroshima Daigaku Bungakubu Kiyō* 12 (1957): 1–21.

Okutomi Takayuki. *Kamakura Hōjō-shi no Kisoteki Kenkyū,* (Fundamental Research on the Hōjō Clan of the Kamakura Period). Tokyo, 1980.

Ōhashi Shunnō. *Ippen Shōnin.* Tokyo, 1983.

Ono Sumio and Ono Mitsuo. "Zenkōji Nyorai Ibun: Suwa ni kita Zenkōji Nyorai" (An Unusual Story Concerning the Zenkōji Buddha: the Zenkōji Buddha Comes to Suwa). *Nagano* 108: 67–69.

Ōsumi Kazuo. "Buddhism in the Kamakura Period." In Kozo Yamamura, ed. *The Cambridge History of Japan.* Vol. 3, *Medieval Japan.* Cambridge, 1990.

Ōsumi Kazuo and Nishiguchi Junko, eds. *Shiriizu Josei to Bukkyō* (Women and Buddhism Series). Vol. 1, *Ama to Amadera* (Nuns and Nunneries). Tokyo, 1989.

Paine, Robert T. and Alexander Soper. *The Art and Architecture of Japan.* 1st paperback ed. Baltimore, 1975.

Philippi, Donald L. trans. *Kojiki.* Tokyo, 1968.

Ricoeur, Paul. "Myth and History." In Mircea Eliade, et al., eds. *The Encyclopedia of Religion.* Vol. 10, pp. 273–282. New York, 1987.

Rowland, Benjamin. *The Art and Architecture of India.* 1st paperback ed. Baltimore, 1971.

Ruch, Barbara. "Medieval Jongleurs and the Making of National Literature." In John Whitney Hall and Toyoda Takeshi, eds. *Japan in the Muromachi Age.* Berkeley and Los Angeles, 1977, pp. 279–309.

————. "The Other Side of Culture in Medieval Japan." In Kozo Yamamura, ed. *The Cambridge History of Japan.* Vol. 3, *Medieval Japan.* Cambridge, 1990.

Sakai Kōhei. *Zenkōji-shi* (History of Zenkōji). 2 vols. Tokyo, 1969.

Sakamoto Tarō, et. al. *Nihon Shoki* I and II. Vols. 67–68 of *Nihon Koten Bungaku Taikei,* (Iwanami Shoten). Tokyo, 1980.

Sakurai Tokutarō. "Engi no Ruikei to Tenkai" (Types of Engi and their Development). In Sakurai Tokutarō, et al., eds. *Jisha Engi.* Vol. 20 of *Nihon Shisō Taikei.* Tokyo, 1975.

Sanford, James H., William R. LaFleur, and Masatoshi Nagatomi, eds. *Flowing Traces: Buddhism in the Literary and Visual Arts of Japan.* Princeton, 1992

Sansom, George. *A History of Japan.* 3 vols. Stanford, 1958–1963.

Sasaki Ginmi. *Muromachi Bakufu* (The Muromachi Bakufu). Vol. 13 of *Nihon no Rekishi* (Shōgakkan). Tokyo, 1975.

Sasamoto Shōji. *Takeda-shi Sandai to Shinano: Shinkō to Tōchi no Hazama* (Three Generations of the Takeda Clan and Shinano: The Interval Between Faith and Rule). Matsumoto, 1988.

Satō Akio. *Hōryūji Kennō Kondō-butsu* (Gilt Bronze Images Donated by Hōryūji). Tokyo, 1975.

Sato, Elizabeth. "The Early Development of the Shōen." In John W. Hall and Jeffrey Mass eds. *Medieval Japan: Essays in Institutional History.* New Haven and London, 1974.

Satō Kazuhiko. *Nanbokuchō Nairan* (Internal Disturbances of the Nanbokuchō Period). Vol. 11 of *Nihon no Rekishi* (Shōgakkan). Tokyo, 1974.

Satō Shin'ichi. *Nanbokuchō no Dōran* (Disturbances of the Nanbokuchō Period). Vol. 9 of *Nihon no Rekishi* (Chūō Kōron). Tokyo, 1965.

Schopen, Gregory. "Burial 'Ad Sanctos' and the Physical Presence of the Buddha in Early Indian Buddhism: A Study in the Archaeology of Religions." *Religion* 17 (1987): 193–225.

Shimaguchi Yoshiaki. "Jisha Engi to Minzoku: *Zenkōji Engi* o Chūshin ni" (Jisha Engi and the People: Centering on *Zenkōji Engi*). In Ōtani Daigaku Kokushi Gakkai, eds. *Ronshi Nihonjin no Seikatsu to Shinkō* (Studies on the Lives and Beliefs of the Japanese). Kyoto, 1979, pp. 577–605.

Shimizu Mazumi. *Kamakura Daibutsu: Tōgoku Bunka no Nazo* (The Kamakura Great Buddha: The Riddle of the Culture of the Eastern Regions). Tokyo, 1979.

Shimizu Yoshiaki. "The *Shigisan-engi* Scrolls, c. 1175." In Herbert L. Kessler and Marianna Shreve Simpson, eds. *Pictorial Narrative in Antiquity and the Middle Ages*. Washington, 1985.

Shimizu Zenzō. "Seiryōji-shiki Shaka Zō" (Seiryōji Style Shaka Images). *Nihon Bijutsu Kōgei* 440 (1975): 15–21.

―――. "Kamakura Chōkoku ni okeru 'Sō-fū' ni tsuite: Joron-teki Kōsatsu" (Concerning the "Sung Style" in Kamakura Sculpture: An Introductory Analysis). *Bijutsu-shi* 75 (1969): 75–88.

Shinano Bijutsukan, ed. *Zenkoku Zenkōji Nyorai-ten* (Exhibition of Zenkōji Buddhas from the Entire Country). Nagano, 1967.

―――. *Zenkōji Eden-ten* (Zenkōji Pictorial Art). Nagano, 1973.

Shinjo Tsunezō. *Shaji Sankei no Shakai Keizai Shiteki Kenkyū* (Historical Reseach on the Social and Economic Aspects of Pilgrimage to Shrines and Temples). Tokyo, 1964.

Shinozaki Shirō. "Zenkōji-shiki Sanzon" (Zenkōji Style Triads). *Hoshioka* 119 (1940): 3–5.

Shōwa Daishūri Kanjin Zenkōji-ten (Exhibition of Zenkōji at the time of the Shōwa Reconstruction). Tokyo, 1986.

Sickman, Laurence and Alexander C. Soper. *The Art and Architecture of China*. 1st paperback ed. Baltimore, 1971.

Snellgrove, David L. *The Image of the Buddha*. Tokyo, 1978.

Soper, Alexander C. *Literary Evidence for Early Buddhist Art in China*. Ascona, 1959.

―――. "Representations of Famous Images at Tun-huang." *Artibus Asiae* 27.4 (1965): 349–364.

Steenstrup, Carl. *Hōjō Shigetoki (1198–1261)*. Copenhagen, 1979.

Sugiyama Hiroshi. *Sengoku Daimyō* (Daimyō of the Sengoku Period). Vol. 11 of *Nihon no Rekishi* (Chūō Kōron). Tokyo, 1965.

Takada Ryōshin. "Zenkōji Nyorai Gosho-bako no Roman" (The Story of the Letter Box of the Zenkōji Buddha). *Nihon no Koji Bijutsu*, Vol. 1, *Hōryūji* 1: *Rekishi to Ko Bunken*. Tokyo, 1987, pp. 166–172.

Takeda Kōkichi. *Dewa no Zenkōji-shiki Sanzon Zō* (Zenkōji-style Triads in the Dewa Region). Yamagata, 1970.

Takemitsu Makoto. *Shōtoku Taishi: Nihon Shisō no Genryū* (Shōtoku Taishi: The Origins of Japanese Thought). Tokyo, 1984.

Takeuchi Rizō, *Bushi no Tōjō*. Vol. 6 of *Nihon no Rekishi* (Chūō Kōron). Tokyo, 1965.

Tamura Enchō. "Hōkōji no Sōken" (The Establishment of Hōkōji). In Ienaga

Saburō Kyōju Tokyo Kyōiku Daigaku Taikan Kinen Ronshū Kankō Iinkai, eds. *Kodai-Chūsei no Shakai to Shisō* (Society and Thought in the Ancient and Medieval Periods). Tokyo, 1979.

———. "Kinmei Tennō Jūsan-nen Bukkyō Denrai Setsuwa no Seiritsu" (Formation of the Legends Concerning the Transmission of Buddhism in the 13th Year of Emperor Kinmei). In *Asuka Bukkyō-shi Kenkyū* (Research in the History of Asuka Period Buddhism). Tokyo, 1969.

Tamura Yoshirō. "Tendaishū." In Mircea Eliade, et al., eds. *The Encyclopedia of Religion*. Vol. 14, pp. 396–401. New York, 1987.

Tanabe Saburōsuke. "Kamakura-jidai no Kondō-butsu" (Gilt-bronze Sculpture of the Kamakura Period). *Koen-kai Shiriizu 2*. Kanazawa Bunko, 1971.

Tanaka Hisao. *Kamakura Bukkyō*. (Kamakura Buddhism). Tokyo, 1980.

Tanaka Shigehisa. "Shinano Zenkōji Nyorai Genzō no Dōzō Tōshin Setsu" (Theory that the Original Zenkōji Buddha of Shinano was a Life-sized Bronze Image). *Bukkyō Geijutsu* 82 (1971): 11–46.

Tanaka Yoshiyasu. *Tanjō-butsu* (New-born Buddhas). Vol. 159 of *Nihon no Bijutsu* (Shibundō). Tokyo, 1979.

Teiser, Stephen F. *The Ghost Festival in Medieval China*. Princeton, 1988.

ten Grotenhuis, Elizabeth. "Rebirth of an Icon: The Taima Mandala in Medieval Japan." *Archives of Asian Art* 36 (1983): 59–87.

———. "Chūjōhime: The Weaving of Her Legend." In J. Sanford, W. LaFleur, and M. Nagatomi, eds. *Flowing Traces: Buddhism in the Literary and Visual Arts of Japan*. Princeton, 1992, pp. 180–199.

Tokoro Shigemoto. *Kamakura Bukkyō* (Kamakura Buddhism). Tokyo, 1967.

Tokuda Kazuo. *Egatari to Monogatari* (Illustrated Stories and Tales). Tokyo, 1990, pp. 90–111.

Tokyo Kokuritsu Hakubutsukan, ed. *Tokubetsu-ten Zuroku: Kondō-butsu—Chūgoku, Chōsen, Nihon* (Special Exhibition Compilation: Small Gilt-bronze Buddhist Deities—China, Korea, Japan). Tokyo, 1988.

———. *Hōryūji Kennō Homotsu Tokubetsu Chōsa Gaihō*. Vol. 5, *Kondō-butsu* I. Tokyo, 1983–84.

Tsuji Hidenori. *Kodai Sangaku Jiin no Kenkyū 1, Hasedera-shi no Kenkyū* (Research on Ancient Mountain Temples 1, Research on the History of Hasedera). Kyoto, 1979.

Tsuji Nobuo, ed. *Zusetsu Nihon no Bukkyō 5, Shomin Bukkyō* (Popular Buddhism). Tokyo, 1990.

Tsukada Masatomo. *Nagano-ken no Rekishi* (History of Nagano Prefecture). Tokyo, 1977.

Turner, Victor. "Death and the Dead in the Pilgrimage Process." In Frank E. Reynolds and Earle H. Waugh, *Religious Encounters with Death: Insights from the History and Anthropology of Religion*. University Park, Penn. and London, 1973.

Tyler, Royall. *The Miracles of the Kasuga Deity*. New York, 1990.

Tyler, Susan. *The Cult of Kasuga Seen Through Its Art*. Ann Arbor, 1992.

Udaka Yoshiaki. *Edo Bakufu no Bukkyō Kyōdan Tōsei* (The Control of Buddhist Organizations by the Edo Bakufu). Tokyo, 1987.

Udaka Yoshiaki and Yoshihara Hiroto. *Kai Zenkōji Monjo* (Documents of the Zenkōji of Kai Province). Vol. 5 of *Kinsei Jiin Shiryō Sōsho* (Collection of Historical Records of Early Modern Temples). Tokyo, 1986.

Uehara Shōichi. *Kokuhō Chozō* (National Treasure Sculpture). Tokyo, 1967.

Uematsu Mataji. "Shingen no Shinano Keiei to Zenkōji: Toku ni Zenkōji Nyorai ni tsuite" (The Activities of Takeda Shingen in Shinano and Zenkōji: Especially Concerning the Zenkōji Buddha). *Kai-ji* 17 (1970): 19–23.

Ushiyama Yoshiyuki. "Zenkōji Sōken to Zenkōji Shinkō no Hatten" (The Establishment of Zenkōji and the Development of the Zenkōji Cult). In Itō Nobuo, et al., eds. *Zenkōji: Kokoro to Katachi* (Zenkōji: Spirit and Form). Tokyo, 1991.

Varley, H. Paul, trans. *A Chronicle of Gods and Sovereigns: Jinnō Shōtōki of Kitabatake Chikafusa*. New York, 1980.

———. *Imperial Restoration in Medieval Japan*. New York, 1971.

———. "The Hōjō Family and Succession to Power." In Jeffrey P. Mass, ed. *Court and Bakufu in Japan: Essays in Kamakura History*. New Haven, 1982.

Wajima Yoshio. *Eison-Ninshō*. Tokyo, 1959.

Watanabe Tamotsu. *Hōjō Masako*. Tokyo, 1961.

Wayman, Alex. "Contributions Regarding the Thirty-two Characteristics of the Great Person." *Liebenthal Festschrift, Sino-Indian Studies* 5 (1953): 234–260.

Weinstein, Lucie R. "The Yumedono Kannon: Problems in Seventh Century Sculpture." *Archives of Asian Art*, 42 (1989): 25–48.

Yamada Yasuhiro and Yoshihara Hiroto. *Kai Zenkōji*. Kōfu, 1982.

Yamada Yasuhiro. "Kōfu Zenkōji no Shōzō Chōkoku: Minamoto Yoritomo Zō Nado" (The Portrait Sculpture of Kōfu Zenkōji: The Image of Minamoto Yoritomo and Others). *Miura Kobunka* 29 (1981): 14–21.

Yamaguchi Jun'ichi. "Wakatsuki Shutsudo no iwayuru Zenkōji Kawara ni tsuite" (Concerning the so-called Zenkōji Tiles from the Wakatsuki Excavations). *Nagano* 134 (1987): 39–51.

Yamanoi Daiji. "Shōchō Taikei to shite no Zenkōji Shinkō" (Symbolic and Structural Approaches to the Rituals and Organizations at the Zenkōji Buddhist Temple). *Taishō Daigaku Kenkyū Kiyō* 67 (1982): 85–121.

———. "Bukkyō Kyōdan no Dōtai" (Buddhist Community Movements). *Taishō Daigaku Kenkyū Kiyō* 70 (1985): 43–73.

———. "Shūkyō-teki Shōchō no Idō: Shinshū Zenkōji no Degaichō" (Shifting Religious Symbols: The Ceremony of Traveling Exhibition at the Zenkōji Temple in Shinshū). *Taishō Daigaku Kenkyū Kiyō* 72 (1986): 185–200.

———. "Zenkōji Reijō to Degaichō" (Sacred Space at Zenkōji and the Degaichō"). In Sakurai Tokutarō, ed. *Bukkyō Minzoku-gaku Taikei* 3: *Seichi to Takaikan* (Collection of Essays on Folk Buddhism 3, Sacred Places and Views on the Other World). Tokyo, 1987, pp. 227–247.

———. "Zenkōji no Nenjū-gyōji" (The Annual Rituals at Zenkōji). In Itō Nobuo, et al., eds. *Zenkōji: Kokoro to Katachi* (Zenkōji: Spirit and Form). Tokyo, 1991, pp. 210–223.

Yasuda Motohisa. *Kamakura Shikken Seiji: Sono Tenkai to Kōzō* (Government by the Kamakura Shikken: Its Development and Structure). Tokyo, 1979.

Yiengpruksawan, Melanie Hall. *The Buddhist Sculpture of Chūsonji: The Meaning of Style at the Hiraizumi Temples of the Ōshū Fujiwara.* Ph.D. dissertation, University of California, Los Angeles, 1987.

Yoneyama Kazumasa. "Zenkōji Ko Engi ni tsuite" (Concerning the Old Zenkōji Engi). *Shinano* 9.6 (1957): 356–368.

———. "Sengoku Bushō to Zenkōji Nyorai" (Warriors of the Sengoku Period and the Zenkōji Buddha). *Shinano-ji* 39 (1982): 74–77.

Yoshihara Hiroto. "<Chūsei-teki> Jisha Engi no Keisei" (Formation of the <Medieval Type> of Jisha Engi). *Kokubungaku: Kaishaku to Kanshō*, 51.6 (1986): 122–127.

———. "Kōgyoku Tennō no Dajigoku Dan: *Zenkōji Engi*" (The Story of Empress Kōgyoku's Fall into Hell: *Zenkōji Engi*). *Kokubungaku: Kaishaku to Kanshō* 55.8 (1990): 74–78.

———. "Zenkōji Honzon to Shōjin Shinkō" (The Main Image of Zenkōji land Belief in Living Images). In Nishikawa Kyōtarō and Tanaka Yoshiyasu, eds. *Butsuzō o Tabisuru: Chūō-sen.* Tokyo, 1990, pp. 61–64.

Yumoto Gun'ichi. "Hōjō-shi to Zenkōji" (The Hōjō Clan and Zenkōji). *Nagano* 121 (1985): 1–7.

———. "Hōjō-shi to Shinano no Kuni" (The Hōjō Clan and Shinano Province). *Shinano* 19 (1967): 841–860.

———. "Shinano no Kuni ni okeru Hōjō-shi no Shoryō" (Hōjō Clan Estates in Shinano Province). *Shinano* 24 (1972): 800–813.

Zaleski, Carol. *Otherworld Journeys: Accounts of Near-Death Experience in Medieval and Modern Times.* New York, 1987.

Zuesse, Evan M. "Ritual." In Mircea Eliade, et al., eds. *The Encyclopedia of Religion.* Vol. 12, pp. 405–422. New York, 1987.

Index

Illustrations

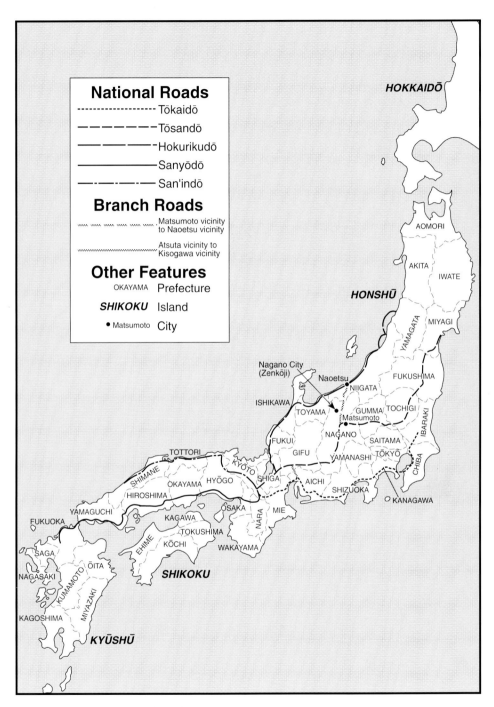

Map 1. Important National Roads.

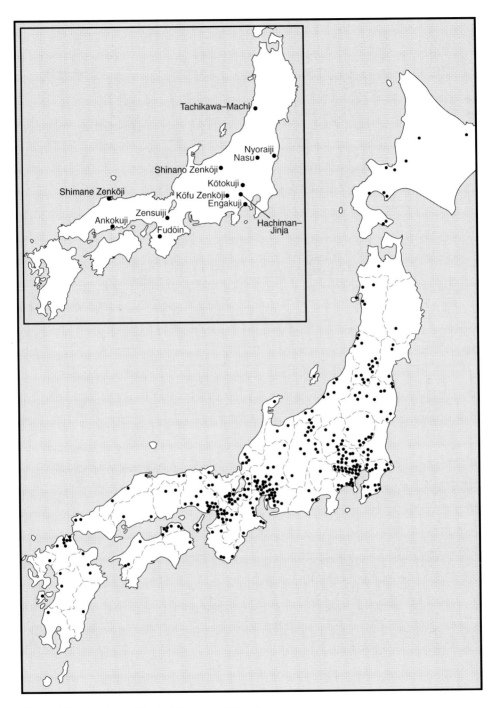

Map 2. Distribution of Zenkōji Icons and Temples.

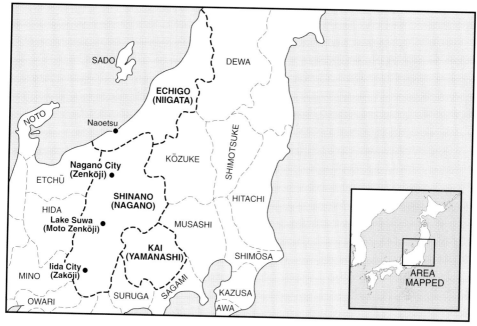

Map 3. Shinano and Adjacent Provinces.

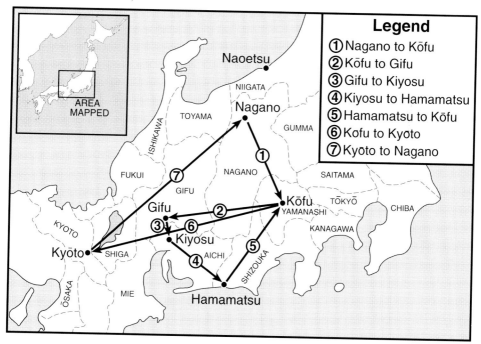

Map 4. Movements of the Zenkōji Triad, 1555–1598.

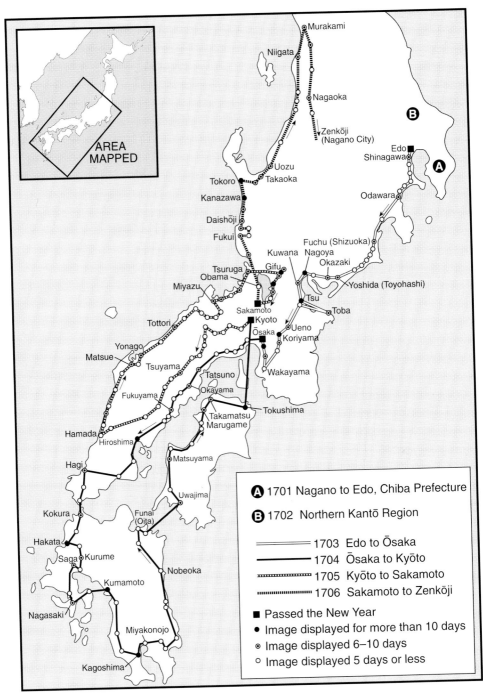

Map 5. The Kaikoku Kaichō (Nationwide Display), 1701–1706.

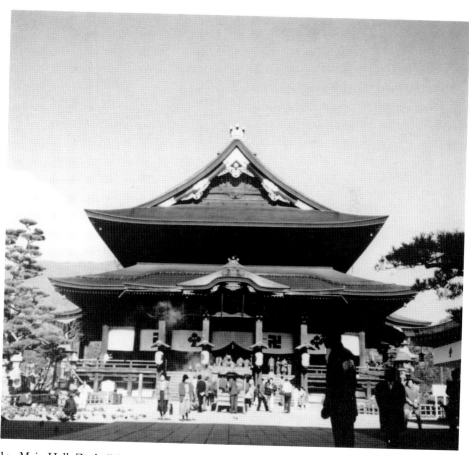

1a. Main Hall, Zenkōji (1707), Nagano City. Edo Period.

1b. Ground Plan of Zenkōji, Modern.

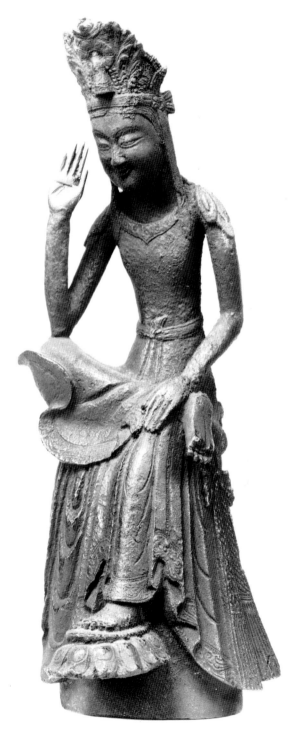

2. Hanka Bosatsu, Kanshōin, Nagano Prefecture. Three Kingdoms or Asuka Period. H. 16.4 cm. Gilt-bronze.

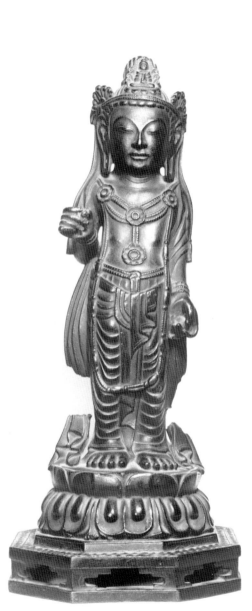

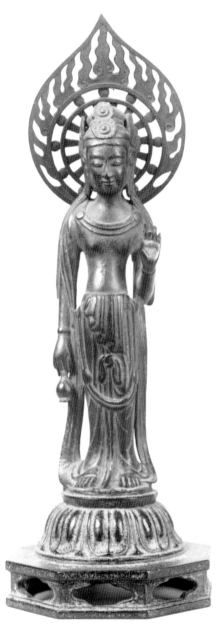

3. Kannon Bosatsu, Sanzenji, Nagano
Prefecture. Hakuhō Period. H. 29.7 cm. Gilt-
bronze.

4. Kannon Bosatsu, Chōfukuji, Nagano
Prefecture. Hakuhō Period. H. 26.7 cm.
Gilt-bronze.

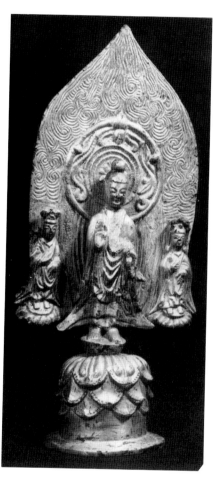

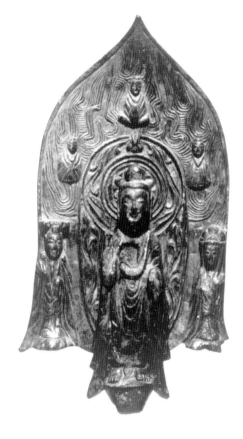

5. Buddha Triad (dated 563), Kansong Museum, Seoul. Three Kingdoms Period. H. 17.5 cm. Gilt-bronze.

6. Buddha Triad (dated 571), Kim Collection, Seoul. Three Kingdoms Period. H. 15.5 cm. Gilt-bronze.

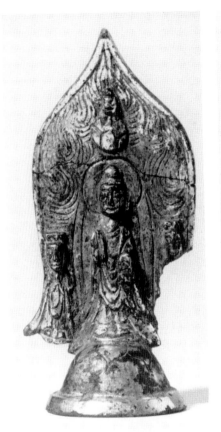

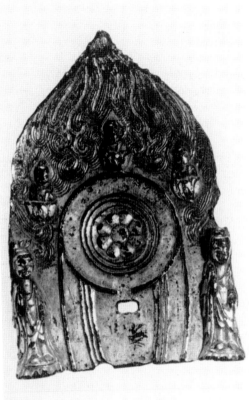

7. Buddha Triad, National Museum of
Korea, Puyo. Three Kingdoms Period.
H. 8.5 cm. Gilt-bronze.

8. Mandorla (dated 596), National Museum of
Korea, Puyo. Three Kingdoms Period. H. 12.3
cm. Gilt-bronze.

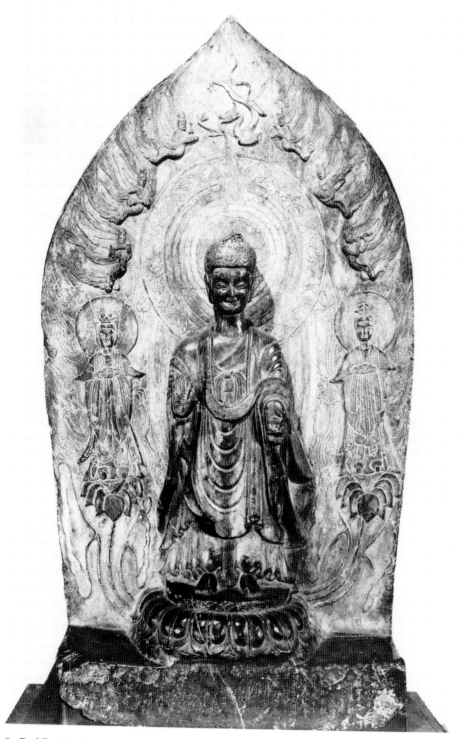

9. Buddha Triad (dated 536), Fujii Yūrinkan Museum, Kyoto. Eastern Wei Period. H. 179 cm. Stone.

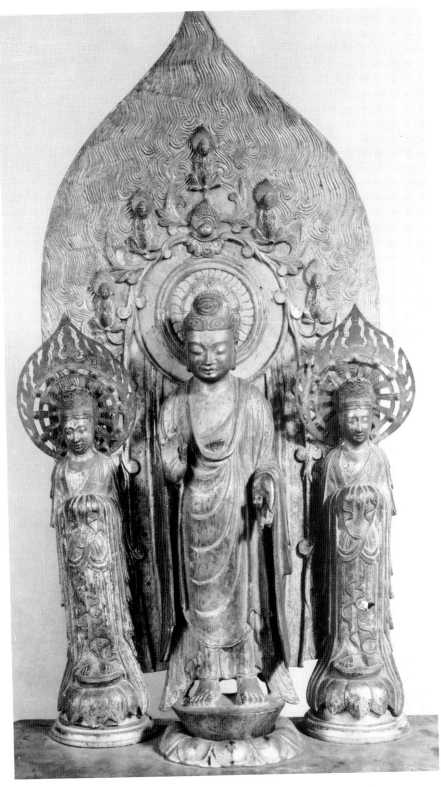

10. Buddha Triad, designated Number 143, Tokyo National Museum. Three
Kingdoms or Asuka Period. Buddha, H. 28.7 cm; Bosatsu, H. 20.5 cm. Gilt-bronze.

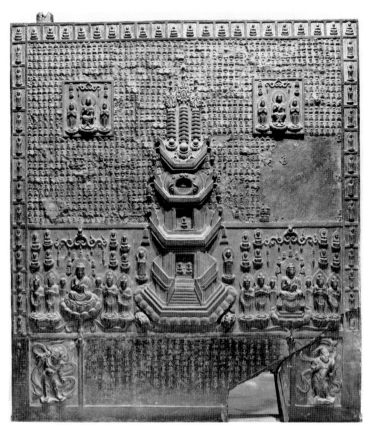

11a. Lotus Sutra Plaque, Hasedera, Nara. Hakuhō Period. 83.3 × 75 cm. Gilt-bronze.

11b. Detail of Lotus Sutra Plaque.

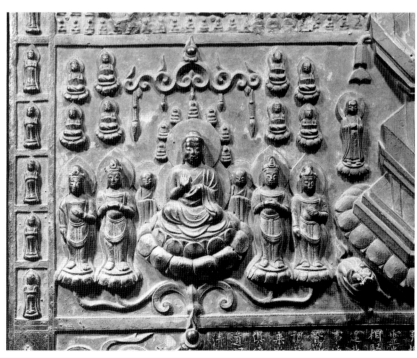

12. Portrait of Minamoto Yoritomo, Zenkōji, Kōfu City. Kamakura Period. H. 137 cm. Wood.

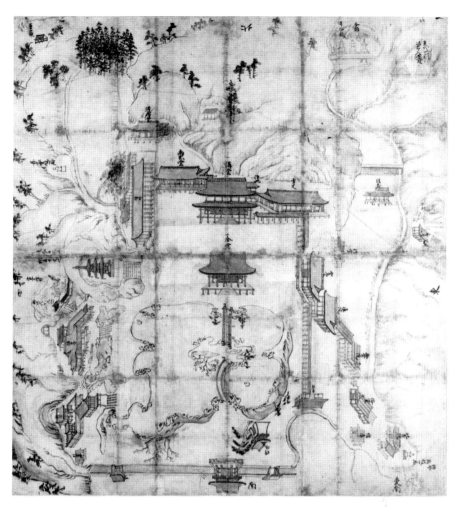

13a. Map of Shōmyōji,
Kanazawa Bunko, Yokohama.
Kamakura Period. 95 × 91 cm.
Ink/colors on paper.

13b. Detail showing the tomb
labeled "Zenkōjidono-byō."

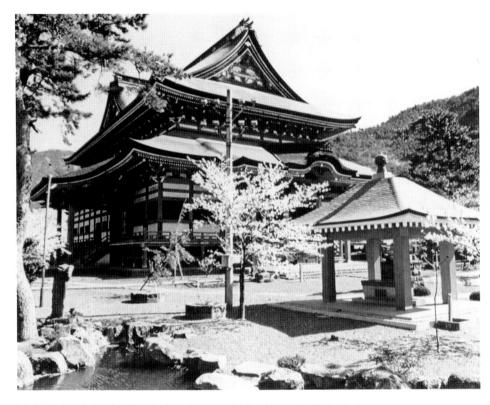

14. Main Hall, Zenkōji, Kōfu City, Yamanashi Prefecture. Edo Period.

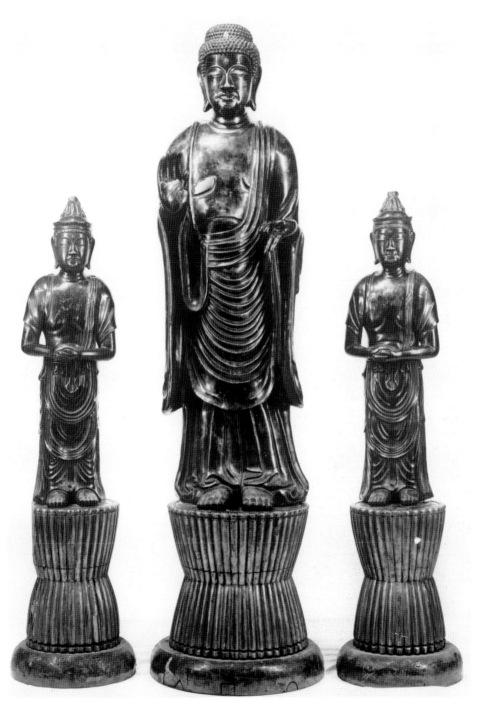

15a. Amida Triad (dated 1195), Zenkōji, Kōfu. Kamakura Period. Amida, H. 147.2 cm; Bosatsu, H. 95.1 cm and 95.4 cm. Gilt-bronze.

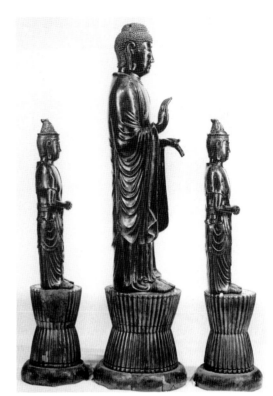

15b. Right side view.

15c. Back view.

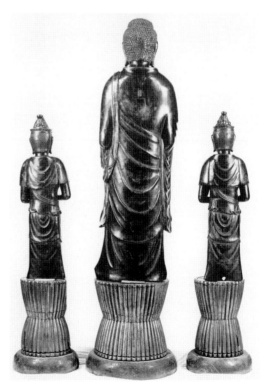

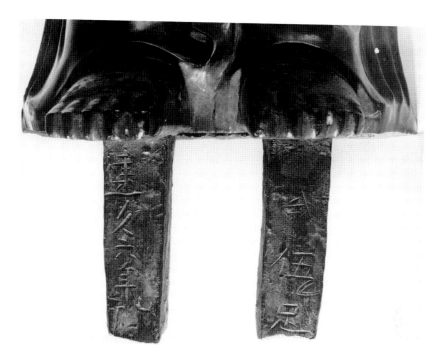

15d. Inscription.

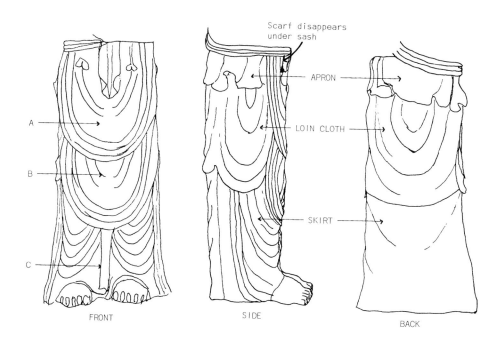

Scarf disappears
under sash

APRON

LOIN CLOTH

SKIRT

A

B

C

FRONT

SIDE

BACK

KOFU ZENKŌJI AMIDA TRIAD

15e. Diagram of Bosatsu's drapery.

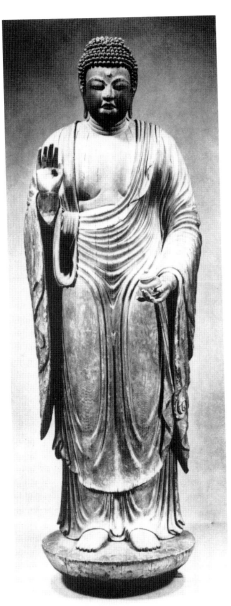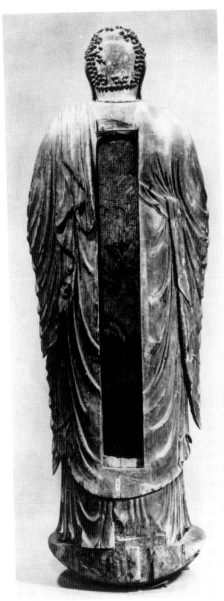

16a. Yakushi Buddha, Gangōji, Nara. Early Heian Period. H. 165.4 cm. Wood.
16b. Back view.

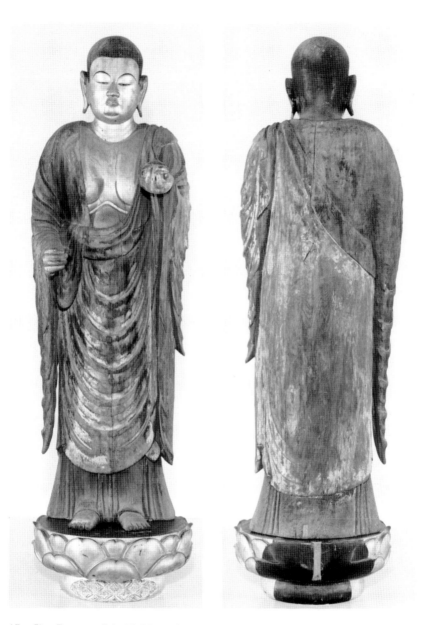

17a. Jizō Bosatsu, Seisuiji, Matsushiro, Nagano Prefecture. Early Heian Period.
H. 157 cm. Wood. 17b. Back view.

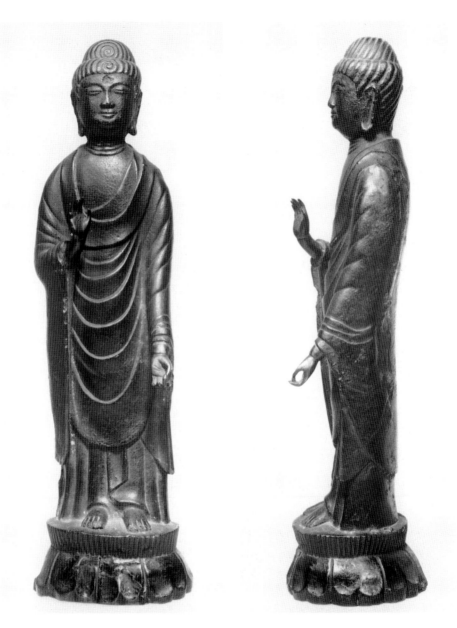

18a. Amida Buddha (dated 1206), Zensuiji, Shiga Prefecture. Kamakura Period. H. 36.9 cm. Gilt-bronze. 18b. Left side view.

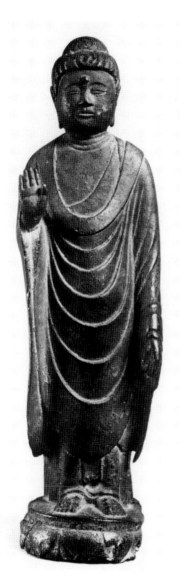

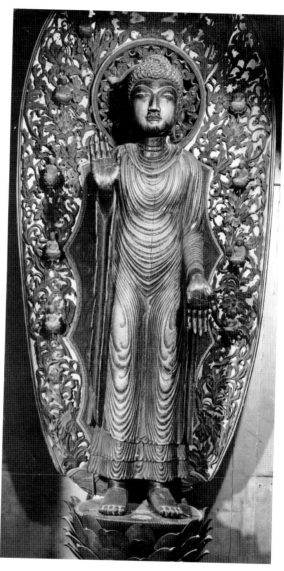

19. Amida Buddha (dated 1206), Private Collection, Tokyo. Kamakura Period. H. 31.5 cm. Gilt-bronze.

20. Shaka Buddha (dated 985), Seiryōji, Kyoto. Northern Sung Dynasty. H. 160 cm. Wood.

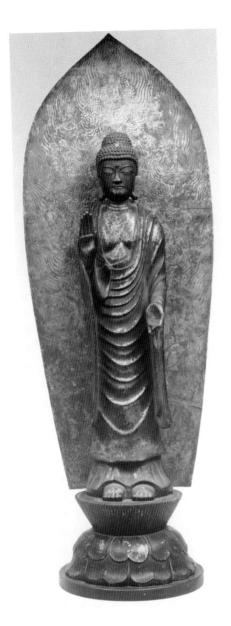

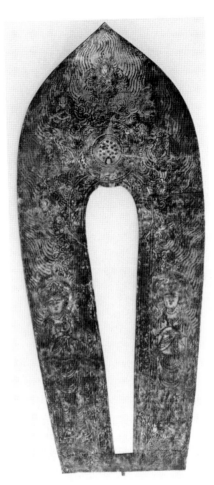

21a. Amida Triad, Zenkōji, Shimane
Prefecture. Kamakura Period. Amida,
H. 53.5 cm. Gilt-bronze.
21b. Mandorla.

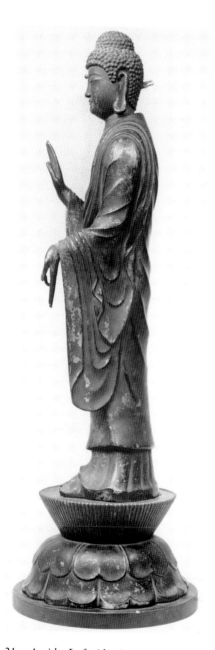

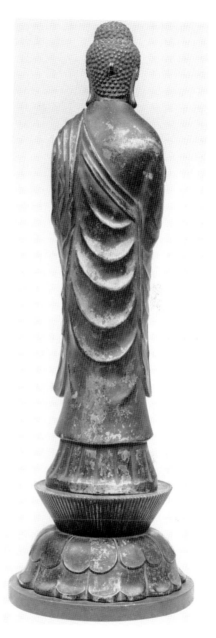

21c. Amida, Left side view.

21d. Amida, Back view.

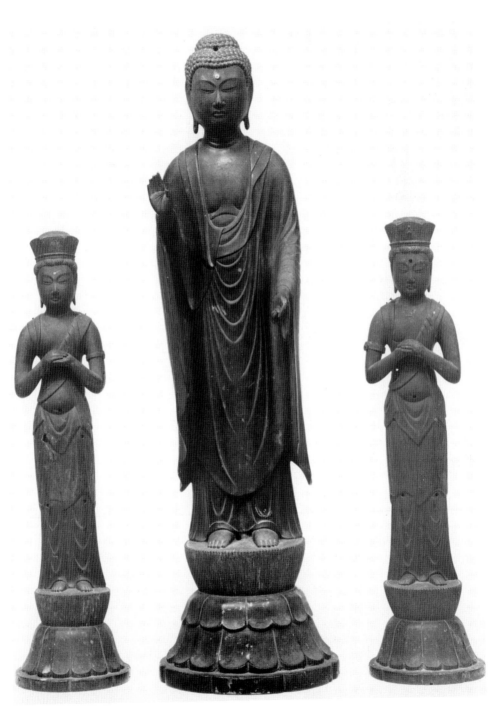

22a. Amida Triad (dated 1249), Kōtokuji, Saitama Prefecture. Kamakura Period. Amida, H. 47.6 cm; Bosatsu, H. 36.8 cm. Gilt-bronze.

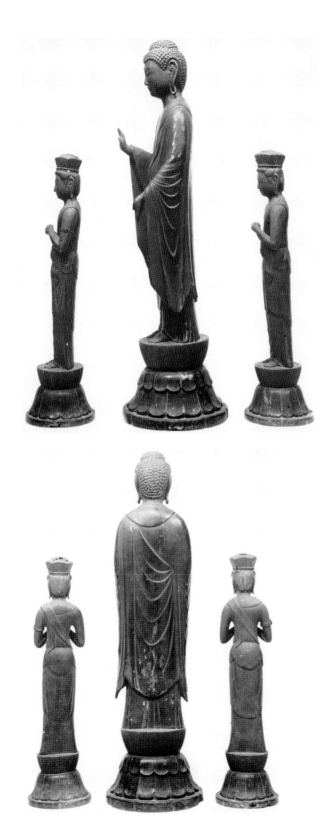

22b. Left side view.

22c. Back view.

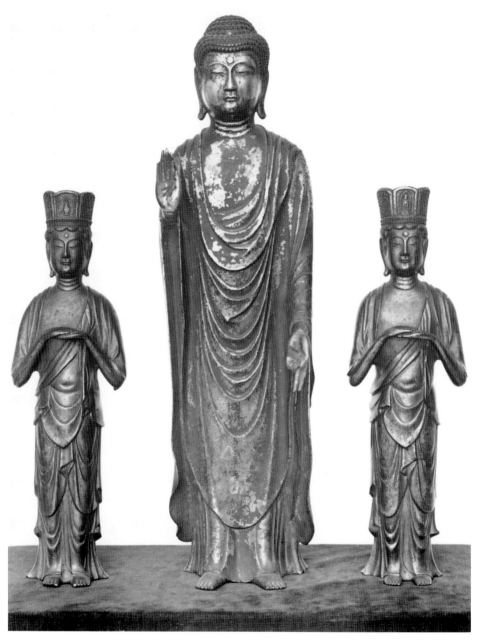

23a. Amida Triad (dated 1254), Tokyo National Museum. Kamakura Period. Amida, H. 42.6
cm; Bosatsu, H. 32.8 cm and 33.2 cm. Gilt-bronze.

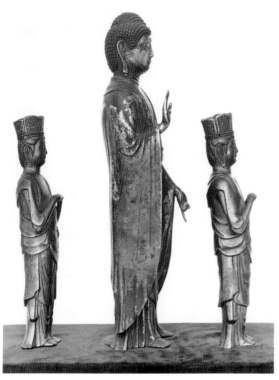

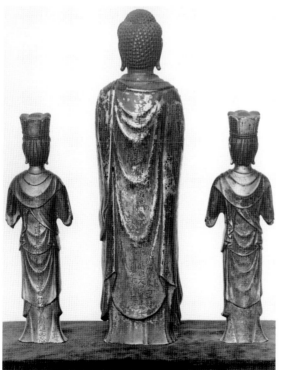

23b. Right side view.

23c. Back view.

24. Amida Buddha (dated 1261), Jōshinji,
Ibaragi Prefecture. Kamakura Period. H. 50
cm. Gilt-bronze.

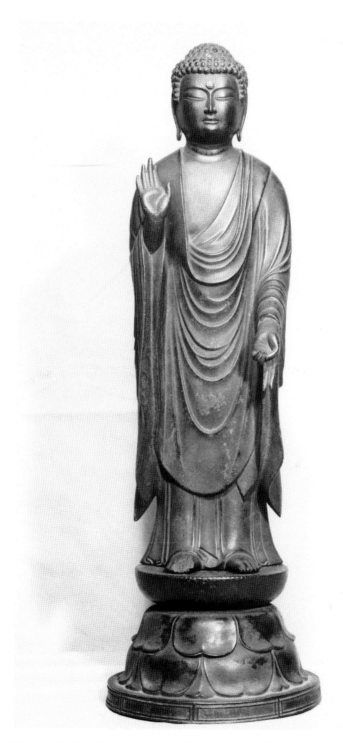

25a. Amida Buddha (dated 1261), Hachimanjinja, Tokyo. Kamakura Period. H. 48.5 cm. Gilt-bronze.

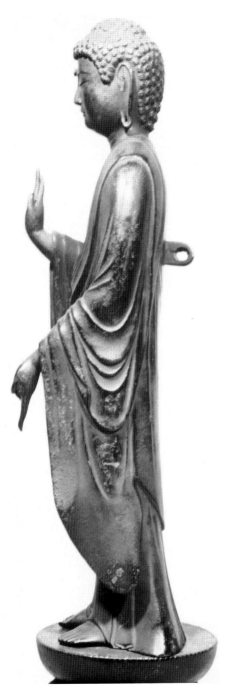

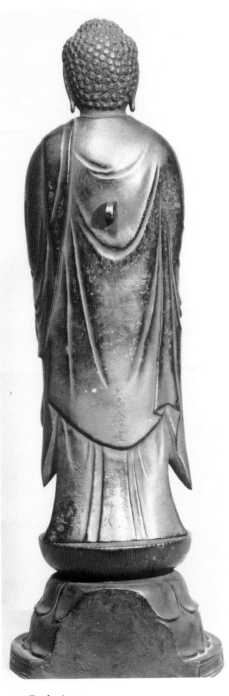

25b. Left side view. 25c. Back view.

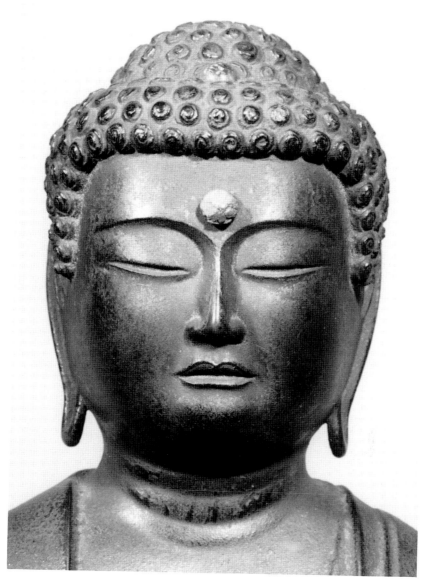

25d. Detail of face.

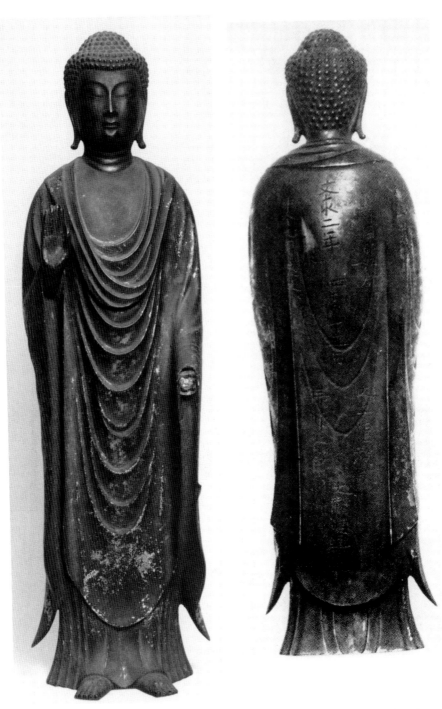

26a. Amida Buddha (dated 1265), Ishikawa Collection, Saitama Prefecture. Kamakura
Period. H. 47.5 cm. Gilt-bronze. 26b. Back view.

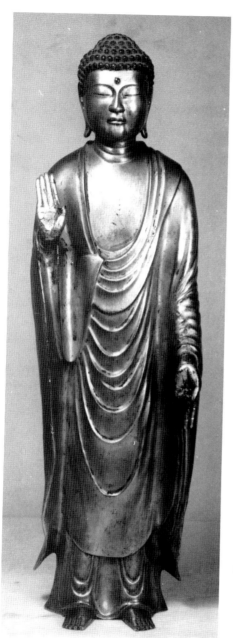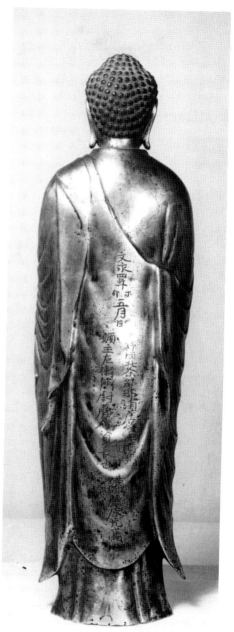

27. Amida Buddha and Seishi Bosatsu (dated 1267), Senshōji, Tochigi Prefecture. Kamakura Period. Gilt-bronze. a. Amida, H. 47.3 cm. b. Amida, Back view.

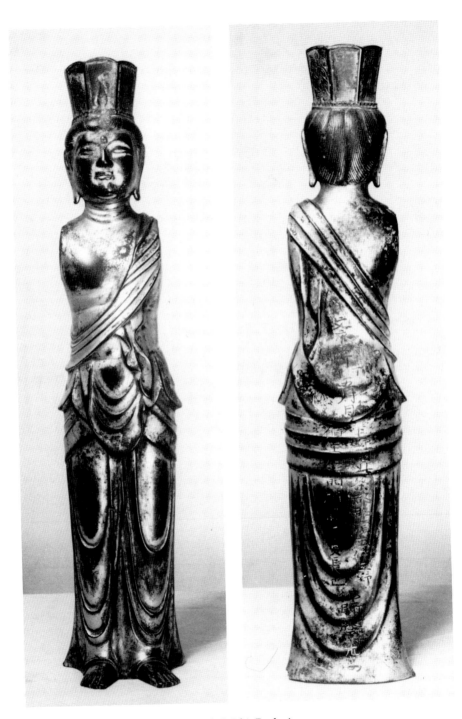

27c. Seishi Bosatsu, H. 33.6 cm. 27d. Seishi, Back view.

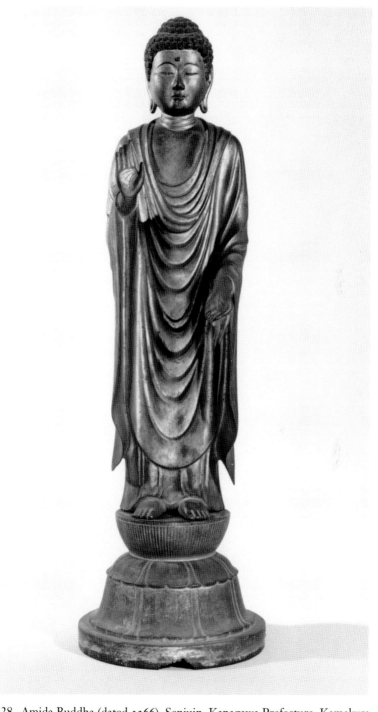

28. Amida Buddha (dated 1266), Senjuin, Kanagawa Prefecture. Kamakura
Period. H. 49.6 cm. Gilt-bronze.

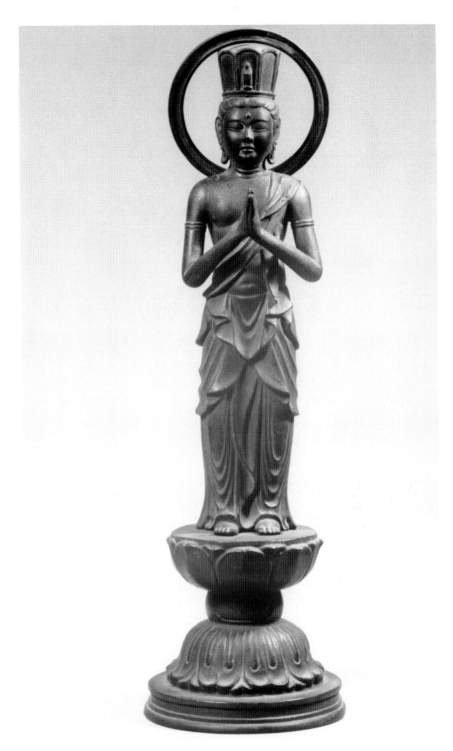

29. Kannon Bosatsu (dated 1266). Seichōji. Chiba Prefectre. Kamakura Period. H. 33.5 cm. Gilt-bronze.

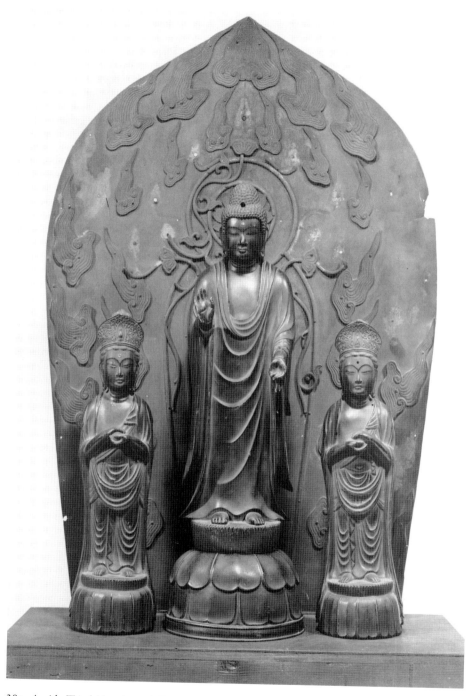

30a. Amida Triad (dated 1271) Engakuji, Kamakura City. Kamakura Period. Amida, H. 42.2 cm; Bosatsu, H. 33 cm. Gilt-bronze. Triad and Mandorla.

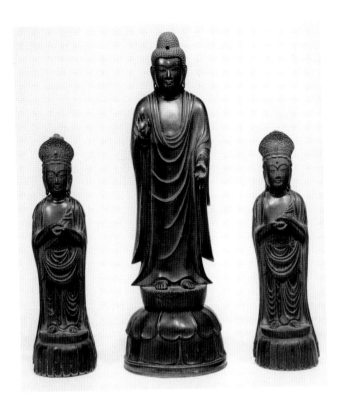

30b. Triad from front.

30c. Right side view.

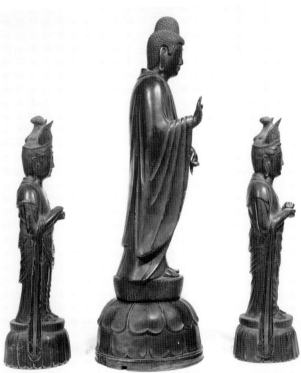

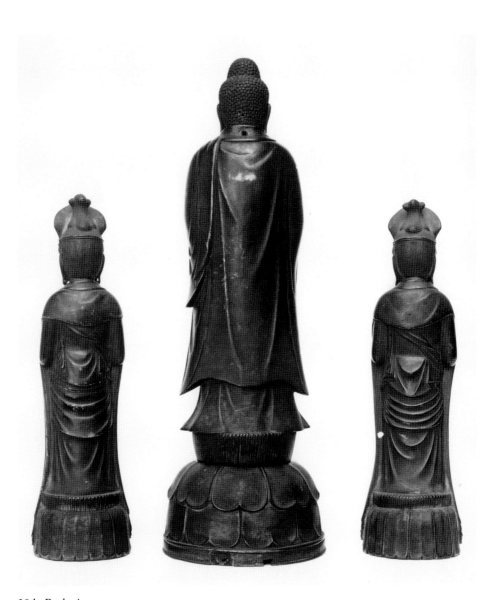

30d. Back view.

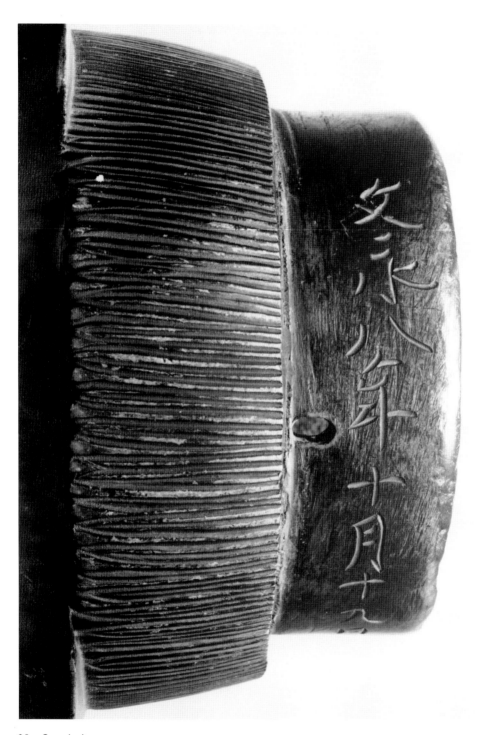

30e. Inscription.

31. Main Hall, Ankokuji, Hiroshima Prefecture. Kamakura Period.

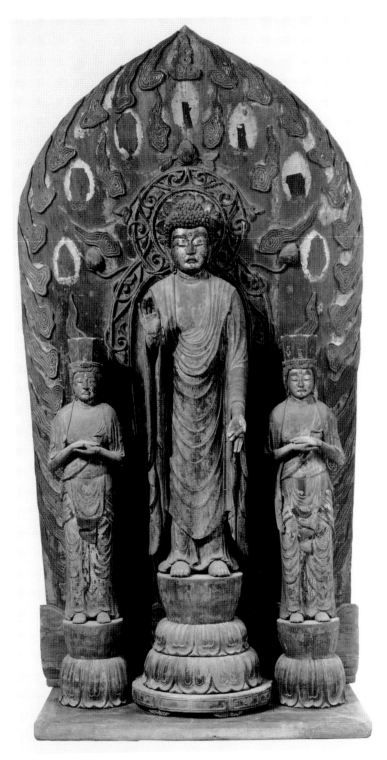

32a. Amida Triad (dated 1274), Ankokuji, Hiroshima Prefecture. Kamakura Period.
Amida, H. 171.2 cm; Bosatsu, H. 131.8 cm. Wood. Triad and Mandorla.

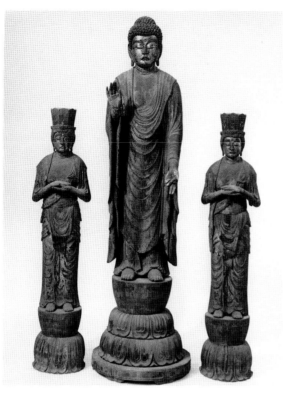

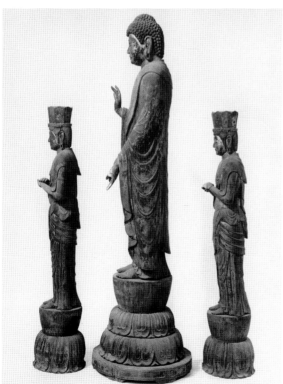

32b. Triad from front.

32c. Left side view.

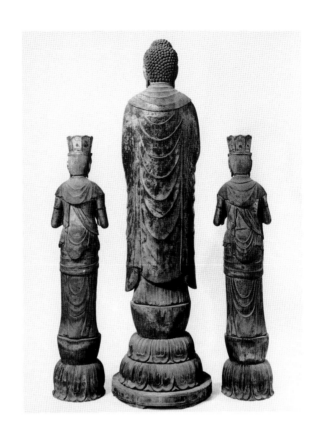

32d. Back view.

32e. Mandorla.

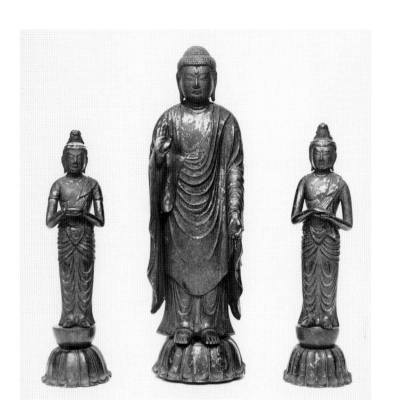

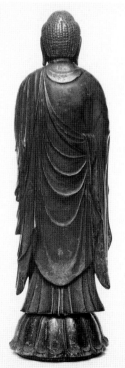

33a. Amida Triad,
Fudōin, Mt. Kōya,
Wakayama Prefecture.
Kamakura Period.
Amida, H. 48.8 cm;
Bosatsu, H. 32.8 cm
and 33.8 cm. Gilt-
bronze. 33b. Back
view.

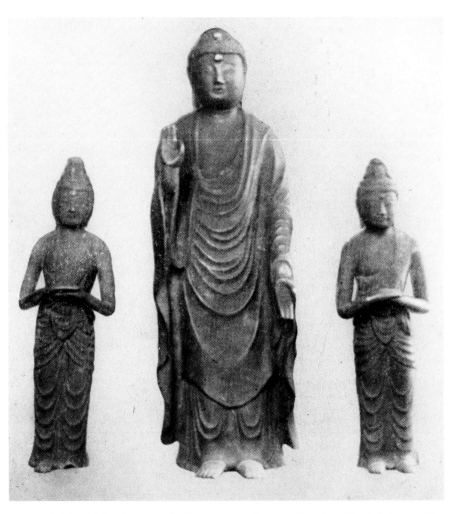

34. Amida Triad, Tachikawa-machi, Yamagata Prefecture. Kamakura Period. Amida, H. 48.2 cm; Bosatsu, H. 33.3 cm. Gilt-bronze.

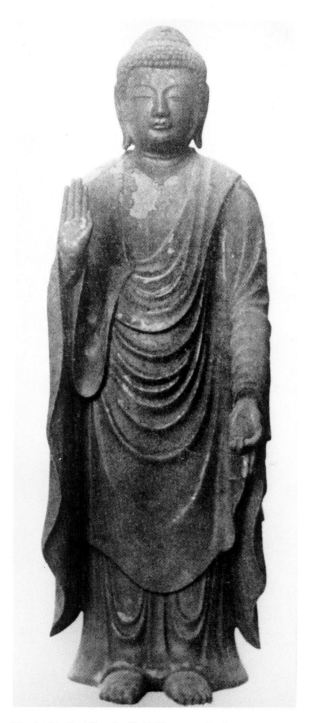

35. Amida Buddha, Amidaji, Yamagata Prefecture.
Kamakura Period. H. 49 cm. Gilt-bronze.

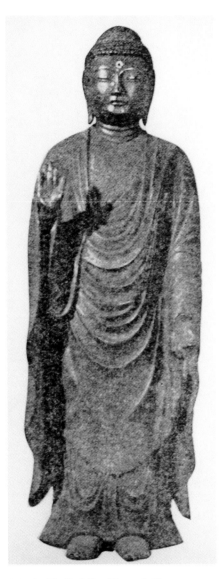
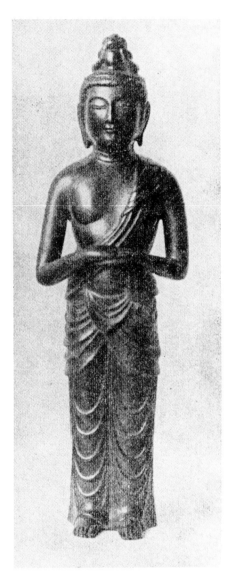

36. Amida Buddha, Hōsenji, Yamagata
Prefecture. Kamakura Period. H. 48.5 cm.
Gilt-bronze.

37. Bosatsu, Jōman Kōmin-kan, Yamagata
Prefecture. Kamakura Period. H. 33.6 cm.
Gilt-bronze.

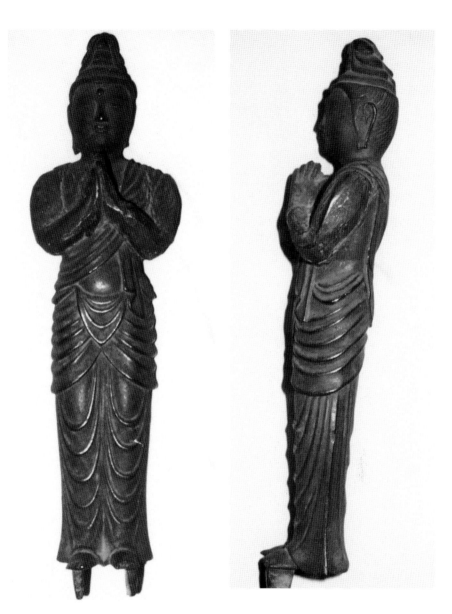

38a. Bosatsu, Sōgonji, Tochigi Prefecture. Kamakura Period. H. 32 cm. Gilt-bronze.
38b. Left side view.

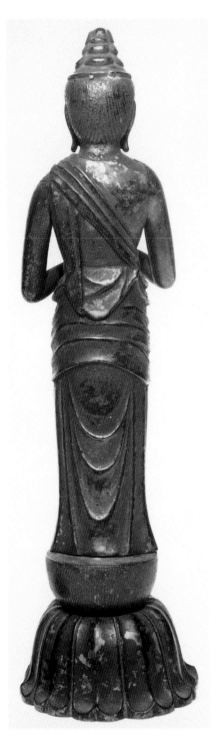

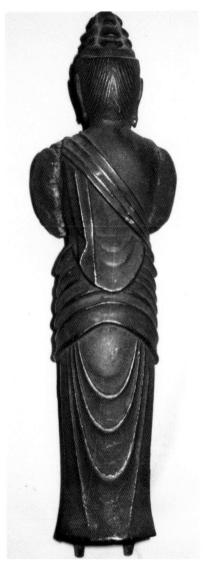

39. Comparison of back views: Left—
Bosatsu, Fudōin; Right—Bosatsu,
Sōgonji.

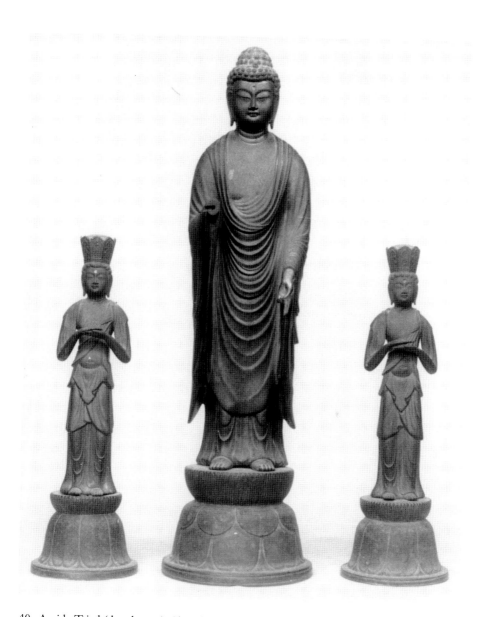

40. Amida Triad (dated 1290), Shūtokuin, Chiba Prefecture. Kamakura Period. Amida, H.
48.7 cm; Bosatsu, H. 30 cm and 30.5 cm. Gilt-bronze.

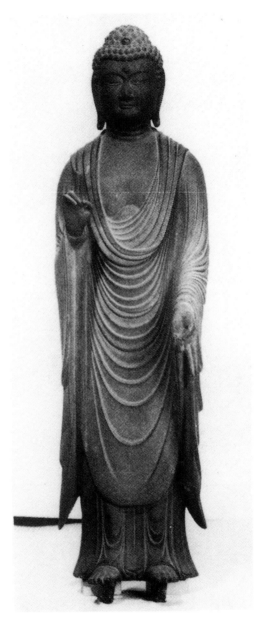

41. Amida Buddha, Eimyōji, Saitama Prefecture.
Kamakura Period. H. 48 cm. Gilt-bronze.

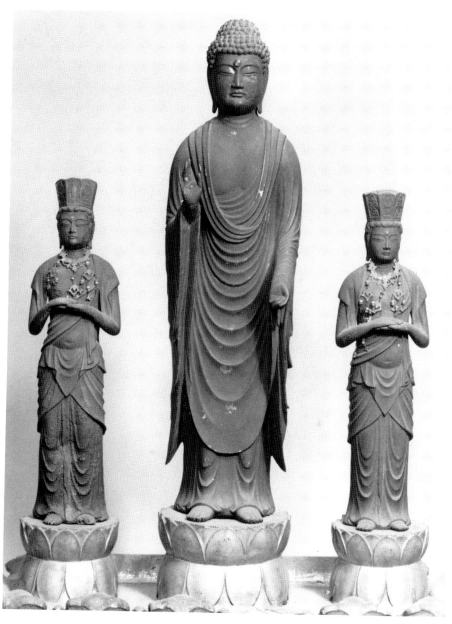

42. Amida Triad, Hōshōji, Kanagawa Prefecture. Kamakura Period. Amida, H. 47.5 cm;
Bosatsu, H. 33 cm and 34 cm. Gilt-bronze.

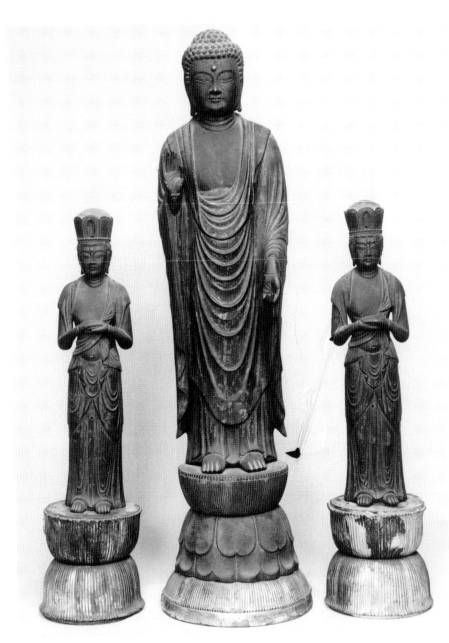

43a. Amida Triad (dated 1295), Manpukuji, Ibaragi Prefecture. Kamakura Period. Amida, H. 50 cm; Bosatsu, H. 34 cm. Gilt-bronze.

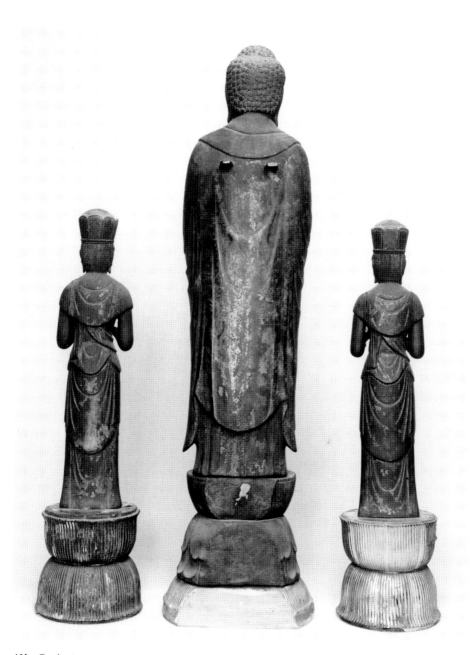

43b. Back view.

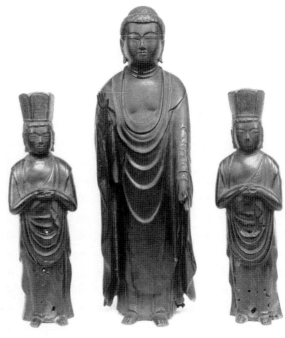

44. Amida Buddha (dated
1295), Kōmyōji, Saitama
Prefecture. Kamakura Period.
H. 48.5 cm. Gilt-bronze.

45. Amida Triad (dated 1300), Seikōji, Chiba Prefecture.
Kamakura Period. Amida, H. 48.3 cm; Bosatsu, H. 34.7 cm
and 34.9 cm. Gilt-bronze.

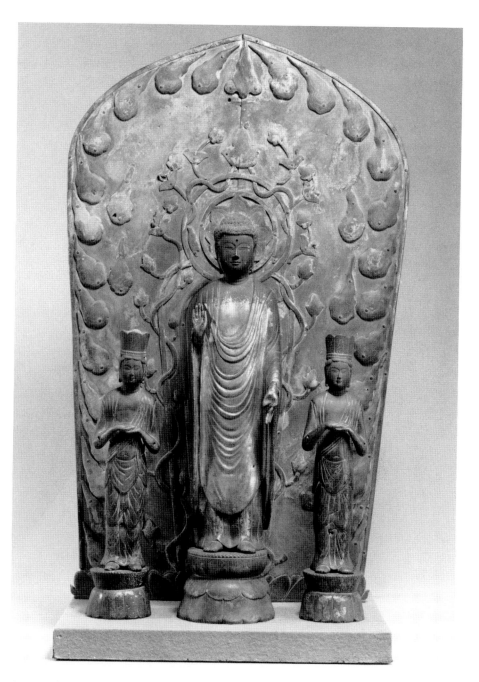

46. Amida Triad (dated 1304), Nyoraiji, Fukushima Prefecture. Kamakura Period. Amida,
H. 46.9 cm; Bosatsu, H. 33.1 cm and 33.3 cm. Gilt-bronze.

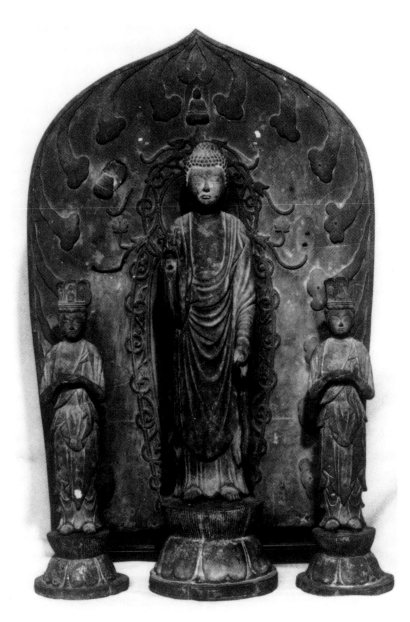

47. Amida Triad, Gyōtokuji, Chiba Prefecture. Kamakura Period. Amida, H. 43.3 cm; Bosatsu, H. 29.4 cm and 29.6 cm. Gilt-bronze.

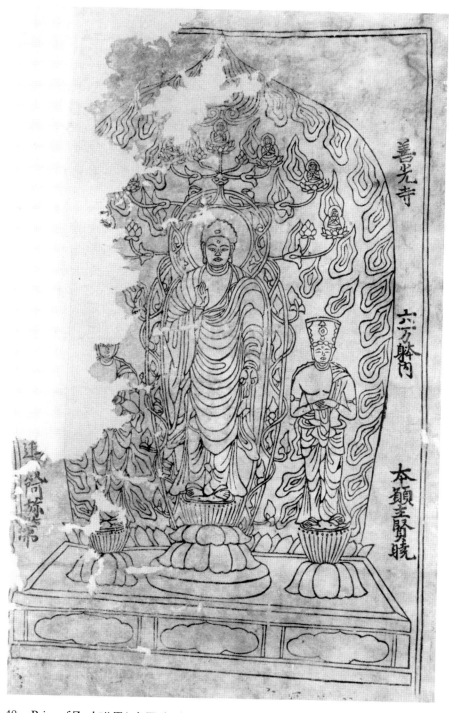

48a. Print of Zenkōji Triad, Tōshōdaiji, Nara. Kamakura Period. 46.5 × 28.2 cm. Paper.

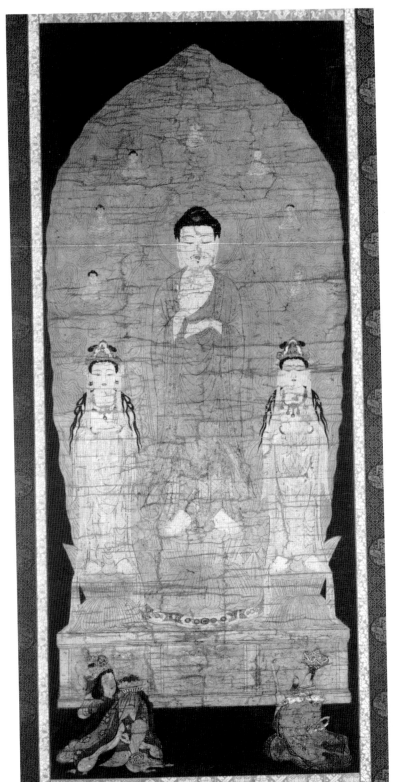

48b. Painting of Zenkōji Triad, Freer Gallery of Art, Washington, D.C. Kamakura Period. Colors/ink on silk.

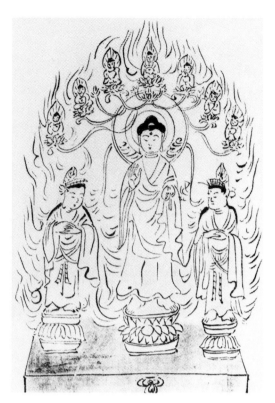

48c. Drawing of Zenkōji Triad, from the *Kakuzen-shō*. Kamakura Period. Colors/ink on paper.

49. View of Hōkōji, Kyoto. Detail from "Scenes of Life in and Around the Capital" (Rakuchū rakugai zu), Seattle Art Museum. Edo Period. Folding screens, total 67 7/8 × 149 3/4 inches.

50. View of the Kaidan-meguri, Main Hall, Zenkōji, Nagano City.

51. Receiving the Go-inmon, Zenkōji, Nagano City.